COLLABORATIVE
CIRCLES

———

COLLABORATIVE

CIRCLES

———

Friendship Dynamics & Creative Work

MICHAEL P. FARRELL

The University of Chicago Press Chicago and London

The University of Chicago Press, Chicago 60637
The University of Chicago Press, Ltd., London
© 2001 by The University of Chicago
All rights reserved. Published 2001
Printed in the United States of America
25 24 23 22 21 20 19 18 17 16 2 3 4 5 6

ISBN-10: 0-226-23866-0 (cloth)
ISBN-13: 978-0-226-238678 (paper)

Library of Congress Cataloging-in-Publication Data

Farrell, Michael P., 1942–
 Collaborative circles : friendship dynamics and creative work /
Michael P. Farrell.
 p. cm.
 Includes bibliographical references.
 ISBN 0-226-23866-0 (alk. paper)
 1. Social groups. 2. Artistic collaboration. I. Title: Friendship
dynamics and creative work. II. Title.
HM716 .F37 2001
305—dc21

 2001000924

TO MY CHILDREN

Michael, Colleen, and Jennifer

AND MY GRANDCHILDREN

Keighley, Griffin, Hannah, and Grayson

Contents

Acknowledgments

I began the research for this book more than twenty years ago when I discovered first John Rewald's historical study, then Mary Roger's sociological study of the French Impressionist artists. In their separate accounts of that group, I recognized many of the dynamics I was observing in my research on group development in laboratory groups, and I saw the possibility of using group theory to understand the dynamics of circles of artists and writers. Ever since that initial discovery, I have been gathering data on case studies of artists, novelists, poets, scientists, inventors, social reformers, and others who did their most creative work while working with a circle of like-minded friends. I am indebted to numerous biographers and historians who have told the stories of these circles. Without their careful work, the kind of analysis I have done would not be possible.

A number of people have pointed me toward these cases, and as friends and collaborators, many of them have patiently listened to my thinking as it evolved. Theodore Mills introduced me to the study of groups, and on his sailboat and in his home, he has served as a critical audience to my ideas about circles. Stanley Rosenberg has been my friend and collaborator since graduate school, and during my early years of working on this project, his encouragement and his knowledge about adult development were invaluable. As the project gained momentum, the critical responses of several people helped to clarify my thinking and encouraged me to go on. I especially want to thank Robert Freed Bales, Dean Pruitt, Milton Albrecht, Walter Sangree, Gary Alan Fine, Murray Levine, Gloria Heinemann, Barbara Illardi, Bruce Jackson, Thomas Spence Smith, Warren Bennis, Karen Reixach, Ted First, Deborah First, Stanford Segal, John and Victoria Cooley, Ted Perry, J. Paul Farrell, Jr., Christopher Densmore, Grace Barnes, Donald Sabo, Merrill Melnick, and Diane Bessel. I also want to thank my students, who, through their participation in my course on group analysis, as well as through their insights in discussions and papers, have taught me an enormous amount about groups.

I have received immeasurable help from the staff of several libraries and

museums, most notably, the University at Buffalo, State University of New York; the University of Rochester; Vanderbilt University; Cornell University; Columbia University; the Bodleian Library, Oxford; the British Library; the Freud Museum, London; the Art Institute of Chicago; Art Resource Archives; the Library of Congress; Wheaton College; and the University of Texas, Austin. Over the past few years I also have come to appreciate all the researchers who create Web sites on the Internet. Especially when it came to hunting down archives, my research often was shortened by the numerous leads I discovered on their Web sites.

I have been fortunate to receive the guidance of some gifted editors. Early in this project Margaret Zusky saw its value, and her seasoned editorial input as well as her faith in the project helped give it form and bring it to life. Doug Mitchell is one of the finest sociology editors in the business. His enthusiasm for the project was critical in bringing it to its final form. Robert Devens's patient support kept me going while completing all the fine detail work necessary in publishing. Carlisle Rex-Waller's attention to the details of the manuscript as well as the sound of each sentence contributed much to the readability of the work.

From the beginning to the end of this work, my wife, Madeline Schmitt, has been at the center of my collaborative circle. Her concerns about gender differences in circles were critical in setting me on the path of comparing male and female circles. She generously shared her observations about collaboration and group dynamics, and on numerous occasions we have arrived at some of the ideas in this book by thinking aloud together. She has critically edited numerous drafts, and each time the work has improved as a result.

Finally, I want to thank my children, Michael, Colleen, and Jennifer; their spouses, Shannon, Diavail, and Ted; and my nephew, Paul, for their encouragement and support throughout this project.

Although these people have all contributed to bringing this book to fruition, the responsibility for the book, especially any errors, are mine.

Introduction

In his study of Nathaniel Hawthorne's life, Henry James (1909) character-izes the writer as an isolated "empiric" during his young adult years. Because Hawthorne worked alone to develop a writing style, James sees him as "apt to make awkward experiments." In his own journals, Hawthorne describes this period as "that heavy seclusion in which I shut myself up for twelve years after leaving college, when everyone moved onward and left me be-hind." James argues that Hawthorne's isolation delayed his development. He suggests that, without a community of peers, a writer develops with more difficulty, and he contrasts the early work of such loners to the work of those who develop within a group:

> The best things come . . . from the talents that are members of a
> group; every man works better when he has companions working in
> the same line, and yielding to the stimulus of suggestion, comparison,
> emulation. Great things have of course been done by solitary workers,
> but they have usually been done with double the pains they would
> have cost if they had been produced in more genial circumstances.
>
> (James 1909, 31)

James is not alone in his observations about how a group of collaborat-ing friends—a collaborative circle—can affect creative work. Numerous artists, writers, composers, scientists, social reformers, and other creative people report that a collaborative circle played an indispensable part in their development. Yet there has been very little examination of the dynamics of these groups. In what kinds of settings do collaborative circles form? At what point in their lives do people join them? What are the stages of circle development? Why do some circles flourish, while others fall apart? How do the dynamics of a circle affect the creativity and adult development of its

members? The objective of this book is to explore these questions by analyzing and comparing case studies of collaborative circles that profoundly shaped the creative work of their members.

A collaborative circle usually begins as a casual association among acquaintances working in the same discipline. Members of a social network meet and find they enjoy one another's company. At first the circle may play a peripheral part in a person's life, no more than a group of companions who provide good conversation and occasional distraction from work. Then, for a variety of reasons, the members escalate their commitment to one another and deepen their interdependence until the circle becomes the center of their creative lives. Under some conditions, as the circle develops, the dynamics of the group transform the work of the members. Those who are merely good at their discipline become masters, and, working together, very ordinary people make extraordinary advances in their field. A circle usually lasts for approximately a decade, but rarely longer than fifteen years.

Circles often play a part in the development of artists and writers (Becker 1982; Cowley 1973), but these are not the only professionals who form them. Physicists, physicians, engineers, political leaders, and members of numerous other disciplines form collaborative circles with similar dynamics. In this book, I have chosen to focus mainly on artists and writers because the stages of circle development and their effects on creativity can be more readily observed in groups where members write, paint, or in some other way lay down "visible" tracks. I have chosen to deal with deceased people simply because of the greater availability of biographical data and expert evaluation of their work.

In the course of my research on circles I have examined, among others, the French Impressionist painters; Kandinsky and the Bleu Rider group; Picasso, Braque, and the Cubists; the Fugitive poets at Vanderbilt University; Freud and his early collaborators; John Steinbeck and his Pacific Grove circle; the Rye circle that included Joseph Conrad, Ford Madox Ford, Stephen Crane, Henry James, and H. G. Wells; the Canadian Group of Seven painters; the Bloomsbury group in London; Susan B. Anthony, Elizabeth Cady Stanton, and the early women's rights collaborators; C. S. Lewis, J. R. R. Tolkien and the Inklings; William Morris, Edward Burne-Jones, Dante Rossetti, and the later Pre-Raphaelites; Godowski and Mannes—the inventors of Kodachrome film; and others. Not all the cases are discussed in this book, but all have contributed to my conceptualization of the dynamics of circles.

My approach is one of comparative analysis of case studies. Working

with letters, journals, autobiographies, and biographies, I have reconstructed the history and developmental dynamics of each group. With each circle, I have examined the expert evaluations of the work that members produced before, during, and after the period of involvement with the group. I chose experts on the basis of citations to their work, current reviews, and advice of scholars in the relevant disciplines. In looking at the historical context of each group, I have relied on the work of historians and biographers, evaluating their work based on the same process used to evaluate the work of critics in a field—citations, currency of the publication, thoroughness of scholarship, and reputation among members of the relevant discipline.

For each case, I have laid out the history of the group on a time line beginning when the members first met. For example, the time line for the Impressionist painters' circle begins in 1862, when Monet, Renoir, Bazille, and Sisley first met in Gleyre's studio (Farrell 1982). It tapers to an end around 1885, when the members were living and working alone and had developed their own, more individuated styles. On the time line, I laid out the works produced by the members and the events in the development of the group. Making use of descriptions of the members' interaction and their accounts of one another's behavior, I demarcated the stages of the circle development based on periods of stability and change in their interaction and in the types of work done; then I carried out an analysis of the group processes that occurred at each stage. After completing an analysis of one case, I analyzed the next case, and examined how well my emerging conceptual framework fit that case. The theory was then revised based upon my analysis of each succeeding case. Finally, by comparing the cases, I developed a general theory of the factors that contribute to the formation of circles, as well as the common processes that occur at each stage of circle development.

Over the course of my professional career, I have been a member of three collaborative circles in which friendship and collaboration became intertwined. These experiences have affected me in numerous ways, and my observation of the dynamics of these relationships has been another source for my thinking about the dynamics of collaborative circles. The theory also draws on my observations of development in self-analytic groups (Farrell 1976; Mills and Farrell 1977; Farrell, Heinemann, and Schmitt 1986; McCollom 1990). Self-analytic groups are groups in which students collaborate in learning about group dynamics by observing and analyzing events in their own group. Finally, the theory draws upon survey research studies of friendship and social support across the life course (e.g., House, Umberson, and Landis 1988; Farrell 1986; Fischer 1982). Although survey research can-

not provide the depth of information about group processes that can be obtained from biographies and direct observation, it can provide clues about the conditions that lead to the formation of collaborative circles.

Although I have been gathering data for these case studies for more than twenty years, in many ways I feel the task is incomplete. Qualitative data is always amorphous, and approaches to analyzing it often are open-ended. When you discover new cases, or when new information about a group you have already studied emerges, it is hard to know when you are done. I started to write this book, in part, to get down what I had learned and to let go of the project. Along the way, as I compared the cases, I discovered regularities that I had not noticed when I looked at each case individually. I have also discovered that some processes that I thought were important for circle development occurred in only one or two groups. I noticed something new with each case, which forced me to go back and look again at earlier cases in a new light. At times it seemed this process could go on indefinitely, with each new case stimulating new questions that had to be checked against the earlier cases. But eventually, as I examined new cases, I reached the point where I was not making major changes in my emerging theory.

Although I still feel the conceptualization is incomplete, I want to present what I have learned up to this point in hopes that others will become as interested in circles as I am. People who began their careers in collaborative circles often tell how crucial a circle was in their own personal development and in the development of their work. I believe them, and I think there is much to learn about the group processes that occur in these groups.

Overview

The book is organized so as to engage the reader in the process of inductive analysis that I used in the case studies. Each chapter is organized around the development of one collaborative circle. Wherever possible, I have included letters and excerpts from journals and interviews, so that the voices of the members convey the processes that occur as a circle develops. The excerpts are presented as evidence, but I intend that they also provide enough information for the reader to evaluate my analyses.

Chapter 1 introduces the basic concepts of the theory, using as an example the Inklings, a group formed by C. S. Lewis, J. R. R. Tolkien, and their friends. After introducing the basic characteristics of a collaborative circle, I outline a theory of circle development that will be discussed in detail in subsequent chapters.

In chapter 2, I examine the complete life course of one case—the French

Impressionist painters. The core group consisted of four young men who met in an art teacher's studio in 1862 when they were all in their early twenties—Claude Monet, Pierre Auguste Renoir, Alfred Sisley, and Jean-Frederic Bazille. Eventually the core group expanded to include others. This group is a prototypical case of a collaborative circle in which the members first became friends, then developed a shared style and built their careers within the context of a circle. I will return to this case throughout the book, comparing what I observed in this group to processes that occur in other groups.

In subsequent chapters, I look more closely at the stages of development in sequence. In chapter 3, I examine the early stages, that is, the formation and rebellion stages of circle development. Using the Fugitive poets as the case study, I examine in detail the conditions under which circles form, as well as the roles, rituals, and interaction that characterize the early stages of development. The Fugitives included John Crowe Ransom, Donald Davidson, Allen Tate, Robert Penn Warren, and other members of the Southern Renaissance circle of poets who first met at Vanderbilt University just before and for a while after World War I. I have chosen to focus the analysis on the development of Donald Davidson, who, though less well known than some of the others, played a crucial role in the development of the circle and was profoundly influenced by it.

In chapter 4, I examine the dynamics of the intermediate stages, or the quest and creative work stages, of circle development. The case study for this chapter is the circle that included Joseph Conrad and Ford Madox Ford. This circle formed in the late 1890s out of network of friends who lived near Rye in Kent and East Sussex, south of London. The group also included Stephen Crane, Henry James, and H. G. Wells. Although Conrad and Ford developed into a collaborative pair, the rest of the group never became successful collaborators. After examining the factors that blocked the full development of this group, I will focus on the dynamics of the collaborative pairing of Conrad and Ford.

In chapter 5, I focus more closely on the interaction within collaborative pairs. The case study is Freud's early circle of collaborators—Ernst Breuer and Wilhelm Fleiss. The correspondence of Freud and Fleiss between 1887 and 1904 constitutes one of the most detailed accounts available of the interaction between collaborators across the life course of their friendship. The letters cover the period leading up to the most creative period in Freud's life, when he broke free of his commitment to a reductionist, neurological theory of neurosis and developed the foundations of a purely psychological theory. Throughout this period, Fleiss was his closest friend and

collaborator. Because they lived in separate cities and met only a few times each year, they corresponded often, and their correspondence constitutes a remarkable record of interaction in a collaborative circle.

In chapter 6, I examine the dynamics of the "Ultras," the name taken by the extremists among the women who led the drive for women's rights in the United States in the 1850s. The circle included Elizabeth Cady Stanton and Susan B. Anthony, along with Lucretia Mott, Lucy Stone, and Antoinette Brown. In analyzing this case, I focus on the transformation of the relationships in circles as they move through the collective action and separation stages. In addition, I explore some of the gender differences in the dynamics of circles. In the nineteenth and early twentieth centuries, women were excluded from collaborative circles in most disciplines. It was rare to find women included in the café discussions of the Impressionists or in the private chambers of the Oxford dons. As the roles of men and women have converged at the end of the twentieth century, women have become more likely to participate in collaborative circles. However, the structural and cultural constraints on women's participation, which to a certain extent are still present, stood out more visibly in the nineteenth century; and the unique resources that women bring to circles may also stand out more clearly.

In the final chapter, I summarize my emerging theory of circle development, placing my findings in the context of research on social networks as well as previous theories of group and adult development.

Chapter 1

Collaborative Circles and Creative Work

A collaborative circle combines the dynamics of a friendship group and a work group. At the core is a set of friends who, over a period of time working together, negotiate a shared vision that guides their work. As the group evolves, the members develop their own rituals and jargon, and each member comes to play an expected role. To illustrate a collaborative circle, I begin with a sketch of the formation of the Inklings, a circle formed by J. R. R. Tolkien, C. S. Lewis, his brother Warner, and their friends (plates 1–2).

C. S. Lewis had his first conversation with J. R. R. Tolkien in May 1926, after a faculty meeting of the English department at Oxford University. For both men it was the end of their first academic year there. Lewis, age twenty-eight, was a fellow, and Tolkien, age thirty-four, was a professor. They met at a time when Lewis, who had studied at Oxford as an undergraduate, felt distant from his remaining undergraduate friends and a growing disillusionment with his faculty colleagues. For his part, Tolkien was in a period of conflict with his wife and in the midst of a struggle with his colleagues over restructuring the curriculum in the department.

Lewis liked Tolkien as a person, but he opposed the position he took in the faculty meeting. Tolkien had argued that the English curriculum should focus on the "language"—a code word for classical English literature. He opposed inclusion of "modern" literature, which to him meant anything written after Chaucer. Despite their differences, over the course of the next academic year Lewis was drawn into a large discussion group that had formed around Tolkien. The group, known as the "Coalbiters," met to read and discuss Nordic literature and language. Over the next few years, Lewis ambivalently began to support Tolkien's position on the English curriculum. Often they supported one another in faculty politics and debates, but occasionally they still found themselves on opposing sides.

7

In December of 1929, the relationship took a new turn. In the course of that month, their collegial association deepened, and the friendship became the nucleus of a collaborative circle that profoundly influenced each man's development. Until this point, Tolkien had been a relatively successful philologist and scholar of early English literature. His publications suggested he would have a distinguished career in an esoteric corner of the academic world. Lewis had published two books of poetry that hardly anyone had noticed, and even after he became famous, they were never well regarded (Hooper 1996; Wilson 1990). On 3 December 1929, Lewis wrote to a friend: "I was up till 2:30 on Monday, talking to the Anglo Saxon professor Tolkien, who came back with me to college from a society and sat discoursing of the gods and giants of Asgard for three hours, then departing in the wind and rain—who could turn him out, for the fire was bright and the talk good" (Carpenter 1979, 28).

Nordic epics had enthralled Tolkien when he was a child. His fascination led him to create his own imaginary mythology, and from the time he was eighteen he worked sporadically at casting his stories of elves and wizards into an epic poem. Only once had he allowed anyone to see this work. In 1925 he showed it to an old mentor, who advised him to drop it. The rebuff reinforced his decision to keep the work secret. But after discovering that Lewis shared his interest in "Northernness" and epic poetry, a few days after the late night conversation, Tolkien gave Lewis one of the unfinished poems to read. It began:

> There once, and long and long ago,
> before the sun and moon we know
> were lit to sail above the world,
> when first the shaggy woods unfurled,
> and shadowy shapes did stare and roam
> beneath the dark and starry dome
> that hung above the dawn of Earth . . .

Lewis read the whole poem and immediately wrote to Tolkien (Carpenter 1979, 30):

My dear Tolkien,

Just a line to say that I sat up late last night and have read the geste as far as to where Beren and his gnomish allies defeat the patrol of the orcs above the sources of the Narog and disguise themselves in the reaf. I can quite honestly say that it is ages since I have had an evening of such delight, and the personal experience of reading a friend's work

had very little to do with it. . . . So much for the first flush. Detailed criticisms (including grumbles at individual lines) will follow.
Yours,
C. S. Lewis

When Lewis sent his criticisms, he playfully presented them as annotations to Tolkien's text—pretending that the text was an ancient manuscript and that his comments were long footnotes in which imaginary scholars with names like "Pumpernickel," "Peabody," "Bentley," and "Schick" debated about the authenticity of particular lines and speculated about how the lines should actually be worded. Tolkien rewrote most of the lines singled out by Lewis, and in a few cases incorporated his suggested revisions.

Over the next several months, the culture and structure of their collaborative circle crystallized. Tolkien learned that Lewis liked to read aloud, and at Lewis's suggestion he read sections of the poem to him. Gradually others were invited into the group, including Lewis's brother, Warner; Hugo Dyson; Lewis's close friends R. E. Havard and Owen Barfield; and later in the decade, Charles Williams. As the meetings became more frequent, the members established a ritual of taking turns reading aloud their works in progress. Borrowing a name from a previous group, Lewis called the group the "Inklings." Tolkien characterized the name as a "pleasantly ingenious pun in its own way, suggesting people with vague or half-formed intimations and ideas plus those who dabble in ink" (Tolkien 1967). By the second half of the decade, they had established a regular meeting time on Thursday nights in Lewis's room in Magdalen College. On Tuesdays some members of the group met for lunch and a pint of ale at the Eagle and Child pub— "the Bird and the Baby," as they called it.

Even before the regular meetings became ritualized, the dialogue between Tolkien and Lewis had led to profound changes in Lewis's identity and worldview. On the evening of 19 September 1931, one of their conversations about language and poetry suddenly became personal. Lewis had invited Tolkien and Hugo Dyson, who was a lecturer at Reading, to dinner at Magdalen. Dyson was a talkative, witty man, whose conversation was a "flow of fantasy, keen literary appreciation and occasional learning" (Wilson 1990, 124). Their conversation flowed from a discussion of myths, to Christianity, to the origin of ancient words, and, jokingly, to the differences in how elves and humans understood language. After dinner they continued the discussion, walking the paths around the courtyard and gardens of Magdalen College until three in the morning. As the conversation went on, they gradually began talking about their religious views.

For an Oxford scholar at this time to take religion seriously and to disclose his beliefs to a colleague was unusual, to say the least. As Lewis later put it, Oxford was in a "post-Christian" era (Hooper 1996). When he was in his early twenties, Lewis had decided he was an atheist, but after the death of his father when he was thirty-one, he began to reconsider his beliefs. Privately, he came to accept the idea that there was a deity, but this belief was not anchored in any religious tradition. He felt particularly skeptical about Christianity, which he viewed as a religion built on recycled mythology. For him, the story of the death and resurrection of a god resembled too closely the ancient Egyptian myths about gods who died and returned to life (Lewis 1995). Until the discussion with Tolkien and Dyson, he had not disclosed his thinking to anyone; but in the deepening exchange that night, he risked exposing his views.

The three men shared enough assumptions that they were open to each other's arguments. Tolkien, who was Roman Catholic, agreed that the New Testament story was a myth, but he argued that it was a profoundly different myth, for it was also a true story based on historical events. Like all good myths, he argued, it expressed some fundamental truth. His argument, which may have seemed particularly persuasive to Lewis in the wee hours of intense conversation, was that the historical events had unfolded in the form of a familiar myth so as to create a story that would penetrate human consciousness. Like an alien visitor, the deity had borrowed the language of a familiar myth to convey a theological "reality." Although perhaps not firmly grounded in logic or evidence, Tolkien's argument had many fine points, and after several days' germination the outcome of the conversation was that Lewis, the urbane Oxford scholar, decided to become a Christian. Possibly because of his Northern Irish Protestant background, Lewis could not allow himself to become a Roman Catholic, like Tolkien, but he did decide to become an Anglican. Over the next year, with some variations in individual positions, the Inklings incorporated Christianity as a core component of the culture of their circle.

As the structure and culture of the circle evolved, and as their discussions continued, the members did not always agree, but they negotiated a shared "mythopoetic" vision of narrative, literature, and religion that inspired and shaped their work. Their shared Christian religious beliefs and their fascination with the form of myth were the foundations of a vision that influenced the members' writing for the rest of their lives. For example, many of the themes in Tolkien's Lord of the Rings series and Lewis's Narnia tales first emerged in these weekly discussions. After discussing a theme, a member might go home, write a chapter that gave form to the theme, then read what

he wrote in a Thursday evening meeting. As the men reacted to the reading, they helped to reshape the work and in doing so sharpened their own understanding of the emerging group vision.

The early discussions in the Inklings circle dramatically altered Lewis's thinking, and over the course of the next few years the group interaction shaped both the themes and the style of his literary work. Recounting how the circle freed him to construct his own imaginative work, Lewis wrote: "Alone among unsympathetic companions, I hold certain views and standards timidly, half ashamed to avow them and half doubtful if they can after all be right. Put back among my friends and in half an hour—in ten minutes—these same views and standards become once more indisputable. The opinion of this little circle . . . outweighs that of a thousand outsiders. . . , it will do this even when my Friends are far away. (1960, 114).

In his diary from this period, Tolkien wrote that the "friendship with Lewis compensates for much and besides giving constant pleasure and comfort has done me much good from the contact with a man at once honest, brave, intellectual, a scholar, a poet, and a philosopher." Many years later, Tolkien wrote of Lewis: "The unpayable debt I owe to him was not influence as it is usually understood, but sheer encouragement. He was for long my only audience. Only from him did I ever get the idea that my stuff could be more than a private hobby" (Carpenter 1977, 148).

This sketch of the Inklings suggests the ways collaborative circles develop and provides a glimpse of the processes and influences we will be examining throughout this book. With the Inklings as our starting point, let us move on to a discussion of what we mean by "collaborative circle."

Definitions

A collaborative circle is a primary group consisting of peers who share similar occupational goals and who, through long periods of dialogue and collaboration, negotiate a common vision that guides their work. The vision consists of a shared set of assumptions about their discipline, including what constitutes good work, how to work, what subjects are worth working on, and how to think about them. For a group of artists, the shared vision might be a new style. For a group of scientists, it might be a new theoretical paradigm. Each member comes to play an informal role in the circle, and each role may have a history as the group develops over time. Even while working alone, the individual members are affected by the group and the roles they play in it. As C. S. Lewis observed, the group vision and the roles each participant plays in the group continue to guide and sustain the mem-

bers, "even when . . . Friends are far away." For members of the collaborative circle, each person's work is an expression of the circle's shared vision filtered through his or her own personality.

It is important to distinguish a collaborative circle from a mentor-protégé relationship. Although a mentor often plays a part in the development of a creative person, that role differs from the part played by a collaborative circle. A mentor is an older, more established professional who conveys the vision of a previous generation and guides the protégé's early steps into a discipline. The protégé may in time become ambivalent about and rebel against the dependence inherent in this subordinate role (Levinson et al. 1978). In other circumstances, the protégé might become the disciple of the mentor, reluctant to accept creative advances that challenge the mentor's work. In contrast, collaborative circles are groups formed by peers who negotiate an innovative vision of their field. Often they first come together as a friendship group that only later evolves into a collaborative circle. Although protégés of the same mentor sometimes form a collaborative circle, when they do, their relationship to the mentor and the mentor's vision may be clouded by ambivalence.

Collaborative Circles as Pseudo-Kinship Groups

In modern and postmodern societies, collaborative circles play a more important part in adult development than they did in traditional societies. In traditional societies, children learned their occupational skills in their families. In modern and postmodern societies, where technological and cultural changes are relentless, family members rarely have the expertise to socialize a child into a discipline. Each professional discipline has a constantly changing body of knowledge and skills that must be mastered before a novice can become a practicing member. In the period between adolescence and adulthood when a person disengages from the family, masters a discipline, and crystallizes an adult occupational identity, a collaborative circle often becomes the primary group that completes socialization.

For those who begin their careers in a collaborative circle, the group provides informal socialization into their discipline. Working side by side, they master new techniques. In backstage discussions, they fine-tune their understanding of concepts and hone their ability to speak the jargon of their discipline. They orient each other to the great debates of the day, and even act them out in their arguments with one another. They learn about the political coalitions and animosities between important people in their field, and what should or should not be said to whom. They also learn about the

social structure and career ladders. Eventually, they come to know where they stand on the current issues in their discipline, or, in other words, they clarify their professional identities. Most important, the shared vision, style, or culture of the group shapes their work during a large portion of their careers.

Transference of Familial Relationships

In a sense, the circle becomes a surrogate family, and the interpersonal relationships within the circle often are weighted by the emotional transference of familial relationships. Members may consciously or unconsciously see one another as brothers and sisters, or "family," and a mentor may be seen as a parental figure. In turn, the mentor may see the members of the collaborative circle as intellectual "children."

Once these transferences are engaged, the circle has the potential to work like a therapy group. Members may use the group to restage the dynamics of their family relationships and free themselves from constraining patterns. For example, one member may be overly compliant to authority because of anxiety about pleasing a parent; another may transfer a competitive relationship with a sibling onto someone in the circle. If compulsive styles of relating to authority and peers interfere with creative work, the interaction in the circle may enable members to work free of them and achieve a more mature style of working and relating to others. As they dispel the shadows of their familial relationships, the members gain increased mastery over the psychological processes that block or distort their creative work.

Freud himself was enmeshed in a collaborative circle laden with transference dynamics when he developed the foundations of psychoanalytic theory (Mahony 1979; Erikson 1989; Schur 1972). It could be argued that he crystallized his understanding of the dynamics of transference in part through his analysis of his relationships to the members of this circle. For example, some of his fundamental insights about transference emerged out of his analysis of the dynamics of his friendship with his collaborator, Wilhelm Fleiss. In 1897, while he was in the midst of his self-analysis and working on *The Interpretation of Dreams,* Freud became fascinated by the parallels in a youthful relationship with a nephew very close to him in age and his adult relationship with Fleiss.

In the 1890s, his friendship and collaborations with Ernst Breuer and Wilhelm Fleiss stimulated and sustained him through a decade of professional isolation and discouragement. As he theorized about the causes of hysterical paralysis and other psychological symptoms, he saw himself as a member of this collaborative circle, and he saw the work of all three mem-

bers potentially converging on a common theory. For example, 4 April 1896, he wrote to Fleiss that he was "busy thinking out something which would cement our work together"(Bonaparte, Freud, and Kris 1954, 141). Reluctantly preparing to abandon his initial neurological theory of neurosis in favor of a purely psychological theory, he explained to Fleiss: "It is primarily through your example that intellectually I gained the strength to trust my judgement, even when I am left alone . . . and, like you, to face with lofty humility all the difficulties that the future may bring. For all that, accept my humble thanks! I know that you do not need me as much as I need you, but I also know that I have a secure place in your affection" (1 January 1896, in Masson 1985, 158).

Collaborative Circles as Delinquent Gangs

Collaborative circles usually form among persons in their twenties or early thirties. Although the participants are usually well beyond adolescence, in many ways the dynamics of a circle resemble those of a delinquent gang. By definition, creative work is deviant, in that, in form or content, it does not conform to established traditions in a field. Particularly in the early stages of the development of a circle, as members are developing a culture that encourages creativity, they often are more than simply innovative—they are deliberately provocative toward those in authority. During this period, the work sometimes resembles acts of vandalism, in which the members desecrate symbols of authority in their field. The group members see themselves as rebels, and responding to one another's dares, they take pride in devaluing the sacred icons of the previous generation. An example of work done during this stage of circle development is Marcel Duchamp's replica of the Mona Lisa. The replica is nearly identical to Leonardo's original, except, reflecting the iconoclastic style of his Dadaist circle, Duchamp penciled in a moustache and goatee on Mona Lisa's face. There is an element of conspiracy, or as Miller (1983) calls it, "complicity," in a circle during this early stage of development. In his analysis of his own experience in the Inklings, C. S. Lewis takes just this tone: "Every real friendship is a sort of secession, even a rebellion. It may be a rebellion of serious thinkers against accepted claptrap or of faddists against accepted good sense: of real artists against popular ugliness or of charlatans against civilized taste; of good men against the badness of society or of bad men against its goodness. Whichever it is, it will be unwelcome to Top People" (1960, 114).

For some circles, the targets of rebellion are broader than just the authorities within their own discipline. At times members may engage in pranks, vandalism, or more serious protests aimed at a wide range of au-

thorities. For example, in February 1910, before they crystallized their mature styles in art and literature, several members of the Bloomsbury group carried out an elaborate prank on the British navy that came to be known as the "Dreadnought Hoax" (Edel 1979; Stansky 1996). As Stansky notes, the pranksters were a group of "disrespectful young people" with "some degree of subversive thought about the concept of Empire" (1996, 18). Instigated by Horace Cole and Adrian Stephen, Virginia Woolf's younger brother, they concocted a plan to "hoodwink the British Navy, to penetrate its security and to enjoy a conducted tour of [the H.M.S Dreadnought], the flagship of the Home Fleet, the most formidable, the most modern and the most secret man o' war then afloat" (Bell 1972, 157).

They first sent a telegram that appeared to come from the undersecretary of the British Foreign Office, announcing a visit by the "emperor of Abyssinia." A few hours later the group of six friends, including Virginia, age twenty-eight, and Adrian, age twenty-seven, Horace Cole, age twenty-eight, and Duncan Grant, age twenty-five, arrived at the ship. Four of them, including Virginia, who played one of the princes, wore robes, turbans, and dark makeup, and pretended they could not speak English. Adrian pretended to be their translator. The navy reception crew met them on the dock and escorted them aboard the ship boasting about its capabilities. The guests were introduced to the admiral. Adrian bowed and struggled to translate the nonsense words of his charges into appropriate English phrases; then he struggled to translate the admiral's English back into the visitors' gibberish. The "prince" requested a rifle salute, and the admiral graciously complied. Bowing and smiling, the group of visitors returned to shore. The navy officers were completely fooled, until, much to their embarrassment, Horace Cole leaked the story to the press and provided photographs as evidence. Virginia Woolf participated partly in response to pressures from her brother and partly for the fun of it, but the events contributed to her feminist perspective on masculine subcultures. In summing up the significance of the event, Quentin Bell notes that "the theme of masculine honour, of masculine violence and stupidity, of gold-laced masculine pomposity remained with her the rest of her life. She had entered the Abyssinian adventure for the fun of the thing; but she came out of it with a new sense of the brutality and silliness of men" (1972, 167).

In the early stages of circle development, not only do the members' attitudes toward external authority resemble those of a delinquent gang, but their interpersonal relationships have some ganglike qualities. The members of the circle, like members of a gang, goad one another on, encouraging their creative endeavors, until they cross the boundaries of accepted

ways of thinking and working in a field. They set a pace for working, and they escalate the level of risky play on the edges of acceptability. While working alone, a member may be tempted to try something new, something even forbidden by authorities in the field; but alone, the person does not follow through on the impulse. When the impulse is validated by other members of a circle, the conflicted member is more likely to act. An outrageous work by one member of the group becomes a dare for the next member to match. A wild idea thrown out in the midst of an argument may be picked up and incorporated into the emerging group vision. Like delinquents, the members say and do things together that none would ever have done alone. In analyzing his experience in the Inklings group, C. S. Lewis recognizes the thin boundary between collaborative circles and delinquent gangs:

> Friendship . . . is born at the moment when one man says to another "What! You too? I thought that no one but myself . . . " But the common taste or vision or point of view which is thus discovered need not always be a nice one. From such a moment art, or philosophy, or an advance in religion or morals might well take rise; but why not also torture, cannibalism, or human sacrifice? Surely most of us have experienced the ambivalent nature of such moments in our own youth? It was wonderful when we first met someone who cared for our favorite poet. . . . But it was no less delightful when we met someone who shared a secret evil. This too became far more palpable and explicit; of this too, we ceased to be ashamed. Even now, at whatever age, we all know the perilous charm of shared hatred or grievance.
>
> (1960, 113)

Of course, creative work is much more than delinquency. If the rebellious urges are not sublimated into disciplined mastery of a field, and if they are not guided by the circle's emergent vision, the creative work will not amount to much more than the graffiti of real delinquents. Nevertheless, in the early stages of circle development, the work of the members may be more like rebellious acts of vandalism than disciplined works of art or science. And, as we shall see, the conditions under which circles form resemble those in which some types of delinquent gangs form.

Circles and Creativity

In his analysis of Freud's relationship with Fleiss, Kohut (1985) notes the limitations of conventional theories of creativity. Traditional theories propose that creativity requires isolation and individuation, and that creative

work is most likely to be done by highly autonomous individuals working alone (e.g., Storr 1988; Williams 1960). Kohut suggests that this theory has obscured our understanding of cases in which creative people, including Freud, have done their most creative work while embedded in a collaborative circle. He refers to the strong bonds that often characterize relationships in circles as "mergers with selfobjects." To underline his conceptualization of interdependent, "merging" selves, Kohut spells "self object" as one word. The creative person experiences the selfobject as an extension of self, at once a fascinated audience and an idealized model. In a state of interdependent merger with one another, members of a collaborative circle trust one another with their wildest ideas, use each other as sounding boards and critics, and develop a sense of common mission. Erik Erikson characterizes Fleiss as Freud's "other," his coconspirator, applauding audience, and cautioning chorus who "seems to have had the stature and the wide education which permitted Freud to entrust him with imaginings, transpositions, and guesses . . . [that] turned out to be elements of a true vision and blueprint for a science" (Erikson 1989, 395).

Embedded in a relationship with a selfobject, the creative person feels more cohesive and centered (Kohut 1980), more free to explore untried or even objectionable ideas, less distracted by guilt, self-doubt, resentment, or jealousy. Under the spell of the selfobject, the creative person invests more energy in an inner life and is able to carry out sustained periods of creative work.

The Stages of Development of Collaborative Friendship Circles

Each stage of the development of circles will be examined in detail when we discuss the case studies in later chapters. At this point, I present a brief sketch of the stages. Although this conceptualization appears at the beginning of the book, it should be clear that it has emerged inductively as the end product of the research.

1. Formation

Collaborative circles are formed by friends who meet one another in a social network consisting of members of the same discipline or occupation. Fischer's (1982) findings on the effects of social class and place of residence on friendship networks suggest that collaborative circles are more common among upper-middle-class people living in urban settings. Friendships of working-class people or of people living in rural areas are more likely to be with family members and neighbors. But in cities, middle-class people are

likely to reach beyond their families and neighborhoods to form adult friendships with members of their occupational networks. In rare cases, family members and neighbors may have the expertise to socialize a novice into a field, but it is more likely that those who break free of these local networks will form collaborative circles.

Occupational networks vary in structure, opportunities for advancement, and the rate at which members move from the periphery to the center. Some networks are highly centralized, and at the center a small number of people control most of the opportunities to work and win acclaim. For example, in the network of Hollywood composers studied by Faulkner (1983), a relatively few prestigious composers at the center of the network wrote most of the music for movies, and freelancers on the periphery were highly dependent upon them for assignments and opportunities to prove themselves. This kind of network encourages a strong mentor-protégé system, but it does not seem to foster collaborative circles. In the forward to Faulkner's work, a highly successful composer, Fred Steiner, contrasts this system to the one he knew in the earlier Hollywood studios:

> Many of filmdom's most accomplished composers learned the nuts and bolts of the profession from the inside . . . as anonymous cogs in the . . . large, flourishing music departments which were such vital parts of the studio system. They usually worked first as arrangers and orchestrators; then perhaps as member[s] of those two-, three-, and four-man writing teams who pooled their efforts scoring the hundreds of quickie B and C "program" pictures . . . composing by committee. . . . An invaluable adjunct to this apprenticeship was the opportunity to profit from interaction with a group of talented and industrious colleagues . . . constantly exploring new ideas, developing and perfecting older techniques, and sharing knowledge with each other.
>
> (Faulkner 1983, 4)

Collaborative circles are more likely to form in occupational networks where socialization is prolonged, mobility is slow and uncertain, access to mentors is limited, and peers interact frequently with one another. Popular music, which is frequently composed and performed by groups, seems to combine these network properties in a way that fosters collaborative circles (e.g., Peterson 1997).

In the formation stage, the members may be no more than acquaintances who happen to be in the same place at the same time. Although it may seem that they met by chance, it is likely that their shared values and as-

pirations led them to gravitate toward a "magnet place." By magnet place I mean an art studio, a laboratory, an artist community, a hospital, or some other place where people value the expertise and practice the skills the prospective members hope to acquire.

Often a group forms when a gatekeeper or a matchmaker who knows each member individually introduces them to one another. In other words, circles often begin as radial networks centered on a single person. The personality and values of the gatekeeper act as filters in the formation of a circle. When circles form in a magnet place out of the friendship network of a gatekeeper, the members are more likely to share a common language and set of values, and they are likely to possess similar levels of "cultural capital" (Bourdieu 1993; DiMaggio and Mohr 1985); that is, they are likely to be roughly similar in their levels of expertise in their disciplines as well as in their familiarity with the elite and popular cultures of their society. In short, they can talk to each other.

If they are selected by a gatekeeper, they may also share a constellation of personality characteristics. For example, they may embody poles of conflicts that the gatekeeper is attempting to work out in his or her own mind. One friend might represent the more traditional approaches to a discipline, while another friend may be seen as "wild" or fun to be with because he or she experiments with new ways of thinking. At a deeper level, the gatekeeper may be externalizing through transference some unresolved tensions in familial relationships. Regardless of the gatekeeper's motives, because circle members are filtered through the gatekeeper's personality, all members are likely to share a number of characteristics, including a similar orientation to their discipline, similar levels of ambition, a common language of discourse, and common attitudes toward success in their field.

Although most collaborative circles form when the members are in their twenties or early thirties, chronological age is probably less important than stage of psychological and career development. From a life course perspective, people appear to be most ready to form circles during transition periods—when they leave home, when they divorce or become widowed, when they change professions, or when they begin a new stage in their career. Novice members of a circle are likely to be in a state of identity moratorium (Erikson 1964)—at a stage when they have decided what they want to do in life and are working to master a set of occupational skills, but before they have established a professional identity.

Collaborative circles often form among those who are marginalized in their fields or blocked from advancement. Although circles sometimes form among those who are more established, such people are likely to become

part of a collaborative circle only if, like Tolkien, they feel their current roles block them from pursuing deep interests. In cases like these, the culture of a collaborative circle may nurture a vision that is devalued in one's public role or tangential to one's work, as the religious, mythopoetic culture of the Inklings was devalued at secular Oxford.

Collaborative circles usually do not form among people on the fast track. As several writers have suggested (e.g., Kanter 1976; Bourdieu 1993), those who rise rapidly in a field are usually focused on winning the approval of established authorities in their discipline. Because they are more comfortable with authorities, they are likely to be protégés of an established mentor, and their commitment to the mentor often is stronger than their commitments to their peers. Rather than form a rebellious circle and create a new vision, protégés often reaffirm or elaborate the visions of their mentors. Although a sensitive mentor can nurture creativity in a protégé, the power differential in the relationship makes it more difficult for the protégé to acquire a separate voice.

Even when mentors are readily available in an occupational network, personality factors may influence whether a person chooses to work predominantly with a mentor, a collaborative circle, or alone. Sulloway's (1996) work on birth order and creativity suggests that firstborns may feel more comfortable in the protégé role, while later-borns may be more likely to form collaborative circles. He finds that when innovative theories emerge in a scientific discipline, firstborns are more likely than later-borns to resist them. Firstborns seem more likely to defend the theories of the previous generation, whereas later-borns seem more open to new ideas. Collaborative circles of peers nourish the kind of thinking that Sulloway attributes to later-borns.

Like most friendships, collaborative circles are usually formed by persons of relatively equal status who possess relatively equal resources. With relative equality in economic, social, and cultural capital, all members are able to keep pace in the interaction and maintain balanced exchanges. One common characteristic of successful circles is open, egalitarian relationships among members. When the distribution of resources among members is unequal, it is more difficult for them to maintain equality in their exchanges. In circles that become successful, early in the relationship the members evolve norms that encourage open communication and wide-ranging exchanges. However, in the formation stage, rather than focusing on their current work, the conversations usually center around more peripheral, less threatening, concerns. If they exchange work, they are likely to exchange finished products rather than work in progress.

INFORMAL ROLES IN THE FORMATION STAGE. Each stage of circle development is characterized by a constellation of informal roles. Informal roles are relatively stable patterns of behavior that come to be expected of each member. In the formation stage, the roles of the novice members have a quality of courtship about them. Brought together by a gatekeeper, they size one another up, discover areas of commonality, and engage in activities that require little commitment. Besides the roles of gatekeeper and novice member, in successful groups there is likely to be one member who plays the part of the charismatic leader—a narcissistic member, idealized by the other members, whose energy and vision sweep them into exploratory activities. This leader and the new members have reciprocal impact on one another: the charismatic leader sparks the involvement of the novices, and the dynamics of the group draw out the energy and vision of the charismatic leader.

2. Rebellion against Authority

Early in their relationship, before members develop the trust to explore their deepest interests, and before they sharpen the boundaries between themselves and nonmembers, they often discover a common antipathy toward authorities in their field. In this stage, they find it easier to talk about what they dislike rather than what they like. They may be vague about the kind of work they value, but they are very clear about the kind of work they reject. Indeed, there may be a "slash and burn" quality to their interactions as they attack with relish the conventional work in their field.

One of the most common group activities in the rebellion stage is the ritual of sharing anecdotes about the "outrageous" work of those in positions of authority. When they are apart, members gather gossip about these authorities, then, when they come together, they share their stories. The stories serve as legends in the group: by repeating the themes in the stories the members come to understand more clearly who they are and what they reject in their field. At times the shared antipathy may be focused on a peer who serves as a scapegoat—someone who is seen as currying the favor of the authorities, or who embodies the conservative values that members are attempting to distance themselves from. When a scapegoat is present at a meeting, the group's ritualistic activity may involve baiting him or her into an argument; and when the scapegoat is absent, they may ritualize storytelling about his or her faults.

In addition to the scapegoat, the role constellation during the rebellion stage includes an authority figure who is seen as a "tyrant." The tyrant, a person outside the group, is a constraining or threatening authority who

has some power over the members. A third role is the "lightning rod," a member who is most articulate in expressing the group's shared hostility toward authority figures and scapegoats. Finally, the constellation includes the conflicted members who are ambivalent about rebelling. Caught in the middle, they share some of the values of the rejected authorities, but they also enjoy the flamboyant expression of contempt by the less conflicted, charismatic leader. For them, the group interaction serves as a stage on which their internal conflicts are externalized and dramatized.

3. The Quest Stage: Negotiating a New Vision

In the third stage of development, the members begin the process of constructing their own vision. By vision I mean a socially constructed set of beliefs about the basic "facts" that should be taken into account in a field, the most important problems to work on, and the best ways to work on them. For artists, it is a shared style—an approach to painting, including a set of beliefs about what to paint and how to paint it. For scientists, it is a shared theory and method of doing research. For social reformers, it is a shared set of beliefs about what is wrong with the world and how to go about changing it. In brief, a vision is a theory and a method for doing work in a field. A circle arrives at a vision through trial and error, argument, and eventual consensus.

INFORMAL ROLES IN THE QUEST STAGE. The role of "boundary marker" becomes important at this point in group development. Members of circles often talk to one another as if they are on a journey in a cultural space. Ahead of them are members who have "gone too far" in rebelling and embracing new ideas and techniques. Behind them are members who are "lagging behind"—too slow to abandon conventional or outdated approaches to the discipline. Those out in front are the "radicals"; those lagging behind are the "conservatives." By reacting to the positions taken by these boundary-marking members, and by exploring tentative alternative ideas, the members begin to crystallize areas of agreement about a shared vision. By arguing about and clarifying what they reject in the work of the boundary markers, the members begin to build consensus about the kind of work they value (Erikson 1966; Farrell 1979).

PAIRED COLLABORATION DURING THE QUEST STAGE. Collaborative circles usually consist of three to five members; only rarely do they consist of more than seven or eight. Regardless of group size, as knowledge of one another's values, abilities, and personalities deepens, each member is

likely to pair off and work more closely with one other person. During the quest stage, these pairs become more established as coalitions within the circle. Most episodes of creative work occur within these pairs. Although the dynamics leading up to the pairing may include the whole group, it is the paired members who are likely to make the discoveries or to develop the style or the theory that defines the group culture. The moments of discovery, the "collaborative moments," take place when a pair of friends are so open and trusting with one another that they can share their wildest, most tentatively held ideas. In these moments, new ideas seem to emerge from the dialogue without "belonging" to either of the pair, and afterward they may not be able to say who had the ideas first.

As they share their ideas, experiences, and ways of thinking, the partners become like two linked computers, sharing one another's hard drive memories and software programs. I refer to this type of dyadic exchange as "instrumental intimacy." While engaged in this type of exchange, members are vulnerable to one another. When they open up and exchange wild ideas that go far beyond accepted approaches in their field, they not only risk appearing sloppy, foolish, or even mad; they risk having someone steal their most original ideas. Before two members are able to establish this kind of exchange, they usually must test one another's responses in less intimate exchanges and negotiate a high degree of trust. In an escalating set of exchanges, the collaborative pair develop a set of norms that facilitates trust, openness, and exchange. The norms can be explicit or implicit. They include rules about a time and place to meet, a pace for producing and exchanging work, and a constructive style of critical response. The rules may also include expectations about confidentiality and ownership of ideas.

Once these norms are in place, the stage is set for merging cognitive processes. At the least, creativity involves combining two or more ideas so as to produce something new and useful or beautiful. When two minds are linked in a trusting relationship, such that they can openly share ideas and cognitive processes, the likelihood of discovering new solutions to problems increases.

Throughout the quest stage, the members alternate between meeting in pairs and meeting with the whole group. The quest stage tapers to an end when the collaborating pairs refine their new vision in discussions with the whole group. While individual pairs may be supportive and nurturing, the larger group may be skeptical and critical. In these whole group meetings, a member who takes the role of devil's advocate plays an important part in challenging the pairs to refine their thinking. A center coalition of members assumes responsibility for weighing and integrating the innovations into a

new vision. Through dialogues with the creative pairs and the devil's advocate, the center coalition eventually negotiates consensus on a coherent and engaging vision. The center coalition comprises members who have won respect through their contributions to the work of the group, and who use their emergent authority to socialize marginal members into the emerging group culture.

4. The Creative Work Stage

During the creative work stage, the group members alternate between times when they work alone or in pairs and times when they meet as a group. Often the place where they meet as a group is a particular restaurant, a bar, or a member's home. Public meeting places of circles often have the qualities that Oldenburg (1999) attributes to "third places," unpretentious settings away from both work and family life, like the English pub or the French café, where a set of regulars feel welcomed and participate in an ongoing conversation. The physical setting may become an important part of the group's identity. The group may claim an accustomed table, and members may each claim their accustomed chairs. If they have not already done so, during this stage the group is likely to develop interaction rituals, such as reading aloud and discussing one another's work. The rituals and established place for meeting contribute to a more self-conscious group identity. If they haven't already chosen a name for their group, they are likely to do so at this point, and they are likely to think of themselves as a "we." The boundaries between insiders and outsiders become more apparent.

Having reached consensus about core elements of the circle's vision, each member of the circle begins to follow through on the implications of that vision. Working alone, they may attempt new approaches, run into obstacles, and become discouraged. The group meetings are occasions where members replenish their self-esteem, sharpen their understanding of the vision, and share solutions to problems. They often leave the meetings with renewed energy and commitment to work.

5. The Collective Action Stage

The collective action stage begins when the members decide to carry out a large project together. A group of artists may decide to stage an exhibition; a group of writers may decide to start a journal; a group of scientists may decide to develop a research proposal. New roles emerge as members divide up the labor of the project, make decisions, and become interdependent over a long period of time. The demands of obtaining resources outside the group require energy from someone who acts in the executive role (Mills

1984), or as the "wheeler-dealer" (Dunphey 1972) for the group. This person may spend a great deal of time organizing the group and negotiating with outsiders for such things as space, equipment, and money. The demands of the executive leader for decision making, increased commitment, equity in workloads, and coordination of efforts may generate tension and conflict in the circle. The group lightning rod—the member who had been most vocal in attacking authorities outside the group—may now be called upon to act as an agent of control inside the group, saying what needs to be said to the members who are not contributing to the group project. As conflicts among the members escalate, the role of peacemaker is likely to become more salient. The peacemaker spends time clarifying miscommunications, soothing hurt feelings, and negotiating compromises to conflicting demands from members.

During the collective action stage, the circle participants deal directly with the outside world. Members may be attempting to sell their work or to win recognition for it from authorities in their field, such as editors, grant reviewers, or art juries. The public's reactions to the circle can have significant consequences for the group. Labels and criticisms addressed at the group as a whole may affect the group identity as well as the individual self-concepts of the members. Reactions to an individual's work may alter the internal status structure of the circle. For a variety of reasons, conflict among members is likely to increase during the collective action stage.

6. The Separation Stage

In part because of the strains of collective action, the group begins to disintegrate in the later stages of its existence. Conflicts may accumulate and go unresolved. The conflicts may polarize the group, so that the same subgroups confront each other over and over again. Difficulties in decision making may lead some members to act without group support. Chronic conflicts may eventually swamp the member who plays the role of peacemaker. Eventually, some members may conclude that the costs of working together outweigh the gains. To the others, those who leave may be seen as disloyal to the group.

Perhaps an equally important factor that speeds disintegration is the individuation of the group members. Over time each member gains from the interpersonal relationships in the circle in ways that contribute to more autonomous functioning. The increased emotional independence, along with the increased skill and intellectual maturity, lead some members to pursue separate projects. Earlier the members may have experienced the group as an aid in nurturing individuation from authorities. Tyrants outside the

circle were seen as the constraining forces to be overcome. But in the separation stage, the culture of the circle and the pressures within the group may be experienced as constraining. Some members may become obsessed with breaking out of the circle and gaining recognition on their own.

As the interaction with the public increases, some members may receive more recognition than others. The question of who deserves credit for what idea may lead to divisions and antagonism. For authors, the order of their names on publications may cause tensions. For artists, the visibility of each artist's paintings at exhibits, or the degree of recognition for originating a style may become a matter of contention. For scientists, credit for an important discovery may be a subject of dispute. Behind many of the conflicts is a sense of resentment and betrayal because of confusion about ownership of ideas and inequities in recognition. As these stresses mount, the members develop even stronger urges to strike out on their own.

7. The Nostalgic Reunion Stage

As the members become more distant from one another, one member may emerge as the group's "alumni representative." This member gathers information about the whereabouts of the others, and may attempt to bring them back together. Although some reunions may occur, reunited circles rarely achieve the synergy they had in the earlier stages of their development.

The circle as a whole, or individual members within the circle, may acquire loyal disciples during this stage—younger protégés who attempt to codify the group's vision or construct a narrative account of the group's history. The attempts to construct a final vision and an official history of the group may divide the group even more, as some members' roles are seen as more important than others. But often the bonds of affection transcend the divisions over history, intellectual property, and differential success, and the members support one another during the personal crises of later life.

To begin our examination of the stages in the development of a collaborative circle, we turn first to the French Impressionists, a prototypical case against which to measure the group dynamics in other collaborative circles.

Chapter 2

——

The Life Course of a Collaborative Circle:
The French Impressionists

Although numerous art historians have noted that the artistic style of the French Impressionists evolved within a collaborative circle (e.g., Bonafoux 1986; Denvir 1987; Rewald 1973), and although much has been written about that style, there has been little written about the dynamics of the friendship circle itself (for an exception, see Rogers 1970). Theodore Duret, an art historian who was a member of their network, noted: "A constant feature of the history of the Impressionists was their influence on each other and their mutual borrowings . . . they developed side by side. They contributed their share to the common stock of invention day by day, each drawing on what the others had discovered by adapting and modifying it according to his temperament" (Duret 1910, 129). In this chapter, I trace the development of the French Impressionist collaborative circle from formation to disintegration (plates 3–12). In later chapters, I use this circle as a prototype and compare it to other cases.

The Social and Cultural Environment of the Impressionists

In the mid-nineteenth century, the art world of France was a relatively centralized network dominated by the Académie des Beaux-Arts, the state sponsored agency charged with nurturing and censoring art (see Bellony-Rewald 1976; Bourdieu 1993; Rewald 1973; White and White 1965). Most of the academy members saw it as their duty to ensure that art stayed within prescribed moral and aesthetic boundaries. They controlled most of the studios where artists were trained, and they controlled the means for artists to become known.

When the young Impressionists arrived in Paris in the early 1860s, they were confronted with three major cultural currents in the art world: classi-

cism, romanticism, and realism. The academy members favored classicism, a style that emphasized idealized, pastoral scenes, with allusions to mythology, history, or religion. Within this tradition, a painting was expected to illustrate a narrative that conveyed classical virtues as well as the esoteric knowledge—the cultural capital—of the painter. Dignified portraits of members of the emerging middle class were also acceptable, so long as they were done in the classical style. Teachers of the classical tradition, such as Ingres, expected students to paint in a studio, to develop careful drawings with clean lines, and to use somber colors. Romanticism, represented by Delacroix and other more marginal members of the academy, allowed a wider range of colors than classicism. Artists guided by this tradition were expected to portray passionate moments of ecstasy, heroism, or suffering. An acceptable scene would be one of brave men struggling to survive a storm at sea. The third major tradition, realism, was even more marginal to the academy. Represented by artists like Courbet and Corot, the realists painted contemporary scenes of peasants at work in rural landscapes. In contrast to the classicists, the realists preferred painting outdoors in front of "nature." A minor style that the academy members valued least was genre painting—sentimental or humorous scenes of contemporary everyday life.

Each year on the first of April, all artists were invited to submit three of their paintings to a jury of fourteen judges. The method for choosing judges was debated each year, but in the early 1860s half were appointed by the superintendent of fine arts, and half were elected by established artists. Those works chosen by the jury, usually about half of the five thousand paintings submitted, were displayed for the public in April at the Salon in the huge Palais de l'Industrie. The jury members were the gatekeepers to the artistic world. Their approval legitimated the works of art and assured the middle class that an artist's work was a worthwhile investment. In their reviews of exhibits, the journalists, who also played a part in shaping the tastes of the middle class, took their cues from the academy and jury members. Only by exhibiting through the Salon and receiving favorable reviews could an artist become known, win commissions, and sell paintings.

At the time the Impressionists were forming their group, classicists dominated the jury, and they rewarded those who followed the formulas taught in the studios approved by the academy. The kinds of work they approved are illustrated by Cabanal's *Venus,* which won first prize at the Salon in 1863—a reclining nude, floating on a puffy cloud, arm outstretched above her head as if to shield her eyes from the sun, attended by winged cherubs. In the same year the protests of painters whose work was rejected by the

jury led Louis Napoleon to set aside a section of the Palais for a Salon des Refuses—an exhibition of rejected works.

The most controversial work in the Salon de Refuses was Edouard Manet's *Le Bain,* which he later renamed *Dejeuner sur l'herbes.* Using unusually sharp contrasts of black and white, Manet portrayed two contemporary middle-class men, fully dressed in black topcoats, lounging on the grass at a picnic. Sitting with them in the foreground is a completely nude woman, who looks out at the viewer. Behind them in the background is another nude woman bathing in a stream. While the jury awarded first prize to Cabanal's nude painted in the classical manner, they considered Manet's painting shocking. The journalists scorned it as obscene and ridiculed his painting style as crude and unfinished.

Stages 1 and 2: Formation and Rebellion Stages of Circle Development

Most collaborative circles consist of a core group who interact frequently and a peripheral "extended" group who vary in their degree of involvement. The core comprises those members who meet together on a regular basis, discuss their work, and through their interaction develop a new vision. In the formation stage, the core group of Impressionists consisted of four men—Claude Monet, who was then twenty-two; Frederic Bazille, twenty-one; Auguste Renoir, also twenty-one; and Alfred Sisley, twenty-three. They first met as students in the studio of Charles Gleyre in the fall of 1862. The core group expanded during the 1860s, so that, by the latter half of the decade, when the group established a ritual of weekly meetings in Café Guerbois, it included Camille Pissarro, Edouard Manet, and Edgar Degas. Because Berthe Morisot was a woman, she did not attend the café meetings, though she was considered a member of the group. Other members on the margins of the group, occasional attendees of the meetings, were accepted by some members, rejected by others. Paul Cézanne was one of the most notorious of the marginal members. Finally, the group included "extended" members from other disciplines—novelists, poets, sculptors, musicians, and photographers who participated in the café discussions, supported the group with their resources, and were influenced by their emerging theories of art. For example, Emile Zola, who came to Paris with his close friend Paul Cézanne, was a journalist who became part of the extended group in the mid-1860s.

In 1862 the group consisted of four young men who had little in common other than the ambition to become painters. Claude Monet (plate 3)

had painted off and on for the previous two years, but neither he nor any of the other members of the initial group possessed a style resembling Impressionism. Bazille, Renoir, and Sisley were still struggling to master the basics of drawing and color. Nevertheless, Bazille (plate 4), who became the gatekeeper of the group, seems to have sensed some commonalities among them. In recounting to his son how the group formed, Renoir exclaimed, "How I wish you had known Bazille!" For Renoir, Bazille was the one who introduced him to the sophistication of Paris, where "[y]ou can choose. . . . [Y]ou gather in groups because you believe in the same things and you would rather die of hunger than retract" (Renoir 1988, 95).

Renoir (plate 5), the son of a tailor, was an artisan who decorated porcelain and blinds, but he wanted to develop skill in figure drawing and painting. Bazille was a tall, dignified son of upper-middle-class parents who supported his interest in art, so long as he continued his studies in medical school. Both men enrolled in the studio of Charles Gleyre, a liberal teacher who painted romantic themes in the classical tradition, but who tolerated a wide range of styles in his students. Renoir described his first impression of Gleyre's studio: "[A] big room crowded with young art students working away at their easels. A large bay window on the north side shed a grayish light on a nude male model. Old Gleyre had made the model wear a pair of short drawers so as not to offend the female students" (Renoir 1988, 95).

One evening when Renoir had been at the studio for about a week, Bazille approached him and asked if, since they were going in the same direction, Renoir would like to walk home with him. They became friends and, according to Renoir, they "drank, day-dreamed, and worked" together. Bazille had strong opinions. He wanted to paint everyday scenes of people in their habitual surroundings. Renoir greatly admired Bazille's talent, as well as his courage in resisting the pressures from his family to become a bourgeois "society man." Bazille may have been drawn to Renoir by his quiet, serious commitment to his work despite the frequent criticism he received from Gleyre. For example, after examining Renoir's work one day, Gleyre quipped sarcastically, "No doubt it's to amuse yourself you are dabbling in paint." Renoir's reply was, "Why, of course. If it didn't amuse me, I beg you to believe that I wouldn't do it!" (Rewald 1973, 71).

Soon after forming a friendship with Renoir, Bazille brought Sisley to Gleyre's studio. Sisley's father was English, his mother French. The family lived in Paris, where Sisley's father owned a successful business exporting artificial flowers. Sisley's father supported him in the 1860s, and during the early phases of the circle's development, the other members of the group saw him as a dilettante. Renoir describes him as preoccupied with women

(plate 6). He recalled: "We would be walking along the street, talking about the weather or something equally trivial, and suddenly Sisley would disappear. Then I would discover him at his old game of flirting" (Renoir 1988, 108). After each day in Gleyre's studio, Renoir, Bazille, and Sisley would drink together at the Closerie des Lilas.

Monet was the last to join the group. He was more colorful, rebellious, and narcissistic than the others. As a teenager he had been encouraged to pursue art by Boudin, a landscape painter, who took notice of some of Monet's caricature drawings in the window of a framing store. His father would have preferred that Monet stay at home and work with him in the grocery business, but in 1860, at age twenty, he went to Paris to study art. Against his father's advice, he chose to study at the Académie Suisse, one of the few open studios where a student could pay to have access to a model without having to bother with a teacher. Monet repeatedly resisted his father's attempts to steer him toward teachers who would give him a solid foundation in art. The rebellious strain had deep roots. In a retrospective interview he stated: "By nature I was undisciplined; never, even as a child, would I submit to rules. . . . School seemed like a prison to me and I could never bear to stay there even for four hours a day, especially when the sunshine beckoned and the sea was smooth" (Denvir 1990, 16).

Monet met Pissarro (plate 7) at the Académie Suisse, shortly before being conscripted into the army for two years. Returning home in 1862, he was told by his father that he would only receive support if he studied with a teacher. Because Gleyre had a reputation for tolerating diverse styles, Monet agreed to go to his studio. Renoir describes his arrival: "Eventually Monet came to reinforce the group. He had so much self-assurance that he soon became the leader. . . . Monet amazed old Gleyre. Everyone was impressed, not only by his virtuosity but also by his worldly manner. When he first came to the school the other students were jealous of his well dressed appearance and nicknamed him the dandy. He was penniless, [yet] he wore shirts with lace at the cuffs" (1988, 101–2).

Except for his friends, who shared his taste for realism, Monet looked upon the rest of the students as a sort of anonymous crowd—just a lot of "grocer's assistants," he called them. His attitude toward women was just as condescending: "To a rather pretty if somewhat vulgar girl who started to make advances to him [Monet] said: 'You must pardon me, but I only sleep with duchesses—or servant-girls. Those in between nauseate me. My ideal would be a duchess's servant'" (Renoir 1988, 102).

Gleyre liked to stand on the model's platform to address the class. One day he found Monet there in his place. When Gleyre confronted him,

Monet excused himself with the explanation that he needed to be nearer the model "to examine his skin more closely." Gleyre soon labeled him the class rebel, which made Monet even more interesting to Bazille, Renoir, and Sisley, whose realistic paintings were also disparaged by their teacher. The group was already developing a somewhat delinquent subculture.

Bazille knew Edouard Manet, and through him he met Pissarro. Recalling his own meeting with Pissarro, Renoir reported: "At that time (1863) I had a little studio in the Rue de la Condamine in the Batignolle quarter, which I shared with Bazille. Bazille came in one day accompanied by two men. 'I've brought you two fine recruits!' he announced. They were Cézanne and Pissarro" (Vollard 1925, 36). Monet already knew Pissarro from the brief time they had worked alongside one another in the Académie Suisse. Pissarro was about thirty at this point, eight or nine years older than the other group members. He had been born in Saint Thomas, the son of a Jewish import-export merchant. His family sent him to a boarding school in France to be educated when he was twelve. After returning home and attempting to work in his father's business, he finally persuaded his father to allow him to return to Paris to become an artist. Renoir characterized him as "having a way of expressing himself slowly, in a soft, musical voice. He was careless in his dress, but not in his words" (Renoir 1988, 102).

Renoir was ambivalent about many of the issues that animated the group's discussions. Monet's aggressive rejection of classicism and studio painting appealed to him, but he also admired the careful drawing and classical themes of Ingres. He was torn between painting outdoors and painting in the studio, between subjectivism and objectivism, between Manet and Cabanal. He often characterized himself as "a cork" floating in a stream "tossed about on the current" (Vollard 1925, 40). As he put it to his son: "I have an aversion to making decisions: the 'cork,' you remember. . . . You go along with the current. . . . Those who want to go against it are either lunatics or conceited; or, what is worse, 'destroyers.' You swing the tiller over to the left or to the right from time to time, but always in the direction of the current" (Renoir 1988, 72).

In heated discussions, Renoir often avoided taking sides, but instead let the dialogues in his head play out in the discussions in the group. In many ways, he represented the center of the group: ambivalent, conflicted, overtly agreeing with everyone, but covertly not agreeing with anyone completely. He often used humor to dispel conflict. He reports that the early group meetings were occasions where "ideas were tossed about, controversies broke out, and declarations poured forth. Someone very seriously pro-

posed burning down the Louvre. [I] suggested the museum should be kept as a shelter for children on rainy days" (Renoir 1988, 101).

In these early stages of circle development, when they were Gleyre's pupils, the members were held together as much by their shared commitment to the role of student and their shared rejection by Gleyre as by their commitment to one another. Their growing friendship spilled over from their roles as students. They enjoyed one another's company, they shared the ambition of becoming artists, and they shared the same negative reactions to the established styles of the academy, but none had yet developed a personal style. They were companions who met after school. Their meetings were casual occasions where they drank, conversed, and discovered more about one another's views.

Stage 3: The Quest for a Shared Vision

In the formation stage of the Impressionist circle, the fledging artists were together because they shared the same teacher and studio. In the rebellion stage, they discovered they shared a sense of alienation from their teacher's preference for classical, idealized forms, and they enjoyed mocking his approach. However, they did not yet agree about what or how to paint. They knew what they did not like, but they did not agree on what they liked. As Renoir put it, "We were full of good intentions, but yet were groping in the dark" (Vollard 1925, 64). In the next stage, the quest stage, the artists' commitments to one another deepened and intensified. They interacted with each other more, exchanged material resources more frequently, and began to experiment with styles and content. As they shared the results of their experiments with one another, they slowly began to piece together the insights that crystallized into a new vision of what art should be.

In the late spring of 1864, Gleyre, who was going blind, had to close his studio, leaving the painters on their own. Monet had repeatedly spoken of the advantages of open air painting, and after the studio closed down in May, he persuaded the group to paint together in the woods of Fontainebleau, south of Paris, where he had taken Bazille during the previous spring recess. They stayed at the White Horse Inn at Chailly-en-Briere.

Outdoor painting was not approved by the academy members, who saw the studio as the only place a painter could acquire the concentration and discipline to produce the clean lines and Platonic forms they considered real art. Monet, the most rebellious member of the circle, played a catalytic role at this point by persuading the other members to try the forbidden activity.

Some of the seductive flavor of his role is preserved in his early letters to Bazille, coaxing him to leave his medical studies and join him at painting in the forest: "What on earth can you be doing in Paris in such marvelous weather . . . ? It is simply fantastic here, my friend, and each day I find something more beautiful than the day before. . . . Damn it man, come on the sixteenth. Get packing and come here for a fortnight. You'd be far better off" (13 July 1862, in Denvir 1993, 33).

Paired Collaboration and Creative Work

During the next few years, the group frequently painted in the Forest of Fontainebleau. While working side by side, the young painters shared their ideas about what art should be and began to develop their own vision. The group was like an amoeba that sends out a pod in one direction, pulls it back, then sends another one out in a new direction as it feels its way toward nourishment. There were numerous false starts, and some of the most daring steps resulted in apparent failure. At any given moment, the members did not know whether they were making progress or following a dead-end tangent. But at each step, the courage to take a risk emerged out of the group dynamics, and the evaluation of the results took place in the group discussions.

The most daring risks—the sharing of half-baked hunches, some of which went somewhere, some of which went nowhere—occurred not when the whole group was together, but rather within the more intimate context of pairs. Each pair functioned like an extended pod of the amoeba. Two members would experiment or discover something they liked while together, then they would take what they had learned back to the others. Although the intimacy of the dyad was more conducive to taking risks and opening up to one another, the abrasive dialogue with the whole group led to clarification of the idea. The new idea might be a discovery of the presence of colors in shadows, a new brushstroke technique, or a new idea about what subjects to paint. Over time, through dialogue with the whole group, these insights and experiments gradually were woven into a more coherent style.

In the first few years of open-air painting, 1863 to 1867, Monet paired with Bazille, and Renoir paired with Sisley. Monet was the dominant member of one dyad; Renoir of the other (for discussion of these relationships, see Bellony-Rewald 1976, chap. 2). With his refined manners, sharp intellect, and contacts with some of the elite of Paris, Bazille was respected by Monet; but Monet was the more skillful artist. He had firm convictions about painting landscapes in open air, and he had a forceful way of presenting his ideas that swept Bazille along. In the other dyad Renoir dominated,

not because he was forceful, but because of his talent and commitment. Sisley lagged behind because, at this point in his life, painting was more of a diversion than a profession. In the evenings, the foursome would gather together at an inn, where they would discuss their work, argue about various approaches to art and literature, and chew over the great issues of the day. Working in pairs during the day and discussing their work at night, the men began to develop the ideas that became the foundation of their shared vision.

The influence of the previous generation of landscape painters shaped their work both directly and indirectly. By choosing to paint at Fontainebleau, they were already following the example of the older landscape painters. Monet shared with the group the principles he had learned while painting outdoors alongside Boudin and Jongkind. Like these old masters, they developed the consensus that "nature" was the best teacher. They believed they could learn more from working with their immediate perceptions of nature than by copying works in the Louvre or by following the instructions of a teacher.

Because Fontainebleau was a popular place for artists, they met some of the older painters there by chance. For example, one day in the summer of 1864, while Renoir was painting alone, a group of adolescents began to ridicule his artisan's frock—a baggy shirt worn by porcelain painters (Vollard 1925, 33). Concentrating on his painting, he did not notice that one of the boys had crept up behind him until he kicked the palette out of his hand. Renoir put up a fight, but was losing ground when an old man with a lame leg and a walking stick joined him in the fray. His defender turned out to be Diaz de la Pena, an established landscape painter. After driving off the attackers, Diaz examined Renoir's work and decided he liked it. That summer they painted together several times, and Diaz shared his paints with Renoir, who was still using the somber colors characteristic of the classical style. It was Diaz who persuaded him not to use dark colors—"bitumen and tobacco juice"—even when painting shadows. Renoir later remembered: "I immediately began another landscape, and tried to render the light on the trees, in the shadows, and on the ground as it really appeared to me. . . . 'You're crazy!' exclaimed Sisley when he saw my picture. 'The idea of making trees blue and the ground purple!'" (Vollard 1925, 33, 34). But after some experimenting of his own, Sisley adopted the innovations, and the pair passed the ideas on to Bazille and Monet. Renoir's experiments reinforced some of the lessons Monet had learned from Jongkind.

The group members also learned from one another's failures. For example, in the summer of 1865, the twenty-five-year-old Monet in his flam-

boyant, aggressive style, planned to complete an enormous, life-sized work that would surpass Manet's *Le Bain*. He planned a painting that would be three times larger than Manet's and would be completed on time for submission to the Salon jury in the spring of 1866. Unlike Manet, who had painted his work in the studio, Monet would paint his in the open air of the Fontainebleau forest. To avoid the rejection Manet suffered because his painting portrayed nude women alongside fully dressed men, Monet planned to have everyone fully clothed in fashionable modern dress. However, he planned to go beyond Manet by incorporating the circle's new discoveries about light and color, and he also planned to go beyond the scale of previous landscapes by incorporating life-sized human figures—twelve of them in an open-air landscape.

He ran into obstacles from the start. Because of costs, and perhaps because of the need for encouragement in this daring project, he wanted Bazille to pose for several of the male figures in the painting. Despite repeated letters from Monet beginning in the first week of May, Bazille, who by then had abandoned his plans to go to medical school, delayed coming until mid-August. Monet soon discovered the obstacles to working outdoors on such a huge canvas, so he decided to make large sketches at the scene and complete them in a studio. After completing the sketches, he moved into Bazille's studio in Paris, where he worked all winter on his masterpiece. The work became a sensation among other artists. Bazille wrote to his parents about the numerous artists who dropped by to see and praise it. However, Monet never completed the work. Some historians suggest that criticism from Courbet led him to make alterations that spoiled the work (e.g., Bellony-Rewald 1976). He eventually cut it into three smaller paintings.

Nevertheless, the group was inspired by his audacity in attempting to outdo Edouard Manet's controversial work. Monet learned from his experiment and tried again the following year. This time he dug a trench and rigged up some pulleys, so that as he painted from the bottom to the top of the canvas, he could gradually lower the painting down into the hole. Impressed by Monet's projects, in 1867 Renoir "swung the tiller" away from Courbet's influence and directly modeled his *Lise* after Monet's subsequent outdoor experiment *Woman in the Garden* (Tinterow 1994, 140). Even Cézanne (plate 8), who was committed to constructing imaginary scenes in his studio, followed Monet's example. Monet's daring and the attention he received encouraged the whole group to be bolder and more ambitious.

Edouard Manet (plate 9) himself may have felt his leadership of the "New Painting" movement was threatened by the young upstart, Claude Monet. When he saw the reception Monet's *Dejeuner sur l'herbes* was re-

ceiving from younger artists, he changed the name of his own *Le Bain* to *Dejeuner sur l'herbes,* perhaps in an effort to assert his claim on leadership of the painters of modern life in the open air (Tinterow 1994, 131). It was not the only time Claude Monet had annoyed him. In the Salon of 1865, two of Claude Monet's marine paintings were hung alongside Manet's *Olympia*. Several attendees confused the names of the two artists, and before he realized what was happening, Manet found himself receiving compliments for Monet's work (Rewald 1973, 122). Duret reported Manet's complaint: "Who is this Monet? He appears to have appropriated my name with a view to benefiting by all the stir that is being made about me" (Duret 1910, 147). According to Monet, the confusion occurred again in the 1866 Salon, when Manet was mistakenly complimented for Monet's *Woman in Green* (Denvir 1990, 33).

Instrumental and Emotional Support

Throughout the 1860s, the four core members of the group continued to live and work together, which allowed them numerous occasions to experiment and to share resources. In 1864, Monet invited Bazille to visit his parents' home in Normandy. Turning the trip into a tour, they took a steamship together down the Seine and up along the coast. Bazille wrote to his parents that he and Monet painted together from early morning until eight at night. The next summer, when Bazille came to Fontainebleau to model for Monet's *Dejeuner,* Monet injured his leg. Bazille used his medical knowledge to care for Monet, and while he recuperated, lying in bed with his leg propped up on a blanket, Bazille painted his portrait. When he was short of money and supplies, which was often, Monet stayed with Bazille. Sisley, who received support from his family throughout the 1860s, took Renoir on a similar cruise down the Seine in the mid-1860s. In turn, Renoir did portraits of Sisley's family. In 1867, both Renoir and Monet lived with Bazille in his apartment, while Sisley lived downstairs in the same building with his mistress. Bazille wrote to his parents: "The news, since my last letter, is that Monet has dropped in on me with a collection of magnificent canvases. He will have a spare bed with me till the end of the month. Here then, with Renoir, are two needy painters staying with me. My flat is like a regular infirmary, and I'm delighted. I have plenty of room for them, and they are both so cheerful" (Bonafoux 1986, 49).

Bazille was particularly generous to his friends. In 1867, during an extended visit, Renoir painted a portrait of Bazille at his easel (plate 4). In the painting, Bazille is shown working on a still life of two dead herons. Behind him is a landscape by Monet, who also shared the studio. Sisley is not shown

in Renoir's portrait, but he painted the same set of birds, suggesting that he was also working alongside Bazille in this period. Most likely, Bazille had paid for the birds as well as the paints and canvases. While they lived together, Bazille painted a portrait of Renoir that shows his friend seated casually on the floor (see plate 5). In 1870, Bazille painted a group portrait of the members of the circle engaged in various conversations and activities around his studio (plate 10). The painting centers on Monet, Manet, and Bazille as they discuss a work that stands on Bazille's easel; other members of the group are scattered around the room, one playing a piano, others conversing on a staircase.

Throughout the 1860s and 1870s, the group faced numerous hardships (Rogers 1970). Monet, Renoir, and Pissarro were impoverished. Cézanne had only a modest allowance from his father. Sisley's support was threatened when he had children out of wedlock with his lover, who was his family's servant. He and his mistress had one child in 1867 and a second in 1869. He lost all support from his father after the war in 1870, when his father lost his business. Monet formed a liaison with Camille Doncieux in 1866 and had a child in 1867. At one point, Monet was forcibly evicted from an apartment for not paying his rent. By the end of the 1860s, Pissarro already had several children to support. Despite the mounting needs of the artists, their paintings were repeatedly rejected by the Salon jury, and they had little time or inclination to earn income in other ways. Support from the circle played a critical part in sustaining them during this period.

Emile Zola was in contact with the group during this time, and true to his "naturalist" writing style, he took notes on what he observed. In his novel *The Masterpiece,* he describes the solidarity of the group and its impact on the artists. After a frustrating week of trying to complete a painting, the fictional hero of the book, Claude Lantier, who seems to be a combination of Cézanne, Monet, and Manet, is in despair and goes walking with his four friends:

> They . . . sauntered along, with an air of taking over the entire width of the Boulevard des Invalides. When they spread out like this, they were like a free-and-easy band of soldiers off to the wars. . . . In their old shoes and their worn coats, they marched along in all sureness of triumph, disdainful of their poverty, feeling themselves bound to become masters through the sheer power of their talent and will. With all this self-confidence, they felt, too, a consuming scorn for everything that was not art: scorn for wealth, scorn for all the mass of ordinary people that made up the great outside world, scorn most of all

for politics. . . . Sometimes they would spend a whole day in one of these excursions, walking as long as their legs would stand up under them, as if they were trying to conquer every quarter of Paris . . . flinging their theories against the house fronts to echo behind them as they passed. . . . In this company, and under their influence, Claude began to cheer up; in the warmth of shared hopes, his belief in himself revived.

(Zola 1946, 99–103)

Group Dynamics and the Evolution of a Shared Vision

In the latter half of the 1860s, as their shared vision developed, the group began to extend their scope, applying the techniques developed in the woods of Fontainebleau to urban scenes of Parisian life, to portraits, and to still lives. Some of these experiments led to negative reactions by members and were eventually weeded out of the emerging group vision. For example, in 1867, Renoir painted a mythological image, *Diana, the Huntress.* He later destroyed it. Several members experimented with Corot's method of scraping paint onto the canvas with a palette knife, but eventually abandoned the technique. Manet, Degas, and Cézanne were not part of the initial group, and until they became integrated into the emerging group culture, their work included a wide range of themes and styles. Thus Manet, whom the members idolized, continued to paint both historical-political and religious themes as well as scenes from modern Paris. He did not attempt open-air painting until the early 1870s, when Berthe Morisot and Claude Monet finally persuaded him to try it. Degas painted images of Spartan youth at the same time as he was painting contemporary racetrack and beach scenes. He never abandoned his commitment to finishing his paintings in the studio. In the 1860s, Cézanne painted mostly religious and mythological themes in his studio. Only after 1872, when Pissarro took him under his wing, did Cézanne shift his focus to landscapes. In the larger group meetings, through discussion and often acrimonious debates, the artists eventually reached consensus about discarding historical, religious, and mythological themes and focusing exclusively on images of everyday modern life and landscapes.

Castagnary (1867), a contemporary critic, captures something of the excitement of this emerging vision: "Nature and man, country and city . . . What need is there to go back through history, to seek refuge in legend, to examine the registers of the imagination? Beauty is in front of the eyes, not inside the brain: in the present, not in the past; in truth, not in dreams; in life, not in death. The universe we have here, before us, is the very one that painting ought to translate" (Tinterow and Loyrette 1994, xv).

The Crystallization of the Impressionists' Vision

Castagnary's characterization of the group's emerging paradigm was accurate, but that vision was not the exclusive domain of the Impressionists. There were others who painted landscapes and contemporary life. The crucial innovations that distinguished the style of the Impressionists emerged only at the end of the decade. In 1868–69, some changes occurred in the internal coalitions of the group, and the changes coincided with the innovations that came to define the Impressionist vision.

Possibly because Bazille had tired of Monet's constant demands, or possibly because Manet and Degas had invited the circle to attend their meetings at Café Guerbois, Bazille began to move away from Monet and to model his work after Manet's. In Bazille's 1870 portrait of the members of the circle in his studio, Manet stands in front of Monet as they view the painting that Bazille displays. Initially, Bazille left a blank spot by the easel where he himself should have been depicted. Perhaps it is telling that when he decided to complete the portrait, he asked Manet rather than Monet to insert his figure. All of Bazille's paintings in 1869 and 1870 directly refer to Manet's work. At the same time that Bazille was moving closer to Manet, Sisley was moving away from Renoir. Sisley now had a wife and two children who occupied his time, so Renoir lacked a companion. These changes set the stage for a critical reconfiguration of the group.

In the summer of 1869, Renoir and Monet decided to paint together at a popular watering spot near Bougival, west of Paris. At La Grenouillere—the Frog Pond—people met to swim, dance, and drink. The restaurant, located on a barge in the Seine, has been described as unsavory, a nineteenth-century singles' bar, where a fast crowd of women known as "frogs" hung out. But most saw it as a fashionable place for the emerging middle class to enjoy the new pleasures of suburban Paris.

In their surviving works from that summer, it is clear that Renoir and Monet usually painted alongside one another, and indeed it is possible to infer who was standing on the left and who was on the right as they did so. They painted scenes of boats and swimmers, and of couples strolling on the docks. In their experiments and dialogue, they converged on a method for capturing the play of light on water. They painted rapidly with short, commalike brushstrokes, and they juxtaposed sharply contrasting, unmixed colors. This technique brought a shimmering life to water that no one had ever achieved before. It enabled them to portray the transitory effects of light and atmosphere—goals they had been pursuing for years. They also discovered the value of painting many views of the same scene quickly, capturing the changes in light and atmosphere as the day progressed. They

came to value the sketchy, unfinished quality of the work. Finally, they incorporated many of the things they admired from Japanese woodcuts, like those of Hiroshiga: bright colors and an elevated perspective angled downward at snapshots of contemporary life. The discoveries they made and the techniques they developed that summer are considered the definitive elements of the Impressionist style. For example, Kenneth Clark claims, "The riverside cafe of La Grenouillere is the birthplace of Impressionism" (Blunden and Blunden 1970, 75).

As usual, Monet incorporated the innovations into his paintings the most boldly, but it is not possible to say whether he or Renoir initiated the new techniques. At several junctures in the group history, when Monet had "led," he seemed to need an intimate audience for his experimentations. On the other hand, Renoir, the "cork," needed a current to navigate, a theme around which he played his variations. As Bernard points out, in that summer of collaboration, "They came closer in feeling to the [later] Impressionist painting of the 1870s than anything either man had done before" (1986, 23).

They arrived at the vision as they worked alongside one another, commenting on each other's work, experimenting, making mistakes, deciding to include some mistakes, and eventually discovering the effects they preferred. It is not likely that either would have arrived at the new style alone, but together they had the courage to go beyond the limits, creating a new synthesis of the elements they had been working with. Perhaps Monet led, but would he have had the courage to pursue his own impulses or the judgment to know when they were worth retaining without Renoir as an alter ego? The paradigm that they were developing enabled them to reach consensus about which of their solutions to painting light and water were good solutions, and which should be abandoned. The creative solutions emerged not while they were isolated and working alone, but while they were together and in constant communication. Creative innovations emerged not so much from the depths of the unconscious of the men, but from the interaction between them, the merging of their minds, and from their collaborative search for solutions to problems that had been defined by the group.

They worked together numerous times, especially after the Franco-Prussian War, and several of their works between 1872 and 1874 are amazingly similar. One pair of paintings of a roadside fence are so much alike that, much later, when Monet saw them side by side for sale in Durand-Ruel's gallery, he could not say which was his without looking at the signature (Rewald 1973, 284–86).

In retrospect, their innovations in the summer of 1869 were extremely

important in the consolidation of the group's vision, but in one surviving note from the period, Monet indicates that he was not fully aware of what they had accomplished. As usual, in September after that summer, Monet was begging for money from Bazille, who wrote back to him suggesting that he should consider chopping wood to generate some income. Monet replied:

> [Chopping wood] is harder than you think, and I'll bet that you would not split much wood. . . . All the same, I have probably not reached the end of my troubles. Here is winter at hand, a season not very pleasant for the wretched. Then comes the Salon. Alas! I still won't be in it, for I shall have done nothing. I have a dream, a picture of the bathing spot at the Grenouillere, for which I've made a few poor sketches, but it is a dream. Renoir, who has just spent two months here, also wants to do this picture.
>
> (25 September 1869, in Bonafoux 1986, 72)

In the winter of 1869–70, Monet painted with Pissarro, and shared the new methods he and Renoir had developed. In the latter half of 1870, when the Franco-Prussian War broke out, Monet went to England. While visiting Durand-Ruel's shop in London, he learned that Pissarro had also come there to avoid the war. He sought him out, and they continued to work together.

The Incorporation of the Marginal Members

In the early 1860s Paul Cézanne's father, a self-made banker in southern France, wanted his son to become a lawyer or a banker (Mack 1989). To the dismay of the elder Cézanne, Paul's secondary school friend, Emile Zola, went off to Paris and sent back a steady stream of letters trying to persuade Paul that his real future lay, not as a lawyer in Aix-en-Provence, but as a poet or artist in Paris. After a long family struggle, Cézanne left for Paris in 1861 with the ambivalent support of his father, who hoped he would soon discover his folly and come back home. Like other members of the circle, Cézanne refused to study with teachers. In 1861 he entered the open Académie Suisse, where he met Pissarro. Throughout the 1860s, Cézanne was a marginal member of the Impressionist group. He was introverted and sullen, his behavior was erratic, his style unfocused, and his painting technique seemed undisciplined. Unlike the core members, he still preferred painting indoors; and while they aspired to be accepted at the Salon, he openly held the annual juries in contempt and mocked their values in his work.

Although Cézanne was marginal to the group, he did play a part in

arousing the interest of his friend, Zola, in the new painting. In 1866, the twenty-five-year-old Zola, then a journalist for *L'Evenment,* wrote a series of articles praising the works of Manet, Monet, and Pissarro. The reactions to the first six articles were so negative that the paper discontinued the series. In May of that year, Zola published all of the articles as a pamphlet. In the introduction, he includes a letter to Cézanne, evoking the spirit of their friendship as an antidote to the attacks on his writing:

> It gives me profound pleasure, my friend, to write to you directly. . . .
> For ten years we have been talking together about the arts and litera-
> ture. We have lived together . . . and often dawn would find us argu-
> ing, exploring the past, questioning the present. . . . We have ploughed
> through so many hopeless masses of ideas . . . and . . . arrived at the
> conclusion that apart from one's own strong and individual life there
> was nothing but lies and foolishness. . . . Happy are those who have
> such memories! . . . You are my entire youth; you are part of all my
> joys, all my suffering. In their fraternal closeness, our minds have de-
> veloped side by side. . . . I have just managed to say out loud what I
> have been whispering for ten years. . . . No doubt the sound of the dis-
> pute has reached your ears, and you will have seen the reception our
> cherished thoughts were given.
>
> (Denvir 1993, 41)

As a result of the articles, Edouard Manet sought Zola out, welcomed him into the circle, and in 1868, painted his portrait.

Two other members of the group, Degas and Morisot, were brought into the network by Manet. Manet met Degas in 1862 when he was sketching a copy of a Velázquez painting in the Louvre. Both coming from an upper-middle-class background, they enjoyed one another's company and the café life. Berthe Morisot (plate 11), also the product of a privileged upbringing, was a gifted painter who sometimes modeled for Manet. In 1874 she married his brother, Eugene. It has been suggested that her real love was Edouard, but because he was already married when they met, she married Eugene as a means to stay close to Edouard (Friedrich 1992).

Stage 4: Creative Work

One of the defining characteristics of stages 3 and 4 in the life of a collaborative circle is the ritualization of times when the whole group comes together, not because they share a teacher or a workplace, but because of their own choice to meet, exchange ideas, and enjoy one another's company. In

nineteenth-century France, numerous cafés had their regulars, among whom a few stars dominated the conversation and shaped the agendas and visions for art, politics, or other endeavors (Billington 1980; Oldenburg 1999).

By 1869, the Impressionist group had established the ritual of meeting on Thursday nights at Café Guerbois at 11 rue des Batignolles. They had two tables where they met just inside the door on the left. Their area was separated from the rest of the café by a glass partition. Later, in the mid-1870s, the group moved their meetings to the Nouvelle Athenes in the place Pigalle. The Guerbois was near the studio of Edouard Manet, who chose this meeting place. The other men—Monet, Bazille, Renoir, Pissarro, Sisley, and Cézanne—came after the group had already been established by Manet, Degas, and their friends. Berthe Morisot never participated in the café meetings, but in the late 1880s, she carried on the tradition, making her home a salon where the ritual of Thursday-night dinners and discussions continued.

In an interview about the café period of his life, Claude Monet reports:

> It wasn't until 1869 that I saw Manet again, but we became close friends at once, as soon as we met. He invited me to come and see him each evening in a café in the Batignolle district where he and his friends met when the day's work in the studio was over. There I met . . . Cézanne, Degas who had just returned from a trip to Italy, the art critic Duranty, Emile Zola who was then making his debut in literature, and several others as well. I myself brought along Sisley, Bazille, and Renoir. Nothing could be more interesting than the talks we had with their perpetual clashes of opinion. Your mind was held in suspense all the time, you spurred the others on to sincere, disinterested inquiry and were spurred on yourself, you laid in a stock of enthusiasm that kept you going for weeks on end until you could give final form to the idea you had in mind. You always went home afterwards better steeled for the fray, with a new sense of purpose and a clearer head.
>
> (Denvir 1990, 74)

Unlike the paired collaborations, the interaction in the café was boisterous and combative. It was in these contentious arguments that the group members were challenged to achieve clarity and consensus about their emerging vision. As Duret, a contemporary biographer states: "The meetings at the Cafe Guerbois, with painting in light tones and bright colors represented by Manet, and the technique and procedure of open-air painting represented by Claude Monet, Pissarro, and Renoir, were to have fruitful results.

From these meetings sprang the powerful development of art which was soon to go by the name of Impressionism" (Duret, "Renoir," quoted in Blunden and Blunden 1970, 74).

The Informal Role Structure of the Café Group

Like all groups, the Impressionist circle developed a "personality," and while the members were together, they took on informal roles (Farrell, Heinemann, and Schmitt 1986), such as hero, jester, devil's advocate, scapegoat, and peacemaker. Members varied in the degree to which their roles were rooted in their personalities. Roles in such groups are like masks or personas—images of one another that the members negotiate in the course of group development (Bales 1970; Mills 1984). Members assume these personas when they are together and, in many cases, leave them behind when they leave the group. Informal roles may change over the course of group development—a leader may lose charisma, or a second-string member may become central. Even when the roles remain relatively stable, different roles may become salient at different points. Years after circles have disbanded, when they gather together for a reunion, it is often surprising that, despite changes in personalities and status, the members assume the same informal roles they previously played. The same kind of undertow from the group process is sometimes felt in family reunions, when brothers and sisters are drawn into their childhood family roles.

We have already seen that in the earliest phases of the development of the Impressionist circle, Claude Monet played the central role of charismatic leader. It was Monet who pushed the ambivalent members to rebel against their teachers and to paint outdoors. Likewise, it was Monet who attempted to outdo the group's idol, Edouard Manet, at a time when the other members admired Manet as a daring rebel. Sisley was seen as less committed at this time—the pleasant dilettante supported by his father who would just as soon flirt with women as paint. Renoir, who described himself as "the cork" floating in the stream, went along with other members. He seemed willing to try anything. Though Bazille's contributions to the group vision were less innovative and daring than those of Monet or Renoir, he played important roles throughout the decade. Initially, he was the gatekeeper who introduced the core group members to one another. A member of the same social class as Manet, he had social as well as economic capital (DiMaggio and Mohr 1985). He was instrumental in getting the circle invited to Manet's café. Throughout the decade, Bazille was most attuned to the economic realities of life, such as the cost of rent, food, canvas, and paint. And it was Bazille who first began to strategize ways to get the mem-

bers' work exhibited and sold outside the annual Salon exhibitions. He moved from the role of gatekeeper in the formation stage of the group to the role of "executive" leader (Mills 1984) as they approached the collective action stage.

When the meetings of the full group became institutionalized at Café Guerbois in 1869, and as the crucial dialogues occurred that eventually pulled even Manet and Degas into painting in the open-air style, a number of contemporaries sensed the importance of what was happening, and in journals, letters, and novels recorded the interactions of the group. Drawing on these contemporary descriptions, it is possible to recreate the group structure and the norms for interaction.

Manet and Degas were the older, higher-status members of the café group, and as we might expect based on research on the effects of status cues on interaction (Berger and Zelditch 1985), initially they occupied central positions in the group. They had been colleagues and friends since the early 1860s, and their style of interaction set the norm when the group gathered at Café Guerbois. Their exchanges could be characterized as confrontational, sarcastic, and witty, but only rarely were they destructive. Numerous contemporaries describe Manet as a gentleman and dandy—well dressed, articulate, clearheaded, with a devastatingly witty turn of phrase, given to playful teasing, always sunny and even-tempered. George Moore, an aspiring novelist from Ireland, often sat near the group's table and took notes on their interactions:

> At that moment the glass door of the café grated upon the sanded floor, and Manet entered. Although by birth and by art essentially Parisian, there was something in his appearance and manner of speaking that suggested an Englishman. Perhaps it was his dress—his clean cut clothes and figure. That figure! those square shoulders that swaggered as he went across a room and the thin waist; and that face, the beard and bow, satyr-like shall I say? No, for I evoke an idea of beauty of line united to that of intellectual expression—frank words, frank passion in his convictions, loyal and simple phrases, clear as well-water, sometimes a little hard, sometimes, as they flowed away, bitter, but at the fountain head sweet and full of light.
>
> (Moore 1972, 104)

Another firsthand observer, Armand Silvestre, writes:

> Manet was not the leader of a school—nobody ever had a temperament less suited for such a role, for I have never known anyone so free

of the least touch of solemnity. . . . This revolutionary—the word is not too strong—had the manners of a perfect gentleman. With his gaudy trousers, his short jacket, his flat-brimmed hat set on the back of his head, always wearing immaculate suede gloves, Manet did not look like a Bohemian, and in fact had nothing of the Bohemian in him. He was a kind of dandy. Blond, with a sparse, narrow beard which was forked at the end, he had in the extraordinary vivacity of his gaze, in the mocking expression on his lips—his mouth was narrow lipped, his teeth irregular and uneven—a very strong dose of the Parisian street urchin. Although very generous, and very good hearted, he was deliberately ironic in conversation, and often cruel. He had a marvelous command of the annihilating and devastating phrase. But at the same time his expression was benevolent, the underlying idea always absolutely right.

(*Au pays des souvenirs* [1892], in Denvir 1987, 71)

In his memoirs, the artist Joseph de Nittis continues in the same vein: "He was feared because he had such a telling way of putting things, in words of singular originality, the words of a child of Paris, . . . which left their mark ineffaceably on anything mean or ridiculous. He was master of that cheerful mockery in which a touch of disdain was faintly felt. His was a sunny soul, and I loved the man" (*Notes et souvenirs* [Paris, 1895], in Bonafoux 1986, 42).

Manet's relationship with Degas and their style of interacting shaped the group culture, as Ambroise Vollard, an early biographer of the group, makes clear:

[Manet and Degas] were very close. They admired each other as artists and liked each other as chums. Manet assumed the manner of a jaunty frequenter of the boulevards, but behind it Degas found the principled man of breeding that he was himself. . . . Manet found in Degas the middle-class Parisian that he was himself. But in Manet there was . . . a strain of prankishness, which impelled him to pull the wool over your eyes. . . . Degas had in common with Manet this love of practical joking. I have seen him get endless fun, like a schoolboy, from blowing up some artist's reputation, which of course a week later was completely deflated. (*En ecoutant Cézanne, Degas, Renoir* [Paris, 1938], in Bonafoux 1986, 64)

Like Manet, Degas had independent wealth and was somewhat of a dandy (plate 12). He never married, so he was free of the family responsibilities

that weighed on other members, and in the 1860s, his wealth made it easier for him to reject the jury's standards. But in the 1870s, he assumed responsibility for financial setbacks in his family and became more anxious to sell his work. His cynicism, sarcasm, and narcissism prevented him from being a group hero, like Manet. Indeed, he and Manet often baited one another in discussions, and occasionally their underlying competitiveness became overt. For example, Moore reports an exchange between them:

> [Manet] sits next to Degas, that round-shouldered man in a suit of pepper and salt. There is nothing trenchantly French about him . . . except the large necktie; his eyes are small and his words are sharp, ironical, cynical. . . . [Degas and Manet's] friendship has been jarred by inevitable rivalry. "Degas was painting Semiramis when I was painting Modern Paris," says Manet. "Manet is in despair because he cannot paint atrocious pictures like Durand, and be feted and decorated; he is an artist, not by inclination, but by force. He is a galley slave chained to the oar," says Degas.

> (Moore 1972, 105–6)

Although a degree of collegial ribbing pervaded their communication, Degas thought that Manet was too anxious for approval. When De Nittis won a medal at the Salon exhibit, Manet said to him:

> All that contempt, my boy, is nonsense. You have it, that is the point; and I congratulate you with all my heart. . . . If there were no rewards, I wouldn't invent them; but they exist. And one should have, when possible, everything that singles you out. . . . It is one step ahead. . . . It is another weapon. In this dog's life of ours, which is a daily struggle, you can never be too well armed. I haven't been decorated? But it is not my fault, and I assure you that I shall be if I can and that I shall do everything necessary to that end.

> Degas, breaking in angrily and shrugging his shoulders, "Of course you will. I haven't waited till now to find out what a bourgeois you are."

> (de Nittis, *Notes et souvenirs,* in Bonafoux 1986, 142)

On another occasion, Rothenstein, a student of Degas, reported that Degas quipped to Manet: "But you're as famous as Garibaldi; what more do you want?" Manet replied, "In that case old boy, you're well above sea level" (Denvir 1987, 177).

In the 1860s, Degas was an acerbic critic in the group discussions. Like Manet, his sharp wit made members wary of him, but he lacked the grace

and humor of Manet, and his style had a more cutting, defensive tone. Even he noted later in his life how the group dynamics brought out this posture. In an 1890 letter to Evariste de Valernes, a friend he had known since the 1860s, he wrote: "I was, or I seemed to be hard with everyone, through a sort of passion for brutality, which came from my uncertainty and bad humour. I felt myself ill-made, so ill-equipped, so weak, while it seemed to me that my art calculations were so right. I was sullen with everyone and with myself" (Bonafoux 1986, 30). Rothenstein reported that in the 1880s, after Manet's death, Degas often regretted that he had not expressed more positive appreciation for him during his lifetime (Denvir 1987, 177). His contentious style placed him in the role of devil's advocate.

Zola, the ambitious intellectual, was also eloquent, assertive, and task-oriented in the discussions. Though not a painter, his spirited defense of Manet and the others in the series of reviews in 1866, which cost him his position with the newspaper, contributed to his status in the group. His broad interests, his early articulation of his naturalist theory of literature, and his ability with words made him a valued resource. Manet's regard for Zola is conveyed in the portrait he painted of him in 1868. Manet shows Zola at his desk, lost in thought, an open book before him. The writer is surrounded by emblems of the circle's culture: Japanese prints of a landscape and a noble, a print of Manet's *Olympia,* a drawing by Corot, and Zola's own books and pamphlet defending the group.

As the defender who attacked the judgments of the Salon jury and defended the Impressionist circle in public, Zola early on assumed the role of "lightning rod" for the group, the one who internalizes the interests and hostilities of other members and articulates them to unsympathetic, oppressive authorities. In later life, Zola was to play this part of advocate in an even more public way when he came to the defense of Dreyfus during the infamous trial. However, the role of "lightning rod" also applies to one who is particularly adept at mobilizing hostility in the service of the group's problems—the one who gives voice to the discontents of other group members and dresses down a deviant member or a tyrannical leader (Farrell, Heinemann, and Schmitt 1986). Although in the critical early period Zola defended them in public, there is no evidence that he directed hostility at members inside the group. As we will see, at a later period, it was Caillebotte who directed negative feedback to the deviant members during the collective action stage of the circle.

Pissarro, also one of the older members, was less assertive, although highly respected. Rewald (1973) characterized him as the gentle "Abraham" of the group. Several contemporaries described him as a soft-spoken, clear

thinker, the group theoretician, and an egalitarian leader who leaned toward socialism and anarchism in his politics. Deeply concerned about social issues outside the group, he was seen as peacemaker within. When a new member arrived, he would patiently explain what was wrong with the standards of the jury. He repeatedly defended Cézanne when others considered him a problematic member of the group. It was Pissarro who spent eighteen months with Cézanne in 1872 and 1873, persuading him to work outdoors, helping him to develop discipline and to master the emerging group vision (plates 7 and 8). At a later time, Pissarro performed the same role for Gauguin. His role as peacemaker became more central in the next phase of group development when the group mobilized for collective action.

Monet was the central member of the younger foursome consisting of Renoir, Bazille, Sisley, and himself. Although bold, flamboyant, and somewhat of a dandy in his early days, he was not as urbane and assertive as Manet, Degas, and Zola. Nevertheless, he was similar to Manet in his style of interacting in the group—serious, intellectual, and warm, but with a sharp wit.

Renoir, as he himself had acknowledged, was likely to drift in the stream of interaction. He was less serious, enjoyed a good joke, and did not defend his opinions or assert theories that required confrontation. Although not quick in the intellectual exchanges, he acquired a playful, teasing side that sometimes needled his companions. Gustave Geoffroy, the novelist, described a dinner later in the group's history:

> The discussions sometimes got quite heated, especially between Renoir and Caillebotte. The former, nervous and sarcastic, with his mocking voice, and a kind of Mephistophelism which marked with irony and a strange mirth his face already ravaged by his illness [arthritis], took a mischievous delight in irritating Caillebotte, a choleric and irascible man whose face would change in color from red to violet, and even to black when his opinions were contradicted with that sprightly flow of words which Renoir loved to employ against him. . . . The discussion covered not only art, but every possible literary subject, politics, philosophy, . . . reviews and newspapers. Renoir kept himself abreast by buying an encyclopedia, out of which he culled arguments to floor Caillebotte.
>
> (Denvir 1990, 167)

Particularly in the early meetings, Sisley was less assertive than Renoir, and he was also less sociable. Until the 1870s, he still received support from his father, and he was less driven to support himself by selling paintings. In

the 1860s, he was pulled along by his friends in the core group. He acquired the Impressionist style slowly, but later, when the others had abandoned the style, he stayed with it. Sisley is an example of a member of a circle who might never have achieved what he did if he had not been a member of the group.

Bazille's social status, wealth, education, and membership in the elite network frequented by Manet and Degas led him to be more confident and assertive in the group. He was generous to everyone. His integrity and commitment to principle led him to sign up for combat duty in the Franco-Prussian War.

The Group Boundary Markers

As group members interact together and attempt to clarify what it is they value and reject, the group boundary markers or deviants come to play important parts (Erikson 1966; Farrell 1982). In a public context like the café discussions, group members often can express their dislikes more clearly than their likes. It is through clarifying what they see is wrong with the work and behavior of the boundary markers that the group begins to reach consensus about their values.

Cézanne played the part of a boundary marker during this phase, and even may be considered a group scapegoat. His attendance at the meetings was sporadic, and his contributions consisted of enigmatic statements and an occasional abrupt exit without explanation. It was Cézanne who brought Zola to the group, but after Zola wrote his articles championing the group, he was more accepted by the members than Cézanne. About the group at this time, Cézanne is reported to have said, "All those people are *salauds* [shits]. They are as well-dressed as notaries"(Blunden and Blunden 1970, 74).

Cézanne, who cultivated the dress and manners of a peasant, was particularly repulsed by Manet's impeccable dress—his doeskin gloves, silver-topped cane, silk hat, and polished boots. Marie and Godfrey Blunden capture the nature of two men's relationship in their recreation of a café scene. Cézanne enters

> wearing a huge black felt hat deformed by age and a long, weathered overcoat, once black but now sickly green, with buttons all the way down to his ankles. This he unfastens and with galvanic movement of his sturdy shoulders casts it off, then takes a severe hitch up the red belt holding his baggy trousers, a movement which reveals his blue socks . . . [and] large laced boots. . . . He squeezes hands all around,

but when Manet extends his firm, white hand, Cézanne looks up and says, "No, I cannot shake hands with you, Monsieur Manet, for I have not washed for eight days." Then Cézanne sits in a corner, appearing to ignore the general conversation and keeping his opinions to himself, until some particular remark offends him, and he goes off without a word of farewell.

(Blunden and Blunden 1970, 74)

Like the roles of the other members, Cézanne's was evoked by group dynamics. Vollard suggests that Cézanne assumed the role of lout in response to Manet's dandyism: "To tell the truth the vulgarity of speech was actually a pose adopted by Cézanne for Manet's benefit, irritated as he was by his stand-offish airs. Once, for instance, when [Manet] asked his colleague [Cézanne] if he was preparing anything for the Salon, he drew upon himself the retort, 'Yes, some nice dung'" (Denvir 1990, 174).

When the group mobilized to exhibit their work in a rented gallery, most members, particularly Manet, resisted Pissarro and Monet's proposals to include Cézanne. Cézanne seemed to embody what the Salon and the public attempted to pin on them—incompetence and undisciplined rebelliousness. While they sought the approval of the Salon jury and the public, he showed only contempt for their standards by submitting work that was deliberately provocative and sloppy. Though the members had sacrificed success and income to stay committed to the group culture, they still felt ambivalent toward it. Cézanne was thus a boundary marker for the group—embodying traits they denied in themselves. After each jury rejection they could say something like, "At least we are serious. We're not rebellious adolescents like Cézanne."

In *The Masterpiece,* Zola describes several group meetings in which the members attack a second type of boundary marker—the backsliding conservative or "sellout," a member who waters down the principles of the group in order to produce more conventional and marketable paintings. Based on reported arguments over who to include in the group exhibits, conflicts over the sellouts must have been common. Several of Degas's protégés, especially Raffaelli, were viewed as sellouts. As the members became more and more desperate to sell paintings, this role must have become particularly salient, for the sellout represented a direction that many were tempted to go.

Interaction with these boundary markers, and discussions of their faults when they were not present, played an important part in the development of the group. First, having a common target of hostility pulled the group to-

gether. Second, the outrageous behavior of the deviant member provided a stimulus to discuss and clarify the group's central values and shared identity (Erikson 1966; Farrell 1979). In their attacks on the deviants, and in their retelling of episodes where the deviants violated group standards, the circle developed a ritualistic means for reaffirming the group values. In collaborative circles, the deviant becomes an inverted group flag, symbolizing traits and values they reject. In the Impressionist circle, those who, like Cézanne, went too far in rebelling against the jury, and those who sold out to conventional standards, marked the two boundaries of the group.

Although not deviant members, Sisley and Morisot were somewhat marginal in the circle for different reasons. After 1870, Sisley lost all support from his father, and for the first time he had to support himself. It was at this point that his participation in the group served him well. If Sisley had not been part of the group, it is unlikely that at this juncture he would have had the vision and discipline necessary to succeed as an artist. But because he had been a member of the circle, he developed a mature, individualized version of the group vision that led to steady productivity.

Berthe Morisot's problems were different. She had ties with Manet and some of the marginal members of the group, such as Daubigny and Guillemet, but because of the gender roles of the nineteenth century, she was excluded from the give and take of the café discussions. She had to find other ways to absorb the innovations emerging during this period. In the mid-1860s, she seems to have done it on her own, and indeed she succeeded in getting accepted at the annual Salon exhibitions more often than the other group members. In 1868, she met Manet, who became her direct link to Café Guerbois culture. Not only did he convey the emerging vision to her; sometimes, to her dismay, he would take up her brush and complete her whole painting. However, the influence in their relationship was not one way. As we have noted, it was Morisot who first persuaded Manet, who was adamant about painting in the studio, to attempt open-air painting.

During this phase of circle development, the members experienced repeated rejection by the Salon jury, the only agency that had the official authority to validate their work. After each rejection, or after a week of struggle and failure to achieve an artistic goal, the artists working alone must have begun to doubt their talents and the future of the group. But when meeting with the group in the ritualistic café setting, they would review recent events and interpret them in light of the group's emergent vision. The wavering members would receive affirmation of the value of their work and their identities as artists. Examples of the vacuousness of the jury

would be brought to light. New contacts with dealers or respected masters would lead to hope of selling paintings. One member might articulate an impulse that others only vaguely felt. Together they would tease out the implications of the impulse. Together they would work through their conflicts and anxieties, renewing their identification with the values and heroes of the group. As Monet recalled: "Nothing could be more interesting than these causeries with their perpetual clash of opinions. They kept our wits sharpened, they encouraged us with stores of enthusiasm that for weeks and weeks kept us up, until the final shaping of the idea was accomplished. From them we emerged with a firmer will, with our thoughts clearer and more distinct" (Rewald 1973, 197). Duret confirms this sense of being shored up, noting how the group served as a buffer between the members and the authorities who devalued their emerging style: "Manet and his friends strengthened one another in their views to such purpose that not all the opposition, abuse, ridicule, and even at times want that they had to suffer caused them to waver or to deviate from the path they had chosen to go" (Duret 1910, 109).

The Style of Group Interaction
Group discussions in the Impressionist circle were not gentle, but they had many elements of what Simmel calls "sociability"—a form of playful interaction in which the participants set aside status differences and instrumental goals, and just talk for the sheer enjoyment of it (Wolff 1950). Personal feelings and emotional needs are not permitted to intrude. As in many male groups, there seems to have been an underlying norm of competitiveness that prevented the artists from being supportive of one another in the public context of the café. Rather than suppressing their differences when they came together, the members seemed to accentuate them. Their customary pattern was to argue out all sides of an issue, then struggle to reach consensus. Part of the fun was pricking the ego of your opponent, but with humor and goodwill so as not to provoke his anger. Degas might argue for finishing paintings in the studio, emphasizing draftsmanship, like Ingres, and imposing one's vision on nature. The group might then look to Monet to defend the practice of finishing a painting outdoors, emphasizing color, light, and atmosphere, and being true to nature. The exchanges were open, loud, and merciless, but generally remained within limits that allowed most members to maintain their dignity and self-esteem. It would be difficult to imagine members of the group sharing a personal concern about their wives or children in this context. Gustave Geoffrey captured the flavor of the interaction:

They were evenings dedicated to talk and conversation, in which the happenings of the day were discussed with that freedom of spirit which was peculiar to artists who were free from any contact with official organizations. It must be admitted that the Impressionists' table was a very lively and noisy one, and that these men, relaxing from the burden of work, were rather like children just let out of school. . . . I well remember a real duel for and against Victor Hugo which unleashed a flood of passion, ardour and wisdom, and from which everybody emerged reconciled, to go and sit on a cafe terrace and contemplate the ever fairy-like appearance of Paris by night. On other occasions too, the arguments sometimes continued outside on the boulevard, and I am sure that there were some which were never resolved.

(*Claude Monet, sa vie, son temps, son oeuvre* [1922], in Denvir 1987, 167–69)

But hostility could break through the banter, for their criticisms of each other, however good humored, concerned topics about which the artists cared deeply. Indeed, in one incident, a comment led to unexpected violence. After reading a review of one of his paintings by Duranty, who described it as looking like "a philosopher trampling on oyster shells," Manet walked into the Guerbois, slapped Duranty, and challenged him to a duel. In the forest four days later, Zola served as Manet's second. After much clanging of swords and battering of one another, Manet scratched Duranty's chest, and they gave it up. They regretted the whole affair, and as a gesture of reconciliation, Manet offered Duranty his shoes. Duranty refused them because they were too small (Rewald 1973, 198).

Stage 5: Collective Action

Many collaborative friendship circles never develop beyond stage 4, in which the members alternate between working alone and meeting together for discussions. But some go beyond this phase to confront a new set of problems. Having consolidated a shared vision that more or less guides their individual undertakings, having completed works based on that vision, they mobilize to carry out collective action. Expanding upon their relationships as individuals or pairs who meet occasionally to discuss work, the group becomes more organized in order to carry out a project that addresses a shared problem or fulfills a shared goal. The project requires episodes of planning, negotiation, and decision making, as well as coordination of efforts to carry out tasks and meet deadlines. The project could be

an art exhibition, a book, a grant proposal, a political campaign, or some other long-range goal.

For the Impressionists, the chronic shared problems included getting accepted by the jury, getting their work before the public, and selling it. As the members approached middle age and some had families to support, the need to establish themselves and sell paintings became more urgent. Nevertheless, throughout the late 1860s and early 1870s, they experienced repeated rejection by the juries. Perhaps the conservative mood of the country after the Franco-Prussian War (1870–71) contributed to the increased marginalization of the group in the early 1870s. Before the circle acquired the name "Impressionists," they were known in public as the "Intransigents." The name and the radical approach to art led the public to associate them with the political anarchists and the Paris Commune that overthrew the French government for a brief period after the war (Eisenman 1986). At a time when the public hoped for the restoration of order, the wild art of this circle was not well received. If they were ever going to sell their work, they had to do something.

Prior to the war, in the late 1860s, Bazille had initiated a plan to deal with the chronic problem of selling their work, but nothing had come of it. In 1867 when almost the whole group had paintings rejected by the Salon jury —Bazille, Monet, Renoir, Manet, Pissarro, Sisley, and Cézanne—Bazille had written to his parents about a plan for a "group of young people" to organize exhibitions of their own work that would be presented to the public independent of the official jury. In 1869 he had written again with the news that a "dozen talented people" had decided to rent a gallery to present their works. However, before the project could be carried out, the Franco-Prussian War had broken out and the group had dispersed. Monet and Pissarro went to England. Cézanne went home to Aix-en-Provence and avoided conscription. Manet, Degas, Morisot, and Renoir stayed in Paris and participated in the war effort. As the war was coming to an end, a sniper's bullet struck and killed Bazille, the only member of the circle to join the combatants.

When the group reassembled in 1872, the postwar economic depression made it impossible for the group's dealer, Durand-Ruel, to buy any paintings, so they decided to take up Bazille's plan for an independent exhibit once again. On 5 May 1873, in an article for *L'Avenir National* encouraging the idea of an independent "artistic corporation," Paul Alexis alluded to discussions at the Guerbois in which the rules for membership of such a group were outlined. The café meetings, which moved to the Nouvelle Athenes around this time, were given over to planning an exhibit to showcase the

group's work. During these planning meetings, Pissarro emerged as the new leader of the group. As the members clarified what it was they wanted to do, Pissarro's skills at negotiation and peacemaking, his clarity in conveying the new vision, his knowledge of cooperatives, and his integrity contributed to his growing centrality.

Although Monet may have defined the need for action, Pissarro took the initiative in proposing a structure and a set of norms for the exhibition. He drew upon his knowledge of artist cooperatives and a baker's union in his hometown as models for the group charter. The members agreed that, rather than seeking a wealthy sponsor, they would each put up sixty francs to cover the expenses of the exhibition. Membership was open to anyone who contributed sixty francs, which entitled the contributor to hang two pictures. Ten percent of the sales would go to the society's operating budget. Hanging positions would be determined by lot. All members had equal rights and would elect a governing board of fifteen members, five of whom would be replaced each year. The group showed several signs of having moved into a new phase—not only in the plans for collective action, but in the changes in meeting place and leadership, and in the adoption of an explicit set of norms for the group exhibition.

Although the norms and structure of the Impressionist circle evolved over the course of the next decade, their commitment to equal rights and consensus building remained strong. They had reached the phase of group development in which the behavior of members was constrained by an agreed-upon set of norms (Farrell, Heinemann, and Schmitt 1986). Instead of the wittiest speakers, the most charismatic or highest-status members, or the most aggressive personalities dominating the interaction, all members had equal rights to participate. It is indicative of this phase of group development that Pissarro, the peacemaker, teacher, and theoretician, became central, and that the charismatic but volatile Edouard Manet became marginal. External status mattered less in this mature group. Instead what mattered was commitment to the group goals and possession of the resources the group needed to reach its goals. Rather than having decisions made by the most powerful members by fiat, each member had the right to speak out and persuade the rest of the group to accept his or her position. The norms led to more open communication, more equal participation, and, not surprisingly, more open conflict.

Claude Monet played a leadership role in organizing the first exhibit. He revived the argument for bypassing the Salon jury and forming a cooperative to exhibit and sell their works. He argued that the roles of artists were different now than they had been, as different as the railway is to the stage-

coach, and that to survive in their current circumstances artists would have to develop a businessman's perspective (Renoir 1988, 160). However, after the first few exhibitions, Monet was increasingly tempted to submit paintings to the Salon, and finally did withdraw from three of the eight independent exhibitions so that he could do so. Thus, his leadership role, like Manet's, diminished during this phase.

Degas, the devil's advocate, became even more contentious. When only theoretical points were at stake, he had been less problematical. But now real decisions had to be made, he had equal rights, and he had to be dealt with. He argued that, to convey the group's serious intentions of building an independent network outside the Salon jury system, the group should exclude anyone who submitted a painting for jury review. Manet disagreed, arguing that, in the end, the real battle had to be won on the jury's turf. Nevertheless, the members sided with Degas, and as a result Manet decided not to exhibit with the group. Cézanne's presence in the first show was another factor that led Manet to stay out. Although Manet never exhibited with the group, he still played a part in several planning sessions and was identified as the moving spirit behind the group by some reviewers. His refusal to exhibit with them so that he was free to exhibit in the Salon may have contributed to the individual decisions by Renoir, Monet, and Sisley to hold back their work from several group exhibitions and to submit them for jury review.

As Manet pulled back, Degas moved into a more central position. Throughout the collective action phase, he introduced issues that polarized the group, and in his role as devil's advocate, he often refused to compromise. His behavior in the meetings became increasingly negative, and his arguments seemed to muddle more than clarify the issues. For example, not being as dependent upon sales as other members, he argued that the group should be above simply marketing their work. Instead, they should make it their main goal to establish a set of higher standards independent of the jury system. Yet, in an effort to broaden the appeal of the exhibition, he turned around and argued for including several mediocre but commercially successful painters who had won the approval of the jury in the past. Having pushed the jury's values out the front door, he seemed to welcome them in the back. He justified the inclusion of more conventional painters by arguing that the exhibition should not appear to be a radical movement, just a group of independents. Some of the others suspected that Degas simply did not want to be seen alone with them, but they nevertheless agreed to include his friends. Degas seemed to counterbalance his somewhat marginal status in the group by including these protégés. His arguments were contradictory and confused, but nevertheless the group conceded to his demands.

There were eight group exhibitions in all. In the first exhibition, two-thirds of the works were by Degas's friends, but over the next seven exhibitions the members seesawed back and forth between including and excluding Degas and his friends. Especially after Caillebotte joined the group, resistance to Degas and his friends increased. Even Mary Cassatt, Degas's protégée, became exasperated with him. For each exhibition, those who finally displayed their works were the survivors of tedious preliminary battles among the members.

As the disagreements and negative feelings mounted for each exhibition, Pissarro's skills as peacemaker became more and more important. His commitment to the group was unshakable; he was the one member who exhibited in all eight shows. With each exhibition he spent enormous energy shuttling between disgruntled opponents, attempting to soothe angry feelings, and negotiating compromises so that the exhibit would go on. Yet at times, he also contributed to the polarization. His politics were more liberal than those of other members, and he liked the idea of being known as the "Intransigents." He relished the thought of taking on the French establishment, and while Degas sponsored more conservative outsiders, he sponsored the more radical ones—beginning with Cézanne, the old group scapegoat, then including Gauguin, Seurat, and Signac. In contrast, Monet, Renoir, and Sisley just wanted to build their reputations and sell their paintings.

Public Response to the Exhibitions

Having bypassed the Salon jury, the group's success depended on the evaluations of the public and the reviewers. However, the response to the first exhibit was nearly universal derision. Louis Leroy, the art critic for *Charivari,* wrote a satirical review in which he portrayed himself and an imaginary "old master" walking through the exhibit. Monet's *Impression, Sunrise* provoked Leroy's mocking attack on the whole exhibit. Over and over, when Leroy's "old master" expressed shock at an apparently unfinished work, the sketchy figures, and the bizarre colors, the reviewer would pretend to defend the work with the apology, "Yes, but the impression is there." The word was soon taken up by other critics. Because "Impressionists" did not imply a politically radical group, but rather an individualistic response to perceptions of nature, it had certain advantages. By the third exhibition of 1876, the group had adopted the name themselves.

The reaction of the public and the scarcity of buyers could have demoralized the group, but instead they rallied. The steadiness of Pissarro, "the brain of the young movement," was important in keeping them together.

He argued that, despite the setback, it was useless to make concessions in their work. Before the first exhibit they had absolute faith in the public; now they decided the public was not infallible after all. Yet the Salon would never support them, and their best strategy was to stick together and continue the campaign to win over a wider audience.

In fact, after the first group exhibition in 1874, they were closer in style and in commitment to one another than ever before. Even Manet, who was rejected by the jury that year, moved closer to the group. For a while the resolute studio painter adopted the open-air style and the sketchy, short brushstrokes of his friends; and in the summer of 1874, he joined Monet and Renoir to paint outdoors at Argenteuil. One day Renoir arrived at Monet's home in Argenteuil to find Manet in the garden painting Monet's family. Renoir set up his easel alongside Manet and began painting the same scene. Glancing at Renoir's canvas from time to time, Manet finally walked over to Monet and in a humorous stage whisper said, "That boy has no talent. You're his friend, tell him to give it up" (Bernard 1986, 64).

Rejection and meager sales continued at a group auction in 1875 and at a second group exhibition in 1876. As was often the case in the previous decade, Monet responded to the setback with audacity. He began a series of paintings of the Gare Saint-Lazare, near his Paris apartment. To convey how Monet's response inspired him, Renoir relayed a story to his son:

> [Monet] proposed a plan so utterly fantastic that my father laughed whenever he thought about it, even forty years later. Monet's landscape, *Impression,* had been jeered at because no one could see anything in it. . . . One critic had informed him that fog was not a fit subject for a picture. . . . One day he said to Renoir: I've got it! The Gare Saint-Lazare! I'll show it just as the trains are starting, with smoke so thick from the engines you can hardly see a thing. . . .
>
> He put on his best clothes, ruffled the laces of his wrists, and twirling his gold-headed cane went off to the offices of the Western Railway, where he sent in his card—Claude Monet, Painter—to the director. . . . "I have decided to paint your station. For some time I've hesitated between your station and the Gare du Nord, but I think that yours has more character." The trains were stopped, the engines were loaded with coal, and the station was filled with steam and smoke. Monet painted amid respectful awe, then left with a half-dozen paintings, the Director of the company at the head of the whole staff bowing him out.
>
> (Renoir 1988, 158)

The Executive Manager Role

Soon after their second independent exhibit, Monet met Gustave Caillebotte at Argenteuil. Like several other marginal members of the group network, Caillebotte's work was transformed by contact with the group, and he was swept up in their projects. Throughout the 1860s, Bazille's support and organizational abilities had been instrumental to the core group. His death had left a vacuum in the group structure that Caillebotte filled: "A bachelor, wealthy, living quietly outside Paris, cultivating his garden, painting, and building ships, Caillebotte was a modest man whose calm existence seems to have been radically changed by his new friendships. Not unlike Bazille in social position and character—with the same clear mind, dispassionate approach, and deep-seated loyalty—he was now to take in the group the place left vacant since Bazille's death: the place of comrade and patron" (Rewald 1973, 349).

Caillebotte purchased numerous paintings by the group members, and in his will specified that they be given to the Louvre. But his role in the group development and maintenance were also important. For example, it was Caillebotte who navigated through the interpersonal conflicts and dealt with all the mundane problems in mounting the third exhibit in 1877 (Brettell 1986, 189):

> Wednesday
> January, 1877
>
> My dear Pissarro,
> Will you come to a dinner at my house next Monday? I am returning from London and would like to discuss certain matters with you relative to a possible exhibition. Degas, Monet, Renoir, Sisley, and Manet will be there. I count absolutely on you.
> Monday at seven o'clock.
> All my best,
> G. Caillebotte

As the group wrestled with the problems of collective action, the members found themselves polarized over several issues, with divisions falling along a predictable axis. On one side was Caillebotte, the patron and pragmatic organizer who worked doggedly to solve the problems of finding a space in which to exhibit, getting out the advertisement, hanging the paintings, and solving the inevitable problems that arise in staging an event. On the other side was Degas, who in his role as devil's advocate became more and more obstructive. Lacking the patience of Pissarro, Caillebotte became

infuriated by Degas's maneuvering, and he soon took on the role of group lightning rod, expressing the members' shared exasperation.

Before the 1880 exhibition, Degas wrote to Bracquemond: "We open on the first of April. The posters will be put up tomorrow or Monday. They are in bright red letters on a green ground. There was a big fight with Caillebotte about including names. I had to give way and let them be included. When will the stars stand down? . . . Common sense and good taste are helpless against the apathy of the others and Caillebotte's mulishness" (Bonafoux 1986, 45).

After Monet, Sisley, and Renoir decided to pull out of the group exhibition and submit paintings to the Salon jury, Caillebotte wrote to Pissarro, arguing for exclusion of Degas's friends in the 1881 exhibition:

What is to become of our exhibitions? We must go on and go on solely with an artistic aim, in reality the only aim that interests us all. What I want therefore is an exhibition of the work of all those who are or will be really interested in the matter . . . that is, you, Monet, Renoir, Sisley, Mme. Morisot, Mlle. Cassatt, Cézanne, Guillaumin; if you wish, Gauguin, perhaps Cordey, and myself. That's all, because Degas will refuse to participate in a show on such a basis. . . . Degas has spread discord among us. It is unfortunate for him that he has such an unsatisfactory character. He spends his time haranguing at the Nouvelle-Athenes. . . . No, this man has gone sour. He doesn't hold the big place that he ought according to his talent and although he will never admit it, he bears the whole world a grudge. . . . It would take a volume to tell all he has said against Manet, Monet, and you. All this depresses me deeply. If there had been only one subject of discussion among us, that of art, we would always have been in agreement. The person who shifted the question to another level is Degas, and we would be very stupid to suffer his follies. He has tremendous talent, it is true. . . . But let's stop there. . . . As a man, speaking of Renoir and Monet he even went so far as to say to me, "Do you receive people like that at home?" He carries disparagement to the point of rudeness. He claims that we must stick together and be able to count on each other (for God's sake!); and whom does he bring us? [here Caillebotte lists Degas's protégés] What a fighting squadron in the great cause of realism!!!! . . . If Degas wants to take part, let him, but without the crowd he drags along.

(Bonafoux 1986, 145)

Pissarro would not support the break with Degas. He reminded Caillebotte that although Degas argued for many mediocre talents, he also had brought Mary Cassatt to the group exhibits. Pissarro also disagreed that art united the group and egos divided it: "Art in my view is the only subject really fraught with difficulties and calculated to divide us. It is by no means certain that by this criterion you, I or even Degas for his great talent, would be accepted by some artists who let their idiosyncrasies blind their better judgement. After your letter, I am afraid I see little chance of our being able to agree. One day you will see how unstable are opinions in the world of art." Caillebotte could not agree and eventually withdrew from the exhibition: "It is most disheartening. I'm withdrawing into my shell like Degas (but not like him) to wait for better days." Pissarro then appealed to Caillebotte's close friend, Monet: "I must confess I'm baffled. For the past two or three weeks I've been doing my utmost, with our friend Caillebotte, to find some way of bringing our group together again. . . . We can't expect everyone to have the same talent; it's already a lot if no one is obviously out of place" (Bonafoux 1986, 145, 146).

In 1882, Caillebotte succeeded in pulling the prodigal members— Monet, Renoir, and Sisley—back into the exhibition while keeping Degas and his friends out. Preparing for the 1882 exhibit, Caillebotte was in his glory. Describing the hanging of the paintings, a reporter wrote: "Caillebotte came and went, giving orders, surveying the hanging of canvases, and working like a porter. Nearby, Pissarro, seated on a large trunk, watched him with interest . . . and seemed tired from being witness to so much activity" (Moffett 1986, 378).

Stage 6: Group Disintegration and Member Individuation

In the 1870s, the Impressionists organized four of the eight group exhibits. Each year one or two members withdrew from the independent show and made bids for official approval. In 1878, Renoir was accepted by the Salon jury and obtained a commission to paint a portrait of the Charpentier family. Because of the wealth and status of the family, the portrait was a great success at the Salon exhibition. In 1879, when Renoir met his future wife, Aline Charigot, he was in the midst of a crisis of doubt about Impressionism: "I hardly knew where I was any longer; I felt as if I were drowning. I had wrung Impressionism dry, and I finally came to the conclusion that I knew neither how to paint nor how to draw. In a word, Impressionism was a blind alley, as far as I was concerned." As his son explains, Renoir was vac-

illating again between the poles that he attempted to pull together all his life: "one minute an impenitent Impressionist, determined to follow the same line as his friend Claude Monet; and the next, an intransigent classicist, a stubborn disciple of M. Ingres" (Renoir 1988, 221).

Renoir abandoned the sketchy Impressionist style and set out to acquire more draftsmanship, working in the traditional manner with multiple preparatory sketches for work painted in the studio. In 1881, he traveled to Algiers and Italy to study the masters. In 1882 when he returned from Italy, he refused to exhibit with the Impressionists, but in 1883 he agreed to Durand-Ruel's proposal to do a one-man show. There are numerous indications that he was breaking free of the group culture, especially the profound influence of Monet, and that he was synthesizing a more personal style. After his experiments of the mid-1880s, he returned to a more fluid technique, but it was his own version of Post-Impressionism.

Around the same time that Renoir was questioning his future with the group, Monet was also expressing dissatisfaction: "I am no longer a beginner, and it is sad to be in such a situation at my age [thirty-eight], always obliged to beg, to solicit buyers" (Rewald 1973, 420). Indeed, in 1880, Monet dropped out of the independent exhibit and submitted his paintings to the judgment of the Salon. The following year, Durand-Ruel began purchasing Monet's work in advance, and his fortunes improved. In 1883, he developed the style of painting a series of the same scene over and over to capture the transitions in light and atmosphere, hour by hour, day by day. The haystack series were his first landscapes without figures, and he continued this style until his last series of water lilies. In his later work, as his eyesight began to fail, he conceived the idea of painting over and over again large patches of color that were visible to him. By this time, he had come a long way from the original Impressionist style, and his more individuated work in this later period had a profound influence on the artistic movements of the twentieth century.

In December of 1883, Monet wrote to Durand-Ruel: "I am finding it harder and harder to satisfy myself and I begin to wonder if I'm going mad or if what I do is no better and no worse than before, but it is simply the fact that I have more trouble now doing what I used to do quite easily. However, I think I am right in being more particular." By 1884 he and Renoir, who had so successfully painted alongside one another in the past, were finding it difficult to work together. After a vacation with Renoir, Monet wrote: "Nice as it has been to make a pleasure-trip with Renoir, just so would it be upsetting for me to travel with him to work. I have always worked better alone from my own impressions" (Rewald 1973, 488). Both artists had

achieved a degree of individuation that made them chafe against Impressionist culture and the relationships of the past.

They were not the only ones feeling the constraints. Cézanne's variations on themes inspired by the landscapes around Aix-en-Provence provide another example of the individuation process. Cézanne was obsessed with a quest to go beyond the Impressionists and find his own style—capturing the essence of the object beneath the perception. Like Monet, he began painting a series of the same scene. Over and over again, he struggled to find the architectural essence beneath the impressions.

Zola's break with the group was dramatic. In the mid-1880s, word got around that he was completing a novel based on his observations of the group. They expected it to be a sensation that might add to the campaign to build their reputations. The hero of the book, Claude Lantier, was modeled mostly from Zola's observations of Cézanne in the 1860s, but included elements of both Monet and Manet. To the surprise of the group members, Zola portrayed the hero as a failure, and presented his friends as a mutual admiration society caught up in what Janis (1972) might call groupthink— stereotyping, devaluing their critics while overvaluing their own work. Zola felt the group had failed to develop a visual analogue to his naturalist style of literature. In the conclusion of the novel, he had the hero hang himself in front of his unfinished masterpiece, which bore a resemblance to a painting from Monet's Notre Dame series. The members were universally offended, especially Cézanne. Cézanne had already been repulsed by Zola's arrogance and his growing taste for the good life, but this was the last straw. The tie with his childhood friend and colleague was broken for good.

Degas had always had difficulty in his relationships with the other members of the Impressionist group. The Café Guerbois circle had played a significant part in motivating him to focus on spontaneous, contemporary street scenes and to use a wider range of colors, but he had always held himself somewhat aloof. The conflicts over the exhibitions had left him even more isolated. After Manet's death in 1882, he pulled even further away. Although in a series of brightly colored pastels completed in the 1890s he continued to draw on the Impressionist style, he also moved beyond their agenda and experimented with photography and sculpture.

As the others began to receive recognition and sell their works, Sisley and Pissarro lagged behind. Sisley became suspicious that there was a conspiracy against him. Asked whom he admired most of contemporary painters, he did not even mention his old friends. Yet it was Sisley who remained most faithful to the Impressionist vision: "Monet, Renoir, Pissarro each made a personal contribution to the development of Impressionism, but Sisley was

happy to accept it just as it was. He almost seems to have adopted Impressionism because his friends were Impressionists. But after absorbing the style, he penetrated the essence of things far more deeply than they did" (Bernard 1994, 94). Sisley's openness to Monet's influence was still apparent in his series of cathedral paintings in the 1890s, initiated after viewing Monet's cathedrals. Despite the rift in his ties with the circle, when he lay dying of cancer in 1899, he asked for Monet, who rushed to his side.

Several factors contributed to the disintegration of the Impressionist circle during the later stages of its development. First, there were the interpersonal conflicts created during the collective action phase. Second was the differential success of the members. Third, as various members left their youth behind and married, they were confronted with conflicting demands from the group and their families. Finally, as the artists mastered their craft and developed more autonomous values, they had less need to buttress their egos through identification with heroes, attacks on scapegoats, and validation by the group. They became more individuated, both as personalities and in their artistic styles. As a result, they had less need for either the support of collaborative pairing or the challenge of the boisterous café discussions.

Even the steadfast Pissarro, weary from all the battles, showed signs of disillusionment with both the style and the circle. In 1886 he wrote: "It's all over with the Impressionists. . . . Impressionism was only a misunderstanding. The solidarity of the Impressionists was a constraint born of a necessity. Impressionism disappeared with that necessity. It was not by chance that the two began and come to an end together" (Denvir 1990, 147). Renoir concluded his own account of the group's history more poignantly: "We were all one group when we first started out. We stood shoulder to shoulder and we encouraged each other. Then one fine day there was nobody left. The others had gone. It staggers you" (Renoir 1988, 268).

Stage 7: Nostalgic Reunion

In the next decade, the members increasingly became physically separated as well as psychologically and stylistically individuated. For most, the demands to support and be with their families grew more pressing. Some continued to meet in Paris for the dinners that, during the 1880s, moved to Berthe Morisot's home, but each worked in relative isolation. Eventually age itself impeded their interaction. Renoir developed crippling arthritis. He was bound to a wheelchair, his hands were deformed, and the skin became fragile. His son writes:

Rheumatism cracked the joints, bending the thumb towards the palm, and the other fingers toward the wrist. . . . His hands . . . could no longer pick up anything . . . contact with the handle of the brush injured [his skin] . . . he had a little piece of cloth inserted in the hollow of his hand. . . . Visitors who were not used to mutilation could not take their eyes off it. Their reaction which they dare not express, was, "It's not possible. With those hands he cannot paint those pictures. There's a mystery."

<div align="right">(Denvir 1990, 203)</div>

From 1886 until her death in 1895, Berthe Morisot became the anchor, holding the group together. The ritual of the Thursday-night dinners continued at her home. In 1888, Monet enlisted her help in organizing a subscription to buy Manet's *Olympia,* so that it would not be sold to an American collector. It was an occasion for the whole group to rally and to express their solidarity. The only missing name from the list of subscribers was Zola's.

Ironically, it was Cézanne, the Café Guerbois deviant, who became the idol of the younger painters in the 1890s. In 1891, Maurice Denis exhibited his *Homage à Cézanne,* showing the young painters of the new generation gathered around Cézanne's *Still Life with Apples.* Denis's painting was purchased by Andre Gide. Cézanne had succeeded in transforming what he had taken from the Impressionists into a personal style, and he now played for the new generation the role that his old nemesis, Edouard Manet, had played for his. The movement, and the network of artists in Paris, had come full circle.

Chapter 3
————

Voices in the Circle:
The Fugitive Poets in the Formation,
Rebellion, and Quest Stages

> It would be more correct to say that Ransom, the most advanced, was
> the first to choose his orbit; then others, one by one, found theirs, ex-
> erting great mutual attraction, with perhaps some repulsion here and
> there, on one another.
>
> —Donald Davidson, *Southern Writers in the Modern World*

The group dynamics of a collaborative circle can have profound effects on
the development of its members. In many cases, if the members had not
participated in the group, they never would have developed the skills or
psychological resources to do creative work. In this chapter, I examine the
influence of circles on their members during the formation, rebellion, and
quest stages of circle development. The case study for this chapter is the
Fugitives, a group of young poets who first met in Nashville, Tennessee, in
1914 and who formed a collaborative circle that lasted approximately fifteen
years (plates 13–19). The circle included John Crowe Ransom, Donald
Davidson, Allen Tate, and Robert Penn Warren. In the 1920s and 1930s, the
Fugitives were among the most influential voices in the Southern Renais-
sance literary movement. Throughout this chapter, I compare the develop-
ment of their circle to that of the Impressionists, noting the similarities and
differences in their early stages of development. By comparing cases, it is
possible to recognize the common processes that occur as circles develop.

To examine the effects of a circle on its members, I focus on the develop-
ment of one of the Fugitives' core members, Donald Davidson. Although
Davidson is less well known than Warren, Ransom, and Tate, he played a
leadership role in the circle's development, and the circle in turn played a
crucial role in his development. Just as Sisley might never have succeeded as

an artist if not for his role in the Impressionist group, Davidson might never have become a poet, editor, and writer if he had not been a member of the Fugitive group. To orient the reader to the Fugitives, I begin with a brief history of the life course of the circle, drawing on individual reports of the members and the collective accounts of the group (see especially Bradbury 1958; Conkin 1988; Cowan 1959; Davidson 1958; Purdy 1959; Tate 1975). Then, comparing the Fugitives with the Impressionists, I discuss the factors in the environment and composition of the circle that contributed to its formation. Next, examining the story of the Fugitives, I discuss the group dynamics and informal roles that characterize the early stages of circle development. In the final section, I examine in detail how these group dynamics contributed to Donald Davidson's development.

An Outline of the Development of the Fugitive Group

The Fugitive group formed through a developmental process analogous to spontaneous generation. When they began meeting, none of the members had decided to form a literary group, no dynamic leader set out to bring them together for this purpose, and none of the members even considered writing poetry. Their career ambitions ranged from chemical engineering and medicine to banking and classical literature. The initial circle crystallized in 1914 from a network of undergraduate friends that included Donald Davidson, Stanley Johnson, Nat Hirsch, and Nat's older brother, Sidney Mttron Hirsch. This core group later welcomed to its ranks John Crowe Ransom, Allen Tate, and Robert Penn Warren. Together they stumbled onto the conditions for forming and developing a successful collaborative circle. As Davidson put it, the group culture centering on poetry grew like a weed, a "volunteer . . . in the formal garden of higher education" (1958, 73).

When the original members first started meeting at Sidney Hirsch's in the fall of 1914, they were a group of undergraduate companions who enjoyed philosophical and literary bull sessions on Saturday evenings. As they moved from the formation stage into stage 2, the rebellion stage, they became critical of the authorities around them, particularly members of the university faculty. They were critical of the literary establishment that perpetuated sentimental myths about the Old South, as well as the civic boosters who envisioned the New South as an emerging powerhouse of industry and commerce. Over a period of several years, interrupted when the members joined the war in 1917, resuming with their return to Vanderbilt in 1920, their discussions came to focus on free verse. Some favored modern poetry, others despised it, but they were all intrigued by the re-

cently published works of T. S. Eliot, Ezra Pound, and Edna St. Vincent Millay.

During the quest stage, convinced they could write as well as the poets that were getting published, several members began experimenting with their own poems and brought them to read at the group meetings. Eventually, reading poetry became a group ritual: each member was expected to come to the biweekly Saturday evening meetings with enough carbon copies of a fresh poem to pass around the rest of the group. As Davidson recalls, members took turns "steadily composing poems to be read in our close-knit group—composing them in a spirit of friendly emulation, week by week often in great and joyous excitement, but sometimes, too, with more determination than fervor; then submitting the new creations to run the gauntlet of criticism and argument, inside the Fugitive meeting itself or in more intimate and personal colloquies between individuals" (Davidson 1958, 19). Out of their dialogues grew a vision for writing poetry and doing literary criticism. Though they varied in their understanding and acceptance of that vision, their debates became a stimulus for their work throughout stage 4, the creative work stage, as each member struggled to find his own voice as a poet.

Stage 5, the collective action stage, began with the members' increasing confidence in their aesthetic judgments as they assessed the value of their work and received encouragement from occasional guests. In the spring of 1922, feeling that the group had accumulated a number of publishable poems, Sidney Hirsch proposed that the group publish their own poetry journal. They debated the pros and cons of the suggestion, and not much more than a month later they published the first issue of the *Fugitive*. Fearing they might make fools of themselves, they used pseudonyms in the journal's first two issues. However, when the poems were favorably reviewed, and when two reviewers mistakenly attributed all of the poems to Ransom, the others quickly decided to use their own names.

As they carried out this collaborative publishing project, they became more demanding of one another. Not only did the group require poetry of publishable quality from its members, but they also expected the members to contribute to editing and publishing the journal. Between 1922 and 1925, they published nineteen issues. After 1925, their careers led them in different directions. Several of the original members went back to conventional occupations, such as banking and insurance, but others went on to literary careers. For the latter, collaboration in the circle laid the foundations for their careers as poets and critics.

Even when they began to pull apart, they still saw themselves as Fugi-

tives, and the core members continued to exchange letters and criticize one another's work. In the late 1920s, they entered a second period of collective action. The South had become the target of a barrage of attacks from Northern intellectuals. Those attacks intensified when Clarence Darrow came to Dayton, Tennessee, in the summer of 1925 to defend John Scopes, the school teacher charged with violating state law for teaching the theory of evolution. After Darrow lost the trial, several journalists, notably H. L. Mencken, took advantage of the opportunity to sketch a devastating caricature of Southern culture: "Down there a poet is now almost as rare as an oboe-player. . . . It is indeed amazing to contemplate so vast a vacuity. One thinks of the interstellar spaces. . . . And yet, for all its size and all its wealth and all the 'progress' it babbles of, it is almost as sterile, artistically, intellectually, culturally, as the Sahara Desert" (1949, 136).

Incensed by Mencken's portrait, the Fugitive group, led by Davidson, set out to shape an alternative vision of the South. Together they published a volume of essays that defended the agrarian South as an indigenous regional subculture, much like that of New England. They argued that regional subcultures served as antidotes to the dehumanizing effects of modernization, which they saw as spewing out of the industrialized Northeast like soot out of a steel mill's smokestack, threatening to turn the whole country into a wasteland. The Southern way of life, they argued, provided a sense of community that counterbalanced the alienating homogenization of industrial society. They contrasted the religious and communal values of the South with the Northern values of individualism, mass production, mass consumption, and profit. Their book, *I'll Take My Stand,* published in 1930, became a cornerstone of the Southern Renaissance.

Structural and Cultural Conditions Favoring the Development of Circles

Late night bull sessions among college students like the one that grew to be the Fugitive group are ubiquitous, but few survive beyond the members' early twenties. The members usually drift apart when they start to develop more defined aspirations, more specialized skills, and more lasting commitments to work and families (Farrell and Rosenberg 1981; Farrell 1986). Why did this group not only survive beyond the undergraduate years, but thrive as a collaborative circle? The answer to this question lies in three areas: the environment in which the group formed, the composition of the group, and the informal leadership roles that members took in the early stages of development. In this section, I examine each of these factors in turn.

In many ways, a collaborative circle is a vulnerable organism, and it de-

velops best in an ecological niche with particular properties. In an environment with the right combination of supportive resources and challenging obstacles, the members are gradually able to deepen their commitment to one another and the emerging group culture. Without this combination, the members drift apart. The environmental factors that contribute to circle development include (1) a magnet place that draws together ambitious people with similar aspirations, (2) a perception of cultural turmoil at the magnet place, (3) a scarcity of mentors, and (4) a shared sense of marginalization among the members.

A Magnet Place

Like most collaborative circles, the Fugitive group crystallized out of a network of people drawn together by a magnet place. A magnet place is a setting where novices perceive there to be a network that will help them become experts in a discipline. For the Impressionists, the art world of Paris was the magnet that drew them into proximity. For the Fugitives, the magnet was Vanderbilt University. As the young men saw it, Vanderbilt offered access to an education and to the occupational doors of the middle class. The members were drawn to the same place by the promise of the university.

Clashing Cultural Fronts

But there are many magnet places. Was there something unique about Vanderbilt at the time that made it particularly conducive to creative work and to the development of a collaborative circle? One characteristic of magnet places that fosters collaborative circles seems to be the presence of intellectual conflict. As Cowan noted about Vanderbilt at this time:

> In its peculiar mixture of the erudite and the homely, the universal and the local, Vanderbilt was to furnish the Fugitives that contrast of conditions needed for the operation of intellectual creativity. . . . Sometimes in cultural crises there are particular arenas where opposing ideas and beliefs can come together in close contact, as on a stage, the ensuing dramatic conflict revealing their true nature. Vanderbilt during the first three decades of the twentieth century was such a focal point.
>
> (Cowan 1959, 5)

Founded in 1873 at the height of Reconstruction, the university in the early 1900s was in the process of secularizing the religious agenda of its founders (Cowan 1959; Stewart 1965). By combining learning and Christian values, the Methodist founders sought to transcend the divisions between

the North and the South so as to educate not just "Southerners," but Americans. Although this original fervor was diminishing when the Fugitives arrived, remnants of the religious mission persisted alongside a new emphasis on science and the classics. In addition, many faculty and administrators were now committed to making the university a catalyst for modernization in the "New South." To them the university was an outpost for the liberal values and economic expertise that would transform the underdeveloped South.

This fragmented university culture was a multifaceted prism through which the young Fugitives viewed their Southern backgrounds. Just as the opportunities of the Paris art world drew the Impressionists to a place where clashes of artistic style "blew their minds," the promise of Vanderbilt drew the Fugitive network to Nashville, and the new theories of history, literature, and science challenged their worldviews and self-concepts. Their academic work exposed them to the divergent religious, scientific, classical, and commercial traditions, and the conflicting views were suspended in precarious balance within the minds of the young men.

Scarcity of Mentors

Although Vanderbilt was a magnet place, it was a small school with not enough faculty to allow a strong apprentice system to develop. Like the environment that encouraged the Impressionists to pull away from the teachers of the Académie des Beaux-Arts and increase their commitment to one another (White and White 1965), the university environment of the Fugitives had some, but not enough mentors to meet their needs. Characteristically, Robert Penn Warren saw the bright side of having too few mentors: "[I]n a small and close provincial college, anybody who has quality on the faculty stands out like a diamond on a piece of black velvet. . . . [T]heir impact is much greater than it would be otherwise . . . where you follow through the way a few people think or feel and have a model to accept or reject" (Purdy 1959, 117–18). Many faculty lived on campus, and the proximity encouraged communication and more informal teacher-student relationships. But within each department, often only one faculty member taught most of the courses, and the bright students soon learned all he or she had to say (Cowan 1959). Ransom was fond of telling a story of the reaction of his advisor at Oxford when he arrived there to study after graduating from Vanderbilt. In deciding where to start Ransom's reading, the advisor asked what authors he had read for inductive logic. Ransom gave a name—Noah K. Davis—the name of the mentor of his teacher at Vanderbilt. Then the advisor asked whom he had read in deductive logic. Ransom

gave the same name. Asked whom he had read in ethics, Ransom gave the same name. Finally, he gave the same name when asked whom he had read in psychology (Purdy 1959).

A shortage of mentors was a factor that encouraged the Fugitives to turn to one another. They were drawn to the group because it offered something they could not get from their teachers. For both the Fugitives and the Impressionists, either a shortage of mentors or mentors with limitations that left the students unsatisfied led them to invest in their peers as a source of intellectual stimulation and guidance.

Cultural and Structural Marginalization

A number of researchers on creativity have noted that new paradigms in art or science often originate on the periphery rather than at the center of a discipline network (e.g., Arieti 1976; Chubin 1976). Those on the periphery may find themselves there for a variety of reasons, including their religion, race, gender, or age. For example, the young Impressionists discovered one another in the marginal studios of Paris, and one theme in their conversations was the sense of alienation from their teachers and the accepted styles of the day. Likewise, the young Fugitives discovered in one another a shared sense of marginalization in relation to the national and the local community. Hirsch, a Jewish intellectual and world traveler who had had a hand in staging a few off-Broadway plays before returning to Nashville, fostered this sense that Nashville was a remote outpost in the literary world. Particularly after they developed aspirations to become poets, the Fugitives discovered they were far from the center of a professional network.

They felt marginalized by the literary establishment, by the authorities in the universities, as well as by the conventional culture around them. The sense of marginalization was particularly strong in relation to the Northern literary establishment. To many Northern intellectuals, the South was the dark underbelly of American society (Schwartz 1997). Mencken, whose attacks were particularly irksome to the group, portrayed the South as a dead civilization, the "Sahara of the Bozarts," lagging behind both culturally and economically as the rest of the country modernized:

> [The Old South] was a civilization of manifold excellences—perhaps the best that the Western Hemisphere has ever seen—undoubtedly the best that these States have ever seen. . . . It was there that nearly all the political theories we now cherish and suffer under came to birth. It was there that the crude dogmatism of New England was refined and humanized. But consider the condition . . . today. It is as if the

Civil War stamped out every last bearer of the torch, and left only a mob of peasants on the field.

<div align="right">(Mencken 1947, 137–38)</div>

The resentment at these stereotypes comes out in Donald Davidson's account of those early years: "The South became a major target area in a long sustained bombardment which was by no means merely verbal. . . . We lived too much in the past, it was said. We favored a moonlight-and-magnolia type of poetry and fiction. Politically, we were Bourbons, and the Solid South was too solid. . . . We were religious bigots. We were Ku Kluxers. We were lynchers. We had hookworm, we had pellagra, we had sharecroppers, we had poll taxes. We did not have enough schools, colleges, . . . skyscrapers, . . . modern plumbing. We had too many . . . Methodists and Baptists . . . too many old colonels" (1958, 35). Not without reason, the members of the circle felt they were outcasts or "fugitives."

Similarities in Stage of Life, Background, Values, and Style of Interaction

A relatively dense network of ambitious people at the start of their careers, a magnet institution where diverse visions clash, a scarcity of mentors, and a shared sense of marginality are common factors in the environment of collaborative circles in their early stages of formation. However, not all networks that share these conditions develop into successful collaborative circles. Besides these external conditions, successful circles are also likely to have a similar set of internal properties.

In general, members of successful circles are characterized by similarity in their stages of life, social backgrounds, values, and styles of interaction. Although the members are not so similar that they validate all of one another's reactions to the world around them, they are similar enough to be able to find common ground for discussion. As they react to the new ideas they are learning, the positions taken by the others are familiar or plausible. They can identify with and trust one another, but they also know how to provoke and challenge one another.

Even before they were drawn to Vanderbilt, the Fugitives shared "a simple homogeneous background" (Tate 1975, 33). Raised in communities where legends of the Old South were still told, they shared a sense that something precious was being lost in the changes occurring around them. When they listened to one another, they found they took for granted many unspoken feelings and values. Recalling the early meetings, Davidson writes: "Our great good fortune was that we shared pretty much the same assumptions about society, about man, nature, and God. And we were most fortu-

nate in not even having to ask ourselves whether or not we were on common ground in such matters. . . . In the South of those days there were many questions that did not need to be asked, and some of these were large metaphysical questions" (Davidson 1958, 6). And as Tate puts it in his memoir:

> I would call the Fugitives an intensive and historical group as opposed to the eclectic and cosmopolitan groups that flourished in the East. There was a sort of unity of feeling, of which we were not then very much aware, which came out of—to give it a big name—a common historical myth; and its use for the dramatic and lyrical arts, I believe, is that it expresses itself in the simple ritual of greeting a friend in the street. Although we disagreed, and at times quarreled, we had . . . a deep understanding that gave even the quarrels a special intensity and form. . . . All things were possible in that time to us all, the older and the younger men alike.
>
> (Tate 1975, 33)

Although all were Southerners, they all came from families that were not directly connected to the commercial-industrial New South. Most had attended private schools that provided an education centered on the classics. They all had absorbed the Southern tradition of conversation—a "blend of gentility and spirit, honor and humility, sympathy and humor" (Cowan 1959, xxii), intimate, but not too introspective. Because they shared many assumptions, and because they shared a set of rules for conversing—they found they spoke the same language and could argue persuasively with one another.

The combination of shared values and a shared code of communication contributed to a familial sense among the group members. Davidson thought it was important that he and Ransom came from the same rural area of Tennessee, and that his father knew Ransom's family. William Yandell Elliott thought he was a "distant kinsman" of Ransom (Purdy 1959). Because of these connections, they saw one another as "cousins." This familial quality was amplified by the choice of Sidney Hirsch's home as their meeting place: "[Poetry] was as natural and reasonable an act as conversation on the front porch. We dropped into the cousinship of poetry as unhesitatingly as—in those times of unabridged hospitality—one dropped into the house of kinsman or friend without invitation or prearrangement. It was as if we had been cousins all the time, or had good report of one another through some aunt, uncle, or grandparent" (Davidson 1958, 8).

At both a conscious and unconscious level, the members mapped out their relationships as pseudo-kin. Thus, in addition to the environmental factors that caused them to seek one another out, this easy commonality of background, values, beliefs, and styles of communicating bound them closer together.

The Early Development of Circles and Their Members

In this section, I examine the processes that occurred in the formation, rebellion, and quest stages of the Fugitive circle. To highlight the effects of circles on members during these stages, I will focus on how the group processes affected the development of one member, Donald Davidson. The focus is on the interplay between the development of the circle and development of the individual member.

The Formation Stage of the Fugitive Circle

In 1910, after completing his freshman year at Vanderbilt, Donald Davidson (plate 13) dropped out of school to earn money to pay off loans. In September 1914, when he was twenty-one, he returned, still in debt, but determined to resume his studies. He was an even-keeled, hard-working young man whose father, a rural Tennessee schoolteacher, had given him the middle name of "Grady," the name of a famous peacemaker of the nineteenth century. As we shall see, the identity of "peacemaker" stuck.

One day in the fall of 1914, the lanky sophomore walked from the Vanderbilt campus to the nearby home of his freshman friend Nat Hirsch. He had set out for a date with Nat's sister, Goldie. When he arrived, he was introduced to another member of the family, Nat's older half-brother, Sidney (plate 14). Sidney did not rise to greet him. Like a large Cheshire cat, he reclined on a chaise lounge in the center of the living room. He was a big man in his mid-twenties, and although he seemed healthy, he was unemployed, because, he claimed, he had a back injury from his travels in the Orient. Perhaps he did, or perhaps he injured it when he was a boxer in the navy, or after that, when he traveled around Europe with his personal tutor, a sculptor, who, he said, had introduced him to Rodin. He claimed he had modeled for two sculptures by Rodin, and that he had befriended Gertrude Stein and other literary celebrities. The year before, in the spring of 1913, Sidney had brought national attention to Nashville with a pageant he wrote and directed, *The Fire Regained*. The play, thick with allusions to arcane

themes of Greek gods and the occult, included chariots, a winged horse, and a cast of six hundred. It was staged at the replica of the Parthenon in Centennial Park.

Because the family accepted Sidney as a genius and as the traditional scholar in a Jewish family, they tolerated his eccentricity and his unemployed status; but Sidney needed an audience, and he needed to reestablish his role as "genius" with each new visitor to the home. One of his methods was to entangle the guest in a web of esoteric questions about the hidden meaning of everyday words. For example, he might ask an unsuspecting visitor a bewildering series of questions: "What is the meaning of the word, 'wood'? The Trojan horse was made of wood, am I correct about that? And the oak is the sacred tree of kings? How does this relate to Dante, the poet, writing about finding himself lost in the woods?" As William Elliott later put it, one point of Hirsch's questions was that "all truth of the world is essentially esoteric, concealed, carefully passed from one generation to another, available only to the superior people, the initiates" (Purdy 1959, 126).

As this Socrates of Nashville spun out his interrogations, Davidson felt outclassed. Indeed, he later wrote that the conversations made him feel he was "destined to be but a shy guest at the feast of the world's great cultures" (Davidson 1958, 11). But Sidney did not accept self-abnegation. He was unsettling, but his arguments were not impervious, and he welcomed intellectual sparring. Sidney's interests laid the foundation of the group's culture: a fascination with words, philosophy, and storytelling. Sidney also set the initial tone for their interactions—a playful intellectual style, peppered with self-mocking arrogance. He set the norms of confrontation and competition, tempered by warmth, gentlemanly restraint, and undivided attention to words and meaning.

Davidson returned to talk with Sidney, as did several other friends of Nat, notably William Elliott, Alec Stevenson, and Stanley Johnson. Sidney was so charming, and the conversations were so intriguing that Davidson invited his friend and former Shakespeare teacher, John Crowe Ransom (plate 15), to join them. Davidson took over the gatekeeper role from Nat, and later in the group's history, after World War I, Davidson invited his student, Allen Tate (plate 16), to come to the meetings. In 1921, Tate persuaded Davidson to accept into the group his friend Merrill Moore (plate 17); and still later he obtained entrée for his roommate and friend, Robert Penn Warren (plate 18). Only eighteen and an undergraduate junior when he joined the group in 1923, somewhat shy and inclined to solitude, Warren was the youngest member (Watkins and Hiers 1980, 227).

Ransom, Davidson, Tate, Sidney Hirsch, and later, Warren and Moore

became core members of the circle. Stanley Johnson and Alec Stevenson were members during the early stages, as was Hirsch's brother-in-law, James Frank. After the war, Hirsch lived with the Franks, and their home became the Fugitives' meeting place throughout the 1920s. The extended circle included other members, some who were only occasional contributors to the journal, and others who were left behind as the poetic standards of the group rose. The members of the extended circle included Walter Clyde Curry, William Elliott, William Frierson, Jesse Wills, Ridley Wills, Laura Riding Gottschalk, and Alfred Starr.

The Fugitive Initiation Ritual and the Tone of Male Circle Meetings

Once the Fugitives' meetings became ritualized at the Franks' home, the custom was to sit in chairs arranged in a circle around the edge of the room. They met every other Saturday evening between about 8:00 and 10:30 P.M. After the meeting, Rose Hirsch Frank, Sidney's sister, pulled back the curtain separating the living and dining rooms and invited the men to make sandwiches and pour drinks. Initially the interaction centered on Sidney Hirsch, but as the group developed, others took on leadership roles. Nevertheless, Hirsch continued to be the one to initiate new members. In his memoirs, Allen Tate gives an account of his first evening in the group in the fall of 1921:

> I remember the tone of the conversation; it was not very literary but philosophical and even philological . . . and I soon suspected why I had been asked to come. We had two hosts, Mr. James Frank . . . and Dr. Sidney Mttron Hirsch, a man of vast, if somewhat perverse erudition; and it was plain that I had been invited to hear him talk. He was a mystic and Rosicrucian, a great deal of whose doctrine skittered elusively among imaginary etymologies. At that time I was not very consciously a poet. I was studying Greek and Sanskrit, and if I had behaved myself I should no doubt have gone the next year to the American School in Athens. But I had not studied Hebrew, and I never knew what Dr. Hirsch's middle name, Mttron, meant; I understood that it might be archangel. He was a large man, an invalid who never moved from his chaise lounge, and he always presided at our meetings. On this first evening he asked me what I knew about the Trojan Horse. My answer must have seemed to him ignorant, for he brushed it aside and went on to explain that woode in Middle English meant "mad," and that the Trojan horse being the wooden horse must be the mad horse; and since madness is divine, the Trojan horse is the eso-

teric and symbolic horse. Shining pince-nez stood up on his hand-
some nose, and curled Assyrian hair topped a massive brow.

(Tate 1975, 25)

If this was the kind of greeting Davidson had experienced, it is no won-
der he felt disconcerted. In his 1925 novel based on the Fugitive group, *The
Professor,* Stanley Johnson paints a similar picture of the initiation of a visi-
tor. However, it should be noted that Johnson was one of the most con-
tentious members of the group, so it is necessary to balance his perspective
with an awareness of his talent for perceiving and fomenting conflict. Some
of his anger is conveyed in his disdain for the central character in his novel,
Dr. Parkhurst. Portrayed as a stuffy professor, Parkhurst was modeled after
Edwin Mims, who was then chair of the Vanderbilt English department,
where several of the Fugitive members were either students or held junior
faculty positions. Johnson was an instructor in the English department, and
as soon as he published his novel, he fled Vanderbilt, relieved that his career
there was over. In his novel, Johnson depicts the first visit of Professor
Parkhurst to a group meeting in the apartment of Leonard Burk (modeled
after Sidney Hirsch): "The group was gathered in Leonard Burk's sitting
room in a downtown apartment—a group of smug, well-dressed young
men who might have passed for a board of directors of a junior chamber of
commerce. They considered themselves living proof that authors need not
be hungry and long-haired and erratic." After an argument to which we will
return later, Burk suggests they hear from their visitor, Professor Parkhurst.
Turning to Parkhurst, he says:

"Doctor, I understand you're very much interested in Chaucer."
There was a general breath of relief at turning to a new interest.
The others had long wanted to see Burk and Parkhurst cross swords in
a philological discussion, for, though not a university man, Burk had
traveled strange paths of knowledge.
Parkhurst admitted that Chaucer was one of his interests.
Burk advanced. They engaged in a duel.
"I suppose you're familiar with the discussion of the A and the B
versions of the 'Legend of the Good Women,'" suggested Burk.
"Rather," said Parkhurst.
"From my point of view," said Burk, "there's no discussion. If we
discard the lingual nonsense of Verner and Grimm, we can establish
'A' beyond all doubt."
Parkhurst listened contemptuously. But suddenly he thrilled at a
discovery that at least here was the possibility of a new approach to

the problem. If he could piece together the illogical inspirations of this . . . fanatic into some sort of consecutive argument—he began to listen attentively.

<div align="right">(Johnson 1925, 223)</div>

Though their accounts of the group initiation are independent, Davidson, Johnson, and Tate all convey a similar picture of what it was like to enter the group and be greeted by Hirsch—an unpredictable challenge, Socratic dialogue, wild ideas, a mesmerizing performance, but always the promise of learning something new. As the meetings progressed, and as the standards for writing and evaluating poetry were raised, leadership shifted to Ransom, and the members developed rituals for giving the floor to those who had a poem to read. Still later, as the group moved into a stage of collective action and published their journal, the leadership shifted to Davidson. Nevertheless, even at the later stages of development, Sidney preserved the ritual of confronting newcomers. Tate joined the group in 1921, yet his encounter with Sidney resembles that described by Davidson in the fall of 1914. Warren, who was the last of the core members to join the group in 1923, described Hirsch as the "center, almost the idol, of the group . . . the wise man of the tribe" (Watkins and Hiers 1980, 227). Johnson's novel was published in 1925, yet his account of Parkhurst's encounter with Burk, the fictional version of Hirsch, maintains the same tone.

It is not unusual for groups to induct new members by reenacting episodes from their joint past. What they cannot convey in words about their history, collective identity, and rules of interaction, they force newcomers to experience in action. The ritual varies depending on the culture of the group. Sidney's initiations delivered a clear message to newcomers: To be a member of this group, you must be intellectually on your toes, know something about the classics, be ready to play with words and ideas, have the stamina to hold your own in competitive arguments, and have enough self-assurance to abide Sidney's non sequiturs and eccentricities. Later in the group's development, after they had evolved more disciplined patterns of interaction, new members still had to come to terms with Sidney. If they passed the test, they could proceed to the more measured and thoughtful interaction led by Ransom.

Although there is a unique cast of characters in the Fugitive group and the content of the discussions is different, it is striking how much the banter and the give-and-take of discussions resembles the dialogue in the public meetings of the Impressionists. The tone set by Sidney Hirsch, Ransom, and some of the younger men resembles that established in the Guerbois by

Manet and Degas: intellectually competitive, "show no quarter, take no prisoners," rough and playful, peppered with teasing insults, but ultimately nurturing and stimulating. Although they provided thoughtful feedback about ideas, the group meetings of both the Fugitives and the Impressionists were not occasions for compassionate support and "sharing" of personal concerns. Like many male groups, the exchanges had an undertone of competitive sport (Farrell 1986; Nardi 1992; Oldenburg 1999). Points were scored through intelligent debate, sarcasm, and humor, but not through destructive attacks on character. Witty repartee and put-downs fell just short of generating anger or hurt. Communication was open, direct, but confined to the "great issues" of the day, rarely veering toward personal concerns. The dangers of personal intimacy were avoided through abstract intellectualization. For example, Tate's responses during his own initiation were "brushed aside" by Hirsch, who held the floor through the force of his expertise, rhetoric, and charm. Hirsch concealed himself behind a smoke screen of verbal wizardry. Ransom guardedly maintained a cool, analytic persona, which provoked the rebelliousness of Johnson, who regularly assailed Ransom's wall of rationality. Ransom's guardedness is not unusual in male groups, particularly in the early stages of group development. In the transcription of the tape recording of the first session of the Fugitive reunion in May 1956 (plate 19), as members tentatively slip back into their group roles, we can observe the same array of challenges, confrontations, playful insults, and dodges (Purdy 1959). Sidney's initiation ritual tested each newcomer's readiness for this group climate.

In experimental studies of subjects who meet as strangers and are asked to work on a task, researchers find that members defer to those who have higher status outside of the group (Berger and Zelditch 1985). Members with higher outside status often are granted authority inside the new group, even though their expertise may be irrelevant to the task at hand. However, this kind of status-conscious, hierarchical structure is not characteristic of collaborative circles. In successful circles, external status is often like a red flag waved in front of a bull; it invites attack, or at least a test. For example, in Johnson's fictional account of the encounter between Burk, the self-taught group leader, and Parkhurst, the professor, the higher status of the professor meant little. He was immediately challenged to "a duel," put on the defensive, and outclassed. This open, free-for-all style ultimately leads to an egalitarian group in which status is based on demonstrated expertise, rather than external authority. Neither too personal nor too instrumental, members interact as equals.

Although interaction in the formation stage of the Fugitive circle re-

quired a certain guardedness in members whether they were boisterous or reticent, it was nevertheless experienced as fun. In a letter written to Alec Stevenson in July of 1915, William Elliott described a meeting:

> Right now I am having what the debutantes twitter "a gorgeous time." Nat Hirsch, Stanley Johnson, Donald Davidson, John Ransom, and Sidney Hirsch were the company last night and it was Olympian. I am living in rare altitudes this summer. . . . We get together often and I can feel myself grow.
>
> Sidney Hirsch is a wonder, Nat is a World Man. Sidney has the most imposing personality, and a head full of astounding mysticism. But he isn't as genuine as Nat, the One and Only. And good old Johnny Ransom, the Rational, with Stanley Johnson, the Downright, and Donald Davidson, musical as his name, with yours, the Egoist, make up an odd group, but one that will be heard from.
>
> Out on the Hirsch's porch, with the cigar ends glowing occasionally, a debate always insured from the nature of the company, it is The Happiness. Last night it was the Unity of Being discussion, Johnny maintaining a dualism at least—élan vital and material expression, I, admitting a logical duality, maintaining a pluralistic Individuality of Being, but a Metaphysical unity. I learned a great deal.
>
> (Quoted in Cowan 1959, 4)

Like the Impressionists, the Fugitives report that the exchanges sharpened their wits and led to intellectual and emotional growth. In some ways, the members of these groups had effects on one another similar to those observed in groups of children at different stages of cognitive and moral maturation (Kohlberg 1984; Piaget 1952). That is, they challenged one another's cognitive maps of reality, and the members with more advanced cognitive styles pulled the others along. In their discussions, they discovered where their assumptions and beliefs were dissonant, and they pressured one another to make their reasoning consistent. They learned how to think logically and creatively, and as a result, they felt themselves "grow."

Informal Roles in the Formation Stage

Conditions in the environment and the composition of a group may set the stage for the development of a collaborative circle, but without certain informal leadership roles, the group would never get beyond the formation stage. In chapter 2, we noted the roles that were played by members of the Impressionist group, and we noted how the centrality of some roles changed over time. For example, Pissarro, whose role as peacemaker was somewhat

marginal during the early stages of circle development, became central during the collective action stage. The charismatic Monet was central during the rebellion and quest stages, but then became less central as the collective action stage unfolded. However, when analyzing a single case, it is difficult to say whether the roles observed and the changes in leadership are unique to that group, or whether they are examples of a more general process. By comparing groups, we can see the common roles that appear at each stage of circle development, and we can begin to decipher the part the roles play in moving the circle forward.

In laboratory studies of group development, a number of writers have noted that each stage of group development is characterized by a constellation of informal group roles (e.g., Bales 1970; Bennis and Shepard 1974; Dunphey 1968, 1972; Mills 1964; Slater 1967). According to these theories, before a group is able to move from the early to the later stages of development, a series of conflicts is likely to occur among the members playing these informal roles. The conflicts between roles unfold like a morality play in which alternative resolutions to common dilemmas are worked through. How the dilemmas are resolved influences whether the group will move on to the next stage. The participants either successfully resolve conflicts and move ahead, or they remain stuck in a recurrent set of scenes, dreamers caught in a shared nightmare, until exhausted, they finally leave the group in defeat.

The Gatekeeper, the Charismatic Leader, and the Novice Member

There are three roles that characterize the formation stage of collaborative circles: the gatekeeper, the charismatic leader, and the novice member.

THE GATEKEEPER. The gatekeeper is a member who introduces the group members to one another. In the Impressionist group, Bazille played this role. He seems to have singled out Renoir, Monet, and Sisley, not because they were the most successful in the class, but because he recognized in them a set of attitudes that matched his own. In the Fugitive group, the role of gatekeeper initially was played by Nat Hirsch; but even before Nat left Nashville at the end of the circle's first year, the gatekeeper role was taken over by Donald Davidson. Tate describes how Davidson recruited him: "Sometime in November, 1921, I was talking to Donald Davidson, then a young English instructor, on the front steps of old College Hall at Vanderbilt. After some casual talk Don told me that he and a few other men, including John Crowe Ransom, had been meeting at the house of a friend on every other Saturday night to read poems and to discuss 'philosophy.' He

asked me to come the next time" (Tate 1975, 24). The members who entered the group through Davidson became the core group of poets—Ransom, Tate, Warren, Moore, and Davidson himself. Several of those who entered through Nat published in the *Fugitive,* but after 1925 they drifted away from poetry toward more conventional professions.

A circle formed by a gatekeeper is not simply a random collection of people; it is a filtered group. Like most people, the gatekeeper consciously or unconsciously chooses friends who share his worldview and validate his self-concept. As a consequence, a group formed by a gatekeeper is likely to be relatively homogenous in values and beliefs. However, gatekeepers of successful collaborative circles have unusual criteria for companionship. They seem to chose ambitious, challenging peers for friends. If they form ties with persons who are older or younger than themselves, they are with people who can function as equals in a mixed-status group. If the persons chosen are relatively younger members, such as Tate or Warren or Merrill or Johnson, they are not intimidated by status; and if they are relatively older members, such as Ransom, Hirsch, or Frank, they do not treat junior members with condescension. As Warren, the youngest member, put it in a later interview, "Everybody was an equal in that room; no one pulled his long gray beard" (Watkins and Heir 1980, 127). Finally, for the most part, gatekeepers choose friends who have similar career aspirations. Rather than choosing friends who entice them to escape from work, they choose friends who help them deepen their commitment to and understanding of their discipline.

THE CHARISMATIC LEADER. A second role in the formation stage is that of the charismatic leader—a relatively narcissistic member whose self-assurance and charm draw the members into discipline-related activities that go beyond diversion and companionship. The charismatic leader often has a personal vision of some sort, and he or she lends to the group a sense of mission that transcends ordinary life. Monet played the role of charismatic leader in the Impressionist group. He electrified the interaction with his charm and wit, and contrary to the advice of their teacher, he led the members off to Fontainebleau to paint landscapes outdoors. As we have seen, Sidney Hirsch played this role in the initial stages of the Fugitive group. His persona as worldly traveler and eccentric "genius" mesmerized the undergraduates, and he led them on esoteric intellectual excursions. Initially, it was Hirsch's performances that Davidson wanted to share with his friends. However, as the culture shifted toward poetry, Ransom moved into the role of charismatic leader. Though not flamboyant like Hirsch, he led

the group in experimentation with modern poetry, and he set the tone for thoughtful criticism in the group discussions.

THE NOVICE. Finally, in the formation stage, each new member plays the role of novice. Early in a group's development, when the culture is relatively undefined, a circle may be relatively open, such that any pleasant companion of the gatekeeper is welcome. Later, a novice may be required to demonstrate capabilities and attitudes that entitle membership. Regardless, as they induct the novice, the members are challenged to make their emerging norms and values explicit. In the Impressionist group, especially after Bazille's death, it was Pissarro who usually conveyed the group culture to new members. Davidson played this role throughout the development of the Fugitive group.

The Rebellion Stage in the Fugitive Group

The rebellion stage begins when commitment and trust begin to deepen, and the members start to disparage authority figures in their environment. Like most other collaborative circles, the Fugitives had a delinquent streak. Initially, the eccentric and unconventional Hirsch was an exhilarating antidote to the traditional academic culture of the university. He charmed the members with his irreverent attitudes. As Conkin (1988) characterizes him, he was the "cultural outsider . . . undisciplined by logic," who led them on excursions into the "ancient and hidden wisdom" of the occult. Trying to convey the role Hirsch played, Davidson states, "You must feel his power to understand his part in our beginnings" (Purdy 1959, 129). Going to his home for Saturday evening discussions, the group members were literally and figuratively out of school. They saw themselves as exploring an intellectual world beyond the boundaries of conventional academia.

In his novel, Johnson presents Professor Parkhurst as a symbol of the stuffy university culture. In several episodes in the story, the group members entice Parkhurst into looking foolish, either because of his pretensions about his work or because of his misguided dreams of sexual conquest. Parkhurst is portrayed as a lecher. In a minor subplot, the fiancée of one of the group members lures Parkhurst into a scene where he attempts to seduce her, but she rebuffs him. Later, when the conflicts with him escalate, the group members threaten to expose Parkhurst's clumsy sexual advances. The fictional pranks suggest some of the delinquent tone of the Fugitive group's culture.

For members of the Fugitive group, the act of writing poetry itself was seen as rebellious. As a biographer and critic states:

> What happened at Nashville should be regarded as a slow poetic infection, introduced from distant places, with Ransom as prime carrier, breaking out into a fever among a small group, then becoming rapidly epidemic after the launching of the magazine project. Scholars and businessmen, who were never again to commit a public indiscretion, threw off poetic effusions. Undergraduates intended for discreet callings slighted their courses to turn out verse (the remarkable Merrill Moore, it is recorded, learned shorthand in order to get down more sonnets between class and laboratory).
>
> (Bradbury 1958, 5)

Even as late as 1922, with the initial publication of the *Fugitive,* the members' posture was still explicitly rebellious. Of course, the name "Fugitive" suggests outcasts in flight from the community; and in their shared sense of alienation from both the New South and the Old South, the group members were only too conscious of these associations. Alec Stevenson suggested the name, but at the reunion of the group they all agreed that it was an image they had identified with Hirsch—the renegade skirting the edges of conventional understanding (Purdy 1959). In the group's manifesto in the first issue of the journal, Ransom portrays the members, identified only by pseudonym, as masked outlaws, and strikes an irreverent note:

> Official exception having been taken by the sovereign people to the mint julep, a literary phase known rather euphemistically as Southern Literature has expired, like any other stream whose source is stopped up. . . . The Fugitive flees from nothing faster than from the high-caste Brahmins of the Old South. Without raising the question of whether the blood in the veins of its editors runs red, they at any rate are not advertising it as blue; indeed, as to pedigree, they cheerfully invite the most unfavorable inference from the circumstances of their anonymity.

In a letter to journalist Corra A. Harris of the *Charlotte Daily Observer,* dated 10 March 1923, Davidson elaborated on the delinquent connotations of the title of the journal: "If there is significance to the title . . . it is perhaps in the sentiment of the editors (on this point I am sure we all agree) to flee from the extreme of conventionalism whether old or new. They hope to keep in touch with and to utilize in their work the best qualities of modern

poetry, without at the same time casting aside as unworthy all that is established as good in the past"(Cowan 1959,44).

Like C. S. Lewis, who claimed that, because of the support of his Inklings circle, he was encouraged to take more risks and even to express forbidden thoughts, Ransom suggests that support from his friends counterbalanced his anxiety about betraying conventional values. Although he was writing under the name Roger Prim, this sense of being buoyed up comes out clearly in his poem "the Egoist," published in the first issue of the journal in April 1922:

> Friends! come acquit me of the stain of pride . . .
> Giving a little and receiving more . . .
> I have run further matching your heat and speed,
> And tracked the Wary Fugitive with you . . .
> For my part much beholden to you all . . .
> To think to salve the fester of my treason:
> A seven of friends exceeds much multitude.

Informal Roles during the Rebellion Stage
During the rebellion stage of collaborative groups, four new informal roles become salient: the tyrant, the scapegoat, the lightning rod, and the peacemaker.

THE TYRANT. Tyrants are authoritative figures who represent the traditional values that the group members reject. Usually, members of a collaborative circle achieve consensus in their rejection of the values of these authorities long before they establish consensus about their own shared beliefs and values. They are clear about what they reject, but they are vague about what they value.

A group ritual during this stage includes relating stories about the unacceptable or ludicrous behavior of the tyrants. Among the Impressionists, the stories centered on the outrageous decisions and values of the Salon jury. Among the Fugitives, the rejected authorities included the "Brahmins" of Southern literature and their stodgy representatives on the Vanderbilt faculty. Edwin Mims, the chair of the English department, was cast into the tyrant role by the Fugitives. He had hired Ransom, Davidson, Johnson, and the other untenured faculty members in the group, and he was described as "fond of power, . . . able to make uncomfortable any younger men who seemed likely to threaten his control or to divert attention from himself"

(Stewart 1965, 13). In his novel, Stanley Johnson describes a lunch meeting with Parkhurst, the fictional counterpart of Mims. The group members are discussing the value of modern poetry, when one of them speaks disparagingly of the "clever saccharine quality" of Edna St. Vincent Millay: "Parkhurst swarmed to the attack. "Why man—man! You fellows are simply going to the other extreme. You are permitting a legitimate weariness with the old metrical forms to go too far. . . . I have no patience with this youthful anarchy which discards everything" . . . he stormed to justify the old to the new" (Johnson 1925, 60).

THE SCAPEGOAT. Members in the rebellion stage usually have gained enough trust in one another to disclose their dissatisfactions with their discipline, but they have not yet carved out a direction of their own. One of their worst fears during the rebellion stage is that they may be hypocrites; beneath their pretensions they may be no different from those who adhere to conventional thinking. Even worse, they fear that they may be as undisciplined and inept as their most hostile critics claim them to be. To buttress their fragile self-esteem, it is common for members to highlight their own virtues by contrasting them to the vices of a scapegoat—a peer who is seen as embodying "sentimentality," "technical incompetence," "undisciplined rebelliousness," or other such traits that they deny or attempt to suppress in themselves. The scapegoat is often a member of the extended network of the group, rarely one of its core participants.

Scapegoating includes elements of both projection and displacement (Gemmell 1989). Members anxious to suppress or deny traits in themselves are particularly sensitive to them in others and hence swift to attribute them to marginal members. The traits most often denied are loyalty to the tyrant's conventional values and incompetence at creative work. Group meetings frequently become occasions for exchanging stories about scapegoats. When the members gossip about the scapegoat, when they ritualistically share stories about his or her follies, they reassure themselves that they are free of the "vices" the scapegoat represents. The scapegoat becomes an inverted emblem for the group members, symbolizing what they wish to root out of themselves and the group culture (Farrell 1979).

In his description of one of the members of his fictional group of poets, Johnson portrays some of the self-doubt and projective defenses of the Fugitive circle in the rebellion stage. Returning from the "first luncheon of the year" with the department chair and the English faculty, the young faculty member reports to his wife:

Here we are a group of university professors . . . supposedly educated people. Yet our range of interests is narrower than those of a carpenter or bricklayer—they are at least interested in baseball and fishing and in their companions—and we? Books—books—books—who wrote what? Do you suppose ethics, psychology, science, religion, philosophy, history, ever enter our discussions? Never to the extent of one word. Do we ever ask what is truth in life or what we ought to try for? Truth means nothing. Even in our discussions of books we are interested only in imposing our opinion on each other—we do not discuss—we argue. In my three years in this department I have never known one of us to change his opinion—to accept one new thought from some one else. We are as stiff-minded and unalterable as theologians.

No—I'll be damned if I'll say "we"—I mean "they." I'm not one of them. And yet—he said as that sharp blade of self-doubt cut into his thoughts as it always did, "I don't know that I'm any better than they."

(Johnson 1925, 63)

Initially the boundaries of a group's culture are unclear, and rejection of the scapegoats is based on only vaguely understood objections to their behavior. As we shall see in the next stage of group development, the quest stage, the grounds for the attacks become explicit, and the members use the attacks as occasions to clarify their values. But during the rebellion stage, the attacks are based more on gut reactions. As Cowan notes: "[T]here was of course an element of revolt in the thought of these poets, and, although they were to find as they went along that it would turn against liberalism, scientific naturalism, and the Romantic and anti-intellectual aesthetic, in the beginning they recognized only a distaste for the spuriousness of many of the emotions by which they were surrounded. They were unable any longer to mouth the large ideals that were to the Victorians the stuff of poetry" (Cowan 1959, 40).

THE LIGHTNING ROD. The "lightning rod" is the member who senses negative feelings in the group and has the courage to give voice to them. Other members may be more timid, or may feel more vulnerable, so they suppress their anger. As complaints about the tyrants and scapegoats mount, the lightning rod listens to, internalizes, and then voices the feelings of the others and may actually go so far as to confront the culprits.

In the early stages of the Fugitive group, Johnson played the role of lightning rod. It was the argumentative Johnson who spoke out most critically,

not only about rejected authority figures outside the group, but even about those who carried authority inside the group. Most notably, he was the one who voiced negative reactions to Ransom (Cowan 1959; Davidson 1958). Cowan suggests that Johnson's background and education prepared him less well for the interaction in the group and in the university: "Johnson, who had attended Hume Fogg, a public high school in downtown Nashville, was not equipped with a classical background to match that of Ransom and Davidson. . . . He was a forthright, pragmatical boy who could always give his teachers a good argument. More than any of the other Fugitives, he was in rebellion against his upbringing, mistrusting the ideas with which he had grown up, convinced he had to prove everything for himself" (Cowan 1959, 12).

Later in the group's history, when the members had reassembled after the war, Allen Tate moved into the lightning rod role. In his novel, Johnson blends the parts taken by himself and Tate into the role of Tyson Ware, an irreverent student newspaper reporter who takes advantage of every opportunity to mock or embarrass Professor Parkhurst. One of the central plots of the book centers on Parkhurst's attempts to keep Ware out of his classes and to get him expelled from the university. At the climax of the novel, Ware publishes a book exposing the pettiness and hypocrisy of Parkhurst and the other faculty members. Like Tyson Ware, Johnson gave voice to the negative feelings toward authority that the other Fugitives shared, but feared to express.

At times the lightning rod may become the devil's advocate, arguing in support of positions taken by the group's enemies. Negative evaluations by those outside the group are channeled through the lightning rod into the group. Degas often played this role for the Impressionists. At other times, the lightning rod may displace members' negative feelings toward one another onto persons outside the group (Mills 1964; Slater 1967; Wells 1991). This enables the members to maintain a myth of solidarity. For example, in the Fugitive group, some of the negative feelings that Johnson expressed toward the outside authority, Mims (Parkhurst), may have been amplified by barely suppressed negative feelings toward the inside leader, Ransom. Rather than express hostility to Ransom directly, the members vented their feelings in stories about Mims. More will be said about the group's complex relationship to Ransom later.

THE PEACEMAKER. Storytelling, gossip, and argument are common early in collaborative group interactions. As the members attempt to build consensus on their own emerging values, and as they use these values to

evaluate one another's work, the conflicts between them become more intense. As the negative feelings and conflicts mount, the role of peacemaker becomes more salient. Sensitive to the levels of anger or hurt that occur in a group, the peacemaker tries to mediate conflicts, either openly or behind the scenes.

Early in the development of the Fugitive group, Donald Davidson took on the role of peacemaker. Virtually all biographers have characterized him as the "cohesive force" in the group. Moore, drawing on his psychiatric expertise, characterized him as "in his own way, a kind of midwife—often maternal in his kindness to us" (Purdy 1959, 146). As the interaction heated up, it was Davidson who usually stepped in and cooled it down. He played a mediating role in discussions that became polarized between Hirsch, with his eclectic theories, and Ransom, with his rational empiricism; or between Ransom, with his teacherly rationality, and the more rebellious members, such as Johnson. Most important, during the quest stage of circle development, Davidson mediated in the heated arguments between Ransom and Tate over the value of the poetry of T. S. Eliot, Hart Crane, and other modern poets.

Davidson's intermediary position in the demographic structure of the group facilitated his entry into the role of peacemaker. He was younger than Ransom, Curry, and Hirsch, but older than the other members. Initially he was a student, like most of the group members, but he had to support himself as a teacher at a local preparatory school. As we shall see, just as Pissarro's role as peacemaker in the Impressionist circle became more salient in the later stages of its history, Davidson's role as peacemaker became more central as the Fugitives moved into the quest and collective action stages.

The Quest Stage in the Development of the Fugitive Group

Like eras in history, the stages of group development do not begin and end abruptly. Rather, what begins as a minor theme or tangential episode in an earlier stage becomes the major theme or activity in the next stage. The tangential episode that moved the Fugitives into the quest stage grew out of an encounter outside the group between Ransom and Davidson. As we have seen, in their first year of meeting, the discussions of the Fugitive group were wide-ranging and philosophical, but they were undisciplined. The members were not expected to prepare for the meetings. They encouraged openness in their discussions, but they did not discuss personal problems, nor did they share unfinished work. The levels of trust and commitment

reached a plateau, and members were careful not to become too vulnerable to one another.

Deepening Commitment in Collaborative Pairs

In some ways, the relationships of the Fugitives resemble those between J. R. R. Tolkien, C. S. Lewis, and their friends in the Inklings group. Like the Inklings, the Fugitives crystallized out of an academic network. Also like the Inklings, the critical transformation of the culture of the Fugitive group took place when, outside the group meetings, one member risked sharing his work in progress with another. Donald Davidson was a central person in the transformation. Although he did not initiate writing poetry, he, like C. S. Lewis in the Inklings circle, was the member who was most trusted as a listener by others. In the fall of 1916, Ransom showed Davidson the first poem he ever wrote. As Davidson recounts:

> One day of days I remember well. My teacher, John Ransom, beck-oned me aside and led me to a shady spot on the campus near the streetcar stop called "Vanderbilt Stile." . . . Ransom drew a sheet of paper from his pocket. Almost blushingly, he announced that he had written a poem. It was his very first, he said. He wanted to read it to me. He read it, and I listened—admiringly, you may be sure. The title of the poem was "Sunset." But in that moment, I suppose, was the actual dawn of the "Fugitive movement."
>
> (Davidson 1958, 14)

Like other group members, Ransom felt safe with Davidson, who had the ability to listen and nurture creative work in others, even when their work was not in a style he approved. Like a good teacher, he could meet people where they were, and help them to move further in the direction they wanted to go. One cannot help but wonder what Davidson thought when he first heard Ransom's reading. Perhaps he initially thought the "you" in the poem referred to himself, but he later said that he understood the poem was directed at Ransom's lover. The poem in fact concerns the poet's relationship to a woman and her God (cited in Cowan 1959, 21):

> SUNSET
> I know you are not cruel,
> And you would not willingly hurt anything in the world.
> There is a kindness in your eyes,
> There could not very well be more of it in eyes
> Already brimful of the sky.

> I thought you would some day begin to love me,
> But now I doubt it badly;
> It is not a man-rival I am afraid of,
> It is God.
> The meadows are very wide and green,
> And the big field of wheat is solid gold,
> Or a little darker than gold.
> Two people never sat like us by a fence of cedar rails
> On a still evening
> And looked at such fat fields.
> To me it is beautiful enough,
> I am stirred,
> I say grand and wonderful, and grow adjectival,
> But to you
> It is God.

Critics (e.g., Bradbury 1958) have noted that some of the persistent elements of Ransom's later work are already present in this first poem—the balance of intellect and emotion, abstract and concrete, hope and despair. They also have noted the "ineptness" of the lines, yet Davidson, when he first heard them, reacted positively. Encouraged, Ransom wrote three more poems, and after receiving Davidson's reactions, submitted them for publication. They were accepted, and two were reprinted by Ransom's friend from Oxford, Christopher Morley, in a Philadelphia newspaper. The other members were aware of these developments, but their preparations to join the army in the spring of 1917 pulled them apart before this interest found expression in their meetings.

After the war, the group reassembled gradually. Ransom returned in 1919, continued to write poems, and shared them with Clyde Curry, who roomed nearby. Curry and Ransom discovered that Sidney Hirsch had moved into the home of his sister, Rose, and brother-in-law, James Frank, at 3802 Whitland Avenue, and the circle soon reconvened there. Frank, a gracious and gentle man in his early fifties, accepted Hirsch's role as the genius in the family, and he and his wife welcomed the meetings. Occasionally Ransom and Curry's private discussions of poetry spilled over into the Saturday evening meetings, but they did not yet share their own poems with the group.

In the summer of 1920, Davidson and Stevenson returned to Vanderbilt and rejoined the group. Stevenson was in transition from journalism to investment banking. Davidson had come back to teach English at Vanderbilt.

Encouraged by Ransom's success in publishing his work, Davidson had experimented with poetry while in the army. Except for Stanley Johnson, who would return the following year, the original group had now reassembled. It was during the summer of 1920 that the discussions at Hirsch's home gradually shifted from philosophy to literature and poetry.

As the shift occurred, the roles played by various members remained the same, but now they were sublimated in the service of the emerging group goals of understanding and writing poetry. Even Hirsch's energy became more focused, although, based on the reports, he was still a bit loose at times. Davidson described how Hirsch in his enthusiasm would pick out a word, "most likely a proper name like Odysseus or Hamlet or Parsifal, or some common word like fool or fugitive—and then, turning from dictionary to dictionary in various languages, . . . [he would] unroll a chain of veiled meanings that could be understood only through the system of etymologies to which he had the key. This, he assured us, was the wisdom of the ages—a palimpsest underlying all great poetry, all great art, all religion, in all eras, in all lands. All true poets possessed this wisdom intuitively, he told us solemnly, repeatedly" (Davidson 1958, 12).

Ritual Exchange of Work in Progress
Davidson invited Tate to join the group in November 1921. By then, the Fugitives had established a new ritual for their meetings—taking turns reading their poems aloud and receiving criticism from the group. Ransom may have initiated the ritual, for when Tate joined the group, he observed:

> John Ransom always appeared at the Fugitive meetings with a poem (some of us didn't). I can only describe his manner in those days as irony that was both brisk and bland. Before we began to think of a magazine, John had written a poem which foreshadowed the style for which he became famous; . . . I marveled at it because it seemed to me that overnight he had left behind him the style of his first book and, without confusion, mastered a new style. We all knew that John was far better than we were, and although he never asserted his leadership we looked to him for advice.

> (Tate 1975, 77–78)

With Ransom leading, the group established the practice of exchanging work in progress. Ransom, Davidson, Curry, and Hirsch encouraged the others to join them in bringing poetry to read at the meetings. The group pressure to conform was in the service of creative work and productivity. Describing the ritual in a 1949 interview, Davidson stated:

First, we gave strict attention, from the beginning, to the form of po-
etry. The very nature of our meetings facilitated and intensified such
attention and probably influenced Fugitive habits of composition.
Every poem was read aloud by the poet himself, while members of the
group had before them typed copies of the poem. The reading aloud
might be followed by a murmur of compliments, but often enough
there was period of ruminative silence before anyone said a word.
Then discussion began, and it was likely to be ruthless in exposure of
any technical weakness as to rhyme, meter, imagery, metaphor and
was often minute in analysis of details. Praise for good performance
was rarely lacking, though some excellent poems might find the group
sharply divided in judgment. But even the best poems might exhibit
some imperfection in the first draft. It was understood that our exam-
ination would be skeptical. A poem had to prove its strength, if pos-
sible its perfection, in all its parts. The better the poem the greater the
need for a perfect finish. Any inequality in technical performance was
sure to be detected. It was not enough for a poem to be impressive in
a general way. Poems that were merely pleasant, or conventional, or
mediocre did not attract much comment.

(Young 1971, 34)

The Roles of Conservative and Radical Boundary Markers

In the rebellion stage, the targets of hostility are mostly outside of the
group; but in the quest stage, circles often polarize over different visions of
the circle's goals. In this stage, the members go beyond attacking tyrants and
scapegoats on the edge of the group, and they begin to argue openly with
one another about their different values. Two roles become salient during
these conflicts: the conservative and the radical boundary markers.

As we saw in the case of the Impressionists, boundary markers are core
members who become identified with the extremes of the group culture.
The radical boundary markers are the ones who "go too far" in embracing
rebellious, new ideas; the conservatives are those who "lag behind." The
radicals introduce extreme innovations into the group culture, and they are
often seen as wild and undisciplined. The conservatives are seen as stuffy,
outdated, or overly responsive to conventional tastes. In the debates at the
Guerbois, Manet sometimes cast Degas in the role of conservative boundary
marker, accusing him of still painting historical compositions after Manet
himself had begun painting scenes of contemporary life. Until he mastered
the Impressionist style with Pissarro's help, Cézanne was a radical boundary

marker, painting in a manner seen as sloppy and undisciplined by the group. Even the bold Claude Monet, who led the group in the rebellion stage, disparaged Cézanne's work of this period.

During the quest stage, the Fugitive group tolerated a wide diversity of views on poetry, and they ritualized open dialogues between the radical and conservative boundary markers. Each meeting was an occasion for the boundary markers to justify their positions and attempt to win converts. The openness gave each member space to develop his own poetic style:

> [T]he conservatism which so irked Tate at this time was one of the merits of the Fugitive association. Different from a narrow conventionalism, this reluctance to follow new theories held in check any programmatic approach to poetry, so that one persuasive person with insight was not allowed to pull the others over to his point of view. A willingness on the part of each of the poets to attack the work of others and to defend his own made not for unscrupulous egotism and backbiting, but for clarification of ideas and an enforced toleration of dissimilar views.
>
> (Cowan 1959, 85)

The Fugitives seemed to have sensed the value of dissension in stimulating creative work. As Nemeth's (1985) experimental studies of creativity suggest, the presence of a vocal opposition in the group stimulated more careful thought and more creative solutions to writing poetry.

The Role of the Center Coalition in the Quest Stage

The center coalition of a circle consists of two or more highly respected members who are not identified with either the radical or conservative extremes but who make up the audience and jury for the arguments between the boundary markers. The center coalition sifts through the arguments, and then synthesizes the conflicting views into a common vision. The coalition members are the ones who give voice to the shared beliefs and values of the group—their style, manifesto, or vision.

Once the coalition members crystallize a vision, they produce work based on the vision and attempt to persuade the others to use it. In the Impressionist circle, Monet and Renoir were the initial members of the center coalition. It was their synthesis of the circle's experiments that gave definitive form to the Impressionist vision. Monet convinced Pissarro to adopt the new style. Pissarro then socialized Cézanne into it. Monet, along with Berthe Morisot, who also became a member of the center coalition, per-

suaded Edouard Manet to adapt the circle's style. The center coalition distills out of larger discussions the essential elements of the group vision and articulates them to the rest of the members.

Conflicts between boundary markers can reach levels of intensity that threaten to divide the group. In the Fugitive group, as the focus of the meetings shifted to poetry, and especially after the members decided to publish their own journal, conflicts sometimes became acrimonious. As they clarified their ideas about good and bad poetry, and as they raised their standards, the Fugitives became more critical of one another's work. One argument was that they should not publish their work alongside inferior work. Decisions had to be made about who would and who would not be included in each publication, and the works of some members were rejected.

Johnson's novel about the Fugitives captures the tone of their discussions at this point in their history. In the following scene, the characters are meeting after the first issue of their literary journal, the *Little Magazine,* has come out. Davis, a stand-in for Ransom, is defending his esoteric, free verse poem "Ebullient Bean"—an ode to coffee beans. His critic is Crossfield, Johnson's own counterpart, who advocates a more conventional style. Davis addresses his critic somewhat sharply: "I don't care to hear any more of your remarks about 'Ebullient Bean.' If we're going to continue at all, we've got to have a stiff editorial policy for excluding the sentimental and naïve— we've got to have more, not less, sophisticated material . . . [like] your own journalese material." Crossfield replies:

"We've been talking a damn lot lately about tone and critics and constituency and I don't think we're quite honest. Aren't we really each of us trying to prove that the kind of literature we like is the best? I'm not so much interested in the tone of the magazine as I am in getting my own stuff published and I think that's true of all of us. Why call it tone? I objected to the tone of 'Ebullient Bean,' but I didn't object to its going in. What I do object to is having my own poetry excluded because it has a different tone from 'Ebullient Bean.'" He paused uncertainly, struck with doubt—"It may be that what I'm really objecting to is seeing the rest of you take a superior attitude toward my literary taste? But even if your attitude is justified—which I don't think it is—I resent your not realizing that my ego won't tolerate an exhibition of superiority on your part. I'd like just once to see you doubt your own convictions that your stuff is better than mine—I doubt mine frequently—I often think it is pure rot. I want to see one

evidence in this group of a detached viewpoint. This smug certainty that you are right and I'm all wrong is what has brought you my resentment. I don't mind being all wrong—but I resent your never seeing that there may be one chance in six million that possibly, perhaps, you might be wrong." . . .

Davis interrupted. "This revelation of a sick ego, . . . however interesting in itself, doesn't seem to me relevant to the discussion of policies for the magazine. I take absolute exception to the charge that we are primarily interested in publishing our own material—I never believed that. Mr. Crossfield apparently reads his own motives into the actions of others. I move that we table the discussion and pass on to legitimate business."

Crossfield got to his feet. "There it is! that smug certainty which I hate. I'd rather read my own motives into the actions of others than be unable to read even my own motives. At any rate I see how you accept my confession of faith. I've nothing more to say. I'm through. Please accept my resignation from the group. I am not particularly interested in poetry nor criticism either for that matter, and you'll get along better without me."

That doesn't mean," he added, pausing at the door, "that I consider even my poetry inferior to the rest. Looking at it quite impersonally, I am convinced my stuff is better—or at least as good—as half the stuff we've published. Come on, Tyson [Tate's fictional stand-in]—offer your resignation."

"I'm afraid they'd accept it," said Tyson.

(Johnson 1925, 219–22)

Ransom and Davidson were members of the center coalition of the Fugitives. Ransom's style defined the initial mold of the group culture—modern free verse, but with elements of traditional rhythm and rhyme retained. He combined intellect with sentiment, used analogies to find larger significance in common events, and balanced his poetry between clarity and ambiguity. Allen Tate was the radical boundary marker, going further than Ransom in experimenting with free verse. He imitated the less structured styles of T. S. Eliot and Hart Crane. In the meetings, Tate defended Eliot, whose work Ransom and Davidson saw as incoherent, disorganized, and unfinished. As the radical boundary marker, Tate was the catalytic member whose deviant positions stimulated the group members, especially Ransom and Davidson, to clarify their visions of what poetry should be. Es-

pecially in the early 1920s, Tate was seen as too "modernly modern" (see Davidson's letter to Tate of 29 August 1922, in Fain and Young 1974, 41–43; also see Cowan 1959, 73).

At the other end of the continuum, among those who marked the conservative boundary by not going "far enough," were Stanley Johnson, Ridley, and, though his work was less of a stimulus for debate, James Frank. Tate and Ransom both saw the works of the conservatives as too sentimental and pedestrian. Merrill Moore, who wrote numerous conventional rhymes with a speed that astounded other members, marked another boundary. He was seen as "too prolific" and as not serious enough about poetic standards. In his initial works, Robert Penn Warren vacillated between the poles, though he leaned toward the model of his roommate, Allen Tate (Stewart 1965).

A poem read by Frierson, a less active member allied with Johnson and the conservatives, captures some of the flavor of the polarization late in 1922 (Cowan 1959, 87):

> REACTIONS ON THE OCTOBER FUGITIVE
> I am tired of being bitter.
> I am weary of the disillusionists,
> And of those who tell with uncommon zest
> that corpses stink—
> As a joke on the Christians.

In a letter to Tate about a meeting he missed, Davidson summarizes his reactions to how the roles were played out in a typical meeting. He writes about the group's reactions to his reading of his poem "Ecclesiasticus":

> The Fugitives seem to like Ecclesiasticus best among mine. Really, I believe they are a little bit surprised at me, but they were complimentary on the whole, and think I have developed, apparently. . . . Ransom read a two and a half page poem of an extremely philosophic nature, which sounded very good, but which I couldn't really form an opinion of, as he didn't supply carbons. . . . Mr. Frank's and Sidney's were both too esoteric for me. . . . Merrill's two poems were pretty fair, but too hastily done, I think. He needs to cultivate restraint. . . . The Fugitives jumped all over one of his poems particularly.
>
> (23 August 1922, in Fain and Young 1974, 39)

The group made use of its boundary markers to define and measure themselves. Some were seen as going "too far" toward modernism; others were seen as not going "far enough." Some were seen as being too abstract

and obscure; others were seen as being too conventional, or not taking their work seriously. Each of the boundary markers was important to the group in developing a vision of what poetry should be and how the poet should go about his work. In this stage of circle development, the nonconformity of the group deviants became irritants that stimulated debate and clarification of the group values and standards. By reaching consensus and defining what was wrong with the work of the "deviants," the group was able to clarify their emerging vision (Erikson 1968; Farrell 1979). Like navigators finding their position by triangulating the positions of two stars, the group eventually found their own course by clarifying what they did not like in the work of the deviant boundary markers. But this method of building the group culture by placing the group's own members on trial, case by case, took its toll. The solidarity and survival of the group was threatened during the quest stage.

Donald Davidson's Development in the Fugitive Circle

Like many collaborative circles, the Fugitives never reached complete consensus about their standards of good poetry. Although they had wide areas of consensus, there was enough polarization to make the discussions unpredictable, abrasive, and interesting. Most members were ambivalent, even about their own work. The group meetings were important settings for the externalization of the members' internal conflicts, a stage where members could hear the polarities inside their own heads expressed and defended. In the midst of this dialogue, some of the more conflicted members found their voices.

Donald Davidson was one of those conflicted members. As we have seen, although he was the gatekeeper, he felt "destined to be but a shy guest at the feast of the world's great cultures." Ransom trusted Davidson, and he shared his initial experiments in poetry with him, but Davidson did not have the audacity to attempt poetry himself until he was far from the group, in Europe in the army, where he studied Ransom's work. Until Ransom set the example, Davidson had not aspired to be a poet. The identity of "poet" was not part of his self-concept.

Critics (e.g., Bradbury 1958), and Davidson himself, saw his early work as amateurish. The evolution of Davidson's work illustrates how the group processes shaped the development of its members. The themes in his early work included relatively conventional, romantic imagery of tigers, dragons, jungles, and tiger-women strung together in limerick-like rhymes. For example, on the evening Allen Tate first joined the group, he reports that

Davidson read "The Valley of the Dragon." Two of Davidson's poems illustrate his themes and style during this period. In "The Tiger-woman," the poet follows a woman into the jungle (Young 1971, 44):

> And all the leaves of music made,
> Like spirits chanting in the choir
> Along a bamboo colonnade . . .
> The moon rose up as never yet
> A moon of love had blessed the air.
> Oh, give my breast the Tiger's heart
> To tame me and to keep me there.

In "Following the Tiger" (Young 1971, 44), he writes:

> For the feet of the tiger pass
> Where no man ever has trod.
> The lair of the Tiger is blessed,
> Its place is the place of God. . . .
> The tiger slept on the hearthstone.
> The Faery gave me her ring.
> My rose began to blossom;
> My lute began to sing.
> It sang how the ways of the Tiger
> Led me to beauty and to God,
> To the door of the hut of the Faery
> By paths men never have trod.

As Young (1971) notes, these early poems contain the germ of Davidson's later work, but the imagery is trite and romantic, and the structure is unextraordinary. If Ransom and Tate marked the outer boundary of the group culture in the direction of modernity, and Frank and Johnson marked the boundary in the direction of sentimental Victorian rhymes, then Davidson marked the group's center. If it were not for what happened next in the group development, Davidson might never have been heard of as a poet.

Polarization of Tate and Ransom

Davidson's development was interlocked with the development of Allen Tate, one of the lightning rod members who gave voice to the negative pole of group feelings toward Ransom. Tate's evolving insight about his relationship to Ransom illustrates the therapeutic possibilities inherent in the pseudo-kin transference dynamics of circles. He was an undergraduate

senior when he joined the group in 1921. Ransom was then about thirty. Ransom's brilliance, rationality, and leadership invited a dependent, teacher-student, or father-son relationship from Tate, but it was exactly that invitation that triggered defensiveness in Tate. Tate's own father had emotionally deserted his family when Tate was young, then finally abandoned him, his two brothers, and their neurotic mother completely. In describing his father, Tate writes: "[H]is eyes were blue, cold and expressionless. I was afraid of him, for he always spoke to me impersonally as if he were surprised that I was there. . . . I still do not know whether my mother's perpetual motion was flight from her husband, or whether his long absences were flights from her" (Tate 1975, 20–21).

Perhaps in part because Ransom evoked memories of his father, Tate resisted, challenged, and provoked him. Ransom provided a surrogate father with whom Tate could relive, act out, and work free from his resentment toward his real father. As we have seen, during the quest stage of circle development, Tate became the radical boundary marker of the group, going beyond Ransom and the group's limits by embracing the modern themes and style of T. S. Eliot. As Tate rebelled against the limits of modernism in the circle, he played a part in loosening Davidson's and other group members' dependency on Ransom.

In the summer of 1923, Tate's boundary testing and his conflicts with Ransom escalated and spilled over into an arena outside the group. Earlier that year Ransom had published an essay entitled "Waste Lands," in which he attacked T. S. Eliot's "Wasteland" and "Love Song of J. Alfred Prufrock," for their fragmentary style and lack of structure. Tate felt the essay was an oblique attack upon himself. He arrived at this telling interpretation through one of those circular metacommunications that symbolic interactionists think underlie the staging of human interaction ("I thought that he thought that I thought, so I . . ."). In his eulogy to Ransom after his death, Tate wrote:

> I saw the attack [on Eliot] as the result of his irritation with my praise of Eliot, which was that of a distant disciple, to the neglect of [Ransom], my actual master from whom I learned more than I could even now describe and acknowledge. I should have been flattered but was "hurt" instead. That is why I "disliked" him. I had learned from Eliot, too, but I had used him in our "Fugitive" meetings, for my egotistical assertion of superiority over my benighted friends. . . . [Ransom's] reply to my attack on his "Waste Lands" seemed to discredit me as a callow youth in revolt against his teacher; I was that, of course, but his

rebuttal was, more deeply, an indirect assertion of his authoritative role at Vanderbilt University. For a recent student to question that authority menaced his position. The polemic was deeper than logic. His logic justified his anger.

<div align="right">(Tate 1975, 41)</div>

Tate's analysis is retrospective and is as complex as one of his poems. But it has the ring of truth in light of all the other evidence of how he invoked Eliot's name in the group, and of how he positioned himself in reaction to Ransom's opinions. Not only in the discussions of Eliot, but also in arguments about who should be the editor of the *Fugitive,* Tate was the lightning rod who overtly opposed Ransom. T. S. Eliot was Tate's "idealized selfobject" (Kohut 1986); by identifying with him, Tate felt stronger and able to stand up to Ransom.

But Tate's analysis of his relationship to Ransom also suggests that at a deeper level, Ransom was his real selfobject and mentor. Because of his conflicted style of relating to father-surrogates, Tate could not bear to be in such a relationship. By defending T. S. Eliot before the rest of the group, Tate felt strong enough to defy Ransom, whose validation he sought, but whom he also wished to challenge and surpass. Ransom must have been bewildered by Tate's behavior, but he absorbed the attacks, perhaps with his usual sense of irony. In the ensuing meetings, Ransom became the guardian of clarity, rationality, and coherence, and Tate, the heretic, became the champion of free verse and themes of alienation and despair.

In his eulogy to Ransom, Tate delves further into the dynamics of their relationship:

> I hope the reader will understand it when I say that I didn't like him while I was his student. That was more than fifty years ago. I thought him cold, calculating and highly competitive, and I was arrogant enough as his student, and even later, until about 1930, to think I was his rival! But I was not, like him, cold: I was "calidus juventa," running over with violent feelings, usually directed at my terrible family—terrible because my father had humiliated us. . . . My dislike of John was my fear of him. He had perfect self-control; I could see him flush with anger, but his language was always moderate and urbane. I was just the opposite, and some of my dislike came of my exposure to his critical glance. His patience with my irregular behavior only made his disapproval the more telling. What disturbed and challenged me most was my sense of the logical propriety of his attitude toward his students. He never rebuked us; his subtle withdrawal of attention was

more powerful than reproach: he refused to be overtly aware of our lapses. Logic was his mode of thought and sensibility.

(Tate 1975, 39–40)

Of course, there are oedipal themes in this tangled relationship. Tate's image of Ransom seems to overlap his memories of his father. Ransom evoked anger and rebellion from Tate; but then, as Tate reports, he projected his own anger and competitiveness onto Ransom, using the projections as further justification for his attacks. The complex posturing by Tate in this interpersonal relationship resembles his posturing in some of his early poetry—he conceals his feelings in complex "thought boxes" of arcane associations.

As he sought solid ground to build his adult identity, Tate went through two major conversion experiences. The first was a gradual discovery and acceptance of his Southerness, in part under the direct influence of Donald Davidson. The second was his early adult conversion to Catholicism, in part under the influence of Eliot. But while Eliot was a distant mentor, Ransom was a solid teacher and group leader whom Tate ambivalently modeled. Thus, at not quite a conscious level, Eliot was Tate's surrogate for Ransom, and Eliot received the adulation that Tate couldn't give freely to Ransom. At one point around the time of his conversion to Catholicism, when Tate was most assured about himself and felt most whole, he wrote to Davidson about his warmth toward Ransom and his sense of how close Ransom and Eliot were in their work: "Ransom and Eliot are more alike than any other two people alive. . . . It is very hard for me to distinguish the influences they have had on me; they merge" (18 February 1929, in Fain and Young 1974, 226). Although Tate's rebellious streak still breaks through in his memorial eulogy after Ransom's death, he finally concludes with a gracious acknowledgment: "John Crowe Ransom was Virgil to me, his apprentice" (Tate 1975, 45).

Davidson played an important part in mediating the conflict between Tate and Ransom, and he was instrumental in helping Tate extract himself from the defensive posture he had adopted. After the pair's vehement arguments over Ransom's criticism of Eliot's "Wasteland," it was Davidson who mediated and brought about a truce. And it was Davidson whose continued efforts at reconciliation finally led to Tate's insights about what Ransom meant to him.

The Collaborative Pairing of Davidson and Tate

Tate's changing relationship to Ransom had numerous effects on Davidson. In the initial confrontations, Davidson had allied himself with Ransom.

This coalition might have endured if it hadn't been for Tate's sudden departure from Nashville in the summer of 1922, when he was tentatively diagnosed with tuberculosis. Tate left Nashville to spend the summer in the mountains, and Davidson, attentive and concerned, wrote to him immediately. The two began a dialogue in their correspondence that placed Davidson between Ransom and Tate, and eventually led Davidson, in Tate's absence, to become the spokesperson in the meetings for Tate's modernist position. As Davidson first criticized, then experimented with, then internalized the style advocated by Tate, his poetry changed profoundly, and his dependency upon Ransom lessened.

Davidson began the correspondence with a letter on 17 June 1922, "trying to make up for" having missed saying goodbye by "being among the first to write you a letter." He reported on the rejection of one of his poems by the *Double-Dealer,* a journal Tate had recommended to him. He told Tate that just one word had been scribbled on the yellow rejection slip: "Sorry!" Taking the rejection with good humor, he wrote: "Now I don't know what interpretation to put on that scribble. Does it mean that the editor was sorry in the sense of regretful, or does it mean that my poem was a sorry affair?" (Fain and Young 1974, 4).

He went on to report that, following Tate's suggestion, he had purchased a copy of T. S. Eliot's "Wasteland," but, still skeptical about its worth, he joked that he was "wondering very oddly whether my $1.25 was well-spent." Following the Fugitive custom introduced by Hirsch of deciphering hidden meaning in names, Davidson wrote that he was anxious to learn about the name of the place where Tate was staying (Valle Crucis, N.C.). He wanted to know whether the name fit, and what it meant. Tate wrote back immediately explaining away the rejection of Davidson's poem by the journal and encouraging him to submit the poem somewhere else.

In the next exchange both men admitted they were not writing poetry. Tate scolded Davidson and urged him to get busy and to send him a long letter. Davidson responded by enclosing a "small poem" ("Dryad") in which he experimented with a new style—"a satirical touch" combined with "lyrical beauty." Then he made a casual suggestion that changed the lives of both men: "I have two or three more in embryo state, which I will send you when I complete them, if I complete them. I would like to propose to you that we hereby agree to exchange new poems constantly,—that is, if one sends the other a poem, the obligation will be on the receiver to transmit a newly composed poem in turn. What do you say? (2 July 1922, in Fain and Young 1974, 10).

Tate responded by sending four poems—"my output for three weeks."

He had already sent all of them out to be reviewed for publication. He also included a careful critique of Davidson's poem along with praise for the new "restraint" in his work. "Keep it up, Don. I'm with you in this new line. . . . I can't tell you how pleased I am over your new departure" (Fain and Young 1974, 13). Then he conveyed the expectation of criticism—"detailed and ruthless"—of his own enclosed poems.

Davidson responded with effusive praise and claimed he was inadequate to criticize the four perfect poems: "[I] extend all sorts of congratulations on achieving mastery in the sphere you have nominated as your own . . . quite as good . . . as any of Eliot's stuff that I have read." But then he went on to criticize the abstract analytical style and the lack of emotional point of view. He returned Tate's poem heavily marked with suggestions and criticisms: "I am very eager to see your next poems; send them on as soon as you write them. There's nothing so exciting to me as to see these things growing up into black and white out of the unascertainable Kosmos of brain. And there is nothing so stimulating to my own literary efforts as to have such high objects of emulation. Write, write, write!" (8 July 1922, in Fain and Young 1974, 15).

The commitment to exchange new poetry and to criticize each other's work became known as the "compact." Later Davidson wrote about this commitment: "The most helpful criticism I ever received—and the sternest—was from Allen Tate, in the marginal notations on manuscripts that I sent him and in the very frank letters that always came with the return of a manuscript" (1958, 22). Tate himself later described the agreement as "that covenant that was more significant than either of us could guess on the day of its almost casual making" (Fain and Young 1974, 3).

The compact set in motion a system of exchange, in which the two members gradually ratcheted one another into taking greater and greater risks—exposing vulnerable experimental work and responding with more and more honest, detailed, and helpful criticism. But their correspondence, especially Davidson's responses to Tate's work, also lets us hear the voices and emerging standards of the Fugitive group as a whole. For example, in his first responses to Tate's poems, Davidson presented his criticisms as if he were relaying the points of view of several other group members. The parenthetical asides in the following quotes are Davidson's:

> I can criticize you more for what you don't do than for what you do. There is not, I believe, enough lyrical beauty in the two larger poems. Perhaps, while you are holding these objects up to analysis and to some sarcasm, there ought to be an element of pity (Stanley's phrase)

which would naturally express itself in beauty of a regretful, poignant sort rather than in hard, chiseled language. There should be [a] little more warmth (Curry's phrase) here and there, though it is not to be demanded everywhere in this type of poetry.

<div align="right">(8 July 1922, in Fain and Young 1974, 14)</div>

Perhaps Davidson was coyly camouflaging his own criticisms and dodging Tate's irritation by hiding behind the voices of other group members; or perhaps he had not yet distilled his own perspective out of the dialogue in the group. But most likely, he was simply relaying the sorts of comments he would have heard in a meeting. Nevertheless, the group dialogue he carried in his head, and Tate's defense of his style, stimulated Davidson to develop his own style.

As we have seen, one of the major divisions in the group was between those who were "too modernly modern" and those who were more traditionally romantic or Victorian. Davidson, writing to Tate, saw the major camps thus: "You, Ransom, Bill Elliott, Moore, and myself are certainly ranged against Stanley, Stevenson, Hirsch, and Frank. . . . I think the division is a good thing." At this point the dialogue with Tate must have been helpful to Davidson, who was trying to sort out where he stood. Davidson's conflictedness and his role in the group are suggested by another letter to Tate describing a Fugitive meeting:

We had a great debate at the Fugitive meeting Saturday night—the old controversy of the Moderns vs. the Ancients—in which our guest, a Dr. Lockhart of Kenyon College, Ohio, declaimed against modernism, supported mainly by Stanley, and opposed by Ransom and others. I took little part, for I am hesitant to crystallize my present vague and nebulous ideas into comments on theories of poetry, only ranging myself against the Secession bunch, the Dadaists, and the Dialists (of the extreme type). The debate lasted past two o'clock, but left the combatants apparently unexhausted and mutually unconvinced.

<div align="right">(23 August 1922, in Fain and Young 1974, 38)</div>

In the debates within the group and in the correspondence between Tate and Davidson, there were three basic issues:

Language: Should a poet use his own native language or should he invent a new one?

Meaning: Should meaning be conveyed directly, or should it be ambiguous and circuitous?

Theme: Should the theme be a large, significant one or does it only matter that it be handled artfully?

When the correspondence with Davidson began, Tate's positions were clear: invent a new language, be ambiguous, and value art over significance. Davidson's position, though less clear, leaned toward the opposite pole on each issue. He favored a "Southern" voice, in which important themes were presented in a lyrical, narrative style. Although he was willing to experiment with Tate's style, he was at first unimpressed by those efforts: "To tell the truth, I think it is easier to write this kind of thing than the other that I have been dealing in more, and for that reason I am a little inclined to doubt the artistic sincerity of those who affect this style, including you and myself both" (1 July 1922, in Fain and Young 1974, 19). However, as he corresponded with Tate, and as he presented his own position and represented Tate's to the group, he began to change his opinion. Under Tate's influence, as well as that of others in the group, Davidson slowly developed his own version of a more modern form, a more subtle style in which he juxtaposed ambiguous images of defeated Southern heroes over and against images of the wasteland culture of mass consumption that emanated from the North. Some of his later works include narrative poems laced with haunting imagery, like clues in a great mystery.

One of his most enduring poems is "Lee in the Mountains," a portrait of Robert E. Lee in exile after the Civil War. During the last five years of his life, Lee was president of Washington (later Washington and Lee) University in the mountains of Virginia. In the following excerpt from Davidson's poem, Lee walks past a waiting group of students on his way to his study. It has puzzled many scholars that while Lee was at the university, he worked, not on writing his own memoirs, but on rewriting the memoirs of his father, "Light Horse" Harry Lee, the Revolutionary War hero. Instead of telling his own story and redeeming himself, Lee chose to attempt to redeem the memory of his father, whose reputation had been darkened by business failures and bankruptcy in his later years. Lee's last memory of his father was at the age of five when his father left for the West Indies to try to recover the family's lost fortune. The images in Davidson's poem draw on these episodes in Lee's life (Davidson 1966, 43).

LEE IN THE MOUNTAINS, 1865–1870
Walking into the shadows, walking alone
Where the sun falls through the ruined boughs of locusts
Up to the president's office . . .
Hearing the voices

Whisper, Hush, it is General Lee! And strangely
Hearing my own voice say, Good morning, boys.
(Don't get up. You are early. It is long
Before the bell. You will have long to wait
On these cold steps . . .)
 The young have time to wait.
But soldiers' faces under their tossing flags
Lift no more by any road or field,
And I am spent with old wars and new sorrow.
Walking the rocky path, where steps decay
And the paint cracks and grass eats on the stone.
It is not General Lee, young men . . .
It is Robert Lee in a dark civilian suit who walks,
An outlaw fumbling for a latch, a voice
Commanding in a dream where no flag flies.

My father's house is taken and his hearth
Left to the candle-drippings where the ashes
Whirl at a chimney-breath on the cold stone.
I can hardly remember my father's look, I cannot
Answer his voice as he calls farewell in the mist
Mounting where riders gather at gates.
He was old then—I was a child—his hand
Held out for mine, some daybreak snatched away,
And he rode out, a broken man. Now let
His lone grave keep, surer than cypress roots,
The vow I made beside him. God too late
Unseals to certain eyes the drift
Of time and the hopes of men and a sacred cause.
The fortune of the Lees goes with the land
Whose sons will keep it still. My mother
Told me much. She sat among the candles,
Fingering the Memoirs, now so long unread.
And as my pen moves on across the page
Her voice comes back, a murmuring distillation
Of old Virginia times now faint and gone,
The hurt of all that was and cannot be.

As a consequence of vicariously participating in the dialogues between
the group members, and as a consequence of mediating between Tate and
Ransom, Davidson perfected a style that was uniquely his own. Along with

the direct feedback, especially from Tate, the dialogue in the group shaped Davidson's understanding of poetry. His style, and the themes he conveyed in that style, represented his own synthesis of the standards debated in the group. Summing up the internalization process that Davidson's development illustrated, Tate noted at the reunion, "[W]e each knew other's personalities so thoroughly that we could anticipate the response that would be made by anyone in the group to the poem under discussion. And, therefore, we had drained each other dry" (Purdy 1959, 120).

Davidson's psychological and professional maturation during the rebellion, quest, and creative work stages laid the foundation for a role change during the collective action stage. When the group published the first issues of the *Fugitive,* they had no designated editor. However, after the initial excitement, most of the work of compiling the poems and seeing them through to publication fell to Davidson. Tate and Stevenson led a movement to make Davidson the formal editor of the journal. Ransom opposed them. As discussed earlier, some reviewers gave credit for the journal to Ransom. Although he was not the formal editor, he benefited from the ambiguity. At first the group compromised with a policy that each member would take a turn at being editor. However, in a symbolic declaration of independence from Ransom, they finally rallied in support of Davidson. After the journal was discontinued in 1925, it was Davidson, carrying on in his executive role, who reassembled members of the core group to defend the South against the attacks from Mencken and others. He edited their collection of essays, *I'll Take My Stand.* The dynamics of the group continued to provide opportunities and demands for his development.

Conclusions

In this chapter we have examined the processes that characterize the early stages of group development in collaborative circles. As we have seen in the cases of both the Impressionists and the Fugitive poets, collaborative circles form in magnet places where ambitious novices gather in the early stages of their careers. A sense of marginalization and a shortage of mentors make it more likely that the novices will turn to peers for stimulation and socialization. Feeling marginalized contributes to their commitment to one another and to their critical attitude toward authority and tradition. A degree of cultural conflict among the authorities within the magnet place stimulates the critical and creative processes among circle members. When conflicting visions are held with equal force by authorities in the same setting, the clashing visions stand out in relief, and the marginalized novices feel empowered

to try their own hands at constructing a synthesis, or an altogether new vision.

Each stage of circle development is characterized by a constellation of salient roles. In the formation stage, the salient roles are the gatekeeper, the charismatic leader, and the novice members. The gatekeeper is the member who draws the group together. If members of a circle enter a group through a gatekeeper, they are likely to share many values and assumptions. Rather than finding one another accidentally, the members are filtered through the gatekeeper's values and psychological needs. This mode of building a circle contributes to the commonalities among the members and may ultimately increase the chances of success in collaboration. The charismatic leader is a member who seems larger than life, and who leads the group in explorations beyond the boundaries of the world sanctioned by conventional authorities. In the formation stage, the members are often ambivalent about whether or not to commit themselves to the circle. Resolution of the ambivalence occurs when novice members work out a relationship with the charismatic leader that is engaging and empowering for them—one that gives them a sense of making new discoveries, growing stronger, and becoming more competent.

In the rebellion stage, the salient roles are the tyrant, the scapegoat, the lightning rod, and the peacemaker. The tyrant is usually a powerful person outside the group who embodies traditional values that the circle, especially the charismatic leader, rejects. Motives, values, and attitudes associated with the tyrant are sometimes attributed to a scapegoat, who is someone in their extended network who is seen as "too traditional" in his or her thinking and work. This member may become the target of attack, gossip, or may be excluded by the other members. The member who gives voice to the rising negative feelings is the group lightning rod. The peacemaker is the member who attempts to resolve conflicts in the group. In this stage, many members may be ambivalent about whether or not they reject the traditions represented by authorities in their field. Discussion in the circle aids them in resolving their ambivalence.

Beginning in the rebellion stage and growing more salient during the quest stage, the dominant group roles are the boundary markers and the center coalition. There are two types of boundary markers—the radicals and the conservatives. The radicals are those who, in comparison to most circle members, "go too far" in their experimentation and in their rejection of traditional standards. The conservatives are those who do not go far enough. By analyzing what is wrong with the extreme positions taken by the boundary markers, the center coalition members develop a "negative" image of

the group's values. That is, they begin to develop consensus about what they do not value, even though they are not yet clear about what they value. By evaluating the experiments and innovations that are introduced by the boundary markers, the center coalition eventually synthesizes a new vision, distilling out of the group dialogue the areas of consensus that become the foundation for a shared vision.

As we saw with the Impressionist group, creative activity often occurs in pairs rather than in meetings of the whole group. Like the meetings of the Impressionists, the Fugitives' meetings were characterized by heated exchanges where members challenged one another to clarify their positions and to defend themselves. In this combative atmosphere, it is difficult for members to take great risks, present vulnerable new ideas, or suggest totally new directions for the group to follow. It takes a deeper trust and intimacy, more common in pairs, for the members to expose new, half thought out ideas. As in the Impressionist group, the most creative advances in the Fugitive culture took place in intimate, dyadic exchanges, such as those between Tate and Davidson, or between Davidson and Ransom. Donald Davidson found his unique voice through such a relationship. In the next two chapters I will examine more closely the dynamics of these collaborative pairs.

Chapter 4

———

Creative Work in Collaborative Pairs:
Joseph Conrad, Ford Madox Ford,
and the Rye Circle

Just as two boys banded together exhibit far greater daring than each
one alone—for the presence of an accomplice serves to dilute and di-
vide the sense of guilt—so apparently did the spiritual union of these
two inhibited men [Joseph Conrad and Ford Madox Ford] lend to
Conrad, at least, a certain boldness in his willingness to search his in-
ner self.

—Bernard C. Meyer, *Joseph Conrad: A Psychoanalytic Biography*

For members of collaborative circles, creative advances in their thinking
seem more likely to occur when they work in pairs. For example, Monet
and Renoir pieced together the Impressionist style in the late summer of
1869, when they worked together painting scenes of people bathing and
strolling on the docks at a riverside resort. Working side by side, reacting to
one another's tentative experiments, they converged on a style and a set of
techniques that became the foundation of the Impressionist vision. In the
Fugitive poets' circle, at the point when the larger group was polarized be-
tween those for and against modern poetry, Davidson and Tate paired off
and made a "covenant" to correspond and to include a new poem and a cri-
tique of one another's work in each letter they exchanged. As a consequence
of this interaction, they each developed a personal style that synthesized the
opposing perspectives in the group. In both circles, most of the fragile in-
sights that laid the foundation of a new vision emerged, not when the
whole group was together, and not when members worked alone, but when
they collaborated and responded to one another in pairs.

Creativity involves linking together two or more ideas so as to produce
something new and useful, or something new and beautiful, or both (Isak-

sen 1987). A new scientific theory, a new invention, or a new writing style may result from such creative work. Monet and Renoir's synthesis of diverse elements of painting is a prototypical example. They combined the visual perspective and bright colors of Japanese woodcuts, the French and English traditions of landscape painting, and their own methods of juxtaposing dabs of bright color to convey light and shadow observed at a fleeting glance (Stuckey 1995).

Many theorists view extraordinary creativity as a talent reserved to a particular type of gifted personality—a "genius." To uncover the sources of genius, these theorists focus on the individual cognitive and emotional processes associated with creative thought (for recent reviews, see Isaksen 1987; Lavie, Narayan, and Rosaldo 1993; Runco and Albert 1990; Wallace and Gruber 1989). In a classic example of this approach, Kris (1952) suggests that the prototype of all creative work is the preconscious association of images in dreams. For Kris, creativity occurs in a portion of the mind where images and thoughts are combined without conscious manipulation. Likewise, Arieti (1976) argues that the germ of a creative idea, the "endocept," as he calls it, emerges from the associations of ideas in the unconscious. The endocept is a subconscious idea that guides a person's attempts to combine words or images; it is the endocept that makes some combinations feel right while others feel wrong. These theorists assume that creative work occurs within the mind of a single individual, and to explain creativity, they analyze the developmental histories and cognitive processes that characterize the mind of the "genius."

In contrast to this approach, several recent theorists have observed that the isolated genius theory does not always fit what we know about creativity. Noting that episodes of creative work often occur when individuals collaborate, they argue that the dynamics of collaborative creativity should be examined more carefully (e.g., Csikszentmihalyi 1990; Harrington 1990; Kohut 1985). As we have seen in the circles examined thus far, creative insights seem more likely to occur when two members of a circle pair off and work closely together. Even though internal psychological processes contribute to creativity, it may be that these processes are more likely to emerge when the creative person is embedded in certain types of interpersonal relationships. It also may be that some unique cognitive processes occur when two people, working together, open their minds to one another. Are there some unusual interpersonal processes that occur in collaborative pairs that facilitate creative work? When they "put their heads together," do collaborators think in a way that makes innovation more likely? These are the questions addressed in this chapter.

The case study we will examine is that of Joseph Conrad and Ford Madox Ford, who were part of a larger circle that included Stephen Crane, H. G. Wells, and Henry James—all of whom lived near one another at the turn of the century in the area around Rye, south of London (plates 20–26). While Conrad and Ford formed a successful collaborative pair, the other dyadic relationships of the Rye circle were troubled. Henry James invited H. G. Wells to collaborate with him, and they met occasionally to share ideas and to exchange finished manuscripts. But their relationship ended with a set of disastrous public attacks on one another's work. Crane proposed collaboration to Conrad, but nothing came of it. Wells was never at ease with either Conrad or Ford. However, Conrad and Ford did collaborate successfully, and in their work they were guided by a vision that, in part, emerged out of dialogues among all the members of the circle.

In chapter 3, I examined the conditions under which circles form and the dynamics of the early stages of circle development. In this chapter, the focus is on the dynamics of collaborative pairing during the middle stages—the quest and creative work stages. Because the structure and content of the Conrad-Ford collaboration grew out of the dynamics of the larger group of which they were both members, I will begin by briefly examining the history of the Rye circle. After analyzing the factors that slowed this circle's development and ultimately contributed to its disintegration, I will focus in detail on Conrad and Ford, the roles they played when they worked together, and the effects they had on one another. Finally, drawing on the observations in this case study, I discuss how the interpersonal dynamics during paired collaboration contribute to creative work.

Development and Disintegration of the Rye Circle

Over the fall of 1898 and winter of 1899, the circle that included Conrad and Ford crystallized out of a network of writers who lived near Rye, the magnet place for this group (Delbanco 1982; Mizener 1971). The cultural conditions in which the circle formed resemble those we have seen in other groups. Rather than forming at a high point in a literary movement, they came together at the end of the Victorian era during a time of uncertainty and exploration. As Zabel notes, when the circle formed, the English novel had "expanded, explored, digressed, moralized and conquered" but seemed to have arrived "at an impasse of demoralization" (Zabel 1975, 4). Looking back, H. G. Wells (1934) saw it as a time when the shadows of the great writers of the nineteenth century were receding, and young writers, like new saplings, were free to come forth with new approaches. He also saw a new

audience emerging—an educated class that welcomed the circle's anticipation of the new century.

Like the Impressionists and the Fugitives, the members of the Rye circle shared a sense of marginalization. Three of the members were cosmopolitan immigrants to England who hoped to establish themselves as writers: Conrad was originally from Poland, James and Crane were both Americans. Ford, the son of a German immigrant to England, saw himself as the heir to medieval values because of a strong identification with his maternal grandfather, Ford Madox Brown, a member of the Pre-Raphaelite circle. Although Wells was English, because of his class background as the son of a gardener and a maid, he was marginal to English society in his own way. Except for James, the members of the circle were all marginal to the English literary establishment, and even James had reached a point where he was trying to distance himself from that network. Like other collaborative circles in the early stages of development, the members of the Rye circle expressed themes of marginalization, alienation, and rebellion in their work and in their discussions. In one of his autobiographical sketches, Ford reports that Wells characterized the group as a band of "foreigners" gathered in the southern counties to "conspire" against the English novel (Greene 1987, 173).

Except for James, the members were roughly of equal status and at similar stages in their careers, but unlike other groups we have examined, they were widely divergent in age. When they first assembled as a circle in 1899, Crane, who was then twenty-eight, was the only one in the group who had achieved popular success (plate 20). His *Red Badge of Courage* was acclaimed in both England and the United States. Wells, aged thirty-three, had recently finished *The Invisible Man.* Although he had not yet won wide recognition, his first major work, *The Time Machine,* was soon to become a popular success. Like Crane, Wells was supporting himself as a journalist while working to become a serious writer (plate 21). Conrad, aged forty-two, had begun writing only in his late thirties. Both he and Ford, aged twenty-six, had recently married and were at early stages in their careers. James, at fifty-five the oldest member of the group, was unmarried. He had already established his reputation as a serious novelist, but his work did not sell well.

Although James was the senior member, recent setbacks in his professional career may have contributed to his readiness to form new friendships. In January 1895, prior to meeting the group, he had a disastrous failure in his first attempt to stage his only play, *Guy Domville.* On opening night, the audience on the main floor included many of James's friends; the regular London audience was in the gallery. As the play progressed, and the subtleties of

dialogue were lost on those in the gallery, they became increasingly restless and hostile. At the curtain call after the final scene, the lead actor, George Alexander, mortified by the audience's reaction to his ethereal role, found James as he was returning backstage from a walk around the theater district and led him out by the hand to face the angry crowd. James took a bow, and the more his friends applauded, the louder the gallery booed and hissed. He was bewildered and humiliated. Wells, then a reporter sent to review the play, wrote a sympathetic account, but the play was a failure. In the wake of his defeat, James retreated to Rye.

These apparent commonalities contributed to the formation of the group. However, as we shall see, the significant differences of background, age, and stage of life of these writers made it difficult for them to maintain cohesive bonds and ultimately undermined their relationships.

The Formation of the Circle

The first meeting between H. G. Wells, Joseph Conrad, and Ford Madox Ford illustrates the kind of interaction that led to the formation of the Rye circle. Just before Conrad moved to Pent Farm, H. G. Wells, who already lived in the area, had reviewed very favorably Conrad's 1896 novel *Outcast of the Islands.* As soon as Conrad settled in, he wrote to Wells about how pleased he was that they were now neighbors. Conrad and Ford, who lived near one another and were already building a friendship, walked together to Wells's home to pay a visit. Ford reports that when he pushed the doorbell button, it stuck, and Conrad, in mock wonder, exclaimed, "The invisible man!" Wells related his first impressions of Conrad and Ford:

> [Conrad] came into my ken in association with Ford Madox [Ford] and they remain together, contrasted and inseparable, in my memory. Ford is long and blond with a drawling manner . . . oddly resembling George Moore the novelist in posture and person. What he is really or if he is really, nobody knows now and he least of all; he has become a great system of assumed personas and dramatized selves. His brain is an exceptionally good one and when first he came along, he had cast himself for the role of a very gifted scion of the Pre-Raphaelite stem, given over to artistic purposes and a little undecided between music, poetry, criticism, The Novel, Thoreau-istic horticulture and the simple appreciation of life.

> At first [Conrad] impressed me, as he impressed Henry James, as the strangest of creatures. He was rather short and round-shouldered with his head as it were sunken into his body. He had a dark retreating

face with a very carefully trimmed and pointed beard, a trouble-wrinkled forehead and very troubled eyes, and the gestures of his hands and arms were from the shoulders, and very Oriental indeed. He reminded me of Du Maurier's Svengali and, in the nautical trimness of his costume, of . . . Captain Kettle. He spoke English strangely. Not badly altogether; he would supplement his vocabulary—especially if he were discussing cultural or political matters—with French words; but with certain oddities. He had learnt to read English long before he spoke it and he had for example acquired an incurable tendency to pronounce the last "e" in these and those. He would say, "Wat shall we do with thesa things?" And he was always incalculable about the use of "shall" and "will." When he talked of seafaring his terminology was excellent but when he turned to less familiar topics he was often at a loss for phrases.

(Wells 1934, 526–27, 525)

The circle formed out of a sequence of exchanges of collegial letters and visits to one another's homes. The members were far enough along in their careers to have established their identities as aspiring writers, so they were more or less publicly visible to one another. But each saw himself as not yet secure, and none had yet established a reputation equal to his aspirations.

Collaborative Pairing within the Rye Circle
As we have seen in the case of the Impressionists, dyadic relationships often emerge early in a circle's development, and the Rye group was no exception. The members courted one another as collaborators within the first few months of meeting. For example, Stephen Crane admired Conrad's work and sought him out soon after arriving in London. He saw Conrad, the author of *Nigger of Narcissus,* as a role model. Just as Conrad was mining his observations of men at sea, Crane hoped to create stories out of his observations as a war correspondent in Cuba, Puerto Rico, and Greece. In March 1899, Crane proposed to Conrad that they collaborate on a play that would make their fortunes (Delbanco 1982). Perhaps because Conrad had already committed himself to collaborating with Ford during the previous winter, he turned Crane down.

Henry James did not approve of Conrad's collaboration with Ford, but nevertheless, he himself made bids to combine forces with H. G. Wells. Wells occasionally visited and corresponded with James, and James proposed collaboration in 1902. After reading Wells's the *First Men in the Moon,* James wrote to him enthusiastically:

It is, the whole thing, stupendous, but do you know what the main effect of it was on my cheeky consciousness? To make me sigh, on some such occasion, to *collaborate* with you, to intervene in the interest of—well, I scarce know what to call it: I must wait to find the right name when we meet. You can so easily avenge yourself by collaborating with *me!* Our mixture *would,* I think, be effective. . . . Let me in *there,* at the right moment—or in other words at an early stage. I really shall, opportunity serving, venture to try to say two or three things to you about the Two Men—or rather not so much about them as about the cave of conceptions whence they issue.

<div align="right">(7 October 1902, in Edel and Ray 1958, 81–82, James's emphasis)</div>

Although James and Wells never did collaborate, they continued to meet and discuss their work over the next decade.

The Rye circle was still in the early stages of development in the winter of 1898–99, but the members benefited from working in parallel and occasionally exchanging visits. Like the Impressionists in the early stages of their development, they provided one another a variety of forms of social support. For example, Ford gave generous terms to Conrad in renting him a farmhouse cottage. When Henry James first bicycled over to Wells's home for tea, the purpose of his visit was to check discreetly whether Wells was in financial need. Crane hosted parties for the whole network at his home. All the Rye writers were supportive of Crane when they discovered he was ill with tuberculosis. Finally, in their discussions and correspondence throughout the decade, they encouraged one another's ambitions and validated their self-concepts as serious writers.

In addition to this social support, there are signs of cross-influence as well as progress toward a common vision in the works written by the members during this period. For example, around the time the circle formed, each member wrote a story using the same structural device of a narrator within the story telling a story to a group of friends. In Wells's first successful novel, *The Time Machine,* the narrator tells his story to his dinner guests. In Henry James's novel written at this time, *Turn of the Screw,* the narrator tells his story to house guests. In Conrad's *Heart of Darkness,* the narrator tells a story about a second narrator telling a story to old friends on a ship. Leon Edel notes the influence of James on Conrad:

[D]issimilar as the two writers were, and distinctive as Conrad's genius was, James played a much greater role in Conrad's craftsmanship than may have been allowed. No one has noticed that *The Turn of the Screw* and *Heart of Darkness* appeared within a year of each other; and

that both begin in the same way—the quiet circle, the atmosphere of mystery and gloom, the hint of terrible evil, the reflective narrator, the retrospective method, the recall of crucial episodes. And perhaps from the "Mr. Quint is dead" of the ghostly tale there sounds in Conrad a powerful echo, "Mistah Kurtz—he dead." The stories . . . suggest that Conrad . . . learned James' devices for obtaining distance from his materials.

(Edel 1972, 54)

In her contemporary review of Ford's most highly regarded novel, *The Good Soldier*, Rebecca West noted how Ford "used the device invented and used so successfully by Mr. Henry James, and used not so credibly by Mr. Conrad, presenting the story not as it appeared to a divine and omnipresent intelligence, but as it was observed by some intervener not too intimately concerned in the plot" (West 1915, reprinted in Cassell 1987, 40).

Wells visited James on numerous occasions, and as Wells put it in his autobiography, they "bothered" one another about their works. Wells sent copies of each of his novels to James as soon as they were published, and he received back provocative criticism. For example, after reading *The Time Machine* in January 1900, James wrote: "You are very magnificent. I am beastly critical—but you are in a still higher degree wonderful. I rewrite you much, as I read—which is the highest praise my damned impertinence can pay an author" (Edel and Ray 1958, 63). James thought Wells had the potential of a Dickens, but that he fell short because he wrote too fast and paid too little attention to polishing his style, dialogue, and plot. Wells reported that he tried for years to live up to the standards set by James—standards that eventually were shared by other members of the circle. But the influence was not solely from James to Wells. For example, after reading *The Time Machine*, James attempted his own story about time travel. But instead of the protagonist traveling into the future, James's traveler, characteristically, traveled into the past.

By December of 1900, several of the members had moved beyond the stage of being colleagues working in parallel and had begun to build consensus on what a novel should be. Even before they met, they shared many values about literature; and as they reacted to one another's views, they began to articulate the elements of a shared vision. Much later Ford attempted to codify the style, calling it "Impressionism" (Ford 1924). At least James, Crane, Conrad, and Ford reached a degree of consensus that the novel should move beyond the chronological structure and moralizing themes of Victorian literature. The author should build interest through gradually

unfolding both character and plot, moving back and forth in time, using an impressionistic, subjective style closer to the way people actually experience events and talk about them. The plot, imagery, and the narrator's insights should unfold with a "progression d'effect," so that events lead with increasing intensification toward an inevitable climax. Through the literary device of a narrator, these authors embedded doubt about the narrator's perceptions and veracity as a means to intensify the drama. Although economy of words was important, the writer must also pay attention to specificity of detail, and must embellish the surface of the story with careful attention to an individualized style. If the development of the circle had not been impeded, James, Crane, and Conrad might well have become the center coalition of the circle.

Like Cézanne in the Impressionist circle, and like Tate in the Fugitive group, Wells played the role of the radical boundary marker who deviated from the emerging consensus. James in particular criticized him for using sketchy characters and incomplete plots to convey an ideological or scientific thesis. Wells described a quarrel with Conrad:

> I remember a dispute we had one day as we lay on the Sandgate beach and looked out to sea. How, he demanded, would I describe how that boat out there, sat or rode or danced or quivered on the water? I said that nineteen cases out of twenty I would just let the boat be there in the commonest phrases possible. . . . But it was all against Conrad's oversensitized receptivity that a boat could ever be just a boat. He wanted to see it with a definite vividness of his own. But I wanted to see it and to see it only in relation to something else—a story, a thesis . . . ultimately to link it up to . . . my world outlook.
>
> (Wells 1934, 528)

In the wider network of writers outside the circle, Wells was close to George Bernard Shaw in his style—packaging social criticism into literary form. Nevertheless, for many years the Rye circle was the more important reference group for Wells, and he interacted more with them than with Shaw's circle. Wells became a boundary marker—the deviant member who was writing for quick success. The others saw him as a "sellout" to popular taste who would not work hard enough at perfecting an artful style.

Ford was the youngest member of the group, and like Renoir in the Impressionist group, he occupied the centrist position of the ambivalent "cork" during the early stages of group development. Throughout the decade the group worked together, 1899 to 1909, uncertain about the emerging style and slow to master it, Ford vacillated between the stilted prose of his early

work and imitations of the styles of Conrad first, then Wells, then James. However, at the end of the decade when the group moved into a brief phase of collective action, Ford took the role of executive manager. During the winter of 1908–9, Ford, Conrad, Wells, and others initiated publication of the *English Review,* a literary journal they established to showcase the work of neglected modern writers, but it was Ford who followed through and made it happen. During the journal's first fifteen months, he obtained the funding, rented the office, selected the manuscripts, edited the journal, and championed new talent, such as D. H. Lawrence, at literary gatherings. Although he was guided by the group's standards in making his selections of manuscripts to publish, he did not fully integrate this vision into his own work until after the group disbanded.

Factors Contributing to the Rye Circle's Disintegration

Despite the men's potential for becoming a cohesive circle, they never became a collaborative group with ritualized meetings like the Fugitives, the Inklings, or the Impressionists. In pairs, some of the members made progress toward ritualizing meetings, but they did not do so as a group. In pairs, they made progress toward building trust, sharing works in progress, and discoursing with one another; but in each of these pairs there was a strong undertow of discomfort. For Conrad and Ford, the dialogues led to fruitful collaboration on numerous projects, but even in this dyad there is evidence of tension (Meixner 1987). As a whole, the group never gelled into a cohesive unit. Two key factors hampered the development of this circle: the lack of members who were able or willing to play critical leadership roles and the diversity of their backgrounds.

The Absence of the Gatekeeper, Peacemaker, and Charismatic Leader
As we have seen with other groups, three critical roles that contribute to a cohesive circle are the gatekeeper, the charismatic leader, and the peacemaker. Each of these roles facilitates the integration of a group: the gatekeeper selects compatible members; the charismatic leader draws them together on an engaging quest; the peacemaker attends to conflicts and resolves tension. For a variety of reasons, the Rye group lacked members who might have played these leadership roles. Although, as I discuss below, Edward Garnett acted as gatekeeper when he introduced Ford to Conrad, no member of the group took on the task of sifting through the larger network and bringing members together.

Not only did the circle lack a gatekeeper, it also lacked a peacemaker. In

several ways, Conrad had the potential to play this role, but he avoided it. His circumstances placed him in the center of the group and linked him to each of the members. Because he was just beginning a career and a family, he had many things in common with the younger men. On the other hand, because of his age, his cosmopolitan experience, and maturity, he had many values in common with Henry James. However, he did not have the temperament to resolve conflicts, smooth over hurt feelings, or mobilize the whole group for social occasions. Even if he had possessed these qualities, Wells and James might have resisted him in this role. Wells in particular saw him as a stuffy foreigner, preoccupied with his honor and incapable of understanding British humor (Wells 1934).

Crane also had the potential to play an integrative role, maybe even that of the charismatic leader. When he rented Brede castle in 1899 with his mistress, Cora, he moved into a central place in the group. He was both a target of affection and a sponsor of group gatherings and parties (plates 22 and 23). Though young, he had already achieved popular success in England as well as in the United States. His dramatic adventure stories, such as *The Red Badge of Courage,* linked him to Conrad; his attention to style linked him to James; and his age and background as a journalist linked him to Wells. Crane's charisma, along with the charm of his companion, brought the whole group together on a number of occasions. But his growing debilitation due to tuberculosis, along with his dependent relationship to the flamboyant Cora, undermined his leadership role. Wells described Crane as "a lean, blond, slow-moving, perceptive, fragile, tuberculous being, too adventurous to be temperate with anything and impracticable to an extreme degree. He liked to sit and talk, sagely and deeply. How he managed ever to get to the seats of war to which he was sent I cannot imagine. I don't think he got very deeply into them. But he got deeply enough into them to shatter his health completely" (Wells 1934, 522). Ford's description was more sympathetic: "Crane was the most beautiful spirit I have ever known. He was small, frail, energetic, and at times virulent. He was full of fantasies and fantasticisms. He would fly at and deny every statement before it was out of your mouth. He wore breeches, riding leggings, spurs, a cowboy's shirt and there was always a gun near him in the mediaeval building that he inhabited" (Ford 1932, 45).

They all saw Crane as dominated by Cora, who seemed oblivious to how sick he was. Cora seemed intent on tuning their lives to the highest possible pitch of excitement. Edel characterizes Cora as one who had "large social aspirations. She was an egoist, a woman slightly overblown, proud of her blonde hair and fleshly charm, and energetic in her pursuit of pleasure and

'society.' . . . Cora had arranged to rent Brede Place. . . . [I]t ministered to Cora's grandiose dreams of social glory; she would give great parties, she would play the grande dame in baronial halls" (Edel 1972, 61).

The parties at Brede were occasions that drew the whole group together, and they might have evolved into ritualized group meetings. Wells described one of Crane's gatherings in December 1899. The guests were told to plan to stay for a weekend and to bring their own bedding:

> I remember very vividly a marvelous Christmas party in which Jane and I participated. . . . at least we got a room. No one else did—because although some thirty or forty invitations had been issued, there were not . . . more than three or four bedrooms available. One however was . . . large and . . . was Christened the Girl's Dormitory, and in the attic an array of shake-downs was provided for the men. Husbands and wives were torn apart.
>
> Later on we realized that the sanitary equipment of Brede House dated from the seventeenth century . . . and such as there was indoors, was accessible only through the Girl's Dormitory. Consequently the wintry countryside next morning was dotted with wandering melancholy, preoccupied men guests.
>
> Anyhow there were good open fires in the great fireplaces and I remember that party as an extraordinary lark—but shot, at the close, with red intimations of a coming tragedy. We danced in a big oak-paneled room downstairs, lit by candles stuck upon iron sconces. . . . When we were not dancing, we were waxing the floor or rehearsing a play vamped up by A. E. W. Mason, Crane, myself, and others. It was a ghost play, and very allusive and fragmentary, and we gave it in the School Room at Brede. We reveled until two or three at night and came down towards mid-day to breakfasts of eggs and bacon, sweet potatoes from America and beer. . . .
>
> In the night after the party Mrs. Crane came to us. He had had a hemorrhage from his lungs and he had tried to conceal it from her. He "didn't want anyone to bother." Would I help get a doctor?
>
> (Wells 1934, 523–24)

Soon afterward, Crane was diagnosed as having tuberculosis. For a time his slow death pulled the group closer together and encouraged the sharing of deeper feelings among them. The others were repulsed by Cora's unresponsiveness. Her denial of the seriousness of Crane's illness was finally shattered in a crisis that led her to take him on a dash to Germany to find treatment. Crane died in June 1900.

The Strains of Too Much Diversity

The most important factor impeding the development of the Rye circle was the diversity of the group's composition. Unlike the more successful circles, this group had to bridge wide differences in cultural background, age, and stage of career. As we have seen, James and Crane were both Americans, but they were from widely different social networks. Ford was the son of a German immigrant and the grandson of a bohemian English artist; Conrad was from Poland; and Wells was from a working-class English background. James, a generation older than the other men, had been engaged in a long struggle to stake out new directions in the style and form of the novel. He angled for the role of mentor in the group, "cher maitre," which Wells ambivalently encouraged, but resented. In addition to the diversity of social backgrounds, the circle also had to cope with diversity in the degrees of success of its members. Crane's early success caused some envy, and Wells's rapid rise in the early 1900s increased the tension in his relationship with James, whose audience and earnings were never large.

Despite the strains, the circle progressed into the quest stage, and even had a brief stage of collective action. They reached a point where paired collaboration was explored within several dyads. At Crane's party in December of 1899, the whole group collaborated in staging a satirical play based on the theme of the ghost of Brede castle. Perhaps if Crane had survived, this playful joint effort might have evolved into ritualized meetings and more serious discussions. But after Crane's death no one emerged to play the role of assembling the whole group for social gatherings, let alone for ritualized meetings and exchanges of unfinished work.

Strains in the Relationships

The strains within the circle were apparent even in the members' early reactions to one another. As we have seen, James courted Wells and proposed collaboration in 1902. He suggested that Wells allow him to revise his work before he submitted it to an editor. Wells never accepted this proposal, but he maintained open communication and visited James often over the decade. Wells wrote of James:

> He liked me and he found my work respectable enough to be greatly distressed by it. I bothered him and he bothered me. We were at cross purposes based . . . on very fundamental differences, not only of temperament but training. . . . He thought of [the Novel] as an Art Form and of novelists as artists of a very special and exalted type. . . . One could not be in a room with him for ten minutes without realizing the

importance he attached to the dignity of this art of his. I was by nature and education unsympathetic with this mental disposition.

(Wells 1934, 411)

James was not the only member of the circle who bothered Wells. Wells had similar misgivings about Conrad. His characterization of his relationship to Conrad suggests that he saw Conrad and James as similar in their evaluations of him:

We never really "got on" together. I was perhaps more unsympathetic and incomprehensible to Conrad than he was to me. I think he found me Philistine, stupid, and intensely English; he was incredulous that I could take social and political issues seriously; he was always trying to penetrate below my foundations, discover my imaginative obsessions and see what I was really up to. The frequent carelessness of my writing, my scientific qualifications of statement and provisional inconclusiveness, and my indifference to intensity of effect, perplexed and irritated him. Why didn't I write? Why did I not care for my reputation?

(Wells 1934, 527)

Although James and Conrad had many similar values when it came to writing, James also felt uneasy about Conrad (plate 24). Conrad idolized James and was delighted when James responded favorably to his "impudent" gift of a copy of *Outcast of the Islands* in 1897. However, when they met, they discovered that they rubbed one another the wrong way (Edel 1972). They first got together in February 1897, for a lunch at De Vere Gardens. Based on his research, Leon Edel has recreated the tone of that initial visit:

Conrad reached out to James with a predatory emotion—the "cannibalism" of which psychoanalysts have written—that made him on occasion, as he himself avowed, "to howl and foam at the mouth." And he couldn't reach James. The wall of plate glass was there between them. . . . We can imagine the two face to face. Both were short men. James was all repose and assurance. Conrad, with his head tucked between his shoulders, his strong Polish accent, looked at James with eyes which seemed to live in a wild dream and which somehow, for all their penetration, sought the very "heart of darkness." . . . With his slow moving eyes and settled aristocratic manner [James] would have listened to Conrad and answered his questions.

Drawing on reports of one of James's nephews, Edel also provides an account of Conrad and Ford's visits to James's home, Lamb House:

> James's nephew Billy, the second son of William, recalled these visits—and particularly the way in which James would take Conrad's arm and start off with him along the road, leaving [Ford] and Billy to bring up the rear. "[Ford] babbled," the frustrated nephew said, "and I didn't listen. I wanted to hear what the great men were saying up ahead, but there I was stuck with [Ford]. Occasionally a word or two would drift back and what I could always hear was—French!" The two novelists, the American and the Pole, discussed the form and future of the English novel in the language of art and diplomacy, and with appropriate gestures. So it would always be with them—a mask of politeness, a kind of guarded "distance," a mixture of friendliness and anxiety. . . . Conrad induced a state of malaise in James. . . . [Ford] insisted that James actively disliked Conrad; but it would be more accurate to say that he was simply troubled by him—by his nervousness, his "temperament" and the signal James picked up of a deep morbidity.
>
> (Edel 1972, 48)

Despite James's reactions to Conrad, Conrad held him in high regard. In a letter to John Galsworthy dated 11 February 1899, he wrote in defense of James's refined attention to style:

> Technical perfection, unless there is some real glow to illumine and warm it from within, must necessarily be cold. I argue that in H. J. there is such a glow and not a dim one either. . . . The outlines are so clear, the figures so finished, chiseled, carved and brought out that we exclaim, we, used to the shades of the contemporary fiction . . . we exclaim—stone! Not at all. I say flesh and blood—very perfectly presented—perhaps with too much perfection of method. . . . He is never in deep gloom or violent sunlight, but he feels deeply and vividly every delicate shade.
>
> (Zabel 1975, 736)

Ford thought of James as "the most masterful man I have ever met," but James did not reciprocate the high regard. James's secretary recorded that one day, when they were out walking, James made her jump over a ditch to avoid meeting Ford. On another occasion, when he saw Ford coming, James quickly pulled her behind a tree (Edel 1972, 45). Given his reactions to Ford, it is not surprising that James did not savor the idea of Conrad and

Ford collaborating. Recalling a conversation with James about the Conrad-Ford collaboration on *The Inheritors,* Olivia Garnett noted his concern about how dissimilar their traditions were, and how "inconceivable" their collaboration appeared. She recorded in her diary that James had said, "To me this is like a bad dream which one relates at breakfast" (Edel 1972, 47).

The Boundary Marker's Perspective on the Circle

As we have seen in other groups, circles often use their discussions about the behavior and work of their boundary marker members to define their emerging values. Their irritation with these "bad examples" stimulates them to clarify their emerging vision. Wells was certainly used in this way by Conrad, Ford, and James; but in his autobiography, Wells had the final word. He used the group's "artistic" culture as a backdrop against which to judge his own journalistic style and agenda:

> They forced me to define and consider my own position in such matters. . . . All this talk that I had with Conrad and [Ford] and James about the just word, the perfect expression, about this or that being "written" or not written, bothered me, set me interrogating myself, threw me into a heart-searching defensive attitude. I will not pretend that I got it clear all at once, that I was not deflected by their criticisms and that I did not fluctuate and make attempts to come up to their unsystematized, mysterious and elusive standards. But in the end I revolted altogether and refused to play their game. "I am a journalist," I declared, "I refuse to play the artist." . . . I have stuck to that declaration ever since. I write as I walk because I want to get somewhere and I write as straight as I can, because that is the best way to get there. . . . So I came down off the fence between Conrad and [Graham] Wallas and I remain definitely on the side opposed to the aesthetic valuation of literature.
>
> (Wells 1934, 532)

Ultimately, Wells argued for the superiority of the "coldness and flatness" of his journalistic style over the polished, impressionistic style of the rest of the circle:

> I was easy to educate. These vivid writers I was now beginning to encounter were, on the contrary, hard to educate—as I use the word educate. They were at an opposite pole to me as regards to strength of reception. Their abundant, luminous impressions were vastly more difficult to subdue to a disciplined and co-ordinated relationship than

mine. They remained therefore abundant but uneducated brains. Instead of being based on a central philosophy, they started off at a dozen points; they were impulsive, unco-ordinated, willful. Conrad, you see, I count uneducated, Stephen Crane, Henry James, . . . not only was I trying to avoid posing to myself, but I kept up as little pose as possible to the world. I eschewed dignity. I found therefore something ridiculous in Conrad's persona of a romantic adventurous un-mercenary intensely artistic European gentleman carrying an exquisite code of unblemished honour through a universe of baseness.

(Wells 1934, 529–30)

The Final Break between Wells and the Circle

The strains in the circle finally led to the irrevocable alienation of Wells and James. In the spring of 1914, James wrote a two-part installment article for the *Times Literary Supplement.* In it he reviewed the work of "the younger generation," using six representative authors, including Conrad and Wells, to make his points. Conrad came off well, with James praising his attention to style and craftsmanship. Interestingly, his only complaint about Conrad was over his use of the narrator within the story, a stylistic device that James himself had inspired Conrad to use. But Wells received the brunt of James's attack on the new novelists' inattention to style. He saw these bad examples as "simply recording . . . saturation. . . . They squeeze out to the utmost the plump and more or less juicy orange of a particular acquainted state and let this affirmation of energy, however directed or undirected, constitute for them the 'treatment' of the theme" (Edel and Ray 1958, 182–83). James pointed to Tolstoy as a case in point—a writer who "saturates" himself with information then dumps it out without style or art. Later in the essay, he made it clear that he also saw Wells in the same light:

> Mr. Wells, . . . a novelist very much as Lord Bacon was a philosopher, affects us as taking all knowledge for his province and as inspiring us to the very highest degree the confidence enjoyed by himself. . . . If confidence alone could lead utterly captive we should all be huddled in a bunch at Mr. Wells' heels. . . . It is literally Mr. Wells' own mind, and the experience of his own mind, incessant and extraordinarily reflective . . . of whatever he may expose it to, that forms the reservoir tapped by him, that suffices for his exhibition of grounds of interest. The more he knows and knows, or at any rate learns and learns—the more, in other words, his saturation—the greater is our impression of his holding it good enough for us, such as we are, that he shall but

turn out his mind and its contents upon us by any free familiar gesture and as from a high window forever open (Mr. Wells having as many windows as an agent who has bought up the lot of the most eligible to retail for a great procession).

(Edel and Ray 1958, 190)

Up to this point, despite their differences, James and Wells had maintained a cordial, ongoing dialogue about literature and about one another's work. But James's public review riled Wells. The next year, Wells published a rebuttal in the form of a fictional memoir of a writer named Boon:

"You see," Boon said, "you can't now talk of literature without going through James. James is unavoidable. James is to literature what Immanuel Kant is to philosophy—a partially comprehensible essential. . . . He talks of selection and . . . he objects to a saturation that isn't oriented In practice James's selection becomes just omission and nothing more. He omits everything that demands digressive treatment or collateral statement. For example, he omits opinions. In all his novels you will find no people with defined political opinions . . . none with lusts or whims . . . no poor people dominated with the imperatives of Saturday night and Monday morning. . . . All that much of humanity he clears out before he begins his story. It's like cleaning rabbits for the table. Then with the eviscerated people he has invented he begins to make up stories. . . . The only living human motives left in the novels of Henry James are a certain avidity and an entirely superficial curiosity. . . . It is like a church lit but without a congregation to distract you, with every light and every line focused on the altar. And on the altar, very reverently placed, intensely there, is a dead kitten, an egg-shell, a bit of string. . . . Upon the desert his selection has made Henry James erects palatial metaphors. . . . The chief fun, the only exercise in reading Henry James is this clambering over vast metaphors. . . . Having first made sure he has scarcely anything left to express, he then sets to work to express it, with an industry, a wealth of intellectual stuff that dwarfs Newton. He spares no resource in the telling of his dead inventions . . . He splits his infinitives and fills them up with adverbial stuffing. . . . His vast paragraphs sweat and struggle; they could not sweat and elbow and struggle more if God Himself was the processional meaning to which they sought to come. And all for tales of nothingness. . . . It is a leviathan retrieving pebbles. It is a magnificent but painful hippopotamus resolved at any cost, even at the cost of its dignity, upon picking up a pea which has got

into a corner of its den. Most things, it insists, are beyond it, but it can, at any rate, modestly, and with an artistic singleness of mind, pick up that pea.

(Edel and Ray 1958, 242–49)

Wells dropped a copy of the book at James's club, as if it were just another recent publication that he was forwarding to his friend. James sent back a restrained and polite letter severing the relationship: "[T]he falling away of this is like the collapse of a bridge which made communication possible" (Edel and Ray 1958, 262).

Wells tried to deny that the attack was personal, claiming that James was only representative of what he deplored in literature. But James refused to accept the denial, and gave an eloquent defense of his standards. A year later, in 1916, James died.

Joseph Conrad and His "Secret Sharer"

While other members of the circle ambivalently talked about collaborating, Conrad and Ford actually did it. Several critics and biographers have argued that most of Conrad's best work was done while he was paired in this collaborative friendship with Ford (e.g., Morey 1960; Meyer 1967; Meixner 1987; Delbanco 1982). Many of the innovative elements in Conrad's and Ford's works—the psychological "horrors" and the moral dilemmas, the narrator within the narrative structure, the time shifts of the narration, the progressive intensification of effect, as well as the plots and settings of their stories—emerged out of their readings, conversations, and collaboration at Pent Farm between 1898 and 1909. Without that interaction, Ford might never have developed into a serious novelist. Careful analysis of his work during the collaboration, especially his successive revisions of the *Romance* manuscript, shows how he matured as a novelist as a direct consequence of working with Conrad (Brebach 1985). Indeed, Ford himself later said of the time when he was doing his best work: "[I]t is to be remembered that, during all those years, [I] wrote every word that [I] wrote, with the idea of reading it aloud to Conrad" (Ford 1924, 203). Discussing his masterpiece, *The Good Soldier,* Ford notes: "That we did succeed eventually in finding a new form I think I may permit myself to claim, Conrad first evolving the convention of a Marlow who should narrate, in presentation, the whole story . . . just as . . . [it] will come up into the mind of a narrator, and I eventually dispensing with the narrator but making the story come up in the mind of the unseen author with a similar want of chronological sequence" (Ford 1932, 32).

For Conrad, the collaboration contributed to his mastery of English, brought economy of expression to his sometimes flamboyant style, and suggested scenes, settings, and plots for his work. More important, the relationship stabilized Conrad emotionally and contributed to his ability to explore his own psychological conflicts through his writing (Meixner 1987; Meyer 1967). At numerous points, when Conrad was overwhelmed with depression or paralyzed with self-doubt, Ford enabled him to work—sometimes by taking dictation, sometimes by writing lines for him, sometimes by conversation, and sometimes just by being nearby. In his overview of this period, Meixner notes:

> That the two men were not equals is undeniable—no more than the wife or mistress of many a distinguished and famous man has been his "equal." And yet, . . . without that wife, or mistress, or friend, that distinguished mind might well have run to silence or the second-rate. In gaining the partnership of a personality as sympathetic and generous as Ford's, Conrad was as lucky for his work (and surely he knew it) as, say, Virginia Woolf was when she married Leonard. With Ford's arrival on the scene, things fell into place for him. Suddenly he began to write *Heart of Darkness* and *Lord Jim,* and imaginatively to surge.
>
> (Meixner 1987, 21)

Ford reported that they often wrote in the same cottage, one upstairs, the other downstairs; then they read their work to one another in the evening. Conrad's wife, Jessie, who complained that Ford became an intrusive, presumptuous guest, and that Conrad was often more responsive to him than he was to her, nevertheless confirms many of Ford's reports about how he and Conrad worked together (Jessie Conrad 1964; Morey 1960). After Conrad's death, she, like many contemporary critics, doubted Ford's claims about the extent of his role in the collaborations, but nevertheless, she admits that the stimulation of their dialogues and collaboration contributed to Conrad's work: "It is not enough for a man of genius to be warm and comfortable, to have a devoted wife to cook for him and attend to his creature comforts. He needed a mental stimulus, and in the early days [Ford] provided that" (Jessie Conrad 1964, 64).

H. G. Wells, who lived nearby, confirms the role that the collaboration played in the development of both writers (Wells 1934). Ford was more the novice initially, but eventually the two men saw themselves as working within a common vision that they negotiated (Ford 1924). The vision was influenced in part by Flaubert and Maupassant, and in part by Henry James, but ultimately it was their own.

Perhaps the most convincing account of how they worked together comes from Jessie Conrad. As we have seen, she came to despise Ford, and in her memoir she takes pains to present him in an unfavorable light. Nevertheless, she describes the scenes when the Fords stayed with them at Pent Farm during the collaborations:

> Sometimes the two would elect to start work as we, Mrs. [Ford] and I, were retiring for the night. For hours after I had gone to bed the voices would reach me through the floor. Sometimes the tones would appear to mingle in a pleasant accord, their ideas flowing easily, amused laughs and chuckles. At others sounds of wordy strife and disagreement penetrated to my ears, and raised voices came distinctly into my room. Then [Ford], who was a very tall man, would relieve his feelings by thumping the oaken beam that crossed the ceiling below and my small son would stir in his sleep. . . . The small house seemed at times full to overflowing and there were days when the two artists with their vagaries, temperaments, and heated discussions made it seem a rather warm place. Still, to give [Ford] his due, he was the least peppery of the two, being native of a less excitable nation and his drawling voice made a sharp contrast with the quick, un-English utterances of the fellow collaborator.
>
> (Jessie Conrad 1964, 66)

In the beginning there was a clear division of labor. As Ford (1924) noted, Conrad knew the basic "architectonics" of storytelling, while Ford contributed his stylistic skills and his ear for English. Later critics confirm this assessment (e.g., see Cassell 1987; Delbanco 1982). The two men worked alongside one another in Ford's farmhouse while Conrad finished *Heart of Darkness* and while he wrote all of *Lord Jim.* They collaborated on and coauthored three works—*The Inheritors, Romance,* and *The Nature of a Crime.* Ford suggested to Conrad the plots for both *The Secret Agent* and *Amy Foster.* Conrad dictated *A Personal Record* to Ford. Ford began *The Good Soldier* while they worked together, though he finished it after they separated. Conrad wrote *Typhoon, Nostromo,* and *Under Western Eyes* while they worked together. When Conrad was ill, Ford wrote a whole installment of *Nostromo* for the journal in which it was serialized. Analyzing this installment, critics (see Morey 1960) have noted the differences in the fluidity of Ford's writing compared to Conrad's, but they have also noted that, because of their extensive collaboration, Ford was able to take up where Conrad left off and almost seamlessly carry the story and characters forward. On one occasion, in debt and rushing to meet a deadline for comple-

tion of his story, *End of the Tether*, Conrad lost a large portion of the manuscript in a fire at Pent Farm. In desperation he appealed to Ford for help. Telling of how they rewrote the story and completed it on time, Ford explained: "Conrad drove over to Winchelsea [Ford's home]. . . . Conrad wrote; [I] corrected the manuscript behind him or wrote in a sentence—[I] in [my] study on the street, Conrad in a two-roomed cottage that we hired immediately opposite. The household sat up all night keeping soups warm" (Ford 1924, 242–43). Finally, *The Secret Sharer*, Conrad's story of a young captain who rescues from the sea a sailor who is a haunting double of himself—an alter ego who seeks refuge after committing treason aboard another ship—was written during the final year of their close relationship.

Recalling one time when Conrad described their relationship, Ford wrote:

> [N]early ideal literary friendships are rare, and the literary world is ennobled by them. It was that that Conrad meant when, looking up from the play of King John at which he had been glancing for a little while, he quoted to me, who was writing and had to turn my head over my shoulder to listen:
> "Oh, two such silver currents when they join
> Do glorify the banks that bound them in—"
> And he added: "C'est pas mal, ca; pour qualifier nous deux!"
>
> (Ford 1932, 199–200)

Conrad was subject to long bouts of depression and self-doubt during which he was unable to work. The collaboration with Ford seems to have stabilized him, and it enabled him to explore the minds of his characters more deeply. The relationship with Ford enhanced his self-esteem and reduced the internal conflicts that blocked his writing. At one point Conrad said to Ford, "It is a fact I work better in your home, in touch with your sympathy" (Meyer 1967, 151). In *A Personal Record*, a memoir that Ford first persuaded the reluctant Conrad to write, then copied down while Conrad dictated, Conrad states: "It is certain my conviction gains infinitely the moment another soul will believe in it" (1925, 15). The implicit testimony to the impact of his friend is reminiscent of C. S. Lewis's comment about the effects of the Inklings circle on him: "Put back among my friends and in half an hour—in ten minutes—these . . . views and standards become once more indisputable."

After their friendship disintegrated, Conrad's work became less dramatic, less daring, less introspective, and less original (Meyer 1967). He seems to have lost the ability to plumb the depths of the psychic life of his characters. Discussing the period after the friendship broke down, Meixner notes:

For Conrad . . . the break was calamitous. By permitting himself to be separated by pressures conjugal and social from the one person who, through a long tally of supportive actions, had proved to be his single most valuable friend, Conrad was to let go an indispensable life-pump for his spirit . . . whatever the reasons for the break or [Conrad's] breakdown, these twelve months of Conrad's life—from mid-1909 to mid-1910—mark a decisive turning point in his career. In the books that come from his pen thereafter, the heroic psychological probings and vital interior tensions that are the constituent powers of his best fiction have largely vanished, to be replaced by conventional story-telling values.

(Meixner 1987, 22–23)

The Development of the Friendship between Conrad and Ford

Conrad's early life included a number of disruptions and catastrophes that shaped his inner world (Karl 1979; Meyer 1967). He was born in 1857 in Poland, the only child of a Polish nationalist who opposed Russian rule. When he was five, because of his father's political activities and writings, the family was exiled to Russia. Two years later, after his mother died from the hardships of their exile, Conrad's father placed him into the first of a series of boarding schools. After a childhood of moving from school to school, Conrad was finally reunited with his father when he was twelve, only to see him die a year later. Conrad's uncle, his mother's brother, became his guardian. In adolescence he rebelled against his uncle's attempts to guide him toward a respectable middle-class life, and when he was seventeen he left home to work on the docks in Marseilles. At the age of twenty-one, while engaged in smuggling and other marginal activities, he had a disastrous love affair. The broken relationship, along with his escalating debts, led him to attempt suicide. With his uncle's help, he recovered from this episode, but then, against his uncle's advice, he decided to become a sailor.

In 1894, after spending seventeen years at sea and reaching the rank of captain, Conrad decided to quit the sea and become a novelist (plate 25). Over the previous two years, while still a sailor, he had completed two novels. Flaubert was his model, and he began writing his first novel, *Almayer's Folly,* in the margins of his copy of *Madame Bovary.* He was multilingual, and after some indecision about whether to write in French or English, he chose English and settled in England with tentative hopes of building a career. Perhaps to consolidate the change in his identity as well as to make his name more acceptable to English readers, he shortened it, dropping his surname, Korzeniowski, and retaining his two given names, Joseph Conrad.

Throughout his career as a writer, Conrad was racked with ambivalence and self-doubt. If ever a personality was vulnerable to disintegration, bouts of despair, and urges toward panic and flight, Conrad's was it:

> Yet even more fundamental than his apparent need to shore up his dubious virility and potency was Conrad's constant search for a distinct image of his very identity, for . . . he behaved as one who, when stripped of the borrowed trappings of impressive men, evidently viewed himself as nothing, as no one—like Kurtz, "hollow at the core." . . . It is hardly surprising then to learn from his friend [Ford] that Conrad was often discovering presumed resemblances between himself and distinguished figures of history—Napoleon, Louis XVIII, and others [Doctor Johnson].
>
> (Meyer 1967, 97)

Conrad's son, Borys, was born in January 1898. The responsibilities of parenthood contributed to his doubts about a writing career and fed an urgent impulse to go back to sea (Jessie Conrad 1964; Morey 1960). Unable to write and in despair over completing the novel he was then working on, *The Rescuer,* he feared that his literary aspirations had ruined him. In September he wrote to his editor, Edward Garnett, expressing regret about having abandoned his position as a ship captain to become a writer: "There is a time in the affairs of men when the tide of folly taken at the flood sweeps them to destruction."

In part Conrad's self-doubts were a consequence of the difficulties he encountered when writing in English. Polish was his first language, French his second. It was an enormous struggle for him to master the details of English and to develop a coherent style. Lewis Hind remembered a visit with him during this troubled year: "It was a marvel to me then, and always has been how so un-English a man in temperament, looks, and utterance should be able to write such perfect English. . . . That afternoon [in 1898] he dug his fists into the sand, I remember, and said, 'Ah, if only I could write zee English, good, well! But you will see, you will see'" (Mizener 1971, 45). In March of 1898, he wrote to Garnett:

> I sit down for eight hours every day—and the sitting down is all. In the course of that working day of 8 hours, I write 3 sentences which I erase before leaving the table in despair. . . . So the days pass and nothing is done. At night I sleep. In the morning I get up with the horror of that powerlessness I must face through a day of vain efforts. . . . I seem to have lost all sense of style and yet I am haunted, mercilessly

haunted, by the necessity of style. And that story I can't write [*The Rescuer*] . . . is all there . . . yet I can't get hold of it no more than you can grasp a handful of water.

(Cited in Morey 1960, 105, 153)

These fluctuations in motivation and direction were not new to Conrad. They characterized his inner life throughout his adolescence and young adulthood, from the time he left Poland to the time he suddenly abandoned his career at sea (Meyer 1967, 61–62).

In September of 1898, perhaps responding to Conrad's appeals for help, Garnett introduced him to Ford Madox Ford. Garnett was a sensitive and highly respected editor. Ford knew Garnett not only as an editor but also through their family connections, and he once roomed with Garnett's brother-in-law in London. As Ford saw it: "In those days Mr. Garnett was what nowadays we call the White Hope of unprinted genius. His discoveries had been innumerable—including those of Conrad himself and [me]" (Morey 1960, 15).

Playing the role of gatekeeper, Garnett, encouraged by another editor, William Henley, suggested that Conrad might work well with Ford. They saw Ford, who had already published several books, as an up-and-coming writer who might help Conrad improve his command of English style and idiom. Ford describes meeting Conrad on the day that Garnett first brought him to visit his cottage, which was near Garnett's: "Conrad came round the corner of the house. I was doing something at the open fireplace in the house-end. He was in advance of Mr. Garnett who had gone inside, I suppose, to find me. Conrad stood looking at the view. . . . Then he caught sight of me. I was very untidy, in my working clothes. . . . He had taken me for the gardener" (Ford 1932, 52).

When they met, Conrad was forty-one and Ford was twenty-five. Ford's father was German; his mother was the daughter of the Pre-Raphaelite painter Ford Madox Brown. In his twenties, perhaps encouraged by Conrad's decision to change his name, Ford, whose original name was Ford Hermann Hueffer, changed his name to Ford Madox Ford. Ford's father had emigrated from Germany in 1869, three years before Ford was born, and had built a career writing about his philosophy and musicology research. He died suddenly of a heart attack when Ford was sixteen, and Ford went with his mother to live with his elderly, irascible, and opinionated grandfather, Madox Brown. Later he recalled Brown with deep affection, and always remembered his admonition: "Fordy, never refuse to help a lame dog over a stile. . . . Begger yourself rather than refuse assistance to any one

whose genius you think shows promise of being greater than your own (Mizener 1971, 15).

It was while living with his grandfather amid the memorabilia of the Pre-Raphaelites and hobnobbing with the younger Rossettis and various members of the Arts and Crafts network that Ford developed the ambition of becoming a writer (plate 26). He had come to see writing as a priestly vocation. Encouraged by his grandfather and aided by his family connections in the publishing world, Ford published his first books. Madox Brown did the frontispiece for his book of fairy tales. Despite this supportive environment, Ford's belief in his ability to fulfill his high aspirations was always uncertain. As several contemporaries noted, he often relied on props and posturing to buttress a fragile sense of identity. Describing himself during this period he writes: "[I] wore a black coat with a cape over the shoulders, and when [I] walked along it floated out a little way behind." Mizener explains: "The cape had been [Dante] Gabriel Rossetti's and had come down to him through his grandfather; it was over thirty years old. The jacket he wore under it was a water tight German forester's pilot jacket, also second-hand, and under that was a fifteen year old blue-linen shirt of his grandfather's and a red-satin tie. This costume, he felt, was the proper wear for a young man of Pre-Raphaelite descent who sympathized with Morris's socialism" (Mizener 1971, 16).

The age difference between Ford and Conrad is unusual for collaborative pairs, but in several ways when they met they were at the same stage of life. Both were just beginning their careers as writers, both had recently married, and both had become fathers within the previous year. As Morley (1960) notes, at this point Conrad was far from being a master; and Ford, young as he was, had already published and was well connected to the same network of editors as Conrad. They considered Ford a promising young writer with an easy command of English. He had written a novel, *The Shifting of the Fire,* some fairy tales, a book on gardening, and a biography of his grandfather. His aspirations were to become a respected writer, and he hoped someday to write a great novel. In addition to being at similar stages in their careers, Conrad and Ford had other similarities. Both had fathers who were expatriates and who died when their sons were adolescents; both considered French their second language, and both were well versed in French literature. For many reasons, like the young Fugitive poets, Conrad and Ford spoke the same language and felt at home together.

Ford claims that in their first conversation they spoke of the books they were working on. Conrad spoke of *The Rescuer,* and Ford spoke of his current adventure story, *Seraphina,* based on historical records of an Englishman,

Aaron Smith, who was kidnapped by pirates in the Caribbean and forced to serve as their navigator and physician. It was a new direction for Ford, and it was a step toward Conrad's territory. Perhaps this was the reason that Garnett thought they could work together. Ford described Conrad as

> small rather than large in height; very broad in the shoulder and long in the arm; dark in complexion with black hair and clipped black beard. He had the gestures of a Frenchman who shrugs his shoulders frequently. When you had really secured his attention he would insert a monocle into his right eye and scrutinize your face from near as a watchmaker looks into the works of a watch. He entered a room with his head held high, rather stiffly and with a haughty manner, moving his head once semicircularly. In this one movement he had expressed to himself the room and its contents; his haughtiness was due to his determination to master the room, not to dominate its occupants, his chief passion being the realization of aspects of himself.
>
> (Ford 1924, 3)

In their first conversation, Ford learned of Conrad's need for a place to live. Perhaps Garnett led the conversation toward this topic. Ford invited Conrad to stay for minimal rent in his cottage at Pent Farm, where Ford had lived until that July. Conrad moved to Pent Farm in October 1898. Soon afterward, he began work on *Heart of Darkness*.

That November, Conrad wrote a long letter to Ford, indicating that he had read his novel, *Shifting of the Fire,* and included a critique of it:

> We are very happy here [at Pent Farm] from which you may guess we haven't yet set fire to the house. . . . I have read the "Shifting of the Fire." I read it several times looking for your "inside" in that book: the first impression being that there is a considerable "inside" in you. The book is delightfully young. Mind I say "delightfully" instead of drearily, or morally, or sadly, or frightfully or any of those things which politeness would have induced me to paraphrase.
>
> (Morey 1960, 155–56)

The letter included detailed criticism of Ford's story, which, although couched in Conrad's "oriental politeness," provided evidence that they were already negotiating norms for the exchange of criticism. However, at this point in the exchanges, while Ford was the recipient of Conrad's criticism, all he provided in return was the rental of the cottage.

At about the time he received Conrad's letter, Ford, who had been traveling, returned to Rye to live in a second cottage that he owned near to Con-

rad's, and the level of commitment to one another deepened. Writing about that period, Ford reported: "That autumn I had a letter from Conrad asking that he might be allowed to collaborate with me in the novel about pirates that I was writing. He said that he wrote English with great difficulty because he thought his more unspoken thoughts in Polish and his carefully spoken ones in French. These last he translated into English when he wished to write. Henley had suggested that he might gain fluency if he collaborated with some good English stylist" (Ford 1924, 18).

Conrad was proposing a dramatic escalation of their exchanges—from polite criticism of published works to collaboration on unfinished work. In addition, he proposed an exchange of skills. Conrad would collaborate in constructing Ford's novel, and in the process Ford would help Conrad perfect his style in English. Conrad may also have thought that Ford's novel could be finished quickly and the sales would contribute to his income. Ford accepted the invitation.

However, in part because of Ford's immaturity as a novelist, the manuscript was a mess (Brebach 1985). Ford had gathered the details of Aaron Smith's account of his adventure and built a story, such as it was, around the historical sequence of events. The scenes were sketchy and disconnected, characters appeared and disappeared without explanation, no suspense ever developed, and the plot did not progress in a logical flow to the conclusion. Ford described the scene when he first read his manuscript to Conrad at Pent Farm:

> The parlour at the Pent was a deep room with a beam across the middle of the low ceiling. . . . An immense tythe barn with a great, thatched, black mossy roof filled in the whole view if you sat by the fireplace. . . . It was a very quiet, simple room. . . . [I] sat in the grandfather's chair, [my] back to the window, beside the fireplace, reading [my] manuscript held up to the light; Conrad sat forward on a rush-bottomed armchair, listening intently. (For how many years did . . . Conrad [and I] not sit there like that!)

As he read, Ford noted Conrad's agitation:

> [Conrad's response] was like a strong current that operated on a whole roomful. . . . With [my] back, then, to the lamp, and Conrad completely in the shadow, [I] read on. . . . Conrad began to groan. . . . It was by then apparent . . . that Conrad disapproved of the treatment of the adventures. . . . [I felt] now the sense of, as it were, dumb obstinacy with which [I] read on into those now vocal shadows in the fire-

side warmth. The interruptions grew in length of ejaculation. They became, "O! O! . . . O God, my dear Hueffer . . . " and towards the end, "O God, my dear faller, how is it possible."

<div align="right">(Ford 1924, 15–17)</div>

When Ford finished the story, Conrad, appalled by the unexpected ending, jumped up and blurted in alarm, "What? What? What's that? . . . Good God!"

As work on the manuscript progressed over the next two years, Conrad ironed out the lines of the plot and filled in the motivations of characters, but Ford frequently toned down Conrad's prose, gave it clarity and focus, and helped him gain control of English. This two-sided exchange of expertise developed early in the relationship. Conrad began work on *Heart of Darkness* in December 1898. He completed it in January 1899, and when the proofs came back at the end of February, Conrad invited Ford's comments on the last chapter (Ford 1932; Morey 1960). In his memoirs, Ford singled out the final paragraph of that story as "the first passage of Conrad's prose to which I ever paid minute and letter-by-letter consideration" (cited in Morey 1960, 111).

Telling Stories to a Group of Friends

Like members of other collaborative circles, Conrad and Ford developed the custom of reading their work aloud to one another. As Ford noted, "[W]e . . . got so used to reading our own works aloud to each other that we finally wrote for the purpose of reading aloud to the other" (Ford 1932, 32). In several of their individual novels written during the period they collaborated, both Conrad and Ford dramatized the storytelling process as unfolding out of interaction among friends. The friendship group is portrayed as the audience of a story told by a narrator. In their dramatizations of a narrator telling a story to a group, we catch a glimpse of how the dynamics of collaborative relationships contribute to creativity.

It is particularly instructive to examine Conrad's portrait of a group in *Heart of Darkness,* the first novel he completed after becoming part of the Rye circle. Perhaps, when he conjured up the image of the group of friends in the opening scene of the book, he was paying tribute to, or attempting to understand, how the interaction with Ford had contributed to his own recovery. Under the spell of an audience's attention, Conrad's storyteller, Marlow, was able to delve deep into his psyche and tell a story of the dark side of European colonization. Meyer (1967) suggested that, under the spell of collaboration with Ford, Conrad, like Marlow, was able to explore the uncharted space of his own inner world. In his portrait of Marlow and the

group of sailors, Conrad evoked many of the elements of collaborative pairing—trust, intimacy, openness, an egalitarian relationship, acceptance of differences in perspectives, and a kind of empathic attention that enables the creative person to explore his most disturbing thoughts.

In the story, Marlow is a seaman on a yawl at anchor in the mouth of the Thames. He tells his story to four old friends huddled in the candlelit stillness of the ship's cabin, where they have a long wait until the tide turns before they can sail. Conrad suggested that the profound stillness of the setting and the quality of the relationships among the friends evokes the story from Marlow, whom he described as having a yellow complexion, sitting cross-legged, his back against the mast, "arms dropped, the palms of his hands outwards," resembling a Buddha.

Conrad structured the story so that a primary narrator, one of the friends on the boat, is telling about Marlow, the secondary narrator, who is telling his story to his friends. The primary narrator writes: "Between us there was, as I have already noted somewhere, the bond of the sea. Besides holding our hearts together through long periods of separation, it had the effect of making us tolerant of each other's yarns—and even convictions." Describing the meditative mood that came over the men as the sun set on the river, he continues: "The old river in its broad reach rested unruffled at the decline of day, after ages of good service done to the race that peopled its banks, spread out in the tranquil dignity of a waterway leading to the uttermost ends of the earth. We looked at the venerable stream not in the vivid flush of a short day that comes and departs forever, but in the august light of abiding memories" (Conrad 1942, 6). After ruminating about the role of the Thames in the long history of England, and then about the young Romans who once sailed up the river when London was a wilderness outpost on the edge of civilization, Marlow begins his own story about a voyage to the edge of the British empire:

> I suppose you fellows remember I did once turn fresh-water sailor for a bit. . . . I don't want to bother you much with what happened to me personally . . . yet to understand the effect of it on me you ought to know how I got there, what I saw, how I went up that river to the place where I first met the poor chap. . . . It was the farthest point of my navigation and the culminating point of my experience. It seemed somehow to throw a kind of light on everything about me—and into my thoughts . . . not very clear. And yet it seemed to throw a kind of light.
>
> (Conrad 1942, 9)

Rather than tell a polished story, Marlow invites the listeners into his inner world. As the story unfolds, the boundaries between narrator and listeners dissolve. Again writing as the anonymous primary narrator, Conrad conveys this blurring of boundaries:

> It had become so pitch dark that we listeners could hardly see one another. For a long time already [Marlow], sitting apart, had been no more to us than a voice. There was not a word from anybody. The others might have been asleep, but I was awake. I listened, I listened on the watch for the sentence, for the word, that would give me the clew to the faint uneasiness inspired by this narrative that seemed to shape itself without human lips in the heavy night-air of the river.
>
> (Conrad 1942, 38)

In describing Marlow's style of storytelling, Conrad also suggests some of the elements of the vision developed by him and Ford under the influence of James. He tells the reader that, unlike the stories of most seamen, which have a "direct simplicity" and move quickly to the meaning "within the shell of a cracked nut," Marlow's stories are ambiguous. The meaning of his story "was not inside like a kernel but outside, enveloping the tale . . . in the likeness of one of these misty halos that sometimes are visible by the spectral illumination of moonshine" (Conrad 1942, 6).

In his story, Marlow tells of skippering a steamboat up an unexplored river, deep into the Congo, to find Kurtz, who runs one of the most successful trading posts in the interior of Africa and sends out "as much ivory as all the others put together" (Conrad 1942, 25). As he travels up the river, Marlow hears rumors that Kurtz has become ill, but because of a strange, tenacious commitment to his wilderness outpost, has not come out for help. In bits and pieces, he learns that Kurtz has established himself as a god among the natives, and he lives surrounded by adoring savages who view him as a supernatural being. When Marlow finally reaches Kurtz's compound, he discovers that it is surrounded by human skulls impaled high on the ends of a ring of poles: "[T]he wilderness had found him out early, and had taken on him a terrible vengeance for the fantastic invasion. I think it had whispered to him things about himself which he did not know, things of which he had no conception til he took counsel with this great solitude —and the whisper had proved irresistibly fascinating. It echoed loudly within him because he was hollow at the core" (Conrad 1942, 82). "The horror! The horror!" are the last words of the dying Kurtz, as Marlow's boat carries him back down the river.

Ford Madox Ford also made use of the device of a storyteller telling his

story to a friend. He started writing one of his most noted novels, *The Good Soldier,* during the last year that he collaborated with Conrad. Like Conrad, he explored the savagery beneath the veneer of civilization; but for Ford, the primitive impulses lie closer to home, just beneath the surface of an apparently conventional marriage. As the narrator retells the "saddest story he ever heard," moving back and forth in time, he reveals how for nine years he had toured the spas of Europe with his wife seeking relief for her heart condition. They traveled with another couple, a respected friend and his wife, and only after nine years did he discover that his apparently frigid wife and his friend had been carrying on an affair, their secret guarded by his friend's wife. In the novel, Ford presents an image of how he and Conrad worked together in the cottage at Pent Farm. As he brings the story of betrayal to a conclusion, he writes: "I have, I am aware, told this story in a very rambling way so that it may be difficult for anyone to find his path through what may be a sort of maze. I cannot help it. I have stuck to my idea of being in a country cottage with a silent listener, hearing between the gusts of the wind and amidst the noises of the distant sea the story as it comes" (Ford 1989, 201).

As Ford and Conrad worked together and responded to one another's drafts, and particularly as they collaborated in rewriting Ford's *Seraphina,* which they eventually titled *Romance,* they negotiated a vision, or a set of shared beliefs about what a novel should be in structure, style, and content. As Ford recounted: "[W]e each at intervals carried on work of our own. Then we would drop it, have another month's try at "Romance." Then drop that again. Or sometimes one of us would write his own work in the morning; the other would write away at "Romance"; in the evening and till far into the night we would join up" (Ford 1924, 123).

> We would write for whole days, for half nights, for half the day or all the night. We would jot down passages on scraps of paper or on the margins of books, handing them one to the other or exchanging them. We would roar with laughter over passages that would have struck no other soul as humorous; Conrad would howl with rage and I would almost sigh over others that no one else perhaps would have found as bad as we considered them. We would recoil one from the other and go each to our own cottage. . . . In those cottages we would prepare other drafts and so drive backwards and forwards with packages of manuscripts.
>
> (Ford 1932, 197)

The emerging style they created together became something different than either had created alone. Ford reports that, while they were working

together and Conrad found unexpected ideas tumbling out as he wrote, Conrad would exclaim, "By Jove! It's like third person writing!" They reached a point where they each could anticipate the thoughts of the other: "Once we were sitting in the front row of the stalls at the Empire. . . . And during applause by the audience of some too middle-class joke, one of us leaned over towards the other and said, 'Doesn't one feel lonely in this beastly country!' . . . Which of us it was that spoke neither remembered after, the other had been at that moment thinking so exactly the same thing" (Ford 1924, 42, 92).

When Ford published his memoirs, soon after Conrad's death in 1924, a number of critics did not believe his claim to have been Conrad's collaborator. Conrad was then at the height of his reputation, and Ford was hardly known. However, careful analysis of their letters and novels has demonstrated their influence on one another, and recent critics have verified that Ford's claims, though often overdramatized in his self-aggrandizing, "impressionistic" style, nevertheless are mostly true (see Brebach 1985; Cassell 1987; Mizener 1971; Morey 1960). In his own autobiography, H. G. Wells noted: "I think Conrad owed a very great deal to their association; [Ford] helped greatly to English him and his idiom, threw remarkable lights on the English literary world for him, collaborated with him on two occasions, and conversed interminably with him about the precise word and about perfection in writing" (Wells 1934, 532).

Informal Roles in the Conrad-Ford Collaboration

During the formation stage of their relationship, as they shared memories of their pasts and searched for common ground, Conrad and Ford created a mythical history for their friendship that gave it a starting point even before they met one another. Like lovers, who, as they try to account for how they found one another, enjoy discovering unusual connections that suggest their meeting was predestined, Conrad and Ford marveled over times when their paths appeared to cross before they met. Before they were introduced to one another, Ford had published his book on horticulture, and Conrad claimed that the sight of Ford's book in a railroad station in Geneva first led him to consider writing in English. They discovered they were both in Lowestoft, Germany, in 1878, when Ford was just a child. Conrad decided he "remembered" seeing Ford as a blonde four-year-old playing with a shovel and a bucket on the beach.

Both men had experienced disrupted childhoods, and Meyer (1967) suggested that both were seeking a relationship of a parent-child configuration

to compensate for deficiencies in their upbringing. In the initial stages of collaboration, Ford played the part of an attentive, nurturing parent to Conrad; while Conrad played the part of an idealized father for Ford. Conrad possessed characteristics that Ford associated with his father. Like Ford's father, Conrad was a European, nonpracticing Catholic, an expatriate who wore a beard and spoke English with an accent. Despite the fact that Ford was younger than he was, Conrad cast him into a benefactor role paralleling the supportive part played by his uncle earlier in his life (Meyer 1967). Ford often managed Conrad's finances, rescued him from pressing demands from editors, and haggled for him with publishers.

Each had a fragile sense of self, perhaps reflected in the way that both changed their names when they became writers. While Ford often alienated other members of the circle with his patronizing style of interaction as well as his pretentious posturing as heir to Thoreau, William Morris, and the Pre-Raphaelites, Conrad seems to have been the more psychologically vulnerable. They both experienced prolonged nervous breakdowns, but it was Conrad who experienced repeated attacks of overt disintegration. Zabel notes Conrad was prone to "irresolution, excitement, and self-absorption":

> His veerings between indolence and despair, his indecision, his lurking sense of guilt in having abandoned the sacred trust of his family's Polish allegiances, his fretting suspicions and trussed-up sense of honor, his tranced compulsion to write in the face of stupendous handicaps of scruple, language, and mental insecurity—these define the state of soul out of which, by an appalling exertion of will power, his books were shaped, their style determined, their characters wrought, their actual themes and substance evoked. . . . He was repeatedly tortured by exhausted energy and morbid crises.
>
> (Zabel 1975, 11)

Conrad was acutely aware of his handicaps. He compared himself to a convict dragging "the ball and chain of one's selfhood to the end." (Zabel 1975, 12). He knew how the process of writing undermined his stability:

> [I]t is a fools business to write fiction for a living. It is indeed. It is strange. The unreality of it seems to enter one's life, penetrate into the bones, make the very heartbeats pulsate illusions through the arteries. One's will becomes the slave of hallucinations, responds only to shadowy impulses, waits on imagination alone. A strange state, a trying experience, a kind of fiery trial of untruthfulness. And one goes through

it with an exaltation as false as all the rest of it. One goes through it,—
and there's nothing to show at the end. Nothing! Nothing! Nothing!

<div align="center">(Letter to E. L. Sanderson, 12 October 1899, in Zabel 1975, 738)</div>

While Conrad was the tortured, charismatic, and narcissistic member of
the dyad, Ford was the supportive and nurturant member. Ford's malle-
ability and his responsiveness were noted by several members of the circle,
usually in an ambivalent light. They saw his supportiveness as overdrawn,
perhaps hypocritical, and bordering on obsequious; and they saw his lack of
focus in his writing as the sign of a dilettante. Jessie Conrad noted that Ford
"had an uncanny way of picking out people from the point of interest, and
having found someone to his mind was extremely tenacious of them. There
was also some, one might say, promise held out to the other, either of mate-
rial gain or some intellectual reward, which cemented the acquaintance be-
tween them . . . there was some kind of fascination about the man . . . that
I could never understand" (Jessie Conrad 1964, 116). More sympathetically,
Stephen Crane wrote: "You must not be offended by Mr. [Ford's] manner.
He patronizes Mr. James. He patronizes Mr. Conrad. Of course he patron-
izes me and he will patronize Almighty God when they meet, but God will
get used to it, for [Ford] is all right" (Ford 1932, 9).

Despite their differences and their vulnerabilities, Conrad and Ford
gelled as collaborators. Ford described how he supported Conrad:

> I would maneuver [Conrad] towards writing as the drake maneuvers
> the sitting duck back to the nest when she has abandoned her eggs. I
> would read over his last sentence to him. If it provoked no beginnings
> on his part, I would displace him at the desk and write a sentence or
> two. . . . *The Mirror of the Sea* and *A Personal Record* were mostly writ-
> ten by my hand from Conrad's dictation. Whilst he was dictating
> them, I would recall incidents to him—I mean incidents of his past
> life which he had told me but which did not come freely back to his
> mind because at the time he was mentally ill, in desperate need of
> money and above all, skeptical as to the merits of the reminiscential
> form which I suggested to him. The fact is that I could make Conrad
> write at periods when his despair and fatigue were such that in no
> other way would it have been possible to him. He would be lying on
> the sofa or pacing the room, railing at life and literature as practiced in
> England and I would get a writing pad and pencil and, whilst he was
> still raving, would interject: "Now then, what was it you were saying
> about coming up the Channel and nearly running over a fishing boat

that suddenly appeared under your bow?" and gradually there would come Landfalls and Departures.

(Ford 1932, 190)

In 1923, Conrad wrote to Ford acknowledging his part in writing *A Personal Record:* "The mere fact that it was the occasion of your putting on me that gentle but persistent pressure which extracted from the depths of my then despondency the stuff of the Personal Record would be enough to make its memory dear" (Meyer 1967, 152). Writing to another friend, Edmund Gosse, about the importance of the kind of support provided by Ford, Conrad struck a note reminiscent of C. S. Lewis's account of the effects of his friends on the stability of his thinking: "I have often suffered in connection with my work from a sense of unreality, from intellectual self doubt of the ground I stood upon. This has occurred especially in the periods of difficult production. . . . I need not tell you that this moral support of belief is the greatest help a writer can receive in those difficult moments" (23 March 1905, in Zabel 1975, 740). As Delbanco notes in reference to Ford's completion of a twenty-five-page installment of *Nostromo* when Conrad was stricken with gout and in despair about meeting his publishing deadline: "[Ford] is as much a secret sharer in *Nostromo* as when taking dictation for *A Mirror of the Sea.* . . . The chapter may have taken both a conscious and conscientious effort to subordinate his sense of self, the idiosyncratic diction that asserts identity. Or the opposed identities may have, momentarily, merged. It shows the degree to which collaboration can forge prose parts into a seamless whole." (Delbanco 1982, 117).

Ford was younger and less mature, and he benefited in numerous ways from the relationship. In his assessment of the effects of collaboration on them, he observed: "I, at least, learned the greater part of what I know about the technical side of writing during the process, and Conrad certainly wrote with greater ease after [*Romance*] had been in progress some time" (Ford 1932, 188).

As in other collaborative friendships we have examined, there was an element of conspiracy or delinquency in their relationship. As they reached consensus on their style, they egged one another on to explore forbidden themes. These dynamics enabled Conrad to do his best work: "Just as they together can engage in recreation that neither would engage in alone (i.e., shooting rats) so together Conrad was able to explore forgotten and brutal instincts. . . . Secure in the company of the inseparable partner of his existence, Conrad could make that descent, emerging from time to time for

breath and to reassure himself of the presence of his 'ally' and 'accomplice,' and then descend once more" (Meyer 1967, 167).

Informal Roles and Instrumental Intimacy in Collaborative Pairs

The relationship between Conrad and Ford, though unique in many ways, illustrates a number of common characteristics of collaborative pairs. In this section, I discuss the interaction process that leads to collaborative pairing, the roles that emerge within pairs, and the kind of interaction within pairs that facilitates creative work. I first discuss the stage in circle development during which pairs become a visible feature of the interaction. Next I discuss how pairs form through escalating exchanges resembling the dynamics of courtship. Then I discuss the roles of the "mirror" and the "idealized selfobject" (Kohut 1984), noting how each contributes to internal cohesion in the self-systems of the members of a collaborative pair. Finally, I discuss how the merging of cognitive processes in a pair, or as I call it, "instrumental intimacy," contributes to creative work.

Although they may form earlier, collaborative pairs are likely to become a salient feature of the structure of a circle when the larger group has reached stage 3 of development—the quest for a vision. In this stage, the members of the larger circle share a set of positive and negative reference points, heroes and tyrants who serve as targets of idealization and vilification. Usually by this time, the members have established rituals of working alone, then meeting together in pairs or in groups to discuss their work. At least within the pairs, if not within the larger group, the norms of interaction balance criticism with support. As we have seen, in some cases those norms may be rigid and formal (as in the interaction between Joseph Conrad and Henry James) while in other cases they may be playful and informal (as in Stephen Crane's interactions at his parties). In successful circles, the members also are likely to have negotiated norms that set high expectations for the quantity and quality of work done by members. However, during this stage, they have not yet negotiated a shared vision. They may know what kind of work they do not like, and they may be experimenting with a variety of approaches, but they have not yet clarified a theory, style, or method that they agree upon and identify as their group vision.

The collaborative pair emerges out of the larger circle when two members agree to work together to search for a vision consistent with the emerging values of the group as a whole. Usually pairs form as ordinary friendships might: out of a network of associates, two people who are similar to one another in values, temperament, and aspirations draw closer together. For a

variety of reasons, they find it easy to talk to one another, and they begin exploring solutions to the problems defined by the larger circle. The positions they take may be constrained by the emerging consensus about what is wrong with the work of the radical and conservative boundary markers. Out of their discussions and collaborations, they eventually arrive at a new synthesis of theory and methods, or a new style, which they in course bring back to the others. The dynamics of the dyadic relationship facilitate the type of intimate interaction that leads to creative synthesis.

Escalation of Social Support and Social Exchange in Collaborative Pairs

In the early stages of interaction in a collaborative pair, the exchanges between the members could be characterized as ordinary social support. They exchange resources, validate one another's identities as serious professionals, and provide emotional support to one another during crises. For example, two writers may share an apartment, loan money to one another, or help one another find a publisher. The social support exchanged resembles that of any other friendship or support system (Cohen and Wills 1985; Farrell 1986; House, Umberson, and Landis 1988).

As the relationship continues, the value of the exchanges may escalate, so that the process of exchange begins to resemble a courtship. With each rewarding cycle of exchange, the commitment to one another deepens; and as the commitment deepens, the exchanges within the dyad become more intimate. Through gradual escalation of the depth of self-disclosures and the value of the exchanges, the pair test one another's readiness to expand the scope of the relationship. However, during this courtship stage, the members do not risk exposing their less developed ideas to one another for criticism. Rather, they begin by exchanging only finished products. If they are writers or artists, this means they exchange only published works or finished paintings. As the relationship deepens, they may begin to exchange skills and knowledge with one another. For example, one writer may help the other to rewrite a passage, or one artist may teach the other a technique.

As trust builds further, one member may risk exposing to the other a wild, half-baked idea or an unfinished work. If the other reciprocates with a supportive response and makes an equally risky disclosure, the level of exchange escalates, until the pair exchanges their most current, least finished work. I refer to this open exchange of half-finished work in progress as "instrumental intimacy." Instrumental intimacy makes each member extremely vulnerable to criticism, ridicule, or rejection by the other. But, if the other responds with sensitivity and enters into the task of sorting out

the useful from the unacceptable elements of the unfinished ideas, then the relationship may move to an even greater degree of commitment.

A balanced exchange process, characterized by reciprocity and gradual escalation of both critical and supportive interaction, is necessary to move to the most creative stage of the dyadic interaction. Scientists may exchange their most wild hunches; writers and artists may share their least finished work; or social activists may share their most daring plans. Once the level of trust and commitment reaches this point, the collaborative dyad does more than provide support to its participants. While the ordinary social support remains, the quality of the interpersonal relationships and the communication change in a way that facilitates episodes of creative thought, both when the individuals work alone and when they are discussing their ideas together.

Mirroring, Idealization, and the Development of a Cohesive Self
The roles in a collaborative dyad during episodes of creative work resemble those that Kohut (1976) sees as conducive to the development of a cohesive self in childhood and adolescence. Kohut argues that one of the achievements of early childhood is the construction of a cohesive self. An incohesive self is one that is racked by guilt, self-doubt, depression, or anxiety; whereas a cohesive self is characterized by healthy narcissism and exhibits exuberance and delight in exploring and mastering the world. A cohesive self emerges within the nexus of two important types of relationships—a mirroring selfobject and an idealized selfobject.

According to Kohut's self theory, in the early stages of development, to consolidate a self-system, a child needs a "mirror"—a loving, empathic parent who responds to and regulates the needs of the child, and who conveys fascination and joy in each step of the child's development. By responding with appreciative "mirroring" at critical moments when the child initiates actions, such as a first word or first step, the parent contributes to the child's awareness of himself or herself as an active agent. Ideally, the mirroring parent creates an environment with an optimal level of demand and frustration—demands that encourage self-directed action, but that do not surpass the child's capacities to meet them (Smith 1992, 23–26). "Give me a big smile," the mother repeats over and over again to the infant. The child concentrates, focuses all her energy, smiles—and the mother reacts with delight. The delight of the mirroring parent in the child's performance contributes to the child's gradual self-consciousness and narcissistic investment in herself. For the developing child, the thoughts, desires, and abilities that originate on the inside become as intriguing, maybe even more intriguing,

than the perceptions of events that originate outside. Without the responsiveness of the "mirror," the child, overwhelmed with the stresses of mastering developmental tasks, may experience chronic feelings of doubt, panic, depression, and rage. But with responsive mirroring, the child recognizes herself as an agent in the stream of feelings and actions flowing by, and she develops a healthy delight in exhibiting action to an appreciative audience. Appropriate and timely mirroring contributes to a cohesive sense of the self.

Kohut's conceptualization of the process that leads to a cohesive self resembles George Herbert Mead's theory of socialization and self-development (see Charon 1998; Hewitt 2000). According to Mead, the self emerges out of an ongoing dialogue with a significant other. The child acts—for example, she makes a sound, takes a step, or touches an electrical outlet. The parent responds with more or less enthusiasm, with "Good girl!" or "No, no!" In play, the child may perform the act again, then act out the role of the significant other, responding to the performance as the significant other would respond. For example, a toddler may point her finger toward an electrical outlet, as if preparing to touch it, then stand back and say, "No! No!" After repeated cycles of interaction and play, the child internalizes the whole dialogue. In her imagination, she stages the act, imagines the response, and then takes corrective action based on the anticipated response. As Mead would say, she "takes the role of the other." She becomes "self" conscious and self-regulating when she imagines herself into the role of the significant other, sees herself as she imagines the other sees her, plans her actions so as to achieve the desired response from the other, then acts.

In Kohut's and Mead's theories, the audience plays a crucial part. In both models, from the child's perspective the boundaries between the mind of the parent and the mind of the child dissolve. How the child feels about herself, how she responds to her own actions and thoughts, is shaped by her imaginings of how the parent will respond. Eventually, this image of the responding parent, whether we call it a "mirroring selfobject" or a "significant other," becomes internalized as part of the self. The external dialogue becomes the foundation of an internal dialogue within the self. If the parent's responses have been empathic and appropriate, the child invests in the emerging image of herself, and eventually acquires a cohesive self capable of pursuing ambitious yet realistic goals. If the parent's responses have been inadequate, the child may develop a fragmented or disintegrating self-system and be plagued with guilt, low self-esteem, depression, or rage.

According to Kohut's theory, in child and adolescent development a second type of interpersonal relationship can strengthen an incohesive self-

system and restore a healthy balance of narcissism (Kohut 1977). Even if a person has had poor mirroring and, as a result, has an incohesive self-system, she can achieve some integration at a later point in development through identification with an idealized selfobject. An idealized selfobject is a significant person in the child's life whom the child sees as possessing strength and abilities that she wishes to have. By identifying with an idealized selfobject, or in other words, by merging with that selfobject, the child feels stronger and gains a sense of internal cohesion. The internal cohesion frees energy for work, creative thought, and action. For example, in his speech to the Democratic Party Convention in 1988, Jessie Jackson conveyed that, growing up in deprivation, he felt inadequate and hopeless about his future until he met Martin Luther King, Jr. King served as an idealized selfobject that galvanized Jackson's functioning as a young man (Frady 1996). When he identified with King, when he linked himself with his image of King and his mission, he felt stronger and able to act in a sustained, constructive way. Eventually, this personal identification became the foundation for the more abstract values that guided his actions, stabilized his self-esteem, and provided a sense of internal cohesion.

Of course, there are many parallels between Kohut's conceptualization of the idealized selfobject and the concept of role model in social learning theory. The difference is that Kohut focuses less on external behavior and imitation, and more on the internal state of the person who identifies with the selfobject. Identification quiets the discordant internal processes that threaten the self with disintegration. When someone identifies with an idealized selfobject, the boundaries between the self and the other once again dissolve. The actor now sees himself as connected to the mission and the strengths of the idealized selfobject. Rather than being important as a mirror, the idealized selfobject is important because he embodies perceived strengths that the self wishes to incorporate. By identifying with the selfobject, feeling his presence inside the self, and modeling the self after him, the person feels integrated and whole.

Over time, the child internalizes the roles performed by both the mirroring other and the idealized selfobject. Through a form of psychological metabolism, the functions of both the mirroring and idealized selfobjects, and the actions that grew out of the relationships to these objects, are gradually incorporated into the self. As a person makes the actions her own, and as she learns to play the parts of the mirroring and idealized selfobjects for herself, she becomes more individuated. That is, she crystallizes an integrated, less dependent, autonomous self.

Mirroring and Idealized Selfobjects in Collaborative Pairs

As we have seen, collaborative pairs are formed at the end of a series of heightened exchanges that resemble the courtship process. Idealization often accompanies romantic courtship, and the courting lover often finds that he "can't get her out of his mind." Likewise, for the courting collaborators, idealization often plays an integral part in the formation of the relationship, and as each merges with an idealized image of the other, their self-systems become interdependent. If they go on to establish a ritual of meeting that includes episodes of instrumental intimacy, the boundaries between the self and the other become even more permeable. Not only do they share their most fragile ideas, but they begin to play roles for one another similar to those played by a parent for a developing child. The members of the collaborative pair alternate in performing the "mirroring" role for one another.

The process begins when each becomes an attentive audience for the other. As this relationship continues, and as they expose more and more of their most tentatively held ideas, the mirroring process engages deeper and deeper parts of the personality, until eventually each reexternalizes the internalized mirroring other. For each of the collaborators, the self-monitoring process—the internalized part of the mirroring parent—is delegated to the other member of the pair. If the mirroring other responds with delight and encouragement to the creative person's stumbling efforts, that person gains confidence in her creative efforts, attends more closely to the products of her own efforts, and experiences a greater sense of internal cohesion.

Mirroring is a combination of parenting, therapy, and good teaching. It includes a sensitivity to the subjective life of the other person and authentic delight with that person's acquisition of skills and abilities. It includes an ability to appreciate the struggle to create, to reflect back to the other that his creative work is appreciated and understood, and to have one's reactions unclouded by jealousy, rivalry, cynicism, or the desire to control.

In Conrad's first letter to Ford criticizing his work, there are signs that he is attempting to negotiate this kind of relationship. He tries to convey that he is looking for Ford's "inside" in the book and finds it "delightfully young." Then he quickly clarifies that, by "delightfully," he does not mean to be condescending or polite, rather he is responding with sincerity, respect, and appreciation. In this exchange, without knowing it, Conrad was negotiating a relationship that would allow him to serve as a mirror for Ford. For his part, Ford described numerous occasions where he played the part of mirror for Conrad. As both his biographers and critics note, Ford

was hypersensitive to pleasing whomever he was with; "patronizing" was often used to describe his style, and he was extremely nurturing to people he wished to encourage. It was through such responsiveness that Ford lived up to his grandfather's admonition to nourish the genius he found in others.

Although both members of a collaborative pair may alternate in this role, one member may be particularly good at it, and early in the relationship may, like Pissarro in the Impressionist group, like C. S. Lewis in the Inklings group, or like Davidson in the Fugitive group, claim it often. This person may pair with different members of the group at different times. Such empathic persons are skilled in responding to another's strengths, building trust, and encouraging openness in dyadic exchange. However, collaborative pairs are usually characterized by reciprocity. If the member who receives the mirroring never reciprocates, the unbalanced exchange is likely to introduce strains that undermine trust and openness.

Those who are overly specialized in mirroring may appear to be selfless because they are able to enter into the world of more needy, egotistical collaborators and help them work through incapacitating internal conflicts. They have a high tolerance for the egotism of others, but they are not highly egotistical themselves. They listen well, they empathize well, and they suppress their own urges to control or compete with the other. In the presence of a mirroring other, a person who is the recipient of the attention feels stronger, more centered, more ambitious, and takes his own internal cognitive and affective processes more seriously. In other words, he invests more in himself. However, if the mirroring is one-sided, the creative capacities of the one who mirrors may be neglected, and the dyadic relationship will deteriorate.

The second role that emerges in the interaction between members of collaborative pairs is that of the idealized selfobject. Again, both members may alternate in this role, but, at first, only one member is likely to occupy the part. Monet seems to have occupied this role in his dyadic relationships, first with Bazille, then with Renoir. He was seen as the most gifted and daring member of the group of younger men—flamboyant, filled with energy, delighted to be the center of attention, and delighted to initiate something new. However, as his letters indicate, in his younger years his energy depended upon having the audience and encouragement of a mirroring selfobject working with him. His cues to act, and his actions themselves, depended upon having an appreciative audience who responded to his ideas. In the Conrad-Ford pair, Conrad was the one who played the role of idealized selfobject.

Although one member may be more adept at mirroring, and although

the other may be more apt as an idealized selfobject, as the exchanges continue both members eventually perform both these roles at different times. Initially each may idealize the other, and as the interaction unfolds, each may feel stronger because of identification with the idealized other and because of the attentive audience provided by the mirroring other. The identification with the idealized other, along with the mirroring of the appreciative other, strengthens the cohesiveness of the self-system of each of the collaborators; and the cohesiveness contributes to a tremendous release of creative energy, an increment of investment in the self, and a flood of new ideas. As we have seen, during Conrad's first months at Pent Farm, when he was working first on *Heart of Darkness,* then on *Lord Jim,* he showed this kind of surge of energy in response to his exchanges with Ford. These dynamics continued throughout the decade they worked together.

As the relationship develops into its most mature state, and as each partner becomes more productive and receives more outside recognition, the cycles of idealizing one another, as well as the cycles of giving and receiving mirroring, eventually lead to more equality and less differentiation in the dyad. Through repeated cycles of playing both roles, both members internalize those roles. As a result, each member becomes more individuated and less dependent upon the other, and the relationship becomes less necessary to sustain the creative process. The internalization may be more or less conscious. For example, in his autobiography Ford notes how, even after Conrad died, he never wrote a word that he did not imagine reading to Conrad.

Eventually, as a member becomes more individuated, he may feel constrained by the relationship, irritated by the shadow of the reputation of the other, burdened by the neediness of the other, or uneasy about the dependency in the relationship. Although I do not discuss it in this chapter because of the focus on the middle stages of circle development, the strains of individuation, and the demands that intensified because of their familial commitments eventually did undermine the friendship and collaborative relationship between Conrad and Ford.

Instrumental Intimacy and the Creation of Coauthored Ideas

Creative innovations are most likely to occur after a pair of collaborators has gone through a series of exchanges of ideas that each views as relatively equal in value. As the level of risk in the exchanges escalates, as they begin to exchange less finished work, they set the stage for instrumental intimacy. Instrumental intimacy occurs when each begins to use the mind of the other as if it were an extension of his own. An analogy might be two computers that become linked together so that each has access to the hard-drive

memory and the software programs of the other. The boundaries between the self and other diminish until the members are able to think out loud together as if they are one person.

During the stage of greatest instrumental intimacy, when merger is at its highest point, in their dialogues with one another it is common for the participants to find their ideas emerging in a cascading flow, such that neither one knows or cares who thought of the ideas first. In this stage of the relationship, ideas emerge through combinations of thoughts derived from each of the separate members, but the emerging ideas are sometimes experienced as coming from a third source. As we saw, when Conrad and Ford were collaborating, Conrad often exclaimed, "It is like a third person writing!" His refrain conveys that sense that the ideas do not "belong" either to him or to Ford; something new that is separate from either is being created. This sense of a "third person" is similar to the sense of a "muse" that some authors have noted in writing—a voice that is not just one's own but that seems to "visit" the self during the creative process.

In summary, new ideas are more likely to emerge in creative dyads for several reasons. First, creativity is a form of deviance—doing something that authorities do not approve. A "partner in crime," as Freud called it, or to use Conrad's phrase, "a secret sharer," enables the person to neutralize the guilt and anxiety inherent in the creative process. A friend's acceptance of one's "deviant" ideas frees one to follow thoughts through as far as one dares. Second, as a consequence of the mirroring and the identification with one another, each member of the dyad feels more cohesive, invests more in the self, and takes her own ideas more seriously. An idea that may be dropped when a person is alone gets examined with enthusiasm and enjoyment when the pair come together. Each individual's wild ideas are brought to light and given a hearing. Third, the open exchange in free, often playful interaction allows the linking of conscious and unconscious thoughts from both minds. As the members share jokes, fantasies, and hunches as well as polished thoughts, ideas from one person are combined with ideas from the other, and the associations result in new combinations that might never have occurred when either person worked alone. Finally, once the ideas emerge, as each plays the role of critic for the other, the ideas are reworked into useful components for the emerging shared vision. Two are thus able to accomplish what one might never have accomplished alone; and because there is another to act as critic, each participant is freed to suspend critical judgment and let imagination fly, trusting that the other will help clean up the resulting product.

Although the memoirs, letters, and biographies suggest that mirroring,

idealization, and instrumental intimacy were intricate parts of the collaboration between Conrad and Ford, because of the nature of the data, the dynamics of the process are still sketchy. Rather than seeing and hearing the interaction as it unfolded, we have been forced to rely on retrospective reports of the properties of the relationship. In the next chapter, drawing on the more detailed letters of Sigmund Freud to Wilhelm Fleiss, I will tune the microscope down closer and examine the interaction in pairs as the members approach the most creative periods of their careers.

Chapter 5

Instrumental Intimacy in a Collaborative Pair: Sigmund Freud, Wilhelm Fleiss, and the Early Psychoanalytic Circle

Your kind should not die out, my dear friend, the rest of us need people like you too much. How much I owe you: solace, understanding, stimulation in my loneliness, meaning to my life that I gained through you, and finally even health that no one else could have given back to me. It is primarily through your example that intellectually I gained the strength to trust my judgment, even when I am left alone—though not by you. . . . I know that you do not need me as much as I need you, but I also know that I have a secure place in your affection.

—Sigmund Freud to Wilhelm Fleiss, 1 January 1896, in
The Complete Letters of Sigmund Freud to Wilhelm Fleiss

As we have seen with the Impressionists and other groups, members of collaborative circles often do their most creative work while working in pairs. Discussions in the larger circle may encourage the members to rebel against the dominant vision in their field. These discussions also may shape the agenda or the quest of the circle. But it is after the members pair off that they begin to experiment, combine ideas in new ways, and create the elements of a new vision. Pairs develop through a process resembling courtship, and when they are successful, at the culmination of this process they achieve a state I have called instrumental intimacy. In this state they openly borrow one another's ideas, sympathetically criticize one another's work in progress, and in other ways establish interdependence in their cognitive processes. As they work together, each serves as an appreciative audience as the other experiments with solutions to the quest.

In this chapter, I examine more closely the dynamics of the formation, development, and disintegration of collaborative pairs. I take Sigmund Freud's

friendship with Wilhelm Fleiss for my analysis. It was while he was embedded in this friendship that Freud made the creative advances that led him to psychoanalytic theory. Freud's relationship with Fleiss encouraged his rebellion against traditional ways of thinking, gave him confidence in his own imaginative thinking, stimulated his originality, and helped him to shape his hunches and speculations into a coherent theory (Bonaparte, Freud, and Kris 1954; Gay 1988; Jones 1961; Kohut 1985 Masson 1985; Sulloway 1979). In his self-analysis, Freud (1900) reported, "An intimate friend and a hated enemy have always been necessary requirements of my emotional life. I always knew how to provide myself with both over and over." As Peter Gay has noted, "during the decade of discoveries, Freud made Wilhelm Fleiss into that necessary friend, and, later, enemy" (1988, 55).

Collaborative circles take time to form, and once formed, they usually last anywhere from ten to fifteen years. It would be difficult if not impossible to study the flow of interaction in a circle across its whole life course. However, in the Freud-Fleiss collaboration, a great deal of the interaction took place through letters. Freud lived in Vienna, Fleiss in Berlin; and between 1887 and 1904 they corresponded frequently. To Freud, who was marginalized by his colleagues in Vienna, the friendship provided an anchor in his emotional and intellectual life for more than a decade. For example, when he was in the middle of working on his masterpiece, *Interpretation of Dreams,* he wrote to Fleiss:

> You probably do not know how much your last visit raised my spirits. I am still living on it. The light has not gone out since then; bits of insight are dawning now here, now there—a genuine reinvigoration by comparison with the desolation of last year. . . . [F]antasy as the key holds fast. Yet there is still nothing big or complete. I diligently make notes of all that is worthwhile so as to present it to you at our congress. I need you as my audience.
>
> (30 January 1899, in Masson 1985, 342)

Fleiss preserved almost three hundred of the letters he received from Freud, but Freud apparently destroyed all but three of those he received from Fleiss. As Kris noted in his introduction to the first publication of the edited letters (Bonaparte, Freud, and Kris 1954), to read Freud's letters to Fleiss is like listening to one end of a phone conversation; the reader knows what Freud is saying but must guess Fleiss's reply. Yet with a careful reading, it is possible to unravel the gist of Fleiss's letters, and much can be learned about the evolving relationship through close examination of Freud's side of the conversation. The letters are a rich record of the interaction within a collab-

orative pair as one of the participants approaches and reaches the peak of his creative work. Not only do the letters document the evolution of a collaborative pair, they also preserve a record of its decline.

Until recently, the only letters that were published were those in the heavily edited volume by Bonaparte, Freud, and Kris (1954). However, the editors of that volume withheld information important for this analysis. Most notably, they edited out instances of "gossip" about Freud and Fleiss's circle of friends (plates 27–29), especially negative comments about Josef Breuer. As illustrated in previous chapters, during the rebellion and quest stages of circle development, the members often define the boundaries of their culture through discussions of the behavior of scapegoats and boundary-marking deviants. They tell stories about members of their network who are "sellouts" to the orthodox culture, or who "go too far" in rebelling against it. Bonaparte and her colleagues viewed such stories as indiscretions, so they did not publish them. In addition to eliminating the "gossip," the editors also left out references to the ritualized meetings that Freud and Fleiss established—their "congresses." As we have seen, the ritualization of a time and place to meet is a critical step in collaboration, and it is important to trace the rise and fall of this ritual. In a more recent volume of letters, Masson (1985) includes the missing portions of the correspondence. Although Masson's interpretation of the development of Freud's theory is controversial (e.g., see Gay 1988), his inclusion of the missing letters and the edited passages of previously published letters makes his volume a valuable resource. In this analysis I rely on both sets of letters, referring to Masson's when those of Bonaparte, Freud, and Kris are incomplete.

A number of writers have examined the letters with a focus on the development of psychoanalytic theory (e.g., in addition to the scholars cited above, see Clark 1980; McGrath 1986; and Schur 1972). Freud's theory is usually in the foreground of their analyses, and his relationship to Fleiss is in the background. If the friendship is discussed at all, it is treated as all of a piece, with little examination of how it evolved over time (e.g., Erikson 1989; Mahoney 1979; Kohut 1985). The work of these biographers will be used to locate the points of creative innovation in Freud's thinking, but in this study the friendship will be in the foreground and the theory will be in the background.

Compared to other groups we have examined, the evolution of Freud's larger circle had some unusual features. When he was developing the foundations of the psychoanalytic vision, the core members of the circle were Freud himself (plate 27), Fleiss, and Josef Breuer. Roughly between 1882 and 1896, Freud and Breuer worked as a dyad through the formation, rebel-

lion, and quest stages of the circle's development. In his accounts of the development of his theory, Freud was always careful to acknowledge this collaboration. For example, in his lecture at Clark University in 1910, he stated: "Granted it is a merit to have created psychoanalysis, but it is not my merit. I was a student, busy with the passing of my examinations, when another physician of Vienna, Dr. Josef Breuer, made the first application of this method to the case of an hysterical girl." (Freud 1910, 118). Their collaboration culminated with the publication of their book *Studies on Hysteria* in 1895.

Freud met Wilhelm Fleiss (plate 28) through Breuer in the fall of 1887. In arranging the meeting, Breuer played the gatekeeper role, similar to that played by Donald Davidson in the Fugitive circle, or Edward Garnett in the Conrad-Ford collaboration. Perhaps Breuer recognized the similarities in the two men and sensed they would be able to give something to one another. After Fleiss joined the circle, it became a radial network with Freud as the central node, but not the dominant member. While Freud was building a collaborative friendship with Fleiss, he also continued to collaborate with Breuer, and in their letters Freud and Fleiss frequently discussed their encounters with him. As Freud and Fleiss became closer friends, and as their intellectual explorations became more and more deviant in relation to the scientific thinking of their extended network, they cast Breuer in the role of the conservative boundary marker of their circle. For them, Breuer became the backslider who betrayed the circle's vision. One of the ritualistic activities of their correspondence was sharing stories of Breuer's unacceptable comments and behavior. In many ways, when Freud paired with Fleiss during the creative work stage, Breuer was their scapegoat.

In the early 1900s, Freud's relationship with Fleiss disintegrated, and he formed a larger circle of disciples and collaborators. This second circle established a ritual of meeting and discussing their works in progress on Wednesday evenings in Freud's consultation room. They carried the vision into the collective action stage, during which the circle evolved into the core of the international psychoanalytic movement.

In focusing on the collaboration between Freud and Fleiss, I first examine the structural and cultural environment in which the Breuer-Freud-Fleiss circle formed. Next I briefly examine the relationship between Breuer and Freud. Then, by following the evolution of Freud's relationship to Fleiss as portrayed in the letters, I discuss the processes leading to instrumental intimacy in their relationship. Finally, I discuss the dynamics of disintegration and individuation that occurred as the relationship broke down.

The Cultural and Structural Conditions of the Circle's Formation

The University of Vienna was the magnet place that drew Freud, Breuer, and Fleiss to the same location. In 1876, just twenty and still an undergraduate, Freud worked at the Physiological Institute directed by Ernst Brucke. There he met Josef Breuer (plate 29), then age thirty-four, one of Brucke's former students who was doing research at the institute.

Theoretical schools are the subcultures of science, and at the time that Freud began working in Brucke's laboratory there were several subcultures in the network of Viennese biologists. First, there were the reductionists, the hard scientists such as Brucke, who, along with Helmholtz, believed that biological processes could be accounted for by the principles of biochemistry and physics. Although Freud studied with other biologists, Brucke provided his basic socialization into the discipline—teaching him to work in a laboratory and to use quantitative methods to test hypotheses derived from theory. The second major subculture was that of the evolutionists, who emphasized gradual change in species through natural selection in environmental niches. Introduced by Darwin about fifteen years before Freud started his training, evolutionary theory relied on the integration of field observation and laboratory research. Finally, there were the less respectable psychological theorists who argued that mental processes could cause physical symptoms. The most notorious of these theorists were those who advocated the use of hypnotism and suggestion to "cure" physiological symptoms. Many of Freud's teachers, such as Theodor Meynart, saw the physicians who used these psychological treatments as quacks. Between 1876 and 1882, the period when he worked in Brucke's lab, Freud's thinking was firmly grounded in Brucke's reductionism. During that time he published five papers, three on neuroanatomy, one on the gonadal structure of eels, and one on a new method for preparing nerve cells for microscopic examination.

Working in the laboratory, Freud was on the low rung of a stratified professional system. The system included the Vienna hospital, the medical school, the research institutes, and numerous private practices scattered throughout the city (Gay 1988; Sulloway 1979). The private practices were divided into general practitioners and specialists. In some ways, the system resembled the art world in Paris, where the Académie des Beaux-Arts dominated the private studios and schools. Just as success in selling paintings to the middle class depended upon being recognized by the academy at the annual Salon exhibitions, success in attracting middle-class patients depended

upon acceptance and recognition by the medical school faculty. The faculty granted legitimacy by awarding appointments and promotions.

In the spring of 1882, Freud fell in love with Martha Bernays and began to think about getting married and starting a family. When he asked Brucke about a career in research, Brucke warned him that promotions would be slow, and that it would be a long time before he earned enough to support a family. Brucke advised him to complete his education in medicine and open a private practice. Freud decided to follow the advice and to specialize in neurology.

To establish himself as a physician, he had to acquire the credentials to open a private practice, which he did through three years of residency at the Vienna General Hospital. The next step was to acquire a distinguished reputation through publishing, teaching, and winning promotions at the university. If he became known as an expert in his area, he could obtain patients through referrals from an informal network of colleagues. First Breuer, then Fleiss were part of Freud's informal referral network. For example, Breuer referred to Freud the patients he described in *Studies on Hysteria*. Likewise, Freud's initial reason for corresponding with Fleiss was to discuss a patient whom Fleiss had referred to him.

Like a Hen behind a Hawk: The Breuer-Freud Friendship

Like many collaborative friendships, the relationship between Freud and Breuer evolved out of common interests they discovered while working in parallel professional roles in Brucke's laboratory in the late 1870s. Both men came from Jewish backgrounds, but Breuer was fourteen years older than Freud. He had an established medical practice and already had made major contributions to physiological research. Freud was an impoverished student. As the friendship developed, on several occasions Breuer lent Freud money and often invited him for dinner. As the breadth of their exchanges grew, they shared their most confidential thoughts about their work. In the dyad, Breuer played the more supportive role. He was widely known as a selfless, warm-hearted person (Ellenberger 1970, 432), and like Pissarro in the Impressionist group, he was described as "cautious and peace-loving" (Sulloway 1979, 83 n). Breuer shared his wildest hunches with Freud, and Freud encouraged Breuer to take his ideas seriously. As Freud later wrote in his autobiography: "[H]e became my friend and helper in my difficult circumstances. We grew accustomed to sharing all our scientific interests with each other. In this relationship the gain was naturally mine" (Freud 1935, 19).

Rebellion, Quest, and Creative Work Stages of the Collaboration

In November of 1882, Breuer and Freud began discussing the case of "Anna O," a young patient of Breuer's who developed a range of hysterical symptoms, including paralysis and inhibitions, after nursing her dying father. Breuer told Freud that, because of her impatience with hypnotism, he had modified this method when treating her, and over the previous year he and Anna O had discovered a new treatment. He found that, after having her recall one of her symptoms—for example, the paralysis of an arm or a problem in hearing—to the point where she reexperienced the rush of feelings that had attended its onset, the symptom would disappear. He called the new technique "catharsis."

Freud was intrigued by the treatment. One night, as they walked together, they discussed Breuer's findings. Breuer told Freud that when he used the cathartic method, it often led him to discover a traumatic sexual experience in the patient's past. In the midst of their discussion, Breuer turned to Freud and said that hysterical symptoms, like Anna O's, always led to "secrets of the bedroom." Freud never forgot the comment.

Surrounded by mentors who thought mental "cures" for physical symptoms were the work of charlatans, the two quantitative researchers knew they were approaching the edge of respectable science. To pursue this cathartic method of treatment was "delinquent" enough, but to theorize that sexual impulses might play a part in symptom formation, and that the treatment of young women required discussion of their sexual experiences, was to risk being totally ostracized. Like other collaborators in the rebellion and quest stages, the dynamics of the circle sustained them as they explored this forbidden territory.

In the winter of 1885–86, Freud won a travel scholarship and went to Paris for four months to study hysteria with Jean-Martin Charcot. Charcot, the most famous neuropathologist of his day and a charismatic teacher, was intrigued by the symptoms of hysterical paralysis. At that time, hysterics were viewed as malingerers. Charcot demonstrated to Freud's satisfaction that physical symptoms could be caused by a mental trauma, and that these symptoms could be both induced and relieved through hypnosis and suggestion. On 24 November 1885, Freud wrote to Martha Bernays: "Charcot, who is one of the greatest of physicians and a man whose common sense borders on genius, is simply wrecking all my aims and opinions. . . . [W]hen I come away from him I no longer have any desire to work at my own silly things. . . . [N]o other human being has ever affected me in the same way." Charcot had the ability to empower his students. He invited them into his own efforts to understand the causes of hysterical symptoms. Freud wrote:

"He seemed, as it were, to be working with us, to be thinking aloud and to be expecting to have objections raised by his pupils. Anyone who ventured might put in a word in the discussion and no comment was left unnoticed by the great man" (Freud, Freud, and Grubrich-Simitis 1985, 114). Indeed, as a tribute to Charcot's impact, Freud later hung in his consulting room in Vienna a portrait of Charcot engaged in a dialogue with a class, demonstrating the effects of hypnosis on a female patient.

After he returned from his studies with Charcot, Freud was even more convinced that Breuer's cathartic method was an important discovery, and he urged Breuer to publish his findings. But Breuer, the cautious scientist, would not publish on the basis of one case. In their frequent discussions, Freud continued to encourage him. In 1889, Breuer referred a hysteric patient to Freud, and he began treating her by using a combination of hypnosis and catharsis. When he led the patient back through recollections until she came to a traumatic event, the symptoms disappeared. He discussed the case with Breuer, and Breuer referred another case to him.

Freud was intrigued by his findings, confirming those of Breuer, that the cathartic method often uncovered childhood sexual trauma in the lives of his female patients. He also learned that structured interviews distracted his patients. They wanted to follow through on their own thoughts. He gradually discovered the value of allowing patients to recall the trauma through free association. He told his patients, that, as you think about the symptom "you must proceed differently. . . . say whatever goes through your mind. Act as though . . . you were a traveler sitting next to the window in a railway carriage and describing to someone inside the carriage the changing views which you see outside" ("On Beginning the Treatment," cited in Freud, Freud, and Grubrich-Simitis 1985, 145).

Freud felt that he and Breuer had made important new discoveries about the cause of hysterical symptoms and how to treat them, and he wanted to publish their findings and their emerging theory. Breuer was still reluctant. Freud treated two more cases and again experienced some success. Finally, Breuer agreed to collaborate on a publication. As they worked on their theory during the quest and creative work stages, Breuer and Freud formed the kind of interdependence observed in other circles. It was unclear and unimportant to them who originated which idea. As Breuer put it:

It was impossible for a general practitioner to treat a case of that kind without bringing his activities and mode of life completely to an end. When cases came to me . . . I referred them to Dr. Freud. . . . These cases, their course, their treatment, and whatever contributions to

theory arose from them, were naturally constantly discussed between us. In this way our theoretical views grew up—not, of course, without divergencies, but also nevertheless in work that was so much carried out in common that it is really hard to say what came from the one and what from the other.

<div style="text-align: right;">(Clark 1980, 106)</div>

Like Monet and Renoir working alongside one another at the riverside resort, and like Conrad and Ford at Pent Farm, Freud and Breuer discovered the germinal ideas of the theory, with some "divergencies," while in a state of instrumental intimacy. Tentative hunches that might have been dropped were tried out on one another and thought through together. The mutual support enabled them to entertain hypotheses and therapeutic techniques considered deviant by the dominant group in their network, especially by their mentors, Brucke and Meynart. Their theory drew partially on the reductionistic paradigm they had learned from Brucke, partially on Charcot's psychological theory, and partially on their own observations. They saw the hysterical symptoms, such as paralysis of an arm, as the consequence of blocked nerve impulses that had been rerouted into an alternative path. The symptoms could be cured by having the patient relive the experience that had led to the blocked impulses. By reliving the events, the blocked impulses could be redirected and discharged.

Freud thought that the blocked energy was always sexual, and he became increasingly convinced that sexual blocks were the sole source of hysterical symptoms. Breuer thought other blocked impulses were just as important. In 1893, they published their first collaborative work, *Preliminary Communication*. In 1895, they published *Studies on Hysteria*. By then their disagreements were apparent and were openly discussed in the book. Although Breuer saw the disagreements between them growing, he was not alarmed. In the summer of 1895, after his differences with Freud had crystallized, Breuer wrote to Fleiss: "Freud's intellect is soaring; I struggle along behind him like a hen behind a hawk" (Bonaparte, Freud, and Kris 1954, 13).

Freud and Fleiss: The Pessimist and the Optimist

While Freud and Breuer were collaborating, Freud began corresponding with Fleiss. He wrote 286 letters to Fleiss between November 1887 and July 1904. Masson's (1985) data indicate that the rate of exchange was slow at first. He wrote twice in 1887 and three times each year in 1888, 1890, and 1891. Then the rate accelerated: nine in 1892; fourteen in 1893; nineteen in

1894; then between thirty and forty-four a year for five years including 1899. In 1900 the rate tapered to twenty-seven, then dropped to seventeen in 1901, five in 1902, none in 1903, and four in 1904. Only three letters from Fleiss to Freud have been preserved, and all three were written in 1904 when the relationship was disintegrating. In discussing the formation stage of the relationship, I will focus on the early letters in detail. It was in these early exchanges that the pair negotiated the norms of exchange that became the foundation of their relationship.

Formation of the Friendship

During this stage of his life, Freud did not think he came across well to strangers and was anxious about meeting new people. In January 1886, the year before he met Fleiss, he wrote to his fiancée, Martha Bernays: "I consider it a great misfortune that Nature has not granted me that indefinite something that attracts people. I believe it is this lack more than any other which has deprived me of a rosy existence. It has taken me so long to win my friends . . . and each time I meet someone I realize that an impulse, which defies analysis, leads that person to underestimate me" (Freud, Freud, and Grubrich-Simitis 1985, 108).

But his fortunes were soon to change. In the fall of 1887, when Wilhelm Fleiss was at the University of Vienna taking advanced courses in his specialty, he met Josef Breuer. Perhaps because Breuer and Fleiss discussed hysterical symptoms in patients, Breuer suggested that Fleiss go to hear his friend Freud's lectures on brain anatomy. After each lecture, Fleiss stayed to talk with Freud. They most likely discussed neurological theory and discovered many common interests. Fleiss had studied with Helmholtz in Berlin, and just before coming to Vienna he, like Freud, had studied briefly with Charcot (Swales 1989, 305). While he was a student, Fleiss supported himself as a medical journalist, and in this role he traveled around Europe and met many well-known figures in art and literature. One of Freud's early ambitions was to become a philosopher, and he was well versed in European literature. The two men must have found much to talk about. At some point they discussed a female patient of Fleiss's whom he suspected had a physical symptom due to hysteria. Fleiss arranged for this patient to consult with Freud in Vienna.

Contemporaries described Fleiss as a magnetic, forceful, and intelligent conversationalist who struck some people as being a genius. Others saw him as arrogant and dogmatic: "Of those who knew him, . . . everyone spoke of his 'fascinating' personality. He was a brilliant and interesting talker on a variety of subjects. Perhaps his outstanding characteristics were

an unrestrained fondness for speculation and correspondingly self-confident belief in his imaginative ideas with a dogmatic refusal to consider any criticism of them" (Jones 1961, 184). He seems to have appealed to Freud the way Monet appealed to the young Impressionists, and the way Hirsch appealed to the young Fugitive poets. His narcissistic, self-assured manner and his wide knowledge suggested that for him no goal was unachievable, no theory unassailable.

Until they met, Fleiss's publications were limited to journalistic articles for newspapers. His own original theories would evolve, like Freud's, during the years of their correspondence. Though these theories are now considered bizarre, their boldness suggests he had the courage to go far beyond the limits of orthodox science. Fleiss argued that the energy levels of males vary over twenty-three-day cycles and those of females vary over twenty-eight-day cycles and that sexual desire, creative work, vulnerability to illness, and even likelihood of death fluctuated with these cycles. Perhaps because of his training as an ear, nose, and throat specialist, he was particularly interested in the part the nose might play in these fluctuations. He argued that problems in the cycles of energy flow could be diagnosed through nasal symptoms, such as colds, sinus congestion, or nosebleeds; and healthy biorhythms could be restored through surgery on the nasal passages. To treat one woman, a patient of Freud's discussed in their letters of spring 1895, Fleiss came to Vienna and performed nose surgery with disastrous results (see Masson 1985, 116). After he returned to Berlin and the patient's condition worsened, another surgeon discovered that Fleiss had forgotten to remove a pad of gauze, a mistake that led to a life-threatening infection. Despite this evidence of Fleiss's fallibility, Freud continued to idealize him.

In contrast to Breuer, who was somewhat of an older brother to Freud, Fleiss was clearly his peer. Both Freud and Fleiss were young, ambitious researchers in a state of transition from single to married life and from research to clinical practice. Recently married, Freud was a thirty-one-year-old lecturer in neuropathology at the University of Vienna. Fleiss was a twenty-nine-year-old ear, nose, and throat specialist practicing in Berlin. Both were Jewish, outsiders in their communities, and both shared an enthusiasm for the work of Charcot. Both were well grounded in the humanities and shared a passion for Goethe, Shakespeare, and the classics of Greece and Rome. Although they were beginning their private practices, both were determined to continue doing research with hopes of making original contributions to their fields. In short, like members of other circles we have examined, they were ambitious but marginalized men in a state of

transition, and they had a common background and a common language that enabled them to converse and argue persuasively with one another.

The First Currency of Exchange: Patient Referrals and Consultations
On 24 November 1887, soon after Fleiss came to hear him lecture, Freud wrote his first letter to his "esteemed friend and colleague," giving his evaluation of the patient Fleiss had referred to him:

> My letter of today admittedly is occasioned by business; but I must introduce it by confessing that I entertain hopes of continuing the relationship with you and that you have left a deep impression on me which could easily lead me to tell you outright in what category of men I place you.

> (Masson 1985, 16)

Freud went on to discuss the patient. He wrote that he did not think her complaints were indicative of hysterical problems; rather, he thought she had physiological problems and that Fleiss's dietary intervention would be the most effective treatment. He finished with a brief note about his newborn daughter, Mathilde, and then reported he was working on three papers, including one on brain anatomy—which probably was the basis of the lectures he had given when he met Fleiss. The largest part of the letter is constrained by the norms of physicians communicating about referrals. However, while focused on a professional task, Freud hinted that he would like to see more come of the relationship. He finished the letter with a very brief statement about his scientific writing—a glimpse at what eventually would become the central focus of the correspondence.

The tentative overture brought a reciprocating response from Fleiss, along with an escalation of the exchange. Without Fleiss's letter we do not know what he said, but we do know from Freud's subsequent response that Fleiss sent a gift that had special meaning to Freud and brought back "pleasant memories." Freud described the gift as "magnificent." Fleiss also sent two other gifts for Christmas, possibly related to the birth of Freud's daughter. In other words, in his response to Freud, Fleiss matched Freud's opening compliments and raised the ante of exchange. In his reply, Freud wrote: "I still do not know how I won you; the bit of speculative anatomy of the brain cannot have impressed your rigorous judgement for long. But I am very happy about it." He seemed delighted to discover that his admiration for Fleiss was returned and, acknowledging that he now felt indebted, he wrote: "I thank you, and ask you not to be surprised if at the moment I have

nothing to offer in return for your charming present." He then went on to reiterate his declaration of esteem for Fleiss, clarifying the vague statement in the first letter about the "category of men" among whom he placed him: "I have always had the good fortune of finding my friends among the best of men, and I have always been particularly proud of this good fortune. . . . I occasionally hear about you—mostly wonderful things, of course" (Masson 1985, 16, 17).

The relationship thus began to unfold in a series of escalating exchanges. By the end of Freud's second letter, they had gone through one complete cycle of reciprocity. In the first letter Freud sent a vaguely flattering message to Fleiss and suggested he would like to form a friendship. Fleiss responded by accepting the friendship proposal, and he raised the ante by sending gifts. Freud acknowledged the gifts and sent a more explicitly flattering compliment. Freud came out of the cycle feeling he was the net benefactor and in debt to Fleiss. Perhaps Fleiss expressed similar feelings of indebtedness, but without his letters we cannot know for certain. Given how contemporaries described him, it is more likely that he simply accepted Freud's characterization of the exchange. What is important is that Freud continued to see himself as indebted to Fleiss throughout the decade. Until the later half of the 1890s, when he began his self-analysis, he seemed to struggle to reciprocate the value of Fleiss's exchanges.

Expanding the Scope of Exchange: Emotional Support and Intellectual Gifts
Although the patient referral theme continued in the second letter, Freud expanded the scope of exchange by expressing concern about Fleiss being overworked. By this comment he implicitly suggested that a norm of emotional support be added to the relationship. Particularly for nineteenth-century European males, such a suggestion raised the ante once again. Perhaps Fleiss responded in the same tone, for, in Freud's third letter, a new theme appeared that became more frequent as the correspondence continued: Freud conveyed a sense of being overwhelmed and distracted by his work. He complained about fatigue, expenses, a scarcity of patients, his alienation from the medical society, and unnecessary consultations. The theme continued in his fourth letter, dated 28 May 1888, which ended: "In short, one manages; and life is generally known to be very difficult and very complicated and, as we say in Vienna, there are many roads to the Central Cemetery" (Masson 1985, 22). By exposing his vulnerability, Freud opened another door into his subjective world and raised the level of trust and intimacy. As he did so, he conveyed an even greater sense of being "one down" in the exchanges.

Fleiss must have written back advising him to solve his economic problems by becoming a general practitioner. Freud delayed responding. Finally he replied:

> I have been silent for a long time. . . . Your own letter contained much that stimulated my thoughts for a long time and that I would have liked to discuss with you. Without reservation I say that you are right, yet I cannot do what you request. To go into general practice instead of specializing . . . that is certainly the only method that promises personal satisfaction and material success; but for me it is too late for that. I have not learned enough to be a medical practitioner, and in my medical development there is a flaw. . . . I was able to learn just enough to become a neuropathologist. And now I lack, not youth, it is true, but time and independence to make up for it.

He wrote that, in the winter when he was busy, he had no time to study. And even in the best of times he earned just enough to live on. In the summer when business was bad, he was left with "worries that sapped the inclination." Besides, he did not think he could read textbooks again. Finally, he once again expressed a sense of being one down in relation to Fleiss: "The whole atmosphere of Vienna is little adapted to steeling one's will or to fostering that confidence in success which is the prerogative of you Berliners and without which a grown man cannot think of changing the whole basis of his livelihood. So I must stay as I am; but I have no illusions about how unsatisfactory a state of affairs it is" (Masson 1985, 24).

Beginning with Fleiss's advice that Freud return to school and become a general practitioner, the exchange went through another cycle of escalation, ending once again with Freud feeling at a disadvantage. He portrayed himself as ill-equipped to meet the demands placed upon him, and unable to do anything about it—in short, trapped. The deflation of himself now extended to all of Vienna; the inflation of Fleiss to all of Berlin. In this letter, there are several signs that Freud had deepened his commitment to the friendship. First, in his greeting, he dropped the title "Dr." and wrote simply, "My dear Fleiss." He also sent a photograph of himself, because, "I remember your saying you would like to have one when you were in Vienna." Finally, and most important, he expanded the currency of exchange once again by sending a copy of a paper and a book he had recently translated. He presented them with pride: "Now that I am answering I really have something to show for it . . . you cannot expect more in one letter."

Freud's "gifts" represent a further transformation of the norms of exchange in the friendship. Going beyond discussing patients and exchanging

personal gifts, compliments, and worries, he presented copies of his intellectual work. However, at this early point in the exchange, Freud did not present his unedited thoughts to Fleiss. He sent his translation of Bernheim's work on hypnosis and a copy of an already published paper. Nevertheless, he matched Fleiss's gifts, not with purchased objects, but with products of his work—"something to show for . . . having been silent."

At an even more basic level, beyond the exchange of gifts, emotional support, and papers, there were subtle messages conveyed about the distribution of resources between them. Freud initially seemed to gush over Fleiss. His apologetic attitude about himself suggested that he was inflating Fleiss's currency and deflating his own. He seemed to feel indebted to Fleiss, not only for the gifts, but because he felt Fleiss's currency was worth more, and he seemed determined to prove he deserved the friendship. On the first occasion that he sent copies of his published works as repayment for his "debts," Freud hedged his bets by adding some qualifications. He said he took on the project of translating Bernheim's book "reluctantly" because he did not share the author's views. He told Fleiss that, in his introduction he tried to stand up for Charcot, but he was sure he was unsuccessful. In other words, he presented his works as gifts, but he denied they represented his own views or his best work. There was still an element of guardedness in the exchange.

These first five letters thus illustrate some of the synergistic dynamics that motivate collaborators to stay abreast of one another in the exchange process. First, the exchanges are multidimensional; that is, they include both personal and instrumental exchanges. Second, when one member receives something on either of these levels of exchange, he feels a sense of debt. Third, he repays the debt, perhaps with another form of currency, then raises the ante by adding something more. On the personal level the "something more" may be in the form of revelations of more private information. On the intellectual level, the "something more" eventually includes more "intimate" exchanges of work in progress. By exchanging unfinished work and inviting criticism, the collaborators risk rejection and make themselves vulnerable to one another. Yet, by opening themselves up, they also have much to gain.

Mirroring, Merging, and the Restoration of a Cohesive Self

In the formation stage of their collaborative pairing, Freud and Fleiss were still two separate personalities exchanging resources. They had not yet established the kind of interdependence characteristic of the creative work

stage. However, in his seventh letter, sent 1 August 1890, Freud indicated that for him the dynamics of interdependence had begun: "I feel very isolated, scientifically blunted, stagnant and resigned. When I talked to you, and saw that you thought something of me, I actually started thinking something of myself, and the picture of confident energy which you offered was not without its effect" (Bonaparte, Freud, and Kris 1954, 60).

Freud's statement suggests that for him two elements of collaborative pairing were now in place. First, Fleiss was now serving as a "mirror" for him (Kohut 1985; Smith 1992). Like Joseph Conrad, at this point in his life Freud tended to stagnate and disintegrate when left alone. He was prone to episodes of depression, anxiety, hypochondria, and doubts about the value of his work (Gay 1988; Jones 1961). Just as Ford Madox Ford did for Joseph Conrad, Fleiss served as an attentive audience to Freud's thoughts. He played the part of the mirroring audience or the empathic therapist who listens carefully, witnesses, and applauds as another attempts creative work. His attentiveness to Freud's thoughts led Freud to take his own thoughts more seriously and invest in his own inner world. Second, as we have seen, Freud held an idealized view of Fleiss. He seemed to see in Fleiss the energy, self-confidence, and brilliance he wished he had himself. By identifying with Fleiss, seeing himself and Fleiss as two explorers on a mission together, Freud felt stronger. Under the spell of their exchanges, he was more internally cohesive and better able to do creative work. The relationship enhanced his self-esteem, quieted his self-doubts, and freed him to invest in his own imaginative thinking. Even late in the relationship, in a letter dated 3 January 1899, Freud indicated that these dynamics were operating: "So you see what happens. I live gloomily and in darkness until you come, and then I pour out all my grumbles to you, kindle my flickering light at your steady flame and feel well again; and after your departure I have eyes to see again, and what I look at is good" (Bonaparte, Freud, and Kris 1954, 272).

With the synergistic norms of escalating exchange established, with the currency of exchange having shifted toward intellectual work, and with the dynamics of mirroring and merger in place, Freud and Fleiss were ready to move on to the next stage in the development of their relationship.

The Ritualization of Private "Congresses"

After Freud's fifth letter, which was sent in late summer of 1888, there is no record of other letters being exchanged until the summer of 1890. As we have seen, it was then that Freud suggested something of the dynamics at work in their relationship. Most likely the two men visited occasionally when Fleiss came with his wife to see his in-laws, who lived in Vienna. But

when Fleiss visited Vienna, he was constrained by family commitments, and Freud was constrained by both his work and family roles.

In July 1890, Fleiss escalated the exchange once again. He invited Freud to come to Berlin to attend a professional meeting—a "congress"—and to stay with him while he was there. Freud was not interested in the congress, but he was enthusiastic about the prospect of visiting with Fleiss. He wrote back that the invitation was the best thing that had happened to him in a long time, that he was honored, and that he very much looked forward to "rekindling my almost extinguished energy and scientific interests on yours" (Masson 1985, 26).

However, in August he wrote to Fleiss expressing regrets about not being able to come. He opened by saying that he was writing to Fleiss "very much against the grain," not because he cared about going to Berlin or to the congress, but because he was so disappointed that he would not see Fleiss. In this letter, he repeated the familiar refrain of being trapped by his patients' demands, his sick children, as well as demands from his wife in a city where he was "without anyone who can teach me anything." He closed by asking if there were another time they could meet. Was there some professional or family business that might bring Fleiss to Vienna? Fleiss must have responded by suggesting that they meet for a "congress" of their own in Salzburg, where they could hike in the woods for three or four days and continue their conversations. Freud wrote back immediately: "Magnificent! . . . Let us meet there, and walk for a few days wherever you will."

This meeting began a new stage of the friendship. By setting aside a time and place for their exchanges, they eliminated competing demands. To guard against conflicting demands, they protected their ritualized congresses with a norm that the meetings must take place offstage, that is, at a neutral place where neither had any obligations outside of the relationship. Much later, in June 1896, Freud invoked this norm when they were planning a meeting: "Further, against Berlin: did you forget that our congresses should take place neither in Vienna nor in Berlin, because in those two places we are workers who cannot take time off?" (Masson 1985, 191). From the summer of 1890 until the end of the decade, they scheduled yearly "congresses" away from home in a setting where they could hike together for several days and discuss their works in progress. Once this ritual was established, they raised the level of exchange once again. Less than a year after the first congress, in the next existing letter, dated 2 May 1891, Freud indicated that Fleiss was reviewing and criticizing his unfinished manuscripts.

That the relationship had reached a new plateau of commitment was

symbolized by the change in the closings to Freud's letters. Never again did Freud write the formal pledge of friendship—"Your devoted." Perhaps the degree of commitment was now taken for granted. The letter in which Freud agreed to the first meeting was signed, "Yours in pleasurable anticipation." From this point on most letters closed, "With cordial greetings." After 31 October 1892, signifying that formal closings were no longer necessary, Freud dropped the title "Dr." for himself and signed with the more informal, "Dein, S.F." By May 1892, Freud had dropped the more formal salutation "Sie" in favor of "Du." Most likely, Fleiss reciprocated.

Once the meeting ritual was in place, their intimacy and trust deepened to the point where they were exchanging confidential opinions about the works of others as well as hunches and half thought out ideas about their own work. In other words, they had established a relationship characterized by instrumental intimacy. It is at this point in the communication, when disclosure of feelings about others in their network began, that Bonaparte, Freud, and Kris (1954) began withholding letters they thought were indiscreet. Freud first started to write about strains in his relationship with Breuer in the summer and fall of 1892; and as these strains intensified, the bond with Fleiss became stronger.

Throughout the rest of the decade, the ritual of the congresses had an energizing effect on Freud. He repeatedly reported that his ability to write was restored after a meeting with Fleiss. On numerous occasions, Freud returned from their meetings in an almost manic state and poured out his thoughts in writing. He was well aware of this effect. For example, while he was working on *Interpretation of Dreams,* he wrote to Fleiss: "My freshness for work seems to be a function of the distance of our congresses" (15 March 1898, in Bonaparte, Freud, and Kris 1954, 247). It is likely that the exchanges and the congresses had the same impact on Fleiss. Freud's letter of 16 June 1897 after one of their congresses suggests this reciprocal impact: "I could tell from your letter how refreshed you are. I hope you will now remain your old self for a good long time and allow me to go on taking advantage of your good nature as an indulgent audience, because without such a thing I cannot work" (Bonaparte, Freud, and Kris 1954, 200).

The Quest: Negotiation of a Shared Vision

It is during the stage of paired collaboration and ritualized meetings that most circles negotiate their shared vision. In most circles in this phase, there are meetings that include the whole group, but for Freud and Fleiss, it was just the two of them. As far as we know, Breuer never met with them, though he was often the subject of discussion.

A vision is a shared theory, model, or paradigm that guides the work of the members of a circle. According to Thomas Kuhn (1962), for scientists a vision or paradigm consists of a set of assumptions about the basic "things" or structures that must be included in a theory; what properties of those structures are important to take into account; and a set of statements about how these properties are related to one another. When Kuhn first introduced his concept of paradigms, he illustrated it with models of the solar system. Copernicus's paradigm, he noted, included the sun and the planets as the basic structures in the theory. Copernicus isolated some properties of these structures as important, and he ignored others. For example, the properties included in his theory were not the colors or the degrees of brightness of the planets, but their mass, distance from the sun, and force of gravity. Copernicus changed the relationships of the structures to one another. Unlike Ptolemy's preceding paradigm, which placed the earth at the center of the system, Copernicus's placed the sun at the center with the earth as one of several planets rotating around it. The structures were the same, but their relationships to one another had been transformed.

At this point in their quest, the shared elements of the paradigm for Freud, Breuer, and Fleiss included the assumption that physical symptoms could be explained by neurological impulses flowing through the nervous system. Especially for Freud, and to a lesser extent for Breuer, hysterical symptoms, such as temporary paralysis or chronic fatigue, could be explained as consequences of blocked or depleted sexual energy. Blocked sexual energy could be rerouted through the nervous system and could surface as a symptom. Depleted sexual energy led to chronic fatigue and neurasthenia. Sexual experiences, such as coitus interruptus, masturbation, or early sexual trauma were the important causal factors. Early in the discussions between Fleiss and Freud, Fleiss's theory seemed to mesh with these assumptions by adding the hypothesis that male and female energy rose and fell in different cycles. As we have seen, according to Fleiss, blocks in these cycles were manifested by problems in nasal functioning. Freud believed that his theory eventually could be linked to Fleiss's, and that the integration would proceed rapidly if they both could work on the same patients.

During the early 1890s, as the breadth and depth of his exchanges with Fleiss expanded, Freud was collaborating with Breuer on their studies of hysteria. As we have seen, during this time in the discussions between Freud and Breuer there were "divergencies." Freud tried to explain all hysteria symptoms as consequences of blocked sexual impulses. At times Breuer agreed with Freud, but at other times he argued that the sexual theory was

too narrow, and that other trauma could be involved. As Freud's friendship with Fleiss deepened, they often cast Breuer into the role of the conservative boundary marker who adhered too closely to conventional thinking.

Nevertheless, as late as May 1895, the core circle of three was still intact. At that point Freud thought that Breuer had finally come around to supporting both his and Fleiss's theories. He wrote to Fleiss: "Breuer, however, is a new man. One cannot help liking him again without any reservations. He has accepted the whole of your nose [theory]. Not only does he spread your reputation abroad in Vienna, but he has become fully converted to my theory of sexuality. He has become quite a different fellow from the one we have been used to" (Bonaparte, Freud, and Kris 1954, 121). The threesome constituted a circle that Freud, at least, saw as working within a shared vision. He saw them as being on a mission of discovery and conquest. He and Breuer had disagreements, but they were not divisive. He thought Fleiss was on a convergent path, as he conveyed in his letter of 4 December 1896, "I am working at full pressure, with every half-hour occupied. . . . I am busy thinking out something which would cement our work together and put my column on your base. . . . A fragment, naturally for your eyes only, will be ready in a few days. I am curious to hear what you will say about it." And on 1 January 1896, he wrote: "The thought that both of us are occupied with the same kind of work is by far the most enjoyable one I can conceive at present." Finally, on 17 December 1896, he wrote: "My inner joy in suddenly being struck by an idea obviously was related . . . to finding a common ground for the work we share. I hope it will go so far that we jointly build something definitive on it, and thereby blend our contributions to the point where our individual property is no longer recognizable" (Masson 1985, 215).

With more or less consensus, the circle of three had crystallized a vision. Freud felt that each of them was working with variations of the same theory, and that one day Fleiss's theory would link with his and Breuer's. The three had developed into a coalition exerting pressure on one another to stay in step, both in the content of their thinking and in their rate of productivity. At times Freud and Fleiss might see Breuer as the boundary marker or deviant member; at other times they would welcome him back into the fold. The tension about the degree to which members were expected to be committed to the circle resembles the tensions we found in the Impressionist group during the 1870s when they organized their exhibitions. Just as the Impressionists battled over how much to stay within the bounds of conventional styles of art and whether to seek approval from the

academy, Freud's circle battled over how much to stay within the conventional bounds of neurology and whether to seek the approval of the medical school faculty. They suspected Breuer of being ready to abandon them for the sake of conventionality. Like Renoir in the Impressionist group, he was seen as the ambivalent "cork," externalizing his conflicted thoughts, allowing Freud to follow through the implications, drifting in and out of the emerging group culture.

Breuer's Role as Boundary Marker and Scapegoat
As the relationship between Freud and Fleiss became closer, and as their exchange of manuscripts approached its height, the relationship with Breuer broke down. Freud's impatience with Breuer became clear in 1894, when he reported on their disagreements over the etiology of hysteria; but during 1895 his hostility expanded, and he began to raise questions about Breuer's character. Between 1895 and 1900, Freud repeatedly found fault with Breuer's behavior and attacked him as a disloyal friend and dishonest critic. It seemed Breuer could do nothing right. His efforts at reconciliation were seen as further evidence of two-facedness. His compliments were interpreted as weak or backhanded. His criticisms of manuscripts were seen as nit-picking. As the bonds between Freud and Fleiss tightened, their attacks on Breuer intensified. One of the rituals during their congresses became telling the latest stories about Breuer. In the correspondence, Freud averaged two or three attacks a year, with the peak year being 1896, when he made eight negative references to Breuer. It was also in 1896 that the friendship between Freud and Fleiss was at a peak of solidarity as measured by the frequency and warmth of Freud's letters.

It is likely that by scapegoating Breuer, Freud and Fleiss fortified their own bond and dispelled the tension that was building between them. To Freud and Fleiss, Breuer came to embody the traits and behaviors that a friend should not have: insincere flattery, violations of confidentiality, and covert disagreement. Encounters with Breuer were packaged into anecdotes and retold, as if to remind one another what was expected within the circle. Like morality tales, the anecdotes illustrated what a collaborative friend eschewed.

Freud was particularly exasperated with Breuer's wavering support for his hypothesis that sexual trauma was the source of hysterical symptoms. At times Breuer seemed to accept it, and at other times he seemed to reject it. In a speech to the Vienna College of Physicians on 4 November 1895, Breuer presented himself as a convert to the sexual theory. His speech was summarized in a report on the meeting:

Breuer declares right at the outset of his presentation, which was received with lively applause, that one is mistaken if one expected that he is speaking here as a coauthor, because the entire theory of repression is essentially Freud's property. He is intimately acquainted with a large portion of the cases that constitute the foundation of Freud's theories; he has witnessed the birth of the theory at first hand, though not without some opposition; but he now stands, as a result of Freud's illuminating explanations, as a convert before the assembly.

Four days later, Freud wrote to tell Fleiss of the incident. However, he reported an additional twist. After reiterating the "conversion" story, he wrote: "When I thanked him for this in private, he spoiled my pleasure by saying, 'But all the same, I don't believe it.' Do you understand this? I don't" (Masson 1985, 151).

Breuer was seen as the backslider who would not depart from conventional thinking, and as a "bad example" of a friend. In one of his accounts of an exchange with Breuer, Freud suggested that Breuer knew he was being used as a scapegoat: "Breuer is like King David; when someone is dead, he becomes cheerful. . . . Recently, after a polite note from me he indicated that he did not want me to treat him with such exquisite politeness, not him. In his reply he said that it was always easier for me to do so after you had been in Vienna. Because by then I had gotten enough off my chest and was back in form" (13 March 1895, in Masson 1985, 120).

A scapegoat marks the negative boundary of a group. He embodies the "sins" that the in-group wishes to suppress or deny in themselves. At several points Freud contrasted Breuer to Fleiss, painting Breuer as Fleiss's "evil twin": the bad friend whose behavior contrasted with all he valued in his good friend. To both Freud and Fleiss, Breuer became an emblem representing the traits and behaviors they wanted to exclude from their circle. For example, on 8 February 1897, Freud wrote:

Breuer, whom they call the good one, cannot let any opportunity go by when there is a chance of spoiling the most harmless state of contentment. He received my book and thereupon paid a visit to my wife to ask her how the publisher may have reacted to the unanticipated size of this work. The publisher, for whom he is so concerned . . . assured me that it did not matter. . . . Confronted with this contrast, I am, however, especially grateful to you for your friendly evaluation—you, the "blunt one"—and merely give expression to my astonishment that you were at all able to look through it in this short time.

(Masson 1985, 229)

Freud's reports about Breuer were often brief asides, as if he were responding to Fleiss's inquiries. That Fleiss was actively involved in the rejection of Breuer is illustrated by an exchange that took place in the spring of 1896. Breuer sent Fleiss a letter in which he criticized Freud's work, and Fleiss must have offered to relay the letter to Freud. Freud indicated he would like to see it. In March 1896, after receiving it, Freud wrote to Fleiss:

> I was less angry about Breuer's letter than I had expected to be. I could console myself with the thought that the colorblind turns so quickly into a judge of colors. . . . In any event, [he criticizes] an obscure point in the theory, and the opponent rightly makes it into a weak point. The mere fact of this opposition—in an area where no theory can be completely fashioned all at once—shows how superficial are Breuer's conversion and understanding in these matters. . . . I believe he will never forgive that in the *Studies* I dragged him along and involved him in something where he unfailingly knows three candidates for the position of one truth and abhors all generalizations, regarding them as presumptuous.
>
> (Masson 1985, 175)

By 1900 Freud and Fleiss had coined the word "Breuerization," to describe the type of deception and backsliding they saw in Breuer. In another letter, Freud wrote of his disapproval of physicians who, like Breuer, lie to dying patients about their impending death: "The art of deceiving a patient is certainly not very necessary. . . . Breuer's spirit lives in these arts" (6 February 1899, in Masson 1985, 343). Breuer-like behavior was now so clear to them that they could recognize and name it in others. For a while Freud cut himself off from Breuer completely, and structured his visits to patients they shared so as to avoid encountering him.

The Creative Work Stage in the Freud-Fleiss Collaboration

As Freud and Fleiss worked within the shared vision, they were in the creative work stage of circle development. They attempted to work out the implications of the vision in their explanations of particular phenomena, iron out the logical inconsistencies, and weigh the emerging theory against their observations. The cycles of activity included working alone, sharing incomplete work with one another, receiving feedback about the work in letters or meetings, revising the work, and starting another cycle until the work was ready for publication. During periods of working alone, Freud often became discouraged about solving a problem. After meeting with Fleiss, he

felt recharged with a synergistic blast of energy that unleashed another period of creative work.

The way in which the meetings and exchanges sustained the friends during the ups and downs of creative work is illustrated in one of the more important cycles of exchange between Freud and Fleiss during the winter and spring of 1895. By this point, the friendship had reached a high plateau of trust and openness. Fleiss came to Vienna during the Christmas holidays, most likely with his family to visit his in-laws. While there, although it violated the policy of holding their meetings away from other commitments, he met Freud for one of their "congresses." On 7 January 1895, Freud sent a draft of a paper on melancholia to Fleiss in which he attempted to reduce the psychological experience of depression to neurological processes. Along with diagrams showing the flow of perceptions and impulses, he presented a theory of blocked or diminished sexual excitations as a determinant of anxiety. A few weeks later, on 24 January, he sent a draft of another paper in which he attempted to account for paranoia, obsessions, and other psychic states as defenses against unacceptable sexual impulses. He then sent a third paper on migraines in March; but by the end of March, he had begun to burn out: "Am I really the same person who was overflowing with ideas and projects as long as you were within reach? When I sit down at the desk in the evening, I often do not know what I should work on." In April he informed Fleiss: "I am in a bad way; I am so deep in the 'Psychology for Neurologists' that it quite consumes me, until I have to break off for sheer exhaustion. I have never been so intensely preoccupied by anything. And will anything come of it? I hope so, but the going is hard and slow" (Masson 1985, 123, 118).

In May Freud wrote again, indicating that once again the demands of his work as a clinician were derailing his writing. He complained of having an "inhuman amount to do, and after ten or eleven hours with patients I have been incapable of picking up a pen to write to you even a short letter, though I had a great deal to tell you." But he then admitted that his chief reason for not writing was a mounting passion for neurological psychology —his "tyrant." He told of his ambition to "see how the theory of mental functioning takes shape if quantitative considerations, a sort of economics of nerve-force, are introduced into it." He found confirmation of his theories in his observations of patients, and he devoted "every free minute" to writing: "[T]he hours of the night from eleven to two have been occupied with imaginings, transpositions, and guesses, only abandoned when I arrive at some absurdity . . . or had so truly and seriously overworked that I had no interest left over for medical work" (Bonaparte, Freud, and Kris 1954, 119–20).

Freud told Fleiss that at the next congress he "should have a whole series of most remarkable things to tell [him]." However, he said, he could not do it by letter because the notes were so fragmentary, and sending the notes would be like sending a "six-month female embryo to a ball." In early August, he reported having deductively arrived at a physiological basis to psychological defenses. But ten days later he wrote:

> Soon after I proclaimed my alarming news to you, raising your expectations and calling for your congratulations, I came up against new difficulties; I had surmounted the first foothills, but had no breath left for further toil. . . . I threw the whole thing aside and persuaded myself that I took no interest in it at all. It makes me very uncomfortable to think that I have got to tell you about it. . . . I want to hear no more of it.
>
> (Bonaparte, Freud, and Kris 1954, 123)

But Freud and Fleiss had another congress in September, and once again Freud came away charged with energy and excited about his theory. On the train home he began writing in pencil. He continued at a feverish pace in the following weeks. Soon he wrote to Fleiss:

> The only reason I write to you so little is that I am writing so much for you. In the train I started writing a short account of the psychology for you to criticize . . . very rough, of course, but good enough, I hope, to be a groundwork for you to supply the trimmings, on which I set great hopes. My rested brain is now making child's play of the accumulated difficulties. . . . But you provided the great impulse to take the thing in earnest. . . . I think I may send you the thing in two parts. I hope your refreshed mind will do me the favor of finding the imposition a trifling one.
>
> (Bonaparte, Freud, and Kris 1954, 123–24)

Instrumental Intimacy and Creative Work

In the study of the Impressionist circle, we noted that the paired collaboration of Monet and Renoir in the summer of 1869 led to the final creative synthesis that formed the foundation of the Impressionist vision. As they worked side by side, something happened that might never have happened if they had been working alone. In the Freud-Fleiss collaboration, similar processes occurred. The depth of their interdependence reached new levels, and the creative work occurred, not just because of the social support they gave one another, but because of the merger of their two minds and self-

systems. In other words, in their congresses, and in their critical responses to one another's work, they went beyond social support and opened up access to one another's minds in ways that facilitated creative work.

We have already seen that Freud's bursts of work often were motivated by the norm of escalating reciprocity. Freud felt he owed something to Fleiss, who seemed to pour out work endlessly. Freud was motivated to keep apace and to have something to present at their congresses in exchange for all he had received. We have also noted that the mirroring and merger dynamics continued to contribute to Freud's ability to work. Fleiss's mirroring attention, along with Freud's identification with him, seemed to relax Freud's self-doubts. After each meeting he felt stronger, more cohesive, and better able to focus on his own thoughts.

Meeting with a friend and receiving support can lead to a sense of well-being in many people, however it rarely leads to the kind of creative breakthrough in thought that Freud was about to experience. Although supportive and reciprocal exchanges of work may be a necessary precondition for creativity in dyads, it is not sufficient. What was unique about the exchanges during Freud and Fleiss's congresses that contributed to creative work?

It seems to me that once their congresses began, the men's interdependence operated at a heightened level on several dimensions. To use an analogy from the language of computer systems, they "networked" their minds in ways that enabled them to borrow cognitive processes from one another. First, each delegated to the other the critical review phase of creative work. Fleiss seemed to have accepted the role more than Freud did. A creative insight may occur in a flash, but to be useful in a theory, it then must be given shape and tested through critical evaluation—the secondary work of creativity. For Freud, whose scientific standards were formed in Brucke's laboratory and in his collaboration with Breuer, these critical functions could inhibit creative work. Because he could count on Fleiss to perform these functions, he was freed up to pursue his "wildest" ideas. Knowing he could count on Fleiss, whom he saw as a hard-nosed quantitative scientist, he could tune out his own self-critical functions and take risks in his thinking, follow up on hunches, and skip some of the logical steps between points in his theorizing. At several points when Freud was working at top speed, he wrote that he was counting on Fleiss's critical review to find the weak points. For example, on 9 June 1898, when he was at work on *Interpretation of Dreams,* he wrote: "Many thanks for your critique. I know that you have undertaken a thankless task. I am reasonable enough to recognize that I need your critical help, because in this instance I myself have lost the feeling

of shame required of an author. . . . Let me know at least which topic it was to which you took exception and where you feared an attack by a malicious critic" (Masson 1985, 315).

In another letter accompanying a section of the manuscript, Freud made clear he was sending Fleiss his uncensored thoughts. Indeed, he seemed to be sending a record of free associations for Fleiss to review:

> Here it is. It was difficult for me to make up my mind to let it out of my hands. Personal intimacy would not have been a sufficient reason; it also took our intellectual honesty to each other. It completely follows the dictates of the unconscious, on the well-known principle of Itzig, the Sunday rider. "Itzig, where are you going?" "Do I know? Ask the horse." I did not start a single paragraph knowing where I would end up. It is of course not written for the reader; after the first two pages I gave up any attempt at stylization. On the other hand, I do of course believe in the conclusions. I do not yet have the slightest idea what form the content will finally take.
>
> (7 July 1898, in Masson 1985, 319)

Drawing on what he had learned in treating his patients, Freud seemed to cast Fleiss into the role of therapist listening to the free associations of a patient. By delegating his critical functions to Fleiss, Freud was able to suspend his own judgments and do creative work.

Second, not only did Freud and Fleiss serve as one another's critics, they networked their minds such that they shared "hardware and software"— that is, they gave each other access to one another's memory banks and cognitive processes. A thought that Fleiss would articulate might trigger off a thought in Freud; and vice versa: Freud's responses then led to associations in Fleiss's mind. Like two computers networked together, they each had access to more ideas and more ways of processing them, which made creativity more likely. This interdependence of cognitive processes, swapping parts of one another's mind, is an important component of instrumental intimacy.

Freud reported that the concepts of "sublimation" and "latency period" emerged out of this interdependence (Jones 1961, 203; Sulloway 1979), but the best recorded incidence of this process occurred during the exchanges that led Fleiss to propose to Freud the idea of "bisexuality." In one of their congresses, Freud suggested to Fleiss that neurotic symptoms were caused by blocked and redirected sexual energy. After accepting this idea, Fleiss incorporated the idea of ebb and flow of sexual energy into his theorizing about the cycles of energy in men and women. At a subsequent congress, building on Freud's idea, Fleiss proposed that, in their development, hu-

mans are first bisexual, and they experience both masculine and feminine cycles of energy. Using this insight, Fleiss developed complex mathematical formulas combining his male and female twenty-three- and twenty-eight-day cycles to account for ebbs and flows of his patients' energies. Freud then incorporated Fleiss's idea of bisexuality into his own theory. Working together, they developed the idea that human sexual development recapitulates the evolution of species: beginning like a clam with all exchanges occurring orally, and ending with differentiated oral, anal, and genital organs. The instrumental intimacy of Freud and Fleiss led to combinations of ideas that neither would have arrived at alone.

Fleiss played the part of Freud's audience and critic—his "other"—until the completion of *Interpretation of Dreams*. On 18 May 1898, Freud wrote:

> [E]ncouraged by your kind-hearted comments, I wanted to send you another chapter of the dream book before you leave Berlin . . . I shall change whatever you want and gratefully accept contributions. I am so immensely glad that you are giving me the gift of the Other, a critic and reader—and one of your quality at that. I cannot write entirely without an audience, but do not at all mind writing only for you. . . . The most difficult task—the unraveling of the psychic process in dreaming—is still ahead of me and will be tackled only after I have been revived by our congress. . . . If both of us are simultaneously going through the same life periods, as appeared to be the case on some occasions, you must at present be in a better period. I can now withstand anything. The habit of working on the dream [book] is . . . extremely good for me.
>
> (Masson 1985, 314)

When the book was in production, Fleiss reviewed the proofs. In January 1900, two months after its publication, Freud wrote that he considered Fleiss the "godfather" of the book (Bonaparte, Freud, and Kris 1985, 313).

Disintegration of the Pair

Despite the continuing exchanges up to the publication of *Interpretation of Dreams,* the relationship began to unravel as Freud began his self-analysis. A New Year's ritual of the dyad was to exchange letters reviewing the state of their lives and work. On 3 January 1897, Freud wrote:

> We shall not be shipwrecked. Instead of the passage we are seeking, we may find oceans, to be fully explored by those who come after us;

but, if we are not prematurely capsized, if our constitutions can stand it, we shall make it. Nous y arriverons. Give me another ten years and I shall finish the neuroses and the new psychology; perhaps you will complete your organology in less time than that. In spite of the complaints you refer to, no previous New Year has been so rich with promise for both of us. When I am not afraid I can take on all the devils in hell, and you know no fear at all.

<div align="right">(Bonaparte, Freud, and Kris 1954, 182–83)</div>

The letter suggests that all the old elements of the relationship were intact: the idealization of Fleiss, along with the sense of being an interdependent team, surrounded by danger and opposition, on a common voyage of discovery. Freud closed the letter by looking forward to their next congress, no later than Easter, perhaps in Prague. But by June of 1897, there began to appear in Freud's letters some hints of a sharper division of labor. Instead of viewing their relationship through his earlier metaphors of two comrades engaged in a single enterprise of discovery or conquest, he introduced a new metaphor that suggested greater distance: "We parcel things out like two beggars, one of whom gets the province of Posen; you, the biological, I the psychological."

In the same letter, Freud made one of the first references to beginning his own self-analysis: "Your remark about the occasional disappearance of periods and their reappearance above ground struck me with the force of a correct intuition. For this is what has happened with me. Incidentally, I have been through some kind of neurotic experience, curious states incomprehensible to consciousness, twilight thoughts, veiled doubts, with barely a ray of light here or there. . . . Otherwise I am dull-witted and ask your indulgence. I believe I am in a cocoon, and God knows what sort of beast will crawl out" (12 June 1897, in Masson 1985, 254).

In July, Freud's inclination to sharpen the boundaries between himself and Fleiss became more clear. Although he had once again reached a dry period in his thinking and felt he was a "useless correspondent . . . with no right to any claims to consideration," rather than seeking out Fleiss for stimulation, he now saw their relationship as somehow tied up with his stagnation: "I still do not know what has been happening to me. Something from the deepest depths of my own neurosis has ranged itself against my taking a further step in understanding of the neurosis, and you have somehow been involved. My inability to write seems to be aimed at hindering our intercourse. I have no proofs of this, but merely feelings of a very ob-

scure nature" (7 July 1897, in Masson 1985, 255). Freud's ambivalence about Fleiss surfaced when he was engaged in his self-analysis, when, as he wrote, "The chief patient I am busy with is myself." It may be that in writing to Fleiss, Freud was using him as his therapist—his "audience"—and the block in communication was simply a case of resistance (Gay 1988). Regardless, as Freud gained insight into himself, his idealization of Fleiss and his dependency on him declined.

The internal changes were associated with an abrupt change in his thinking. On 21 September 1897, Freud wrote a letter to Fleiss confiding a "great secret." He wrote that he no longer believed that neuroses were caused by traumatic sexual experiences. A number of factors combined to lead to his rejection of the theory: his failure to bring the analyses of any of his patients to a definite conclusion; his doubts that sexual exploitation of children by their fathers could be so widespread; and his realization that, in the dreams and free associations of his patients, he could not distinguish between true events and emotionally charged fantasies. He suspected that the stories of seduction might all be fantasies. However, he reported a "sense of triumph rather than defeat." Quoting a line from one of the Jewish anecdotes he was collecting, he wrote, "Rebecca, you can take off your wedding gown, you're not a bride any longer!" The honeymoon was over. Perhaps he also sensed that the romance and adventure in his relationship with Fleiss was coming to an end. Fleiss was an advocate of the neurological model that Freud was discarding. As he abandoned the reductionistic theory and embraced a purely psychological vision, he wrote: "In the general collapse only the psychology has retained its value. The dream [book] still stands secure, and my beginnings in metapsychology have gone up in my estimation. It is a pity one cannot live on dream-interpretation" (Bonaparte, Freud, and Kris 1954, 218). Although soon after writing this letter, Freud met Fleiss for a brief congress, in subsequent letters his withdrawal from the relationship became more apparent. While Fleiss was deductively deriving mathematical formulas to account for such things as the gender of a child at conception, Freud was engaged in his inductive self-analysis. Around this time, Freud also ceased to play critic to Fleiss's work, excusing himself as incompetent. He now characterized Fleiss's work as "outside my sphere."

Freud made great progress in his self-analysis over the fall of 1897, and he shared what he learned with Fleiss as it unfolded. He discovered memories of a nurse who was responsible for his fear of railway travel, heart attacks, and death. He had some fundamental insights about his jealousy toward his father as competitor for his mother's affection, and he linked his discovery

of these repressed feelings to the Oedipus story and to Shakespeare's Hamlet. He discovered jealousy at the birth of his younger brother, and guilt over that brother's infant death.

Finally, he caught a glimmer of the transference links between his current relationship to Fleiss and his relationship with a childhood companion. His "partner in crime" during childhood was a nephew, a son of his much older half-brother. With his nephew, who was one year older than Freud, he treated his niece, who was a year younger, "shockingly." In *Interpretation of Dreams* he wrote: "My emotional life has always insisted that I should have an intimate friend and a hated enemy. I have always been able to provide myself afresh with both, and it has not infrequently happened that the ideal situation of childhood has been so completely reproduced that friend and enemy have come together in a single individual—though not, of course, both at once or with constant oscillations" (Freud 1900, 485).

Although these insights implied a neurotic component in his friendship with Fleiss, Freud's commitment to the relationship on some levels seemed stronger than ever. Their intimacy had reached the point where Freud not only shared his incomplete thoughts and self-doubts with Fleiss; he also shared his most private dreams and memories, many of which generated feelings of shame and guilt, and could be the basis for attacks on his character. He was thus still functioning within the confines of the norms they had negotiated in the early days of their collaboration. For example, on 5 November 1897, he wrote: "I have really nothing to say, but I am writing at a moment when I feel the need of company and encouragement" (Bonaparte, Freud, and Kris 1954, 228). Nevertheless, although he still confided in Fleiss, and although he relied upon him for support, clearly the momentum toward individuation had begun. As he withdrew from the role of critic of Fleiss's work, he wrote: "In one respect I am better off than you. What I have to say about the mental side of this world finds in you an understanding critic, what you tell me about its starry side raises in me only barren admiration" (15 October 1897, in Bonaparte, Freud, and Kris 1954, 227).

Individuation
By the end of 1897, Freud had settled into a somewhat more differentiated relationship with Fleiss. No longer did he talk about integrating their theories, yet he still found the congresses stimulating and supportive, and he was obviously still open in his communication and invited criticism of his self-analysis. On 22 December 1897, he wrote: "I am in good spirits and eagerly looking forward to [meeting in] Breslau, that is, to you and your beautiful

novelties about life. . . . If there now are two people, one of whom can say what life is, and the other can say (almost) what mind is—and furthermore they are very fond of each other—it is only right that they should see and talk to each other more often" (Masson 1988, 287).

The meeting in Breslau turned out to be a turning point in the relationship. It was at that meeting, as well as at the preceding one in Nuremberg, that they first discussed Fleiss's ideas about bisexuality. Some of what transpired in these discussions can be reconstructed from an exchange of letters that occurred much later, when the friendship was disintegrating. Fleiss published a letter relevant to this period, so we have his perspective as well as Freud's, and Freud discussed the meeting in *Psychopathology of Everyday Life*. By the time this work had been published, the friendship was over, but we must remember that when the two men met in Breslau the relationship was still very warm and open.

In their subsequent accounts of the meeting and their discussions of bisexuality, although they are obviously now withdrawing from one another, they both describe exchanges that are typical of instrumental intimacy during the creative work stage. In his angry letter describing his memory of the Breslau congress as well as the prior one at Nuremberg, Fleiss wrote to Freud: "We first discussed the subject [bisexuality] in Nuremberg, while I was still in bed and you were telling the case-history of somebody who had dreams about enormous snakes. At that time you were very much struck with the idea that undercurrents in a woman might derive from the male part of her psyche. That made me all the more suspicious at your resistance at [the subsequent meeting at] Breslau to the idea of bisexuality in the psyche" (Bonaparte, Freud, and Kris 1954, 241). For his part, Freud initially seemed to deny that Fleiss had been the one to come up with the idea of bisexuality. Although he eventually acknowledged his confusion on that point, he also disagreed with Fleiss's account and argued that it was not at Nuremberg but at the subsequent Breslau congress that Fleiss had first told him about his theory. As he remembered it, they had talked about it while they were walking together in the evening.

We know from the letters exchanged immediately after the Breslau congress (December and January 1997–98) that during that meeting Freud brushed off another one of Fleiss's hypotheses: that right- and left-handedness corresponded with the masculine and feminine sides of the personality, respectively. Fleiss saw bilateralism as indicative of bisexuality—an idea he called his "bi-bi" hypothesis (Masson 1985, 290). Freud rejected this theory on the spot, and in a letter dated 29 December 1897, he wrote that the discussion of the theory, "still ringing in his ears," represented the

"first in a long time on which our hunches and inclinations have not taken the same path." In that letter he joked about carrying out Fleiss's recommended experiment: testing whether he was slightly left-handed by trying to thread a needle first with the right hand, then with the left.

Fleiss must have reacted with anger at Freud's ridicule of the needle experiment. In Freud's next letter, dated 4 January 1898, he wrote he was puzzled that Fleiss was "so amiss" over his rejection of the theory of left-handedness: "To me, it seems to be as follows: I literally embraced your stress on bisexuality and consider this idea of yours to be the most significant one for my subject since that of 'defense.' If I had a disinclination on personal grounds, [it] would have been directed toward bisexuality, which, after all, we hold responsible for repression. . . . I object only to the permeation of bisexuality and bilaterality that you demand" (Masson 1985, 292).

Freud's rejection of his own earlier Bruckean, reductionistic theory of neurosis may have been a factor behind his scorn for Fleiss's "bi-bi" hypothesis. He no longer had patience for simplistic theories that linked psychological and neurological processes. However, although Freud rejected the bi-bi hypothesis, he embraced the bisexuality idea. In fact, the idea that humans are bisexual became so integrated into his thinking that he later forgot that Fleiss was the originator. It was not until Fleiss confronted him with the evidence of appropriation that Freud remembered. In *Psychopathology of Everyday Life*, he wrote:

> In the summer of 1901 [actually 1900] I one day said to a friend with whom I used to exchange scientific ideas: These problems of the neurosis are only to be explained if we base ourselves firmly on the assumption of the initial bisexuality of the individual. My friend replied: "That's what I told you two-an-a-half years ago at Breslau, when we went for the evening walk. But you wouldn't hear of it then!" It is painful to have to surrender one's originality in this way. I could not remember the conversation in question, or that my friend had made a statement of the sort. . . . Indeed, in the course of the following week the whole conversation . . . returned to my mind, and I remembered the answer that I had given him at the time. "I can't accept that," I had exclaimed. "I don't believe it."
>
> (Bonaparte, Freud, and Kris 1954, 38)

Based on Freud's letters during the winter of 1897–98, they both seem to have had it wrong. After Breslau, Freud did accept the idea of bisexuality, but he rejected the idea that a person's dominant sexual orientation was related to which hand was dominant. Freud even began using the idea of bi-

sexuality in his treatment of patients, hypothesizing that homosexuality was a component of all neuroses. Fleiss did not know of Freud's use of the concept in this way, and was quite surprised when Freud told him of it in a letter dated 23 July 1904. Of course, if Freud himself had seen all the evidence, he would most likely have said the tangle of memories was related to his repression of his appropriation of Fleiss's theory. Regardless, it was at the Breslau congress that Freud embraced the idea of bisexuality.

A third aspect of the Breslau meeting is one that is speculative. Fleiss proposed that left-handedness was associated with femininity and suggested that Freud himself might be slightly left-handed. Freud laughed at the thought, and made light of Fleiss's needle-and-thread test that supposedly would decide the question. Nevertheless, the issues of bisexuality and implied homosexuality caused tension between the two men. Curiously, Fleiss recalled that they first discussed bisexuality while he was still in bed and Freud was walking around the room talking about a woman's dream of snakes. What was implied in these exchanges was that Fleiss believed that Freud had a feminine, perhaps homosexual side, and the idea made Freud uncomfortable and defensive. Although Freud claimed this attribution did not bother him, he certainly seemed compelled to joke about it and to ridicule Fleiss. Later, Freud himself admitted that his "feminine" side may have been operating in their relationship: "[T]here can be no substitute for the close contact with a friend, which a particular—almost a feminine— side of me calls for" (7 April 1900, in Bonaparte, Freud, and Kris 1954, 318).

Despite the tensions that continued in the wake of the Breslau meeting, the relationship remained intact over the next two years. As Freud worked on *Interpretation of Dreams,* Fleiss continued to play the attentive audience and sympathetic critic. Fleiss read and criticized each chapter as it was completed. The disengagement process may have begun, but both men continued to value the congresses. For example, in the fall of 1899, Freud had another period of lethargy when his work seemed "far less valuable" and his "disorientation . . . complete." But after a congress during the Christmas holidays, he wrote: "So you see what happens. I live gloomily and in darkness until you come, and then I pour out all my grumbles to you, kindle my flickering light at your steady flame and feel well again; and after your departure I have eyes to see again, and what I look upon is good" (3 January 1899, in Bonaparte, Freud, and Kris 1954, 272).

Another ritual of the exchanges that continued was the periodic scapegoating of Breuer. For example, it is not surprising that, with the tension flying back and forth between the two friends after the Breslau meeting in mid-December 1897, Freud attacked Breuer in his letter of 14 January 1898,

(Masson 1985, 294). Sandwiched between discussion of their disagreement about the bi-bi hypothesis, he related an incident in which Breuer, trying to be generous, had refused to accept Freud's full payment of an old debt. In his letter to Fleiss, Freud seemed to be enraged as he accused Breuer of "disdainful condescension," "craziness," showing the "greatest lack of logic," and "having an unabated need to be good." The next week in the letter of 22 January, he exploded once again at what he perceived as Breuer's "neurotic dishonesty" in spreading rumors about Freud's "conduct of money matters": "My anger at Breuer is constantly being refueled" (Masson 1985, 296). By rejecting the "devious" scapegoat, Freud could reaffirm the norm of honest communication negotiated with Fleiss, even if it led to arguments. As scapegoat, Breuer's image was always shaded to reflect the traits that the friends wished to deny in one another at a given point in their relationship. When Fleiss was acting as Freud's sympathetic critic, Breuer was cast into the role of the bad critic. For example, when he received one of Fleiss's criticisms, Freud wrote:

> You will not be surprised if I write to you today about your evaluation of my dream manuscript, which made my day. No doubt you do not want me to compare you with Breuer in any way; such a comparison is forced on me. I think of the underhandedness with which he doled out praise, for example, the style is wonderful, the most ingenious ideas; and the consideration which led him to express his picky objections to the essentials to other people from whom I then heard about them. Again and again I am glad to be rid of him.
>
> (24 March 1898, in Masson 1985, 305)

Even though the relationship with Fleiss was unraveling, the momentum of the rituals, roles, and normative structure of their friendship carried them through to the completion of Freud's book. Throughout this period, Fleiss acted as an editorial critic and even proofread the galleys. Yet at night in his dreams, Freud was forewarned of the impending disintegration. On 21 September 1899, he wrote to Fleiss: "Absurdity in dreams! It is astonishing how often you appear in them. In the non vixit dream I find I am delighted to have survived you" (Masson 1985, 374).

The Final Break
The disintegration of collaborative circles is sometimes acrimonious. Certainly Freud and Fleiss's collaboration did not end on a positive note. During the summer of 1900, they scheduled a "congress" at Innsbruck. Once again Freud looked forward to it. He was exhausted with work, he had not

found any good reviews of his book, and he felt that "[p]eople's opinions of the dream book are beginning to leave me cold. . . . I have not heard any more reviews and the nice things said to me from time to time by people I meet annoy me more than the general silent condemnation" (10 July 1900, in Bonaparte, Freud, and Kris 1954, 323–24).

But the congress did not go well. Piecing together the references to it by the two men in subsequent letters, it is possible to infer a number of the currents that resurfaced to accelerate the disintegration of their friendship. By this time, each man had developed his theory to the point that their conclusions about the causes of distress were incompatible. As discussed above, Fleiss's theory was based on mathematical formulas about masculine and feminine cycles. Because he now thought that men and women both had masculine and feminine sides, the formulas had become more and more complex. Freud's theory was based on inductive analysis of his dreams and free associations. For Freud, psychological symptoms and states of distress depended upon the degree of repression and the stage of analysis. There is some confusion in their exchanges about exactly when, but either at the Innsbruck congress or at the next one at Achensee, Fleiss first pitted his theory against Freud's. As Freud was discussing his success in treating a patient, Fleiss responded that the ebb and flow of symptoms was due, not to psychoanalysis, but to the periodic cycles of energy. As Fleiss later told the story:

I often used to have meetings with Freud for scientific discussions. In Berlin, Vienna, Salzburg, Dresden, Nuremberg, Breslau, Innsbruck, for instance. The last meeting was in Achensee in the summer of 1900. On that occasion Freud showed a violence towards me which was unintelligible to me. The reason was that in a discussion of Freud's observations of his patients I claimed that periodic processes were unquestionably at work in the psyche, as elsewhere. . . . Hence neither sudden deteriorations nor sudden improvements were to be attributed to the analysis and its influence alone. . . . During the rest of the discussion I thought I detected a personal animosity against me on Freud's part that sprang from envy. Freud had earlier said to me in Vienna: It's just as well that we're friends. Otherwise I should burst with envy if I heard that anyone was making such discoveries in Berlin! . . . The result of the situation at Achensee in the summer of 1900 was that I quietly withdrew from Freud and dropped our regular correspondence. Since that time Freud has heard no more from me about my scientific findings.

(Bonaparte, Freud, and Kris 1954, 324)

Nevertheless, Freud continued to correspond after the Achensee meeting and even expressed hopes for another congress in Rome. But the reply from Fleiss led Freud to conclude that their congresses had become "relics of the past." Throughout 1901, the men continued to tell each other about their work—indeed Fleiss continued to refer patients to Freud—but no rough drafts of manuscripts were exchanged. Freud could "only still rejoice at a distance" about Fleiss's progress in the wider synthesis of his work. Freud's letter of 7 August 1901 is quite explicit about the state of their relationship:

> There is no concealing the fact that we have drawn somewhat apart to some extent. In this or that I can see how much. So too in the judgement of Breuer. I no longer despise him and have not for some time; I have felt his strength. If he is dead as far as you are concerned, then he is still exerting his power posthumously. What is your wife doing other than working out in a dark compulsion the notion that Breuer once planted in her mind when he told her how lucky she was that I did not live in Berlin and could not interfere in her marriage? In this you too have come to the end of your perspicacity; you take sides against me and tell me that the reader of thoughts merely reads his own thoughts into other people, which renders all my efforts valueless.
>
> (Masson 1985, 447)

It is curious that, as the negative undercurrents in the relationship to Fleiss became overt, Freud's relationship to Breuer became more positive. The change suggests that as Freud became more conscious of and began to express his disillusionment with Fleiss, he had less need to use Breuer as a scapegoat.

In the August letter, despite his recognition that the relationship had broken down, Freud acknowledged the great impact their friendship had on his work. He wrote that, if Fleiss viewed him as a mere thought-reader who used magic to treat patients, then Fleiss should throw his copy of *Psychopathology of Everyday Life* into the wastebasket: "It is full of references to you; obvious ones, where you supplied the material, and concealed ones, where the motivation derives from you . . . you can take it as a testimonial to the role you have hitherto played in my life" (Masson 1985, 447).

Dividing up the Intellectual Property
Perhaps in a final attempt to counteract the disintegration of their friendship, Freud proposed in his letter of 7 August that he and Fleiss collaborate on a book on bisexuality. But the paragraph in which he proposed the book

is filled with ambivalence. Freud first wrote, "My next work will be called 'Human Bisexuality.' It will go to the root of the problem and say the last word . . . the last and the most profound." He wrote that he now saw bisexuality, the conflict between masculinity and femininity, as the basis for an explanation of repression, the core problem in his theory. He would need about six months to get it together. But then, after this exuberant outburst, he backed down. Remembering that the idea originated with Fleiss, he wrote, "But then I must have a long and serious discussion with you. The idea itself is yours." Although Freud granted Fleiss primary ownership, he attempted to claim some ownership for himself: "You remember me telling you years ago, when you were still a nose specialist and surgeon, that the solution lay in sexuality. Several years later you corrected me, saying that it lay in bisexuality—and I see you are right. So perhaps I must borrow even more from you; perhaps my sense of honesty will force you to coauthor the work with me . . . which I hope will quite properly unite us again in scientific matters" (Masson 1985, 448). In the course of one paragraph, Freud had transformed "my book" that would say the last and most profound word about bisexuality into a joint project. Fleiss wrote back saying that he thought Freud was exaggerating his share in the bisexuality idea. As they struggled to disengage from one another, one consequence of their era of instrumental intimacy was that they could not agree on the ownership of their intellectual property. They sounded like a divorcing couple dividing up the household.

When they were at the height of their solidarity, a dream that Freud and Fleiss shared was to travel together to Rome for a congress, a trip in which they would arrive in Rome like conquerors—like Hannibal crossing the Alps—invading the heart of the kingdom. But they never made the trip together. Instead, in the summer of 1901, Freud toured Rome with his brother, Alexander. In his next letter to Fleiss, Freud told him about the trip. In that same letter, he attempted to untangle the confusion in Fleiss's reactions to him (19 September 1901, in Masson 1985, 449–50). Fleiss must have said he was insulted by Freud's reactions to his theory and informed him that he would no longer share his ideas. In part Fleiss seemed to fear that Freud would steal ideas from him, and in part he seemed to resent that Freud no longer provided useful criticism. Freud wrote:

Your last letter actually did me some good. I can now understand the attitude you have expressed in your letters to me over the past year. Within myself I know that what you say about my attitude toward your big work is unjust. . . . You know I lack any mathematical talent

whatsoever and have no memory for numbers and measurements; this may have given you the impression that I do not retain anything of what you told me. . . . Perhaps you have been too quick to give up on me as a confidant. The only thing that hurt me was another misunderstanding in your letter: that you connected my exclamation, "But you are undermining the whole value of my work!" with my therapy. . . . If as soon as an interpretation of mine makes you uncomfortable, you are ready to agree that the reader of thoughts perceives nothing in the other, but merely projects his thoughts, you really are no longer my audience either and must regard my entire method of being as worthless as the others do.

In his letter to Freud, Fleiss must have pounced on him for proposing that they collaborate on the bisexuality book. In response to that attack Freud wrote: "I do not comprehend your answer concerning bisexuality. . . . I certainly had no intention of doing anything but working on my contribution to the theory. . . . You will now have seen from my relevant reference to your priority in 'Everyday Life' that I have no intention of expanding my role in your insight. . . . Since almost everything I know about it comes from you, all I can do is cite you or get this introduction entirely from you."

Over the next six months, their letters dwindled to brief discussions of a patient Fleiss had referred to Freud. The friendship was reverting back to professional exchanges between two colleagues in a referral network. One final burst of positive feeling occurred when Freud told Fleiss of his promotion at the University of Vienna. Fleiss wrote back a letter filled with praise about Freud's "mastery" and deserved recognition. Freud replied: "Public acclaim was immense. Congratulations and flowers already are pouring in, as though the role of sexuality has suddenly been officially recognized by his majesty, the significance of the dream certified by the Council of Ministers, and the necessity of psychoanalytic therapy of hysteria carried by a two thirds majority in Parliament" (11 March 1902, in Masson 1954, 457).

But the friendship finally foundered in the escalating conflict over theft of the bisexuality idea. Fleiss not only accused Freud of stealing the idea, but he charged him with relaying his whole theory of bisexuality and left-handedness to a third party, Weininger, who then published a book claiming to have originated the theory. In the book Weininger thanked Freud for his contribution, then, like Fleiss, turned around and attacked Freud's theory of psychological repression as spurious. Soon afterward, Weininger committed suicide. Freud at first denied having leaked the idea, but in his denial he admitted using the concept when treating a patient, Swoboda,

who was a close friend of Weininger. Exasperated by Fleiss's accusations, Freud told him that Swoboda was not, as Fleiss implied, his pupil, but rather a seriously ill patient "who was given the same help and learned the same things as every other patient." He continued:

> I too believe that the late Weininger was a burglar with a key he picked up. Herewith everything I know about it. Swoboda, who was an intimate friend of his and who had learned about bisexuality (which comes up for discussion in every treatment) from me, mentioned the word "bisexuality"—as he tells it—when he found Weininger preoccupied with sexual problems. Whereupon Weininger clapped his hand to his forehead and rushed home to write his book. I am in no position to judge whether this report is correct. . . . Weininger . . . killed himself out of fear of his criminal nature. . . . The correspondence of details [of Weininger's and Fleiss's theories] can no doubt be explained as follows: once introduced to the idea, he deduced some of the inferences correctly—a larger portion no doubt incorrectly. For Swoboda maintains that he did not give him any further information; nor did he have any to give, because he did not learn from me any more than what comes up in treatment—that a strong homosexual current is found in every neurotic.
>
> (23 July 1904, in Masson 1985, 464)

Fleiss wrote back immediately, rejecting Freud's attempt to exonerate himself. Moreover, he wrote: "Until now I did not know what I learned from your letter—that you are using [the idea of] persistent bisexuality in your treatment" (26 July 1904, in Masson 1985, 465). Freud wrote back the next day, apologizing for his part in passing the idea along to the "burglar."

> I see that I have to concede to you more right than I originally was prepared to; I am taken aback by how much I complained about my pupil Swoboda and by my glossing over Weininger's visit to me. . . . I was quite alarmed by [his] chapter on hysteria, which was written to [capture my favor], but the underlying theme of bisexuality was of course recognizable, and I must have regretted at the time that via Swoboda, as I already knew, I had handed over your idea to him. In conjunction to my own attempt to rob you of your originality, I better understand my behavior toward Weininger and my subsequent forgetting.

Until this final set of exchanges, Freud held out the hope of reconciliation. But at this point, he concluded:

You are not alone in regretting—I do too—that this incident in which you reproach me has reawakened our long-dormant correspondence. It is not my fault, however, if you find the time and the inclination to exchange letters with me again only on the occasion of such petty incidents. . . . The fact is that in the past few years—"Everyday Life" is the dividing line—you have no longer showed an interest in me or my family or my work. By now I have gotten over it and have little desire for it any longer.

(27 July 1904, in Masson 1985, 466–67)

Freud's final request of Fleiss was that he read through his forthcoming work—*Essays on the Theory of Sexuality*—to be sure there were no uncredited references to Fleiss's idea. The relationship was now beyond repair.

Conclusions

Instrumental intimacy is the culmination of an escalating process of exchange. Beginning with a collegial exchange of resources or expertise, the collaborators expand the exchanges in scope and deepen their levels of trust in one another. Gradually raising the ante, they exchange information, material resources, and emotional support. If a norm of exchanging gifts is negotiated, each successive gift is chosen to be more and more meaningful to the recipient. Once a norm of exchanging work has been established with exchanges of finished products, it escalates in degree of risk until the partners exchange their most vulnerable work in progress.

When the collaborators reach a plateau of exchanging their most intimate thoughts, they begin to share not just ideas, but also their reasoning styles, their fantasies, and their wildest dreams. The ideas of one collaborator may trigger a new idea in the other, or they may combine ideas in ways that would not be possible if they worked alone. For example, Freud's talk about his theory of sexual impulses most likely stimulated Fleiss's thinking about bisexuality, which he then used in his formula to calculate the permutations of masculine and feminine energy cycles in individuals. Freud then borrowed Fleiss's idea of bisexuality and integrated it into his theory of repression and neurosis. In the state of instrumental intimacy, as the collaborators exchange ideas and share thought processes, the new ideas seem to emerge effortlessly. The pair feel they are a unit—Freud and Fleiss, for example, imagined themselves as crew on a voyage of discovery, embattled warriors on a mission of conquest. Boundaries are let down, altruism outweighs self-interest, and ownership of ideas is unclear or does not matter.

As the exchanges proceed, the collaborators set a pace for productivity, and fall into reciprocal roles. While the creator shares her wildest ideas, the other acts as attentive audience. As the creator attempts to give more coherent shape to the idea, the listener may shift to sympathetic critic. In the final stages of creative work, the critic may shift to the role of devil's advocate, anticipating the responses of an unsympathetic outsider and helping to fortify the product with logic, evidence, or other appropriate armor. Then they may reverse the roles: the critic plays the creator, and the creator takes the role of audience and critic.

The Mirror and the Idealized Selfobject

Jones (1961) argues that the emotional dynamics of the collaboration were more important to Freud than were the ideas he shared with Fleiss. The emotional dynamics freed Freud to do creative work, and they most likely sustained him during his self-analysis. In other words, the emotional dynamics contributed to his adult development. Kohut's (1977) theory of the self provides some of the most useful ideas for conceptualizing these dynamics. He suggests that creative work and adult transformations are more likely in collaborative pairs in which the members play the roles of mirror and idealized selfobject for one another.

As we have seen, Fleiss played both these roles for Freud: at times his "only audience," at other times his esteemed hero. With an idealized collaborator as attentive audience or mirror, the creator seems able to invest more completely in work. As we also saw in the effects Ford had on Conrad, when the creator can anticipate the attentive response of the mirror, rather than being racked with self-doubt or anxiety, he feels more energized, whole, and internally cohesive. Not only does the supportive, empathic mirroring quiet anxiety, guilt, and depressive reactions, it seems to release a surge of healthy energy for sustained periods of work. Kohut (1977) suggests that when the levels of trust, intimacy, and attentiveness are "good enough," the relationship becomes weighted with transference dynamics, so that the mirror becomes a surrogate mother responding to the tentative steps, or the "healthy exhibitionism" of the creative person. In this nurturant relationship, the creator not only works on solving an immediate problem but reexperiences the emotions of an earlier developmental stage, builds self-esteem where there was self-doubt, and acquires confidence in taking new steps. New "structure" is laid down in the ego that can eventually become self-sustaining.

The mirroring partner has the most dramatic effect when also serving as an idealized selfobject, as Fleiss did for Freud. The bond with the idealized

selfobject enhances the self-esteem of the creator. Seeing himself as linked to the charismatic Fleiss on a "crusade," Freud felt encouraged and more determined to pursue his own ambitious goals. In his analysis of the relationship between Freud and Fleiss, Jones (1961) conceptualizes the dynamics in terms similar to those implied by Kohut's theory. Freud's speculative theorizing, he argues, was inhibited by his commitment to the scientific discipline he learned in Brucke's laboratory. When he met Fleiss, Freud, like an adolescent hero-worshipper, overestimated his friend's scientific acumen, painting him as "a man of supreme intellect, of impeccable critical judgement." Because he so inflated Fleiss's credentials as a scientist and theoretician, Freud felt safe in delegating to him his own critical facilities and in letting loose his speculative side: "[I]t was safe to set the feared daemon of curiosity free, when he was guided by someone who believed in physics and operated in mathematical symbols. And that was the creative side of Freud: the original love of mastery . . . one so completely urgent at times that it treacherously beckoned to the short cuts of philosophical speculation" (Jones 1961, 188).

Just as the dynamics of love are most likely to occur in couples, these more intimate dynamics of collaboration—escalating exchange, risk, and trust, along with mirroring and idealization—are most likely to unfold within pairs. Although it may be possible to achieve instrumental intimacy in larger face-to-face groups, it is more likely in pairs, where collaborators are better able to achieve the depth of exchange.

Instrumental intimacy like that of Freud and Fleiss can be both exhilarating and terrifying. When two collaborators share one another's memories, fantasies, and cognitive processes, the outcome is sometimes greater than the sum of the parts. Unanticipated combinations occur, and something new may be created. Vague notions, or as Arieti (1976) calls them, endocepts, can take shape in the nurturant dialogue of the dyad, and each person may discover ideas and solutions to problems that he never would have thought of alone. But the pairing can also be a state in which the collaborators lay open the most vulnerable parts of themselves—their fears, their weaknesses, their prejudices, and their pretensions. Because of the openness in the relationship, collaborators, like lovers, know how to hurt one another. The constructive effects can quickly diminish if one member breaks the spell and begins to attack the ideas, or worse, the character of the other. In addition to being particularly vulnerable to one another's attacks, both collaborators are also vulnerable to plagiarism—the unfinished ideas of one may be claimed by the other.

In the quest stage, when the partners are negotiating a vision, the dangers

of plagiarism are less threatening. At this early point in their collaborative development, letting the other into one's cognitive processes is usually experienced as enriching. If neither has yet settled on a theory or vision of his own, it does not matter where the ideas come from. Ideas seem to be "discovered" rather than owned. As the partners' minds are networked together, and as they stimulate in one another new thoughts and new ways of thinking, their ideas seem to flow effortlessly out of the combined cognitive processes.

It is during the final stages of the creative work period, after the long, arduous process of revising, testing, and consolidating concepts and methods, that ideas come to be experienced as one's own. Once this work has gone on for some time, the networking of minds may become threatening. Ideas that one has honed and tested over the course of many years might be seized by a collaborator and claimed as common property. In retrospect, the earlier stage begins to look less idyllic. As Freud noted in his final letter to Fleiss: "I have suspected that one of us might come to regret our formerly unrestrained exchange of ideas and have striven successfully to forget the details of your communications. At that time I evidently reproached myself dimly, as I do today in complete clarity, for my generosity or carelessness with your property" (24 July 1904, in Masson 1985, 467).

As the consolidation of their individual visions proceeds, and as the friends produce finished work for public consumption, other factors enter into the relationship that may intensify the tension between them. This holds in the larger group as well as the pair. If one member is successful, the other members of the circle may become envious. If the work of one member is attacked by the same critics who support another member of the circle, relationships within the circle may be strained. Like Breuer in his relationship to Freud and Fleiss, the ambivalent member with loyalties divided between the circle and outside critics may be perceived as an unreliable friend. Either of these consequences of interacting with the external world can contribute to disintegration of collaborative relationships.

A third set of disintegrative processes is more subtle. Freud and Fleiss began their relationship at a point when neither had fully established himself as a scholar or clinician. Fleiss had not yet published anything. Although Freud had published a number of articles dealing with neurology, he had not yet made a mark equivalent to his ambition. Freud idealized Fleiss; he projected onto him the scientific abilities and the imaginative originality that he wanted in himself, and as a result he repeatedly felt off balance with or in debt to Fleiss. As time passed and as each man consolidated his own vision, each also had ample opportunity to test reality—that is, to weigh the

reality of his friend's abilities against initial impressions. For Freud this process brought particularly dramatic results, when, in the course of his own self-analysis, he began to discover the role that transference had played in coloring his impression of Fleiss.

At the same time as the image of his friend was becoming more reality based and less shaded by projection or transference, another factor entered in. With each congress, when he discovered he was able to hold his own, Freud took back into himself a bit of what he had projected onto his idealized friend. He measured himself against his friend, and as he discovered his equality, he recognized and accepted in himself the strengths and abilities he had attributed to Fleiss. Freud came back from each congress feeling stronger, more energized. No longer indebted because the energy for his action and creativity resided in another, he felt whole and autonomous, centered and self-sustaining as a creative thinker.

Finally, apart from working free of projections and transference, the collaborators also acquired one another's skills and motivational resources. When writing, they quite literally "took the role of the other." As Freud often said, his collaborator was his "only audience," and as he worked on his theory, he wrote only for him. After repeated cycles of feedback from Fleiss, Freud eventually was able to anticipate his responses, and he began to incorporate them into his writing. Likewise, when Freud met with Fleiss, he came away fired up with the energy that Fleiss exuded and the mirroring he received. After repeated congresses, Freud learned how to be his own mirror. Once the collaborators had internalized one another's roles, pairing became less important, and they ambivalently reestablished their boundaries.

Chapter 6

Two Sticks of a Drum: Elizabeth Cady Stanton, Susan B. Anthony, and the Circle of Ultras

> With all the insecurity of neophytes, they had to find and speak in their own voices, to test their abilities and to form new kinds of bonds with each other.
>
> —Kathleen Barry, *Susan B. Anthony:*
> *A Biography of a Singular Feminist*

In this chapter we examine the collective action stage in the development of collaborative circles. Until this stage, the members of a circle are focused inward. During the formation stage, they court one another, build trust, and lay the foundations for open communication. During the rebellion, quest, and creative work stages, led by a charismatic leader, they break with established authorities in their field. Working alone or in pairs, they develop their skills, crystallize a vision, and produce creative works. The collective action stage begins when they make the decision to carry out a group project aimed at winning public support for their work. For a circle of poets, such as the Fugitives, the shared project may be editing a journal; for artists, such as the Impressionists, it may be staging an exhibition. For social reformers, the project may be a demonstration, a convention, or a campaign to bring about legislative change.

As a case study, I take the circle of women who formed the core of the women's rights movement in the nineteenth century (plates 30–36). At times they were known as the "Ultras" because they advocated positions that went far beyond accepted conventions, even within their own network of social reformers (Anthony 1854; Barry 1988, 93). I have chosen to call the core group by that name. Within the circle, I focus on the friendship between Elizabeth Cady Stanton and Susan B. Anthony. These two core

members of the circle forged their relationship during the 1850s—the first decade of the Ultras' collective action stage. For the most part, I limit the analysis to that decade. The Ultras continued to interact in a complex set of relationships that lasted more than forty years, but the dynamics of their circle during the 1850s provide a rich case study of the collective action stage of circle development.

Many contemporaries noted the remarkable friendship that formed between Elizabeth Cady Stanton and Susan B. Anthony. Theodore Tilton worked with them in the late 1860s and early 1870s when they edited their controversial newspaper, the *Revolution*. In his description of their relationship, he observes many of the characteristics of collaborative circles, including an egalitarian structure, instrumental and emotional interdependence, a "delinquent" subculture, and a shared vision:

> These celebrated women are of about equal ages, but of the most opposite characteristics, and illustrate the theory of counterparts in affection by entertaining for each other a friendship of extraordinary strength. Mrs. Stanton is a fine writer, but a poor executant; Miss Anthony is a thorough manager, but a poor writer. . . . [N]either has any selfish ambition for celebrity; but each vies with the other in a noble enthusiasm for the cause to which they are devoting their lives. . . . [T]o describe them critically, I ought to say that opposites though they may be, each does not so much supplement the other's deficiencies as augment the other's eccentricities. Thus they often stimulate each other's aggressiveness and at the same time diminish each other's discretion. But whatever may be the impudent utterances of the one, or the impolite methods of the other, the animating motives of both are as white as the light . . . the noise-making twain are two sticks of a drum . . . keeping up . . . the rub-a-dub of agitation.
>
> (Quoted in Stanton, Anthony, and Gage 1881, 1:456–57)

Like other circles in the early stages of development, a circle of reformers may work "backstage," away from public scrutiny, as they break from traditional ways of thinking, clarify their vision of change, agree on a political strategy, and acquire skills in writing and speaking. But more than other types of circles, when reformers move into the collective action stage, they become highly visible, especially when they organize public events, deliver speeches, build a political constituency, and attempt to influence legislation or elections. Whether a collaborative circle consists of social reformers, artists, writers, or other types of creative people, public encounters during

the collective action stage add a new dimension to circle dynamics. In addition to the cycles of working alone and meeting as a group, they now add the tasks of managing long-range collective projects that require interdependence, coordination, and responses to feedback from the public. These new tasks often stimulate change in the leadership of the circle.

I have chosen to focus on the nineteenth-century women's rights circle in order to explore some of the gender differences in the dynamics of collaborative circles. It may be that the differences by gender observed in friendships (see Fehr 1996; Farrell 1986) also occur in collaborative circles. If so, then, like women's friendships, collaborative circles of women may be more intimate, less competitive, less hierarchical, and more enduring than those of men. It may be that some of the ingredients that characterize successful collaborative circles, such as collaborative pairing and instrumental intimacy, are more readily found in women's friendships. However, in the nineteenth century, even women renowned for their talent, such as Berthe Morisot, the Impressionist painter, were excluded from much of the informal interaction in their circles. They were excluded by male prejudice, by norms that restricted their access to education and work, by the demands of their roles as wives and mothers within families, and by their own internalized beliefs about what was proper. If gender differences in circle dynamics are the consequences of these constraints, the differences between male and female circles should be more apparent in the nineteenth century, when these constraints operated with greater force than they do today. In our own time, as these constraints have lessened, the roles of men and women have converged, and perhaps these differences will be less apparent.

The Members of the Ultras Circle

The core members of the Ultras circle were the group of friends who planned, organized, presided over, and spoke at the annual women's rights conventions between 1848 and 1860, until the outbreak of the Civil War. The group included Lucretia Coffin Mott, Elizabeth Cady Stanton, Susan B. Anthony, Lucy Stone, and Antoinette Brown. Members of the extended circle included Lucretia Mott's youngest sister, Martha Coffin Wright; Lucy Stone's husband, Henry B. Blackwell; Elizabeth Cady Stanton's cousin and childhood friend, Elizabeth Smith Miller; Amelia Bloomer; and Ernestine L. Rose. Others joined the circle and played a part in the movement, but this core group, linked by friendship and familial ties, interacted intensively during the first decade of collective action.

In her description of the group meetings at her home in Seneca Falls, Stanton captures some of the members' roles as well as the dynamics of their meetings:

> Martha C. Wright, of Auburn, was a frequent visitor at the center of the rebellion, as my sequestered cottage on Locust Hill was facetiously called. She brought to these councils of war not only her own individual wisdom. . . . Lucretia Mott, too, being an occasional guest at her sister['s] . . . in Auburn, added the dignity of her presence at many of these important consultations. She was uniformly in favor of toning down our fiery pronunciamentoes. For Miss Anthony and myself, the English language had no words strong enough to express the indignation we felt in view of the prolonged injustice to woman. We found, however, that after expressing ourselves in the most vehement manner, and thus in a measure giving our feelings an outlet, we were reconciled to issue the documents at last in milder terms. If the men of the State could have known the stern rebukes, the denunciations, the wit, the irony, the sarcasm that were garnered there, and then judiciously pigeon-holed, and milder and more persuasive appeals substituted, they would have been truly thankful that they fared no worse.

> (Stanton, Anthony, and Gage 1881, 1:462)

Of course, numerous other women and many men played significant parts in the women's rights movement. A large social movement is often an alliance of collaborative circles that form separately and fuse into a loosely confederated organization (Fine and Stoeker 1993). After 1870, the core group split into two collaborative circles—one centered on Stanton and Anthony in New York, the other on Lucy Stone in Boston. However, throughout the 1850s when they formulated the women's rights vision and entered the collective action stage, the five core members functioned as a single collaborative circle. In that first decade of collective action, the members of the core circle met together, corresponded, visited one another's homes, and collaborated in writing speeches and organizing events. Each of the core members experienced the humiliation of a "baptism" into the movement by means of a public silencing, not only by conservative audiences, but by the male leaders of social reform. In carrying out the work of the movement, or sometimes just for the sake of friendship, they frequently exchanged services, resources, gifts, and intimate self-disclosures. They negotiated the elements of the women's rights vision together; and together they learned the techniques of how to organize a convention, stage an oratorical performance,

manage a petition campaign, and influence state and national governments to bring about social change.

As we have seen in other circles, and as is often characteristic of women's friendships, the strongest bonds were within pairs. Lucy Stone's strongest tie was with Antoinette Brown, who became the first woman ordained as a Congregationalist minister (Lasser and Merrill 1987). While they were students together at Oberlin College in the late 1840s, Brown idolized Stone, who was five years older. After Stone married Henry Blackwell, Brown married Henry's brother, Samuel. As sisters-in-law their friendship deepened, and it remained strong throughout their lives. As we have seen, Susan B. Anthony paired with Elizabeth Cady Stanton. Lucretia Mott's strongest bond was with her sister, Martha Wright (plates 30 and 31). A generation older than the other core members, Mott played the role of admired mentor to the whole group.

To lay the groundwork for an analysis of the collective action stage, I first examine the structural and cultural environment in which the Ultras formed. Then I briefly trace the evolution of the initial roles of members during the early stages of circle development—formation, rebellion, and quest. After laying this groundwork, I focus on how the leadership roles changed as the circle confronted the tasks of collective action. New stresses emerged during this stage, and, as in other successful collaborative circles, new roles emerged to deal with both the internal strains and the new external tasks. Finally, I examine how the strains of collective action contributed to the disintegration of the circle.

Structural and Cultural Environment of the Ultras in the 1840s

Like members of other collaborative circles, the Ultras formed out of a network of people with high aspirations who perceived themselves as marginalized. In the first half of the nineteenth century, women were blocked from participation in public life. They could not vote or hold office. They were excluded from almost all professions except teaching. When they did teach, they were paid a fraction of a man's salary, and they were excluded from equal participation in professional organizations of teachers. Few saw a need for women to be educated beyond secondary school. Religious custom forbade them from preaching in most churches. The restrictions on public speaking were generalized, so that both women and men, especially clergymen, were outraged at the very suggestion of women speaking in any public gathering of mixed gender.

Even within the network of social reformers, women were marginalized.

At the antislavery conventions and temperance meetings, women were allowed to be in the audience, and they were permitted to speak to small groups of other women. But for a woman to speak to a "promiscuous," or mixed, audience was as unacceptable as for her to sail off as captain of a whaling ship. Public speaking was seen as a "manly" activity, degrading to the women who attempted it.

Women were restricted to the domestic sphere, where they were expected to be subordinate to men—first their fathers, later their husbands. When a young woman left her father's house to marry, she came "under the protection" of her husband, which meant he had rights to all her property and earnings. If he squandered them, she had no legal recourse. If he divorced her, he had the right to custody of their children. He had a right to physically punish his wife, so long as the rod was no thicker than his thumb. She could not testify against him in court. If he died, he had the right to will two-thirds of his wealth to his children, even if it had been earned by, or originally belonged to his wife. All these restrictions were backed by law and custom, and conservative clergy buttressed them with biblical authority.

Like other circles, the Ultras formulated their revolutionary vision in a cultural environment characterized by clashing worldviews. The mid-nineteenth century was vibrant with religious revivals, political rallies, and philosophical debates. Disagreements over worldviews entered families, split generations, and eventually divided the country. During the Second Great Awakening of religious sentiment in the 1830s, the rhetoric of spirituality spread into everyday life—from the private world of courtship to the public world of politics—and it shaped the development of every member of the Ultras circle. For example, when she was eighty, Elizabeth Cady Stanton still remembered how Charles Grandison Finney "seriously influenced [her] character" in 1831, when she was a girl of fifteen attending a revival meeting in Troy, New York:

> His appearance in the pulpit on those memorable occasions is indelibly impressed on my mind. I can see him now, his great eyes rolling around the congregation and his arms flying about in the air like those of a windmill. One evening he described heaven and hell and the devil and the long procession of sinners being swept down the rapids, about to make the awful plunge into the burning depths of liquid fire below, and the rejoicing hosts in the inferno coming up to meet them with the shouts of the devils echoing through the vaulted arches. He suddenly halted, and, pointing his index finger at the supposed procession, he exclaimed: There, do you not see them!

> I was wrought up to such a pitch that I actually jumped up and gazed in the direction to which he pointed, while the picture glowed before my eyes and remained with me for months afterward. . . . Fear of the judgment seized my soul. Visions of the lost haunted my dreams. Mental anguish prostrated my health. . . . Returning home, I often at night roused my father from his slumbers to pray for me, lest I should be cast into the bottomless pit before morning.
>
> (Stanton 1993, 43)

Finney went on to become president of Oberlin College, where he set the tone while Lucy Stone and Antoinette Brown were enrolled there as students.

Both in Europe and in the United States, the implications of the rights of man ideology were still being debated. In the United States, the debates centered on the incongruity of maintaining legalized slavery in a country founded on the values of freedom, liberty, and equal rights. In the 1840s, as religious and political currents of thought converged, some of the reformers, notably William Lloyd Garrison, became lay preachers. Their approach to political change was based on a model of "moral suasion," or individual conversion. For them there could be no political solutions to slavery; slavery would have to be renounced by each individual, one at time, in the search for the soul's "perfectibility." In a speech to the American Anti-Slavery Society in May 1860, Stanton spoke of Garrison's influence on her:

> I have always regarded Garrison as the great missionary of the gospel of Jesus to this guilty nation, for he has waged an uncompromising warfare with the deadly sin of both Church and State. . . . In the darkness and gloom of a false theology, I was slowly sawing off the chains of my spiritual bondage, when for the first time, I met Garrison in London. A few bold strokes from the hammer of his truth, I was free! Only those who have lived all their lives under the dark clouds of vague, undefined fears can appreciate the joy of a doubting soul suddenly born into the kingdom of reason and free thought.
>
> (DuBois 1992, 80)

Conservative and liberal religious thinking colored the arguments of the social reformers. The liberals fused the Quaker concept of "inner light" with the rationalism of the Enlightenment; the conservatives based their positions on biblical teaching. The liberals argued for gradual change through individual persuasion, political compromise, and legislative reform. For example, they argued that slaveholders should be persuaded to

relinquish their slaves, or that money should be raised to buy slaves from their owners one at time and grant them freedom. Like Elizabeth Cady Stanton's husband, Henry Stanton, the moderates argued for building political coalitions and instituting change through federal legislation. The radicals, claiming that it was wrong to cooperate in any way with a society that condoned slavery, argued that slaves should be smuggled to freedom. Like John Brown, many argued for rebellion and war as the only means to bring about drastic structural changes.

Slavery may have been the "sin" of the nation, but drinking alcohol was the cause of "sin" in individual men, and the rhetoric of conversion and salvation pervaded discussions of alcoholism. In the 1840s, temperance meetings usually included the testimony of a reformed alcoholic, with the standard themes of loss, renunciation, and salvation. For the liberal temperance leaders, the agenda was to save alcoholics one at a time through conversion. For the radicals, the agenda was to persuade legislatures to pass laws prohibiting the sale of alcohol. The Ultras absorbed the rhetoric and strategies for change of both the abolitionists and the temperance workers.

In large and small towns, a major forum for education and entertainment was the lyceum lecture hall. The lyceum was a place where larger-than-life characters, like Ralph Waldo Emerson, Daniel Webster, Charles Grandison Finney, or William Lloyd Garrison appeared on the stage and advocated either liberal or conservative routes to individual or national salvation. The dialogue stimulated thought and challenged listeners to piece together their own views on how to save themselves and their society.

The Common Language of the Ultras
Like other circles, the core group of women in the Ultras discovered they had a common language. All the Ultras had read Mary Wollstonecraft's *Vindication of the Rights of Woman,* published in 1792. Generalizing the "rights of man" ideology to women, Wollstonecraft argued that, if women were freed from oppression and granted equality and liberty, they would acquire all the virtues of men and would accomplish as much, if not more. Building on this thinking, the Ultras saw the American experiment as incomplete. With the words of Finney and other revivalists still ringing in their ears, they saw progress and perfectibility as their moral duty.

In the 1840s, influenced by abolitionist rhetoric, some women began to see analogies between the positions of women and slaves. Slavery, like monarchy, they saw as a remnant of the feudal ages, when positions from the top to the bottom of society were based on blood relationships and biology, and legitimated by theological authority. The women went beyond

this position and argued that the institution of marriage was also a remnant of feudal bondage: just as peasants pledged loyalty to the lord of the manor in return for the lord's protection, a woman pledged obedience to her husband in return for his protection. Like slavery and monarchy, they argued, the oppression of women should be eliminated in the modern era. As Stanton wrote: "[A]bove all other causes of the Woman Suffrage Movement was the Anti-Slavery struggle in this country. The ranks of the abolitionists were composed of the most eloquent orators, the ablest logicians, men and women of the purest moral character and best minds of the nation. . . . [T]he broad principles of human rights were so exhaustively discussed, justice, liberty, and equality so clearly taught, that the women who crowded to listen, readily learned the lesson of freedom for themselves." (Stanton, Anthony, and Gage 1881, 1:53).

Women's Rights Conventions as Exhibitions of Oratorical Performance

Beginning in 1848 and continuing throughout the 1850s until their gatherings were suspended because of the Civil War, the women who would become known as the Ultras established the ritual of an annual women's rights convention. At each convention, the Ultras, along with other invited speakers, presented their arguments for change and delivered calls for action.

The annual conventions of the women's rights circle are thus analogous to the art exhibitions organized by the Impressionist circle during their collective action stage. Like works of art, the women's speeches wove together themes of injustice to women, religious imagery, American political values, and moral and legal arguments in favor of reform. Like the circle of artists, each of the women had her own style and vision, but each style was a variation of a larger group vision. Deriving their arguments from the rights of man ideology, they argued for gender equality in access to education, employment, property, divorce, child custody after divorce, and political participation. To Americans in the 1850s, the Ultras' speeches were at least as shocking as the Impressionists' paintings were to the French in the 1870s. Many came to listen to their speeches; but especially during the 1850s, many also came for the novelty of seeing these unusual women and hearing their "outrageous" performances.

News editors reviewed their performances for style and content, and they included sketches of the personalities of the speakers. For example, a reporter at the 1853 Dayton convention of the Ohio State Women's Temperance Society, a network that overlapped the women's rights movement, wrote:

To-day the Ohio State Women's Temperance Society held a meeting at this place. The attendance was not large, but was respectable, both in number and talents. . . . In the course of the meeting, two original poems were read. There were also delivered three formal addresses . . . either of which would not have dishonored any of our public orators if we consider the matter, style, or manner of delivery. Men can deal in statistics and logical deductions, but women only can describe the horrors of intemperance—can draw aside the curtain and show us the wreck it makes of domestic love and home enjoyment—can paint the anguish of the drunkard's wife and the miseries of his children.

(Stanton, Anthony, and Gage 1881, 1:120)

The performances of the members as public speakers were as important to their cause as were the details of their arguments. By daring to speak in public, the Ultras were already creating new roles for women. They learned how to speak, how to organize conventions, even how to dress in ways that advanced their cause while they were in the collective action stage. They were well aware that they were modeling what they were claiming was the right of all women: the right to step out of the "domestic sphere" and into the public sphere of men. Their moral claim on public roles depended, in part, on how well they performed at the conventions. As Amelia Bloomer recalled:

That was the early days of the woman's movement, and a woman speaking in public was a new thing outside of a Quaker meeting-house. We were the first to address an audience of New Yorkers from a public platform; and much curiosity was excited to hear and see the wonderful women who had outstepped their sphere and were turning the world upside down by preaching a new doctrine which claimed that women were human beings, endowed with inalienable rights, among which was the right to life, liberty and the pursuit of happiness.

(Bloomer 1895, 99)

The Formation of the Ultras

It was in this public setting of conventions and rallies for social reform that the members of the Ultras circle met one another. Except for Lucy Stone and Antoinette Brown, the group did not meet at a single "magnet place" to which they had been drawn by shared aspirations. Because of their exclusion from most colleges and professions, it was unlikely that women would

be drawn to such places. Instead, for the most part, the friendships among the Ultras crystallized out of their interactions at the "magnet events" of the reform network, such as the abolitionist conventions.

Stone and Brown were the exceptions. They had met when both were students at Oberlin, the first college in the country to offer a course of study for women. The bond between Lucy Stone and Antoinette Brown was at least as strong as the one that formed between Anthony and Stanton, and it predated theirs. When the twenty-year-old Brown arrived at Oberlin in 1846, she was warned by a family friend to beware of Lucy Stone, who at twenty-eight was known as "a very bright girl, but eccentric, a Garrisonian, and much too talkative on the subject of woman's rights." Nevertheless, Brown was drawn to Stone. Later she described the relationship as one of "intense admiration of a younger girl for one much more experienced and influential" (Lasser and Merrill 1987, 7, 8). In other words, at this point Stone served as a selfobject for Brown. Brown was the more conservative of the two, and she often argued with her more liberal friend about religion, politics, and women's rights. Despite their differences, they "agreed to disagree," grew close, and spent much time together discussing their dreams and providing one another support. When they were barred from taking courses on rhetoric and debate because they were women, they and several friends organized a secret debating and self-improvement society. This pattern of support continued throughout their lives, intensifying after they married two brothers from the Blackwell family and became sisters-in-law. After she became an ordained minister, Brown maintained an active role in the Ultras. As an advocate for a biblical perspective on gender and a more conciliatory approach to the clergy, she was the conservative boundary marker of the group. Stone played an actively radical role in the early 1850s, but like Renoir in the Impressionist group, as the decade wore on, she vacillated and ultimately drifted toward more moderate positions on women's issues, in part as a strategic move to win support of the public. In many ways, she played the role that Renoir called the "cork," adjusting her positions pragmatically over the course of the decade.

If the Ultras had common values and a common language of discourse, it was not because they were chosen by one or two persons who acted as gatekeepers. Abby Kelly Foster played a precipitating role in the commitment of Lucy Stone, Susan B. Anthony, and Antoinette Brown, but she was not a gatekeeper who introduced them to one another. Lucretia Mott exerted a charismatic attraction on the younger members, but because she lived in Philadelphia, she was not easily accessible to them. Garrison was present when Stanton met Mott in 1840, and he was present again when

Stanton met Anthony. But when the women met, it was not through a gate-keeper; it was because of their shared attraction to the speakers in the social reform network. By interacting in the network, the core members of the circle stumbled across one another, discovered shared concerns and aspirations, and began the interaction that led to the functioning circle.

Lucretia Mott and the Radicalization of Elizabeth Cady Stanton

Stanton met Mott in the summer of 1840 at the first World Anti-Slavery Conference in London. It was a time when Stanton was open to change. She was a twenty-four-year-old bride on her honeymoon with Henry Stanton, aged thirty-five, a delegate to the convention from New York state. With his straight back and mutton chops, Henry Stanton, though currently unemployed, had political ambitions and was known in abolitionist circles as an eloquent speaker unafraid of rowdy crowds. Elizabeth Cady Stanton, with her long brown curls, sparkling blue eyes, quick mind, and vivacious sense of humor, was the daughter of Daniel Cady, a distinguished lawyer, judge, and politician from Johnstown, New York.

Until she met Henry in September 1839, like many daughters of upper-class families, Elizabeth Cady's primary occupation had been visiting relatives and friends. Nevertheless, she saw herself as "self-assertive and defiant," and she admired women who were "full of life, energy, and fun" (Griffith 1984, 23). She met Henry while staying with her cousin on her mother's side, Gerrit Smith, an abolitionist known for supporting the Underground Railroad. Judge Cady, a conservative who abhorred radical abolitionists, opposed his daughter's engagement to this unemployed reformer. The impasse between father and daughter took shape in the late fall, and throughout the winter Elizabeth Cady was in a state of indecision and depression. But in the spring of 1840, hearing that Henry Stanton was going off to the London antislavery convention before an eight-month tour of Europe, she brashly decided to marry him. In May they married, and after visiting with Henry's closest friend from Oberlin College, Theodore Weld, and his wife, Angelina Grimke, they sailed for London. Besides the antislavery agenda, the trip was their honeymoon and a means to put distance between themselves and Judge Cady until things cooled down.

At the inn where they stayed in London they met Lucretia Mott, aged forty-seven, the senior woman delegate to the convention, and her husband, James Mott, from Philadelphia. The Motts were accompanied by several other women delegates, who, like Elizabeth Stanton, were also in their twenties. Both the Philadelphia and the New York parties shared the inn with conservative delegates, several of them ministers who favored aboli-

tion but opposed the participation of women in a convention. In most of the disputes among abolitionists, Henry Stanton sided with the conservatives. Describing the meeting with Lucretia Mott's party, Elizabeth Stanton wrote:

> [A]s my husband . . . was on that side [the conservatives], I supposed [Mott's delegation] would all have a feeling of hostility toward me. However, Mrs. Mott, in her sweet, gentle way, received me with great cordiality and courtesy, and I was seated by her side at dinner.
>
> No sooner were the viands fairly dispensed, than several Baptist ministers began to rally the ladies on having set the Abolitionists all by the ears in America, and now proposing to do the same thing in England. I soon found that the pending battle was on woman's rights, and that unwittingly I was by marriage on the wrong side.

Although Elizabeth Stanton had been "outside the world of reforms," she sympathized with the women:

> In spite of constant gentle nudgings by my husband under the table, and frowns from Mr. Birney opposite, the tantalizing tone of the conversation was too much for me to maintain silence. Calmly and skillfully Mrs. Mott parried all their attacks, now by her quiet humor turning the laugh on them, and then by her earnestness and dignity silencing their ridicule and sneers. I shall never forget the look of recognition she gave me when she saw by my remarks that I fully comprehended the problem of woman's rights and wrongs. How beautiful she looked to me that day.
>
> I always regarded a Quaker woman . . . a being above ordinary mortals. . . . I had never spoken to one before, nor been near enough to touch the hem of a garment. Mrs. Mott was to me an entire new revelation of womanhood. I sought every opportunity to be at her side, and continually plied her with questions, and I shall never cease to be grateful for the patience and seeming pleasure with which she fed my hungering soul.
>
> (Stanton, Anthony, and Gage 1881, 1:420)

Mott was well known as an inspired speaker with the ability to mesmerize an audience by speaking plainly and without notes. For the Ultras, she played a part similar to that played by Edouard Manet for the Impressionists—a controversial hero, more established than the younger members of the group, who created a new vision and new techniques that alarmed the established authorities.

Like Stanton, Mott was not much taller than five feet, but with her high forehead, luminous dark eyes, eloquent voice, and penetrating intelligence, she was charismatic. Some who knew her within Quaker circles saw her progressive views as heretical. She identified with the farmer-minister Elias Hicks, and she supported his deeply mystical views of the "inner light"—a belief that spiritual truth emerges through revelation, that the biblical stories were historically bound revelations, that the divine spirit appeared in many cultures and in every era, and that this spirit could speak now through the voices of the reformers, or from any person, male or female, who attended to the inner light. She brought this Hicksite perspective with its egalitarian view of women into the mainstream of the abolitionist movement, introducing a new style and vision into the political arena. But many did not welcome her contributions.

When Mott tried to take her seat at the convention, the conservative men, especially the clergy, objected loudly to a woman participating in a public convention. They thumped their Bibles, quoted St. Paul, and demanded that she stay in her proper sphere. Even though some delegates, such as young Wendell Phillips from New England, and Henry Stanton—ambivalent, but egged on by his wife—supported Mott, the convention voted to forbid the women to speak. The women delegates and female guests of the male delegates were allowed to stay, but only to view the assembly and hear the speakers through a gossamer screen behind a brass bar in the back of the hall. According to reporters, the "woman question" was the most interesting issue at the conference, and Lucretia Mott's place with the younger women behind the screen became a focal point of attention. Elizabeth Cady Stanton was enthralled by Mott, the "lioness of the convention," as an Irish journalist dubbed her. Though excluded, Mott was gracious, and wrote to her children: "Seeing how the thing is viewed on this side of the Atlantic, how altogether unprecedented it is for women to be admitted even by courtesy as visitors in business meetings, we were disposed to regard [being allowed to remain in the hall] as one great step in the history of reform" (Bacon 1980, 92).

When William Lloyd Garrison arrived in London five days late because of a storm at sea, he joined the women behind the screen. Editor of the *Liberator,* he was among the most liberal of the American delegates—a "come-outer"—unhesitant about attacking the clergy, opposed to political compromises, and in favor of a moral crusade to change public opinion. He favored inclusion of women in the abolitionist councils in the United States, and he stood by them in London. Henry Stanton was a member of

the anti-Garrison faction who favored a strategy of political maneuvering. His faction was against women delegates because it was not politically expedient. Nevertheless, when Garrison joined the women, Elizabeth Cady Stanton rejected her husband's position and adapted Garrison's.

Behind the screen, Garrison must have been delighted hearing Elizabeth Cady Stanton's reactions to the speakers. He wrote to his wife, "Mrs. Stanton is a fearless woman and goes for women's rights with all her soul" (27 June 1840, cited in Griffith 1984, 241). But Stanton was more interested in Mott, whom she sought out at dinner and on the tours. Mott wrote in her diary, "Elizabeth Stanton gaining daily in our affection" (Gurko 1974, 84). In her reminiscences, Stanton conveys her enthrallment:

> Seeing the lions in London together, on one occasion with a large party we visited the British Museum, where it is supposed all people go to see the wonders of the world. On entering, Mrs. Mott and myself sat down near the door to rest for a few moments, telling the party to go on, that we would follow. They accordingly explored all the departments of curiosities, supposing we were slowly following at a distance; but when they returned, after an absence of three hours, there we sat in the same spot, having seen nothing but each other, wholly absorbed in questions of theology and social life.

Relating what they discussed, Stanton continued:

> She had told me of doctrines and divisions among "Friends," of the inward light . . . of Mary Wollstonecraft, her social theories, and her demands of equality for women. I had read in . . . Mary Wollstonecraft, though . . . tabooed by orthodox teachers, but I had never heard a woman talk what, as a Scotch Presbyterian, I had scarcely dared to think.
>
> On the following Sunday I went to hear Mrs. Mott preach in a Unitarian church. Though I had never heard a woman speak, yet I had long believed she had the right to do so, and had often expressed the idea in private circles; but when at last I saw a woman rise up . . . and preach as earnestly and impressively as Mrs. Mott always did, it seemed to me like the realization of an oft repeated happy dream.
>
> (Stanton, Anthony, and Gage 1881, 1:420–21)

"Truth for authority, not authority for truth" was the motto that Mott conveyed to Stanton. Stanton was already rebelling against her father's conservative worldview; now Mott freed her to develop her own:

> When I first heard from the lips of Lucretia Mott that I had the same right to think for myself that Luther, Calvin, and John Knox had, and the same right to be guided by my convictions, and would no doubt live a higher, happier life than if guided by theirs, I felt at once a newborn sense of dignity and freedom; it was like suddenly coming into the rays of the noon-day sun after wandering with a rushlight in the caves of the earth. . . . I accepted her words of wisdom with the same confiding satisfaction that did the faithful Crito those of his beloved Socrates.
>
> (Stanton, Anthony, and Gage 1881, 1:422)

When they parted, Stanton reports, "We resolved to hold a convention as soon as we returned home, and form a society to advocate the rights of women."

But when they returned home, Elizabeth and Henry Stanton settled in Boston, set up a home, and had three boys in a little over three years between March 1842 and September 1845. Stanton corresponded several times with Mott, but mostly about religious matters. Once when Mott visited Boston, they discussed the possibility of holding a women's rights convention there, but nothing came of it.

Elizabeth Stanton had gone through a rapid transformation between 1840 and 1842—from favorite daughter to family rebel; from flirtatious dilettante to wife of an abolitionist and mother of a son; from New York social butterfly to European traveler and Boston matron; from a straight-laced Presbyterian family to the society of free thinkers, Quakers, Unitarians, and Transcendentalists. Her adult identity was beginning to crystallize, and recognizing this, she began insisting upon being called by her full name, Elizabeth Cady Stanton. All around her a network of exciting people stimulated her thinking and validated her new identity. But the undertow of the roles of wife and mother began to pull her back (plate 32).

When the Stantons returned from England, Henry studied law with Judge Cady, then attempted to establish himself as a lawyer and politician in Boston. However, Boston was Garrison's territory, and Henry, who opposed Garrison's strategies for change, did not make headway in his career. Besides, he felt, the seaport climate was not good for his health. In 1847, he decided to move his family to Seneca Falls, New York, where the competition would be less steep, the politics more congenial, and the weather, he thought, more suitable.

Henry Stanton prospered in Seneca Falls, but his wife, cut off from the intellectual stimulation of Boston, languished. With three boys ranging in

ages from two to five, she felt the constraints of home and hearth closing in. Near her home was an Irish shantytown bursting with refugees from the potato famine. With her knowledge of homeopathic medicine, Stanton became a source of aid for them. In these families she saw, as if through a distorting mirror, the oppression of women at its worst. Surrounded by sickness and poverty, without education or income, under the "protection" of their heavy-drinking husbands, the Irish women had to function without resources they could call their own. The most abusive drunk could lord it over his wife. For Elizabeth Cady Stanton, the Irish women were living illustrations of what was wrong with women's lives. But there were not many people in Seneca Falls with whom she could discuss her thoughts and feelings.

The First Meeting of the Ultras

As we have seen with other groups, at various points in the development of a circle, the members seem to be ripe for an escalation of commitment. Such a moment occurred for both Mott and Stanton in the summer of 1848. In late June, Lucretia and James Mott traveled from Philadelphia to the Genesee Region Quaker Yearly Meeting in western New York. While in the area, they planned to visit Lucretia's sister, Martha Wright, who lived in Auburn. Mott also may have hoped to visit Elizabeth Cady Stanton, whose home in Seneca Falls was not far from Martha's.

On the journey, several encounters may have prepared Mott for Stanton's state of mind. Because Lucretia and James Mott were on the Indian Affairs Committee of the Philadelphia Meeting, they stopped to observe the community on the Seneca reservation in Cattaraugus. After their defeat during the Revolutionary War, the Seneca were demoralized, and alcoholism became common among the men. Prior to their defeat, the Seneca men had seen farming as women's work, but now farming was all that was open to them. To assist them in the transition, Quakers from Philadelphia had set up a school and a model farm (Bacon 1980; Wallace 1972). In other words, the Quakers sought to encourage gender role change. In a letter to a friend, Lucretia Mott reported her observations of the Strawberry Dance and noted other signs of cultural renewal and political activity among the Seneca. Associating the ferment with the social change in Europe during 1848, she wrote: "[The Seneca] too are learning somewhat from the political agitations abroad, and as a man is wont, are imitating the movements of France and all Europe in seeking a larger liberty—more independence" (quoted in Bacon 1980, 125).

Other encounters heightened Mott's sensitivity to issues of social change

and personal development. After leaving the reservation, she and her husband visited several settlements of escaped slaves. Mott was impressed by the energy the former slaves brought to developing their farms and by their determination to educate their children. "The Spirit of freedom is arousing the world," she wrote. The Motts continued on to the Genesee Region Meeting, and on the way home, they stopped to visit Mott's sister Martha and her husband, David, a lawyer.

Martha was Lucretia Mott's youngest sister. As a young girl of eighteen, she had fallen in love and eloped to Florida with one of her mother's borders, an army captain. She had a child and returned to live with her mother. Consequently, she was disowned by the Quaker meeting. Even after her first husband died the next year, she never rejoined the Quakers. She married David Wright, moved to Auburn, and had six more children. Like Stanton, she was skeptical of organized religion. Nevertheless, Martha, who was described as "warm and humorous," looked up to Lucretia, the respected Quaker minister and eldest daughter in the family. While Mott was visiting Wright, Jane Hunt, a Hicksite Quaker from nearby Waterloo, stopped by to invite the two sisters for tea. Jane Hunt was the fourth wife of Richard Hunt, who owned a large block of property and a Woolen Mill in Waterloo. The Hunts lived in the largest mansion in town (Griffith 1984). Hunt told Mott that her friend, Elizabeth Cady Stanton, would also be coming, along with Ann McClintock, wife of Thomas McClintock, the minister of the Hicksite Quaker meeting in Waterloo for twenty-five years. Ann McClintock was the sister of Richard Hunt's deceased third wife. McClintock's husband was a druggist, and his store was on land owned by Richard Hunt. Except for Stanton, the group coming together for tea were linked by Quaker values and family ties.

Of course, it is impossible to reconstruct the conversation at Jane Hunt's home, but it is possible to make a reasonable guess as to how it unfolded and the roles that members played. Most likely Jane Hunt played the proper hostess, and McClintock, whose husband rented his drug store from Richard Hunt, may have deferred to both Hunt and Mott. But as an influential local Quaker, she would have taken an active part in the discussion. Mott was the oldest and most widely known, and she also had the most experience as a reformer. Wright had no previous experience with social reform. Stanton was the youngest. Like Mott, her travels gave her some status, but in religion, age, and family connections, Stanton was the most peripheral member. Knowing of Stanton's situation in Seneca Falls through their correspondence, Mott may have initiated her invitation to the tea to help her meet people in the area.

The three Hicksite Quakers had just returned from yearly meeting, and the issues they'd discussed must have still been on their minds. One of the most pressing was the question of how the Quakers could work with Native Americans, who were still adjusting to the upheavals in their lives in the decades since the Revolutionary War. Mott's observations at the Cattaraugus reservation were fresh, so most likely she had spoken at the meeting about the changes she saw there. Like the Irish families that Stanton observed, the Native American women frequently dealt with alcoholism in the men, who resisted the gender role changes required to take up farming. Perhaps at the afternoon tea, Mott and Stanton exchanged opinions about these issues.

Another issue at the Genesee Region Yearly Meeting had been whether a regular attendee to a Quaker meeting who was not a full member should be allowed to participate in a business meeting. This perennial issue in Quaker meetings may have evoked in Mott memories of the exclusion of women at the London meeting of the World Anti-Slavery Society.

Regardless of how the conversation unfolded, and regardless of who dominated, Stanton reported that at some point her distress disrupted the interaction. Her energy, intelligence, and sense of humor usually lit up social gatherings, but on this occasion she was in a state of depression. In her autobiography she reports that during her first year in Seneca Falls, she felt for the first time the oppression of women's roles:

> I now fully understood the practical difficulties most women had to contend with in the isolated household, and the impossibility of woman's best development if in contact, the chief part of her life, with servants and children. . . . My experience at the World's Anti-slavery Convention, all I had read of the legal status of women, and the oppression I saw everywhere, together swept across my soul, intensified now by my personal experience. I poured out . . . the torrent of my long-accumulating discontent, and with such vehemence and indignation that I stirred myself.
>
> (Stanton 1993, 147–48)

The Quakers were clearly primed for social action. Mott and Stanton must have discussed their earlier dream of calling their own convention. Stanton wrote that her discontent "moved us all to prompt action, and we decided, then and there, to call a Woman's Rights Convention." They wrote the advertisement that evening and published it the next day, Friday, 14 July, in the *Seneca County Courier,* a semiweekly journal, giving only five days advance notice:

Woman's Rights Convention.—A Convention to discuss the social, civil, and religious condition and rights of woman, will be held in the Wesleyan Chapel, at Seneca Falls, N.Y., on Wednesday and Thursday, the 19th and 20th of July, current; commencing at 10 o'clock A.M. During the first day the meeting will be exclusively for women, who are earnestly invited to attend. The public generally are invited to be present on the second day, when Lucretia Mott, of Philadelphia, and other ladies and gentlemen, will address the convention.

(Stanton, Anthony, and Gage 1881, 1:67)

Perhaps Hunt and McClintock used their influence in the area to have the notice published overnight as well as to obtain approval to meet at the Seneca Falls Methodist Church.

The plan was impulsive, to say the least. After eight years of inaction, Mott and Stanton suddenly decided to hold a convention the next week in the remote town of Seneca Falls. Regardless of who suggested it, Lucretia Mott, the most well known and the only identified speaker in the notice, would have had to approve. Like many circles in the early stages of development, at this point no one cared who had the idea first. Ideas emerged out of the dynamics of the interaction. None of the members would have initiated the plan alone, but because they were together, they had the courage to carry out the "wild" scheme. Not only was the timing audacious and the focus revolutionary, but the mere thought of women organizing a convention for a mixed audience was considered outrageous. Like the Impressionists when they decided to break away from the jury system and organize their own exhibition, the women were ready to commit themselves to a vision and to each other.

On Sunday morning, they met in Ann McClintock's parlor "to write their declaration, resolutions, and to consider subjects for speeches." Stanton later remarked on how overwhelming it felt to step into these masculine roles: "On the first attempt to frame a resolution, they felt as helpless and as hopeless as if they had been suddenly asked to construct a steam engine." They examined "masculine" models of reports from antislavery, peace, and temperance conventions, but all seemed too tame for the "inauguration of a rebellion such as the world had never seen before." When telling about the creative idea of linking their demands to sacred American symbols by borrowing the rhetoric of the Declaration of Independence, once again Stanton does not take or give credit: "After much delay, one of the circle took up the Declaration of 1776, and read it aloud with much spirit and emphasis,

and it was at once decided to adopt the historic document" (Stanton, Anthony, and Gage 1881, 1:68).

When they told this story in their history of the women's movement, Stanton and Anthony knew they were constructing a legend that would anchor the founding of the movement in their immediate circle. Yet there is a ring of truth to the description of the atmosphere of the group: a mix of excitement, impish delinquency, and fun, with suggestions and reactions cascading forth, and dramatic readings mocking the tameness of the "masculine" approach. In her humorous account of the ending of the meeting, it sounds as if Stanton had regained her vivaciousness and set a different tone:

> Knowing that women must have more to complain of than men under any circumstances possibly could, and seeing the Fathers had eighteen grievances, a protracted search was made through statute books, church usages, and the customs of society to find that exact number. Several well-disposed men assisted in collecting the grievances, until with announcement of the eighteenth, the women felt they had enough to go before the world with a good case. One youthful lord remarked, "Your grievances must be grievous indeed, when you are obliged to go to books in order to find them out."
>
> (Stanton, Anthony, and Gage 1881, 1:69)

In this initial meeting, Stanton forged a role in the group that she played throughout the circle's life course. Her charismatic appeal galvanized the group into action, but equally important, once she had mobilized the group she took on the role of radical boundary marker. While the other members of the group thought it was radical enough to demand equal access to education and freedom from archaic laws of property and inheritance, Stanton went further—she proposed that they demand the right to vote. Even Lucretia Mott, who had often stepped beyond conventional limits, hesitated. It will "make us look ridiculous," she argued. Henry Stanton, the budding politician, claimed the demand for suffrage would turn the convention into a farce, and because of that demand, he refused to attend and actually left town. The other women feared the outrageous demand would undermine support for the less controversial ones. But Stanton insisted, and the demand for voting rights stayed. She argued that, without the right to vote, all of the demands would depend upon the whims of men. Rather than being established and protected from a base of political power, the rights would be granted by a ruling class that might one day take them away. Later Stan-

ton claimed to base her boundary testing on a strategy learned from Daniel O'Connell, the Irish leader, whom she met in London in 1840 (Griffith 1984): "Always ask for more than you want, and they will be happy to give you less." She seized the role of radical boundary marker in those initial meetings, and she maintained it to the end of her life.

Developing Performance Skills

The Seneca Falls newspaper was not widely circulated, and the women gave only five days notice, yet the convention drew more than three hundred people. Because the organizers felt no woman was prepared for the role of chair, James Mott chaired the first convention in Seneca Falls. No less a figure than Frederick Douglas came down from Rochester to speak in support of the vote for women "in a long, argumentative and eloquent appeal," stating that "as for himself, he should not dare claim a right that he would not concede to woman" (Stanton, Anthony, and Gage 1881, 1:87).

The women quickly shed the scaffolding that the men's guidance provided for their meeting. Rather than rely on the men, they established a norm of teaching one another how to perform on the floor of the conventions. The minutes of their meetings provide numerous episodes of their socializing one another into the roles of speakers and officers. For example, two weeks after the Seneca Falls convention was temporarily adjourned, it was reconvened at the Unitarian church in Rochester, New York, and the women nominated Abigail Bush as president. Mott, Stanton, and McClintock all opposed a woman president and argued for a man. Stanton argued for James Mott again: "[W]ith such feeble voices and timid manners, without the slightest knowledge of Cushing's Manual, or the least experience in public meetings, how could a woman preside?" But after a debate, the majority approved Bush. Still, as the secretary read the minutes of the preliminary meeting, the audience complained about the quiet voices and shouted, "Louder, louder!" Abigail Bush called the meeting to order: "Friends, we present ourselves here before you, as an oppressed class, with trembling frames and faltering tongues, and we do not expect to be able to speak so as to be heard at first, but we trust we shall have the sympathy of the audience, and that you will bear with our weakness now in the infancy of the movement" (Stanton, Anthony, and Gage 1881, 1:75, 76).

When the secretary still could not be heard, Sarah Anthony Burtis, "an experienced Quaker school teacher, whose voice had been well trained in her profession," volunteered to read the reports. Burtis must have spoken with the authority of a teacher addressing those not paying attention in the back of the class. She modeled a style that others soon adopted. A month af-

ter the convention, Stanton wrote to Amy Post, one of the organizers, apologizing for opposing a woman as chair: "I have so often regretted my foolish conduct. My only excuse is that woman has been so little accustomed to act in a public capacity that she does not always know what is due" (Griffith 1984, 59).

From the first to the last, Elizabeth Cady Stanton's speeches were brilliant. She not only stretched the agenda for women with her bold leadership, she brought to that agenda an eloquence that is engaging more than 150 years later. Even her first speech at the Seneca Falls convention demonstrated these abilities:

> We are assembled to protest against a form of government, existing without the consent of the governed—to declare our right to be free as man is free, to be represented in the government which we are taxed to support, to have such disgraceful laws as give man the power to chastise and imprison his wife, to take the wages which she earns, the property which she inherits, and in case of separation, the children of her love; laws which make her the mere dependent on his bounty. . . . The world has never yet seen a truly great and virtuous nation, because in the degradation of woman the very foundations of life are poisoned at their source. . . . So long as your women are slaves you may throw your colleges and churches to the winds.
>
> (DuBois 1992, 35)

Stanton's Role Conflict

After the convention, the demands of Stanton's family roles closed in once again. Lucretia Mott invited her to come to Philadelphia to organize a convention there, but she could not find the time to go. Perhaps she lacked the motivation for organizational work, but more likely family responsibilities constrained her. As Griffith (1984, 63) points out, unlike Mott, who had relatives and staff to run her household when she was traveling, Stanton was a middle-class housewife. Her responsibilities included "shopping, cooking, preserving, sewing, schooling, and healing." She was torn between the demands of her family and her public life. In addition to the three boys, she had two more children in February 1851 and October 1852. Later in the decade, in 1856 and 1859, she had two more. With his political activities in Albany and New York, her husband was away from home ten months out of the year. Throughout the 1850s, family obligations pulled Stanton away from full participation in the movement.

Beginning in 1849, Stanton did find the time to write letters to conven-

tions and articles for publication under the pseudonym "Sunflower" in Amelia Bloomer's recently launched paper, the *Lily*. Ohio held a state constitutional convention in 1850, and in an attempt to influence the deliberations some women organized a women's rights convention in Salem, Ohio. Stanton sent a letter to that convention and another to a second convention held in Akron, Ohio. In the fall of 1850, she also sent a letter to the First National Woman's Rights Convention organized by Lucy Stone and Paulina Wright Davis in Worcester, Massachusetts. However, she did not attend these or any other conventions that occurred in the 1850s. She might have drifted away from the movement if it had not been for the entry of Susan B. Anthony into her life (plate 33).

The Radicalization of Susan B. Anthony
In the spring of 1848, while Stanton was languishing in Seneca Falls, not far away in Canajoharie, New York, Susan B. Anthony, aged twenty-nine, was burning out after a decade of teaching. In May 1848, she wrote to her parents: "I have a pleasant school of 20 scholars, but I have had to manufacture the interest duty compels me to exhibit. . . . [E]nergy and something to stimulate is lacking . . . a weariness has come over me that the spring vacation did not in the least dispel. . . . I am out of sorts with the world" (Barry 1988, 50).

Looking for something more, Anthony was stirred by the talk of social reform, especially among the Quakers who visited her father's farmhouse that summer in Rochester. When she returned to teaching in Canajoharie in the fall, encouraged by her father, she joined the Daughters of Temperance, a women's auxiliary to the Sons of Temperance. In October she wrote to her mother: "Reform must be the watchword. I am tired of theory. I want to hear how we must act to have a happier and more glorious world" (Barry 1988, 50).

In her letters to her parents and in her first public speech in the spring of 1849, she revealed a sensitivity to women's issues, but at this point her concerns were limited to women as victims of men's intemperance:

> We would that some means were devised, by which our Brothers and Sons shall no longer be allured from the right by corrupting influence of the fashionable sippings of wine and brandy, those sure destroyers of Mental and Moral Worth, and by which our Sisters and Daughters shall no longer be exposed to the vile airs of the gentlemanly-appearing, gallant but really half-inebriated seducer. . . . [W]e still behold some of our thoughtless female friends whirling in the giddy dance, with

intoxicated partners at their side and . . . see them accompany their reeling companion to some secluded nook. . . . [Y]ou would be most happy to speed on the time when no Wife shall watch with trembling heart and tearful eye the slow, but sure decent of her idolized Companion down the loathsome haunts of drunkenness . . . no Mother shall have to mourn over a darling son. . . . How is this great change to be wrought, who are to urge on this vast work of reform? Shall it not be women, who are most aggrieved by the foul destroyer's inroads? Most certainly.

(Harper 1898, 53–54)

Anthony left teaching in the summer of 1849, returning home to work on her father's farm and becoming more and more involved with the network of social reformers in Rochester. She knew of the fledgling women's movement, and although she was not inclined to join it, she was well connected to many of the participants. Her father, mother, and sister, Mary, had attended the August 1848 women's convention in Rochester, and they all signed the Declaration of Sentiments. Every woman mentioned as an officer of the 1848 Rochester convention was a member of the Quaker network that gathered at the Anthony home for Sunday discussions. All of these families—the Posts, Hallowells, DeGarmos, Fishes, Stebbens, Burtises, and the Anthonys—had left the more conservative branch of the Quakers who opposed the agitation of the abolitionists, and all were now members of the Unitarian church that hosted the convention. Sarah Anthony Burtis, the model speaker at the Rochester convention, was Susan B. Anthony's cousin. William Lloyd Garrison occasionally visited the Anthony home, along with Wendell Phillips, Parker Pillsbury, and William Henry Channing, the new minister of the Rochester Unitarian church. Their discussions ranged across all the reform issues: abolition, temperance, and women's rights.

Nevertheless, for Anthony at this point the temperance issue was enough. In 1850 she was elected president of the Rochester Daughters of Temperance. Over the next year she organized temperance societies in the towns around Rochester, and she instituted suppers and festivals to raise funds. At a meeting in Albany that she attended as a delegate of the Rochester meeting, she met Amelia Bloomer, the delegate from Seneca Falls.

The talk of the reformers continued to stimulate Anthony, and by December of 1850, she was ready to listen to arguments that she should join forces with them. That winter she seemed to drift through the reform network. Abby Kelly Foster, the Quaker abolitionist, came through Rochester

in December and persuaded Anthony to accompany her and her husband, Stephen S. Foster, for a week on their speaking tour of surrounding counties.

In May 1851, Anthony went to Syracuse to hear Garrison and George Thompson, the English abolitionist, speak at the annual antislavery convention. Coincidentally, Thompson had spoken at the abolitionist convention in London in 1840, where Elizabeth Cady Stanton had first met Lucretia Mott. While in Syracuse, Anthony ran into her friend Amelia Bloomer. Bloomer invited Anthony to visit her in Seneca Falls on the way home; there she could hear Garrison and Thompson speak once again at their next stop. Susan went, heard the speakers, and as she and her friend walked back to Bloomer's home, they met Elizabeth Cady Stanton, who was leading the speakers back to her home. As Bloomer remembered the occasion: "Returning from the meeting, we stopped at the street corner and waited for Mrs. Stanton, and I gave the introduction. . . . Afterward we called together at Mrs. Stanton's house and the way was opened for future intercourse between them" (Bloomer 1895, 54). Stanton gives her account of the meeting:

> It was in the month of May, of 1851, that I first met Miss Anthony. That was to both of us an eventful meeting, that in a measure henceforth shaped our lives. . . . George Thompson and William Lloyd Garrison having announced an anti-slavery meeting in Seneca Falls, Miss Anthony came to attend it. These gentlemen were my guests. Walking home after the adjournment, we met Mrs. Bloomer and Miss Anthony on the corner of the street waiting to greet us. There she stood with her good earnest face and genial smile, dressed in gray silk, hat and all the same color, relieved with pale blue ribbons, the perfection of neatness and sobriety. I liked her thoroughly, and why I did not at once invite her home with me to dinner, I do not know. . . . I suppose my mind was full of what I heard, or my coming dinner, or the probable behavior of three mischievous boys who had been busily exploring the premises while I was at the meeting.
>
> (Stanton, Anthony, and Gage 1881, 1:457)

Anthony's Commitment to the Ultras

Stanton's consciousness of Anthony's dress is significant. Stanton herself was wearing a bloomer dress, and so was Amelia Bloomer. Anthony's growing commitment to the Ultras can be traced in her gradual acceptance of this dress that, for a brief time, became their emblem. Stanton's cousin and

lifelong friend, Elizabeth Smith Miller, had introduced the women to this practical new style. Miller had seen it worn by residents at a health spa in Switzerland, and when she returned home, she designed one for herself. She wore it to visit Stanton and persuaded her to have one made. Amelia Bloomer published the plans for one in her paper, and because of her advocacy, the style was named after her. The women who cut their hair into a bob and wore the dress—a calf-length smock over a pair of ruffled pantaloons pegged with a ruffle at the ankle—were the "Ultras" of 1851. The style announced that they were modern women, not squeezed into corsets to look attractive to men, not weighted down by hoops and skirts that had to be lifted to ascend stairs and curbs, but free as men to work and to walk where they pleased. But when Anthony first saw the dress, she was not impressed.

That summer Stanton invited Anthony to visit along with Lucy Stone and Horace Greeley, the editor of the *New York Tribune,* to discuss the charter of a People's College that was being considered by the New York State Legislature. During the meeting, the three women argued for opening the college to women. Greeley supported the idea, but he asked them to delay the gender issue until the college was approved, then he would advocate it when the timing was right. This meeting was Anthony's first with Lucy Stone (plate 34), and it was the beginning of her friendship with both Stone and Stanton. As Ida Harper noted in her biography of Anthony: "These women who sat at the dinner-table that day were destined to be recorded in history for all time as the three central figures in the great movement for equal rights. There was certainly nothing formidable in the appearance of the trio: Miss Anthony a quiet, dignified Quaker girl; Mrs. Stanton a plump, jolly, youthful matron, scarcely five feet high; and Lucy Stone a petite, soft-voiced young woman who seemed better fitted for caresses than for the hard buffetings of the world" (Harper 1898, 64).

Amelia Bloomer stopped in while the group was meeting. She wore the bloomer dress, and Lucy Stone admired it. When Stone returned home to Massachusetts, she had one made for herself. Anthony still was not interested.

After the meeting, Stanton invited Anthony to stay over a few days. Stanton had a three-month-old son, her fourth child, Theodore. It was probably during this visit that Anthony was initiated into the "Aunt Susan" role that she played in the Stanton household for the next twenty-five years—helping with child care and housework. The outcome of the visit was that Stanton and Anthony became fast friends. Anthony visited again over that summer, and they corresponded throughout the fall. But Anthony still was

not as radical as Stanton, and her continued refusal to adopt the bloomer reflected her more cautious outlook.

In the fall of 1851, Anthony's reform activities were still limited to temperance issues. However, the events that unfolded in the winter of 1852 suggest that, encouraged by Stanton, she began to challenge the subordinate roles of women in the Temperance Society. In January, she attended the New York Sons of Temperance convention in Albany, going as a delegate from the Rochester "Daughters." As was customary, women were expected to sit in silence. In the midst of the meeting, Anthony rose to speak to a motion. When she was informed by the presiding officer that "the sisters were not invited there to speak but to listen and learn," she and a few other women walked out of the hall. The women who remained characterized them as "bold, meddlesome disturbers."

Given how spontaneously events unfolded over the next day, it is unlikely that Anthony had planned this rebellion, but nevertheless the walkout must have been an outcome of her discussions with Stanton. The rebels sought advice from Lydia Mott, James Mott's relative in Albany, who advised them to hold their own meeting. They obtained permission to meet in the lecture hall of a Presbyterian church, then went to the offices of the *Evening Journal* and told their story to the editor, Thurlow Weed. Weed supported their actions, wrote a story about how the men had silenced them, and announced that the Daughters would hold their own meeting in the Hudson Street Presbyterian Church. He sent a reporter to cover it.

It snowed that night, the lecture hall was dark, the stovepipe leaked smoke, and in the middle of the meeting the pipe fell down. But the women carried on. Samuel May, the Unitarian minister from Syracuse, and Martha Wright's husband, David, were in town, and seeing the announcement, they came to offer assistance. May opened the gathering with a prayer and showed the women how to organize a meeting. Anthony read a letter from Stanton that she had intended to read at the "Sons" meeting. Several of the women considered it too radical for their tastes. She also read letters from Bloomer and Clarina Howard Nichols. Anthony argued that the men's treatment of the women indicated that the time had come for women to have an organization of their own. The outcome of their meeting was the appointment of a committee to call the first convention of the Women's State Temperance Society. They chose Anthony as chair. Afterward, Clarina Howard Nichols wrote to her: "It is most invigorating to watch the development of a woman in the work of humanity: first, anxious for the cause and depressed with a sense of her own inability; next, partial success of

timid efforts creating a hope; next, a faith; and then the fruition of complete self-devotion. Such will be your history" (Harper 1898, 66).

The Division of Labor in the Stanton-Anthony Collaborative Pair

Over the next few months, Anthony and Stanton negotiated an interdependence that proved the foundation of their relationship for the next forty years. Anthony wrote, inviting Stanton to join the new women's temperance organization, and she made two requests. First, she asked Stanton to write a speech for her. Stanton replied:

> I will gladly do all in my power to help you. Come and stay with me and I will write the best lecture I can for you. I have no doubt a little practice will make you an admirable speaker. Dress loosely, take a great deal of exercise, be particular about your diet and sleep enough. The body has great influence on the mind. In your meetings, if attacked, be cool and good-natured, for if you are simple and truth-loving no sophistry can confound you.

Second, Anthony asked Stanton to be president of the association that Anthony was organizing. Stanton wrote back: "As for my own address, if I am to be president it ought perhaps to be sent out with the stamp of the convention, but as anything from my pen is necessarily radical no one may wish to share with the odium of what I may choose to say. If so, I am ready to stand alone. I never write to please any one . . . to claim my highest convictions of truth is always my sole object" (2 April 1852, in DuBois 1992, 54, 55).

The structure of the friendship had now been set. By her request, Anthony had conveyed her deference to "Mrs. Stanton," as she addressed her in all correspondence throughout their lives. She would do the work of organizing the convention, but because she lacked confidence in her writing and speaking, she asked Stanton to write the speeches for both of them and to preside over the meeting. Stanton, caught between her familial roles and her commitment to public life, found the invitation enticing. Long afterward, looking back, Stanton wrote:

> It is often said by those who know Miss Anthony best, that she has been my good angel, always pushing and guiding me to work, that but for her pertinacity I should never have accomplished the little I have; and on the other hand, it has been said that I forged the thunderbolts and she fired them. Perhaps all this is in a measure true. With the cares of a large family, I might in time, like too many women, have

become wholly absorbed in a narrow family selfishness, had not my friend been continually exploring new fields for missionary labors.

<div style="text-align:right">(Stanton, Anthony, and Gage 1881, 1:458)</div>

Stanton, the intellectual, writer, and public speaker, developed the vision for the movement. While Anthony saw a piece of the puzzle, Stanton saw the whole landscape. Going beyond Anthony's focus on the vulnerability of wives to alcoholic husbands, she developed a more broadly framed analysis of all the injustices inherent in women's roles. In addition, Stanton was a gifted speech writer. On numerous occasions throughout the 1850s, Stanton wrote the speeches and Anthony delivered them. As Ida Harper notes: "The readers of history never will be able to separate Miss Anthony's addresses from Mrs. Stanton's: they themselves scarcely could do it. Some of the strongest ever written by either were prepared without the assistance of the other, but most of their resolutions, memorials, and speeches were the joint work of both. Miss Anthony always said, Mrs. Stanton is my sentence maker, my pen artist" (Harper 1898, 187).

After the Stanton children were put to bed, Anthony and Stanton would stay up discussing a speech. In her autobiography Stanton (1993) claims that the earliest memories of her children are of their mother and Aunt Susan sitting at the table in the evening surrounded by papers. Stanton's daughter, Harriet, confirms this observation (Blatch and Lutz 1940). Next morning, Anthony would care for the children while Stanton wrote the speech. After finishing Anthony's speech, Stanton often wrote a letter from herself for Anthony to read at the convention. As Henry Stanton observed, "Susan stirred up the pudding, Elizabeth stirred up Susan, then Susan stirred up the whole state" (Griffith 1984, 74).

Later on, as the relationship evolved during the 1860s and 1870s, Anthony played a more active part in writing her own speeches, and Stanton became more active as a public speaker. But throughout the 1850s, Stanton forged the "thunderbolts" and Anthony delivered them at the temperance conventions, at the annual teachers' conventions, at the women's rights conventions, and on her tours to organize the movement. An exchange in June 1856 conveys the dynamics of the relationship. On 5 June, Anthony wrote to Stanton:

[A]s the Lord knows full well, if I get all the time the world has, I can't get up a decent document. So, for the love of me and for the saving of the reputation of womanhood, I beg you, with one baby on your knee and another at your feet, and four boys whistling, buzzing, hollering Ma, Ma, set yourself about the work. It is of small moment who writes

the Address, but of vast moment that it be well done. I promise you to work hard . . . to pay you whatever you say for your time and brains, . . . don't delay . . . for I must have it all done and almost commit it to memory. . . . Now will you load my gun, leaving me only to pull the trigger and let fly the powder and ball?

<div align="right">(DuBois 1978, 61)</div>

On 10 June, Stanton, tending her sixth child, replied: "Your servant is not dead but liveth. Imagine me, day in and day out, watching, bathing, dressing, nursing, and promenading the precious contents of a little crib in the corner of the room. I pace up and down these two chambers of mine like a caged lioness. . . . I will do what I can to help you with your lecture" (DuBois 1978, 63).

The actual writing process was a collaborative one. For most of the first decade of their friendship, Anthony did the research, "Mrs. Stanton" wrote the drafts, then Anthony critiqued them. As we have observed in other collaborative pairs, the dynamics of the relationship released the creative energies of both women. As Stanton told it:

We were at once fast friends, in thought and sympathy we were one, and in the division of labor we exactly complemented each other. In writing we did better work together than either could alone. While she is slow and analytical in composition, I am rapid and synthetic. I am the better writer, she the better critic. She supplied the facts and statistics, I the philosophy and rhetoric, and together we have made arguments that have stood unshaken by the storms of thirty long years. . . . Our speeches may be considered the united product of our two brains.

<div align="right">(Stanton, Anthony, and Gage 1881, 1:469)</div>

Harper's assessment echoes Stanton's:

No one can excel Miss Anthony in logic of thought or rigor of expression; no one is so thoroughly supplied with facts statistics and arguments, but she finds it difficult and distasteful to put them into written form. When, however, some one else has taken her wonderful stock of material and reduced it to shape, she is a perfect critic. Her ear is as carefully attuned to the correct balance of words as that of a skilled musician to harmony in music. She will detect instantly a weak spot in a sentence of a paragraph and never fail to suggest the exact word or phrase needed to give it poise and strength.

<div align="right">(Harper 1898, 187)</div>

Looking back much later, Anthony wrote about that era in her life: "I never expect to know any joy in this world equal to that of going up and down the land engaging halls and circulating Mrs. Stanton's speeches. If I ever had any inspiration, she has given it to me" (DuBois 1978, 190).

A final component of the relationship was Stanton's ambivalence. She was caught between the demands of her family and Anthony's demands for her participation in the movement. Although she often welcomed "Aunt Susan's" visits, and even added a room to her home for Anthony, she resisted the degree of involvement that Anthony demanded. Some biographers (e.g., Griffith 1984) suggest that, as Stanton got older, she spent much time with her children in Europe in part to create distance between herself and Anthony. Even as the relationship was forming, the ambivalence was present. The convention of the first Women's State Temperance Society, which Stanton had agreed to chair, was scheduled for 22 April 1852. As late as 2 April, Stanton was threatening to back out because of family commitments: "I have been re-reading the report of the London convention of 1840. How thoroughly humiliating it was to us! . . . Men and angels give me patience! I am at the boiling point! . . . Susan! Susan! Susan! You must arrange to spend a week with me before the Rochester Convention, for I am afraid that I cannot attend it; I have so much with all three boys on my hands" (DuBois 1992, 54).

Although she resisted Anthony's demands for public appearances, her personal commitment to Anthony was deepening. Not only did she share the memories of her humiliation at the London convention, but she disclosed her private assessments of members of the inner circle: "[D]o not let the conservative element control. For instance, you must take Mrs. Bloomer's suggestions with great caution, for she has not the spirit of the true reformer. At the first women's rights convention, but four years ago, she stood aloof and laughed at us. It was only with great effort and patience that she has been brought up to her present position. Come and stay with me and I will write the best lecture I can for you" (DuBois 1992, 54).

In the end, Stanton did preside over the first Women's Temperance Society convention. As she had warned, she spoke as an "Ultra" when she delivered her presidential address. She had her hair cut short, and she wore her bloomer dress, "rich black satin . . . full skirt falling six or eight inches below the knee, plain wide trousers of the same material, and black congress gaiters" (Barry 1988, 68). Ida Harper wrote, "In accepting the presidency, Mrs. Stanton made a powerful speech, certain parts of which acted as a bombshell not only at this meeting, but in press, pulpit and society" (Harper 1898, 67). The bombshells were her attacks on the ministry and her

advocacy of divorce. Drawing parallels between the constraints of marriage and slavery, she saw divorce as an "underground railroad to Canada" for women oppressed by marriage. Women as well as men were outraged at her broadsides against the family and the church. Among the few women who supported her radical agenda were those whom I have identified as the core circle: Lucretia Mott, Susan B. Anthony, Lucy Stone, and Martha Wright. However, Antoinette Brown, the conservative boundary marker, did not support her.

The alliance between Anthony and Stanton was now firm. Having gained ground on the temperance front, they plotted their next moves. As Stanton described it:

> Night after night by an old-fashioned fireplace we plotted and planned the coming agitation, how, when, and where each entering wedge could be driven, by which woman might be recognized, and her rights secured. Speedily the state was aflame with disturbances in temperance and teacher's conventions, and the press heralded the news far and near that women delegates had suddenly appeared demanding admission in men's conventions; that their rights had been hotly contended session after session, by liberal men on one side, the clergy and learned professors on the other.
>
> (Stanton 1881, 459)

In June 1852, following the first women's temperance convention in April, Anthony and Bloomer attended the Men's State Temperance Society as representatives of the new Women's Society. Although the women had received an invitation, the men were divided about whether to admit them. When the women attempted to take their seats on the platform, the Reverend Mr. Mandeville, one of the clergy already seated on the platform, turned his chair to glare at them. With his back to the audience, he stuck out his chin, and attempted to stare them "out of countenance." When the secretary welcomed the women, Mandeville jumped to his feet and denounced them as a "hybrid species, half man and half woman, belonging to neither sex" (Harper 1898, 70). Ultimately the women were excluded from participating in the meeting, and supported by liberal clergy, they walked out and once again convened a meeting at a different church hall. Anthony read a speech written by Stanton, and Bloomer delivered the address intended for the men's group.

Anthony was exhilarated by her experiences over the previous months, and she was well aware of how the circle was transforming her. Soon afterward she wrote to her father: "I feel there is great work to be done which

none but women can do. How I wish I could be daily associated with those whose ideas are in advance of my own, it would enable me to develop so much faster" (Harper 1898, 70).

In the summer of 1852, Anthony accelerated her organizational efforts. She canvassed thirty counties, forming women's temperance societies and obtaining signatures for a petition for a New York version of the "Maine law" prohibiting the sale of alcohol. Her socialization into the circle had taught her that petitions were one way women could vote. At age thirty-two, she was honing her skills at canvassing the state, organizing groups, and planning conventions. While Stanton was a genius at expressing women's issues, Anthony was evolving into a genius at building a political organization. The opening line of her appeal that summer, though most likely written by Stanton, conveys Anthony's readiness to break out of her limited focus on domestic issues: "Women, and mothers in particular, should feel it their right and duty to extend their influence beyond the circumference of the home circle, and to say what circumstances shall surround children when they go forth from under the watchful guardianship of the mother's love" (Harper 1898, 71).

In May 1852, a month after the first Women's Temperance Society meeting at which Stanton had presided, Stanton offered Anthony a gift of a bloomer dress. Still not ready for full commitment to the women's rights movement, Anthony refused it, and wrote to Lucy Stone to tell her of the incident. Anthony did not wear a bloomer dress that summer while canvassing for the Women's Temperance Society. Nor did she wear one at her first appearance at a women's rights convention in October 1852. But by December, when Stanton once again offered her the emblematic attire, she accepted it. She wrote Lucy Stone from Stanton's nursery, "Well, at last I am in short skirt and trousers!" Soon afterward she had her hair cut into the "Ultra" bob. Between the first offer in May and second in December, Anthony had made the psychological shift from being a liberal temperance reformer to being a radical women's rights advocate, and she had begun to carve out her role within the inner circle of Ultras. The turning point was at the September 1852 women's rights convention in Syracuse, where Anthony made her debut in the women's movement.

Anthony's Rise to Leadership

Anthony's role in the Ultras evolved rapidly between summer 1851, when she first met Stanton, and fall 1852. In the summer and fall of 1851, she was a novice member being socialized into the group culture, mainly by Stanton.

When she entered the circle, it consisted of some gifted intellectuals, writers, and orators. Mott, Stanton, Stone, and Brown rose to rapid prominence because of the brilliance of their ideas and their eloquence with words, but none was particularly ready to organize a movement. Although Stanton played a catalytic role in the impulsively planned 1848 convention, she faltered when it came to deciding what to do next. In 1850, it had been Lucy Stone who sent out the call to organize the first national convention in Worcester, Massachusetts. Stone had a "silvery" voice, a down-to-earth speaking style, and an intellectual brilliance that could mesmerize even a hostile audience. But when it came time to actually do the organizing, Stone was not available because of a family crisis. She left the work to Paulina Wright Davis, who subsequently was elected president of the group in both 1850 and 1851. Antoinette Brown was always ready to follow Lucy Stone's lead, and she often responded to Anthony's appeals to speak; but she never initiated a convention. Lucretia Mott saw herself as too old for organizational work.

The Executive Manager Role in the Collective Action Stage
In chapter 2 we saw that, when the Impressionists moved into the collective action stage, the leadership of the circle shifted. When the members were building the vision, the central figures were Claude Monet and Edouard Manet, but as the collective action stage unfolded, both gradually moved aside. When the group decided to organize independent exhibitions of their works, the leadership shifted to Pissarro and Caillebotte. Likewise, when the Fugitive poets evolved from a circle that shared drafts of their poems into one that published their own journal, the leadership shifted from Ransom and Hirsch to Davidson. As the task shifts from developing a vision and producing creative work to carrying out collective action, a new set of leadership skills are required. Instead of modeling and inspiring creative work, the new leader must have skill at locating resources in the external world, mobilizing the group for action, and tending to the details of making organized events happen. Mills (1984) refers to this leadership role as the "executive manager."

As the task of the women's movement shifted from articulating the injustices of women's roles to organizing conventions, building coalitions, and changing laws, the skills that Anthony had developed became extremely important. The leadership shifted from the charismatic writers and speakers, such as Stanton, Mott, Stone, and Brown, to the instrumental, executive managers, such as Anthony and Paulina Wright Davis. Eventually, Anthony advanced to the forefront of this new cohort of leaders.

From Group Lightning Rod to Executive Manager

In the development of circles, the group lightning rod is the member who acts as the conduit for negative feelings shared by other group members. Candidates for this role are members who are able to mobilize anger for the sake of a group goal. In the early stages of circle development, the lightning rod may direct hostility toward targets outside the group. She is the member most likely to voice attacks on authority figures in the circle's environment. During the quest stage, the lightning rod polices the members of the group, and may express hostility at the boundary-marking members of the network—the conservatives who lag behind the group, clinging to the rejected traditions, or the radicals, who go "too far" in expressing wild ideas. As the group moves into the collective action stage, the lightning rod once again focuses on targets outside the group. She gives voice to the anger other members feel toward opponents of the group's shared goals.

In her debut in the inner circle, Anthony first carved out a role as the group lightning rod. Perhaps because she was not well known to many of the members of the larger movement, she could risk giving voice to the negative thoughts that other members dared not express. She acquired the role at the Third National Woman's Rights Convention in Syracuse in September 1852, her first public appearance in the women's rights movement.

Along with James Mott and Paulina Wright Davis, Anthony was appointed to the nominating committee at a preliminary meeting. Wright Davis, who had presided over the first two national conventions, was determined to have her friend Elizabeth Oakes Smith appointed president in 1852. In the discussions of the bloomer dress over the previous summer, Anthony had become sensitized to the political significance of clothing. Although she had at this point not yet accepted Stanton's gift of a bloomer dress, the critical appraisals of women's clothing by Stanton, Bloomer, and Stone must have set her to thinking. When Anthony saw Wright Davis and Oakes Smith walk in, arm and arm, dressed like fashionable Newport ladies, she fumed. As Harper reported: "Both attended the meeting and the convention in short sleeved, low-necked dresses, one with a pink, the other with a blue embroidered wool delaine sack with wide, flowing sleeves, which left both neck and arms exposed." At the committee meeting the next morning, James Mott nominated Mrs. Smith for president. He must have been lobbied by Paulina Wright Davis. But Anthony, or as Harper put it, "Quaker Susan B. Anthony"

> spoke out boldly and said that nobody who dressed as she did could represent the earnest, solid, hard-working women of the country for

whom they were making the demands for equal rights. Mr. Mott said they must not expect all women to dress as plainly as the Friends; but she held her ground. As all the committee agreed with her, though no one else had the courage to speak, Mrs. Smith's name was voted down. This is but one instance of hundreds where Miss Anthony alone dared say what others dared think, and thus through all the years made herself the target for criticism, blame, and abuse. Others escaped through their cowardice; she suffered through her bravery.

<div align="right">(Harper 1898, 72)</div>

The role of peacemaker often emerges in tandem with the lightning rod role during the collective action stage. The tasks of the collective action stage are more visible to the public, and they require more interdependent roles within the group. Both the visibility and the interdependence lead to more concern about members' behavior outside and inside the group. As a consequence, conflicts among members may become more abrasive. At first the members may be hesitant to express negative reactions to one another, and as Harper suggests, the negative reactions are suppressed. The lightning rod is the member who senses the anger and finally expresses it, knowing she has the legitimation of group sentiment. As the tension rises, the skills of the peacemaker, if available, become more in demand. The peacemaker is a member who senses conflict and moves to restore harmony in the circle. As we saw, Pissarro played this role in the Impressionist group. In the Ultras circle, Lucretia Mott was the one who often took the part.

At the 1852 convention, operating in this integrative role, Lucretia Mott allowed herself to be nominated and elected president in place of Oakes Smith. Because she was seen as the mentor of all the Ultras, all factions could unite behind her. "It was a singular spectacle," said the reporter from the *Syracuse Standard,* "to see this gray-haired matron presiding over a Convention with an ease, dignity, and grace that might be envied by the most experienced legislator in the country." Paulina Wright Davis and Elizabeth Oakes Smith were both elected vice presidents. Though it was only her first meeting, Susan B. Anthony, along with Martha Wright, were both elected secretaries. Lucy Stone was elected to the business committee.

As the meeting began, Anthony continued to play the lightning rod, giving voice to what others were thinking but not saying. As in previous conventions, an early part of the meeting was spent socializing the women into public speaking. When the issue of how loud to speak came up, Anthony once again squared off with Paulina Wright Davis, this time on the floor of the convention. Harper reported:

Several of the speakers had weak, piping voices which did not reach beyond a few of the front seats and, after one of these finished, Miss Anthony said: "Mrs. President, I move that hereafter the papers shall be given to some one to read who can be heard. It is an imposition on an audience to have to sit quietly through a long speech of which they can not hear a word. We do not stand to be seen, but to be heard." Then there was a protest. Mrs. Davis said she wished it understood that, "ladies did not come here to screech; they came to behave like ladies and to speak like ladies." Miss Anthony held her ground, declaring that the question of being ladylike had nothing to do with it; the business of any one who read a paper was to be heard.

(Harper 1898, 75)

By speaking out against the quiet speakers, Anthony gave voice once again to the antipathy felt toward the traditional ladylike style represented by Paulina Wright Davis. Having spoken out against that style in public settings, Anthony must have made some enemies. But in winning support for her position, she played a part in shifting the culture of the convention away from the New England "ladies" toward the New York "Ultras." The New England ladies did not preside over any other conventions in the 1850s. For the rest of the decade, either Lucretia Mott, Martha Wright, or Lucy Stone took the chair.

Crystallization of Ultras Roles

Convocations of members are often occasions where roles are established and ritualistically reconfirmed. Once set, these roles are difficult to change, especially when the whole group is together. The identity bestowed by the group, the "first impression," shadows a member for a long time. In addition to Anthony's role as lightning rod and Lucretia Mott's role as peacemaker, other roles in the Ultras circle crystallized or were reaffirmed at the 1852 convention.

As they did at every convention, the women debated and fine-tuned their thinking about the justification for women's rights. Antoinette Brown put forth a resolution declaring that the Bible recognized the claim of equality between men and women. Many speakers at the convention objected to this view. Led by Ernestine Rose, who was well known as an atheist and who served as a radical boundary marker in the circle (Barry 1988, 93), they defined the religious argument as Antoinette Brown's alone, and the convention did not adopt the resolution. Instead, the consensus was to base the claim for equal rights, not on biblical authority, but on arguments derived from the rights of man ideology. In other words, Brown was cast as

a member who lagged behind the other Ultras. Her views grounded in the Bible were defined as outside the boundaries of their culture. Nevertheless, though Brown was seen as a conservative boundary marker, she was still a highly valued member of the core circle.

The press reviews after the convention played a part in confirming the emergent roles. The *Syracuse Journal* praised Anthony's stentorian style: "Miss Anthony has a capital voice and deserves to be made clerk of the Assembly." The editor of the *New York Herald* singled out Lucy Stone and Antoinette Brown for ridicule. Arguing for keeping women in their "sphere," he wrote, "how funny it would sound in the newspapers if Lucy Stone, pleading a cause in court, suddenly went into labor and delivered a baby, or if Antoinette Brown delivered a baby in the pulpit while giving a sermon" (Harper 1898, 79).

Anthony's reading of Stanton's letter caused the biggest "breeze," both at the convention and in the press. Once again Stanton challenged the limits of tolerance of even the most radical members of the audience. She argued for civil disobedience, proposing that all property-owning women refuse to pay taxes until they could vote and be represented in government. She pleaded for equal access to education for women. But most disturbing to the audience, she directed a frontal attack on religion and the clergy. She argued that the ministry was filled with a class of "lazy, inefficient" men who disliked work and discovered they could become "pin-cushion" ministers, that is, clergy whose education and life styles were financed by contributions from women. Rather than making women noble and free, these clergy taught lessons that made a woman's "bondage more certain and lasting, her degradation more helpless and complete." Like her speech at the women's temperance convention in April, Stanton's letter caused consternation in the press and among the more conservative women. However, the letter provided support for speakers, such as Mott and Rose, whose justification for women's rights was independent of religious authority (Stanton, Anthony, and Gage 1881, 1:73). The reactions of the press reaffirmed Stanton's position as leader of the Ultras. In addition, by having Anthony read her letter, she and Anthony publicly affirmed their collaborative relationship.

"Woman Must Take to Her Soul a Purpose"
One of the most important outcomes of the 1852 convention was Anthony's full conversion to the women's rights movement. Rather than seeing women's rights as an additional reform apart from her work on temperance, she now saw it as Stanton had proposed—a broader frame that encompassed the temperance issue. She was "convinced that the right which

woman needed above every other, the one that would secure to her all others, was the right of suffrage. She . . . again took up temperance work, but much of her enthusiasm was gone. She felt she was dealing with effects only and was shut out from all influence over causes" (Harper 1898, 81).

As Anthony's commitment to the cause of women's rights deepened, she brought to the core circle the organizing skills she had developed in the temperance movement. Throughout the summer and fall of 1852, as she traveled around New York organizing chapters of the Women's Temperance Society, she had led a campaign to obtain signatures for a petition to support a New York version of the Maine Prohibition Law. She acquired 28,000 signatures in favor of it. In January 1853, she appealed to Lucy Stone to go to Albany with her to speak to the legislature in favor of the "Maine law." Stone refused, arguing from a Garrisonian perspective that to change laws was useless until public opinion changed. Anthony then asked Antoinette Brown to speak. Brown tried to persuade Anthony herself to do the speaking, but Anthony lacked the confidence. Finally, Brown agreed to speak.

After they presented their petition, the two women were abruptly dismissed by the legislators. But in the audience was a wealthy sarsaparilla dealer who was impressed by them, and who saw their message as a vehicle to win support for his beverage. He arranged for them to speak in New York City at Metropolitan Hall. On that occasion, as on many others, Anthony read a speech written by Stanton. Following that event, Anthony and Brown made a two-month speaking tour of New York State during March and April, delivering their arguments for prohibition from Sing Sing to Buffalo. On the tour, it was Anthony who arranged for the halls, handled the publicity, and paid the bills. Brown brought her eloquence as a speaker and the dignity of her role as an ordained minister.

Confirming Anthony's new position in the network, Abby Kelly Foster wrote to her: "So far as separate organizations for women's action in the temperance cause are concerned, I consider you the center and soul" (Harper 1898, 93).

Marginalization and Public Martyrdom

As we have noted, marginalization often is a key factor in the formation of a collaborative circle. Being marginalized by the mainstream decreases the members' commitment to mainstream channels of recognition and increases their commitment to the circle members and the changes they advocate. The marginalization of the Ultras was dramatized in a very concrete way. Virtually every member of the core circle had the experience of being

blocked by men from speaking at a public event. It was almost a rite of passage into the Ultras. The exclusion in London had radicalized both Mott and Stanton. Anthony's exclusion from the 1852 temperance convention started her down the path to radicalization. But the marginalization that became almost a symbolic crucifixion that all women could experience was the dramatic silencing of Antoinette Brown (plate 35) at the 1853 "World" Temperance Convention.

In September 1853, with the first World's Fair ever held in the United States coming to New York City, every variety of social reformer was organizing a convention. Anthony focused her energies on organizing the Second "Whole World" Temperance Convention. Unlike the men's "World" convention that had excluded women the previous year, the "Whole World" convention would include both men and women. Like the Impressionists, who did not want to be seen as the rejects from the Salon exhibition, the women decided to hold their convention prior to the meeting of the "World" convention. Mocking them, the women called the men's meeting the "Half World" convention.

Antoinette Brown was still determined to seek acceptance by the men, and she went to the "Half World" convention as a delegate from Rochester. She was accepted nominally as a member, but when she rose to speak and was invited to the platform, she was greeted with pandemonium—hisses, stamping feet, cries that she be forbidden to speak, and shouts from the clergymen of "Shame on the woman!" As Brown later reported in an interview: "[W]hen I stood on the platform for an hour and half, waiting to be heard, I could read in the faces of men such as these [Wendell Phillips and William Channing] . . . the calm assurance, You are making the most effectual speech for . . . woman . . . that you have ever made in your life" (Stanton, Anthony, and Gage 1881, 1:507). But she was finally compelled to leave the hall. The rest of the convention was devoted to the question of how to contain the women. As Greeley put it in the *Tribune*, the convention had spent three of its four days crowding a woman off the platform, gagging her, and voting that she stayed gagged. The attack on Brown was seen as an "insulting outrage upon all womankind," and she became a symbol of the women's movement (Stanton, Anthony, and Gage 1881, 1:121).

"The Napoleon of the Woman's Movement"
In the wake of Brown's silencing, Anthony accelerated her activities in support of women's rights. She organized on three fronts: equal rights for women in the temperance movement, in the teaching profession, and in the marital relationship. Within a month of the 1853 New York conven-

tions, she had carried the story of Brown's exclusion to the Fourth National Woman's Rights Convention in Cleveland. There she learned of efforts to introduce a women's property rights bill into the upcoming Ohio constitutional convention. Returning to Rochester, she organized a convention in November to petition for a New York law guaranteeing equal property rights for women. After obtaining signatures for several weeks, she arranged for a women's suffrage convention in Albany when the legislature convened in February 1854. Once again, she mobilized Stanton to write a speech for her and to speak to the legislature.

The campaign to change New York's law failed in 1854, but Anthony's determination hardened, and over the next few months, she demonstrated the resilience and endurance needed to lead the circle in the collective action stage. First, in March she traveled to Washington to speak in favor of a women's property law. Failing to reach an audience there, she traveled with Ernestine Rose on a lecture tour of Virginia and Maryland, ending with a stop in Philadelphia, where James Mott had arranged for her to speak to the Quakers. Following that, having won the right for women to speak at the 1853 teachers' convention, in the summer of 1854 she asked Stanton to write her a speech arguing for women's right to hold office in the teachers' association and to be principals of public schools. Once again Mrs. Stanton agreed, and Anthony won rave reviews for her eloquence.

After seven months on the road, she returned home on October 1, then immediately set out for the National Woman's Rights Convention in Philadelphia. Signifying her full ascension to the leadership of the movement, Lucretia Mott sent her an invitation: "It will give us great pleasure to have thy company at 338 Arch Street, where we hope thou wilt make thy home. . . . We think such as thyself, devoted to good causes, should not have to seek a home." At dinner, Garrison sat on Lucretia Mott's right, and Anthony sat on her left; and after dinner, Mott washed the dishes, while Anthony dried. Anthony's position of leadership was now fully recognized. Channing dubbed her the "Napoleon of the woman's movement." By 1860, when she wrote to mobilize Stanton for yet another campaign to pass a women's property rights act in New York, Stanton responded: "If Napoleon says cross the Alps, they are crossed. You must come here and start me on the right train of thought, as your practical knowledge of just what is wanted in getting up the right document" (Harper 1898, 122, 187).

Group Dynamics, Public Opinion, and the Bloomer Dress
As the Ultras made a full-scale shift into collective action focused on women's rights, they once again changed costumes. The bloomer dress had

been a banner of solidarity for the Ultras. But as the women shifted all their energies toward building the organization and initiating legislative change, the dress became a liability. The press ridiculed the costume relentlessly, and on the street and in convention halls the dress drew catcalls and heckling. Boys in the street chanted:

> Heigh Ho
> Thru sleet and snow,
> Mrs. Bloomer's all the go.
> Twenty tailors take the stitches
> Plenty of women wear the breeches,
> Heigh Ho
> Carrion Crow!

Anthony and Stone had worn bloomers to the World Temperance Convention in September 1853. It was at this convention that Anthony had led a walkout after the men refused to allow her to take a seat on the business committee. Except for Greeley's *Tribune,* the New York papers had uniformly opposed and ridiculed the women. The comments in the *New York Commercial-Advertiser* typify the sarcastic tone of the women's critics:

> On Saturday evening the Broadway Tabernacle reverberated with the shrill, defiant notes of Miss Lucy Stone and her "sisters," who have thrown down the gauntlet to the male friends of temperance. . . . Henceforth the women's rights ladies—including among them the misses Lucy herself, . . . Susan B. Anthony, Antoinette Brown, some Harriets and Angelinas, Melissas and Hannahs, with a Fanny too . . . are to be in open hostility to regularly constituted temperance agencies.
>
> (Harper 1898, 90)

The bloomer dress became a prominent target of the attacks. "Women in pantaloons" came to symbolize what the press saw as the freakish spectacle of women acting like men, as this account from the *New York Courier* makes clear:

> Anniversary week has the effect of bringing to New York many strange specimens of humanity, masculine and feminine. Antiquated and very homely females made themselves ridiculous by parading the streets in company with hen-pecked husbands, attenuated vegetarians, intemperate Abolitionists and sucking clergymen. . . . Shameless as these females—we suppose they were females—looked, we should

really have thought they would have blushed as they walked the
streets to hear the half-suppressed laughter of their own sex and the
remarks of men and boys. Bloomers figured extensively in the anti-
slavery amalgamation convention, and were rather looked up to, but
their intemperate ideas would not be tolerated in the temperance
meeting at the Brick Chapel. . . . [T]he women were compelled to
hold their tongues and depart, followed by a number of male Betties
and subdued husbands, wearing the apparel of manhood, but in real-
ity emasculated by strong-minded women. . . . So the Bloomers put
their credentials in their breeches pockets.

(Harper 1898, 90)

As the Ultras became more intent on bringing about change in public
opinion, they began to see the dress as a distraction. One by one, they began
to appear in public in more conservative dress. Ironically, Anthony, who
had been the last to adopt the bloomer, was also the last in the circle to dis-
card it. The letters exchanged over discarding it illustrate how the circle col-
lectively thought through issues of strategy during the collective action
stage.

As was often the case, Stanton was first to see the problem and solution.
Having led in the adoption of the dress, she was first to see that, rather than
have their audiences distracted by the dress, it was wiser to discard it. She
wrote to Anthony and Stone urging them to "take it off": "I know what you
must suffer in consenting to bow again to the tyranny of fashion, but I
know also what you suffer among fashionable people in wearing the short
dress; and so, not for the sake of the cause nor for any sake but your own,
take it off! We put it on for greater freedom, but what is physical freedom
compared to mental bondage?" (Harper 1898, 115).

Stone stood in the middle, as she often did on other issues. She wrote to
Anthony telling her she had purchased material for a new dress, but she was
undecided about whether to have it made into a bloomer:

I have bought a nice new dress, which I have had a month, and it is
not made because I can't decide whether to make it long or short. Not
that I think any cause will suffer, but simply to save myself a great deal
of annoyance and not feel when I am a guest in a family that they are
mortified if other persons happen to come in. I was at Lucretia Mott's
a few weeks ago, and her daughters took up a regular labor with me to
make me abandon the dress. They said they would not go in the street
with me. James and Lucretia defended me bravely.

(Harper 1898, 116)

Anthony, the most recent convert to the Ultras and to the emblematic dress, anxious to stick to principles no matter what the cost, was most confused. Once she had taken a position, ever the serious responsible Quaker, she found it hard to change course. She replied to Stone:

> Your letter caused a bursting of the floods, long pent up, and after a good cry, I went straight to Mrs. Stanton and read it to her. She has had the most bitter experience in the short dress, and says she now feels a mental freedom among her friends that she has not known for two years past. If Lucy Stone, with all her power of eloquence, her loveliness of character, who wins all that hear the sound of her voice, can not bear the martyrdom of the dress, who can? Mrs. Stanton's parting words were, "Let the hem out of your dress today, before tomorrow night's meeting." I have not obeyed her. I have not obeyed her but have been in the streets . . . rude, vulgar men stare me out of countenance and I heard them say as I opened a door, "There comes my Bloomer!" . . . Here [in Albany] I am known only as one of the women who apes men. . . . Oh I cannot, cannot bear it any longer.
>
> (Harper 1888, 116)

Lucy Stone wrote back:

> I am sure you are all worn out or you would not feel so intensely about the dress. I never shed a tear over it in my life or came within a thousand ages of martyrdom on account of it. . . . I don't think I can abandon it, but I will have two skirts. I have this feeling: Women are in bondage; their clothes are a great hindrance to their engaging in any business. . . . [I]s it not better, even at the expense of a vast deal of annoyance, that they whose lives deserve respect and are greater than their garments should give an example by which woman may more easily work out her own emancipation? . . . [The bloomer dress] is part of the "mint, anise, and cumin," [i.e., the spices] and the weightier matters of justice and truth occupy my thoughts more.
>
> (Harper 1898, 116)

Nevertheless, Stone had abandoned the dress by the end of the year. Altogether, Anthony wore the dress for a little more than a year, but she was identified with it for many years afterward. Even when she was not wearing it, newspapers would report that she appeared in "the regulation bombazine Bloomers." Later, reminiscing, Anthony wrote:

> I felt the need of some such garments because I was obliged to be out every day in all kinds of weather, and also because I saw women ru-

ined in health by tight lacing and the weight of their clothing, and I hoped to help establish the principle of rational dress. I found it a physical comfort but a mental crucifixion. It was an intellectual slavery; one never could get rid of thinking of herself, and the important thing is to forget self. The attention of my audience was fixed upon my clothes instead of my words. . . . I have felt ever since that experience that if I wished my hearers to consider the suffrage question I must not present the temperance, the religious, the dress, or any other besides, but must confine myself to suffrage.

(Harper 1898, 117)

In the end, from the mid-1850s on, the core circle cultivated a feminine, even matronly look, so as to connect with conservative women and avoid being easy targets for the press.

Conflict between Family and Circle Roles

In collaborative circles of men, once the members marry and have children, their commitment to the circle often declines. For example, Renoir's marriage sped his withdrawal from the Impressionist group, C. S. Lewis's marriage led to tensions among the Inklings, and Ford's divorce scandal led to the breakup of his friendship with Conrad. Marriage and family life not only create an alternative set of supportive relations, they also create a set of role demands that conflict with the roles in the circle. For male members of a circle, it is often the case that the pressure to earn enough to support a family tempts them to "sell out," that is, to abandon the more radical ideas of the group in favor of ideas that are more marketable. Once again, Renoir's midlife change in style is an example of this process. After he married, and especially after he had young children, he withdrew from the Impressionist exhibitions, returned to a more conservative style, painted several portraits for wealthy families, and submitted work to the Salon exhibits of the academy.

For the Ultras—all except Anthony, who chose not to marry—conflicts between their roles in the circle and their roles in their families were chronic. Stanton raised seven children during the 1850s and 1860s. In 1854 when she spoke before the New York legislators, one of the men accused her of not caring for her children. On that occasion her children were staying nearby because she had brought them with her—and she was delighted to say so. But more often when she participated in a speaking campaign, she had to leave them at home. When they were young, she often refused to leave them. As we have seen, it was largely through her collaboration with Anthony that she was able to maintain her position of leadership. Not until

the 1870s, when she saw her children as more independent and her husband set up his own apartment in New York City did she feel free to join Anthony on speaking tours.

Stone and Brown, both unmarried when the circle formed, were able to participate in Anthony's campaigns during the years between 1852 and 1855. However, in May 1855, Lucy Stone married Henry Blackwell. Henry was a member of the famous Blackwell family of Ohio, which included Elizabeth, the first woman physician in the country. Lucy Stone was always an influential model for Brown. Whatever the psychological dynamics, soon after Stone married Henry Blackwell, his brother Samuel began to court Antoinette Brown. Within a year, in January 1856, Brown married Samuel Blackwell and had her first child eleven months later. The marriage of these two close friends into the same family cemented an already strong alliance.

Lucy Stone had married a man whose moneymaking schemes, brilliant family, and psychological manipulations would be problematic for her for the next two decades. His demands that she live up to his family's expectations of a good wife and mother wore her down, and she had repeated episodes of depression. In November 1855, while Anthony was recovering from a back pain that developed from her traveling, she wrote to Stone asking for help in a new campaign. Stone wrote back: "Your letter full of plans reaches me here. I wish I lived near enough to catch some of your magnetism. For the first time in my life I feel, day after day, completely discouraged. . . . I am going to retire from the field; and if you work too much and kill yourself, the two wheelhorses will be gone and then the chariot will stop" (8 November 1855, in Kerr 1992, 91).

In September 1857, Stone had a daughter, Alice Stone Blackwell. When Anthony wrote asking her to participate in a convention in 1857, Stone wrote back: "I know how you feel with all the burden of these conventions. . . . I wish I could help but I cannot. You are one of those who are sufficient unto themselves and I thank God every day for you. Antoinette can not come because she is so busy with that baby!" (Harper 1898, 151). Around the same time Stone wrote to her husband, Henry, about their baby, Alice:

> She has the most radiant little face I ever saw and is a very promising child. . . . I never feel her little cheek beside of mine, never hear her sweet baby voice without the earnest purpose to gather to myself more symmetry of being—to sustain all my relations better. . . . I am trying to be a good wife and mother . . . but I have tried before, and my miserable failures hitherto make me silent now. But if I have conquered myself, or gained anything in all these weary weeks, you will

find it in my actions—I hope to be more to you and better—when you come to me.

<div align="right">(Hays 1978, 161)</div>

Until she married and had a child, Stone was the dominant member of the pair she made up with Antoinette Brown Blackwell. But after the marriage, her repeated bouts of depression and her withdrawal to raise her daughter changed the relationship. During this period, the balance of the exchanges became more equal. As sisters-in-law, they formed a nucleus within the Blackwell clan, and they often looked after one another's children. Brown helped Stone cope with her depression and to stay in touch with the movement. Ultimately, Brown was instrumental in drawing Stone back into a leadership position during the 1870s. In the late 1880s and early 1890s, when the history of the movement was being written, Brown took the lead in arguing for Stone's central role.

As the family constraints of the core members began to conflict with movement events, Anthony, the executive leader, often became frustrated with Stone, Brown, and Stanton. Anthony was not impressed with the constraints of marriage and motherhood. After being disappointed in her efforts to mobilize both Stone and Brown to speak in 1856, she wrote to Stanton once again requesting help in writing a speech: "Those of you who have the talent to do honor to poor—oh! poor—womanhood, have all given yourself over to baby-making; and left poor brainless me to do battle alone. It is a shame. Such a body as I might be spared to rock cradles. But it is a crime for you and Lucy Stone and Antoinette Brown to be doing it. . . . Oh dear, dear! If the spirits would only just make me a trance medium and put the right thing into my mouth" (5 June 1856). Stanton wrote back defending Stone and Brown: "Let Lucy and Antoinette rest awhile in peace and . . . think great thoughts for the future . . . do not keep stirring them up or mourning over their repose. . . . We cannot bring about a moral revolution in a day or a year." Later that summer, Stanton tried again to console Anthony: "You and I have a prospect of a good long life. We shall not be in our prime before fifty, and after that we shall be good for twenty years at least" (20 August 1856; letters in DuBois 1992, 63).

But the strains continued to wear on the relationships. When Stone found that Anthony had been criticizing her for withdrawing from the movement, she wrote to her saying that she had heard from friends that Anthony was saying

that I did not appear quite right [and that] in such doting ease I should become nothing. [The criticism left me feeling] wounded,

grieved, hurt, almost as I never was before. . . . I felt a mountain of ice between us. I felt that without any reason, you had lost faith in me. And I wondered at the kiss you proffered. But I am in no state of body or mind to write about it. I must make the path for my own feet. I have no advice or explanation to make to anybody.

(20 July 1857, in Kerr 1992, 102)

Stone and Anthony reconciled after this rift, but after her child was born, Stone made it clear that she was unavailable for speaking engagements: "I can not speak well while I nurse the baby. You are tired with 4 months work. If you had had measles and whooping cough added to all you have done it would not be half as hard as the taking care of a child day and night is—I know" (1 April 1858, in Kerr 1992, 106).

Renewed Involvement later in Life

As it turned out, Stanton was right in predicting that the women would renew their involvement after their children were raised. The alliance between Stanton and Anthony took on new life in the late 1860s and continued to function for the next twenty years. Together they became seasoned political activists on a national stage, and they steered the women's rights movement through numerous crises, some of which were of their own making. Feeling betrayed when the Republicans refused to support women's suffrage until the vote was assured for black men, they courted the Democrats. Supported by controversial Democrats, they founded a newspaper, the *Revolution,* and used it to argue for divorce reform, better wages for working women, and other radical changes. As leaders of the National Woman's Rights Association, they allied themselves with legal cases involving issues symbolic of women's rights, such as a notorious child custody case in Massachusetts and a scandalous prostitution case in San Francisco.

Stone and Brown also resumed their activism after their families matured. Like Stanton and Anthony, Stone, with the help of her husband, Henry, founded a newspaper, the *Woman's Journal,* which published articles on women's issues. During the 1880s, Stone and Brown worked together to organize the American Woman's Suffrage Association. Although Stone and her husband became embroiled in scandals and crises, she remained active in the women's movement until the end of her life.

Group Disintegration and Member Individuation

The escalation of demands for interdependent work during the collective action stage creates numerous opportunities for conflict among circle mem-

bers. In the early stages, they work in parallel or in pairs and exchange re-
sources, but in the collective action stage they make decisions as a group
and depend on one another to complete interdependent tasks on a sched-
ule. For the Impressionists, exhibition space had to be rented, exhibits had
to be scheduled, paintings had to be selected, and some had to be rejected.
For the women's rights circle, conventions had to be organized, speakers
had to be lined up, officers had to be elected, petitions had to be gathered,
money had to be collected, and bills had to be paid. Repeated cycles of such
interdependent work create opportunities for conflict, disappointment,
and resentment.

The Ultras frequently disappointed Anthony while she was acting as the
executive manager. Often when she attempted to organize an event, other
members of the circle did not do what she expected. For example, in the
summer of 1854, Anthony thought she had persuaded Stone, Stanton,
Mott, and Brown to come to Saratoga to speak. Both the abolitionists and
the temperance workers had scheduled conventions there, and Anthony
wrote that it would be an ideal place for the women to hold one, too. With
the understanding that they all would participate, she scheduled a hall and
got out the advertisement. But on the morning of the event, she discovered
that none of them were coming. She rallied, found two young women's
rights advocates in town, and persuaded them to speak. Anthony delivered
one of the speeches that Stanton had written. The event was a success, but
the failure of the circle to respond to Anthony contributed to the growing
tensions in the group.

In response to yet another refusal from Antoinette Brown, Anthony
wrote to her: "O, dear, dear, how I do wish you could have kept on with me.
I can't tell you how utterly awful is the suspense these other women keep me
in; first, they can't, then they can, then they won't unless things are so and
so; and when I think everything is settled, it all has to be gone over again"
(Harper 1898, 177–78).

Differential Recognition

A second factor that contributes to the disintegration of collaborative
circles is the differential recognition of members' contribution to the work
of the group. The collective action stage requires interaction with the pub-
lic. Almost inevitably, when a group interacts with the public, some mem-
bers of the circle receive more recognition than others. For collaborative
writers, someone has to be listed as first author. For artists who share a sim-
ilar style, some members will be given more credit for the style than others.
The differential recognition may go beyond differences in the quality of

press reviews. Some may receive more monetary rewards than others, or some may receive major prizes while others are ignored. In the women's rights circle, some members received more recognition from the audiences at the conventions, from the press, and eventually, from the next generation of leaders. The strains of differential recognition challenged the solidarity of the circle.

In the early stages of collective action, when the women were fighting a series of urgent battles and when they were embedded in intimate friendships with one another, none cared who received recognition, so long as the cause was advanced. For example, there are no records of Stanton's complaining when Anthony delivered her speeches and was given credit for them. Likewise, Anthony was pleased rather than jealous when Stanton agreed to be president of the Women's Temperance Society that she had built. Almost always self-effacing, Anthony pushed Stanton forward at every opportunity. But as each woman invested more and more into the women's movement, and as each had more of her identity and reputation tied up in it, jealousies surfaced. After Stanton's early departure from a speaking tour through the West that she and Anthony had initiated, Anthony wrote home expressing resentment that she had not been given as much recognition as her friend:

> I miss Mrs. Stanton, still I can not but enjoy the feeling that the people call on me, and the fact that I have an opportunity to sharpen my wits a little by answering questions and doing the chatting, instead of merely sitting a lay figure and listening to the brilliant scintillations as they emanate from her never-exhausted magazine. There is no alternative—whoever goes into a parlor or before an audience with that woman does it at the cost of a fearful overshadowing, and that cheerfully, because I felt that our cause was most profited by her being seen and heard, and my best work was making the way clear for her.

Writing about the differences in responses to them in San Francisco, where the audience booed Anthony for defending a prostitute while reporters praised Stanton for her eloquence, Anthony stated: "You never received such wholesale praise—I never such wholesale censure" (Harper 1898, 396–97).

However, the distribution of recognition changed in the later stages of their collaboration. Throughout the 1880s and 1890s, as Anthony persisted in her efforts to reunite the divided movement, she received more and more recognition from the new generation of leaders who were known as Aunt Susan's "nieces." Seeing the recognition that Anthony received, Stanton

wrote to one of her supporters: "If my suffrage coadjutors had ever treated me with the boundless generosity they gave my friend Susan, I could have scattered my writings abundantly. They have given Susan thousands of dollars, jewels, laces, silks and satins, and me criticisms for my radical ideas" (DuBois 1992, 121).

Member Individuation

In the early stages of circle development, the members are likely to be both psychologically and instrumentally dependent upon one another. They rely on one another for help with everyday problems, for emotional support, and for ideas. They may, like Stanton and Anthony, have complementary personalities and skills, such that each provides resources that the other lacks. Establishing instrumental intimacy in collaborative pairs, they network their minds in ways that stimulate creativity. In their group meetings they buttress one another's self-concepts as competent professionals. But as they acquire expertise, and as they begin to establish themselves in networks outside of the circle, they become less dependent upon the group. As they seek independent recognition for their work, some may even see identification with the circles as a liability.

As we have seen, in several cases individual members of the Ultras never would have sustained commitment to social reform if it had not been for the circle. For example, Anthony's demands on Stanton kept Stanton involved. Likewise, Stanton's writing abilities were critical to Anthony's development as an orator, theorist, and leader in the movement. Stone inspired Brown's initial involvement and socialized her into reform work. Later, Brown was instrumental in helping Stone cope with depression and encouraging her to return to a leadership role. However, as members matured both cognitively and emotionally, developed their own positions on the issues, and became invested in their own reputations, they developed a desire for more autonomy.

At least three processes contributed to the women's motivation to distance themselves from each other. First, after repeated cycles of interaction they had learned from one another and acquired one another's skills. For example, by the 1870s, Stanton had learned how to organize her own speaking tours, and she no longer needed to rely on Anthony. Likewise, by then Anthony had developed skill in writing her own speeches. As we have seen, Anthony even began to resent being neglected when she appeared on a stage with Stanton.

Second, after internalizing the vision of the circle, each member began to crystallize a unique perspective on it. When they were novices, it did

not matter who thought of something first or who received the recognition. But as each developed her own perspective and became concerned about a public reputation, these differentiating signals mattered more. For example, in 1852, Stone supported Stanton's position that marriage was a source of women's oppression and that divorce reform was an essential component of the group's agenda; but by 1860, Stone had rejected this position. This disagreement was an early sign of the divisions that culminated in their split during the 1870s and 1880s. In the Stanton-Anthony relationship in the 1890s, as Anthony strove to unite the conservative and radical factions of the movement, Stanton's attacks on the clergy strained their relationship. After repeated cycles of interaction with the public, each member developed an identity anchored in networks outside the original circle.

Third, in their interpersonal relationships, members of circles mature beyond the psychological dynamics that drew them together in the first place. Brown idolized Stone when they were in college together. Stone was a selfobject that connected Brown to larger aspirations. But over time they grew out of these dynamics and their relationship became more egalitarian. Likewise, very early in the relationship, when they first negotiated the division of labor, Anthony idolized Stanton. In her letters Anthony always addressed Stanton as "Mrs. Stanton," whereas Stanton addressed Anthony as "Susan." But after years of working together, not only did they acquire one another's skills, but they also worked free of these big sister–little sister dynamics.

The women's rights paradigm generated a sensitivity to the issues of dependency and autonomy that are often less salient in other circles. Throughout the 1850s, the women were concerned with freeing women from dependence upon men. When the circle reached the stage of development where autonomy from one another became more salient, their analyses of male-female relations spilled over into their analyses of their own relationships. The link is subtle at times, but at other times it is transparent.

For example, after Brown's marriage, Anthony wrote to Lydia Mott, who, along with Anthony, was one of the last unmarried women in the extended core circle: "The new encyclopedia is just out and I notice in regard to Antoinette Brown Blackwell that it gives a full description of her work up to the time of her marriage, then says: She married Samuel Blackwell and lives near New York. Not a word of the splendid work she has done on the platform and in the pulpit since." Anthony then went on to complain of a woman's loss of self once she marries. Lydia responded, defending interdependence among friends and collaborators as well as marital partners:

For my part, when you speak of individuality of one who is truly married being inevitably lost, I think you mistake. If there ever was any individuality it will remain. I don't believe it is necessary for development that the individual must always force itself upon us. We naturally fall into the habits and frequently the train of thought of those we love, and I like the expression "we" rather than "I." I never feel that my interests and actions can be independent of the dear ones with whom I am surrounded. Even the one who seems to be most absorbed may, in reality, possess the strongest soul. This standing alone is not natural and therefore can not be right.

Anthony granted that a true woman will never be crushed by marriage, or, by implication, collaboration, but she conveyed her preoccupation with commitment, individuation, and autonomy when she argued that "[w]oman must take to her soul a purpose and then make circumstances conform to this purpose, instead of forever singing the refrain, if and if and if! (Harper 1898, 170).

Anthony and Stanton's relationship had many marriagelike features. Stanton had a room set aside for Anthony in every place she lived after the mid-1850s. Some of Stanton's children claimed that Anthony played a part in weakening the bond between their mother and father. In the 1880s after the death of Stanton's husband, Anthony invited her to move to Rochester where they could form one of the "homes of single women" that Anthony often praised in her speeches. But by that time Stanton was very clear about her need for distance from Susan, and she refused.

Stanton's Farewell Address
One of the most dramatic instances in which the Ultras' public rhetoric reverberated with implications for relations within the circle occurred in Stanton's final speech to the reunited National American Woman Suffrage Association in 1892. Many consider this speech Stanton's masterpiece. She was seventy-five years old when she wrote and delivered it. She stood before an audience that was uneasy with her leadership, a coalition that Anthony had built that included the conservatives and the radicals, the religious and the secular, the young and the old. In the new movement, suffrage was the overarching goal, and all other issues—especially Stanton's concerns with liberalizing divorce laws and attacking the conservative clergy—were placed on hold. Stanton stood before the delicately balanced coalition and delivered a speech that sounds fresh today—more than one hundred years later.

Anthony waited with trepidation to hear what Stanton would have to

say. As she had in 1852 when she formed the Women's Temperance Society, Anthony once again had played "queen-maker." It was due to her efforts that Stanton had been elected president of the reunited association in 1890. However, at this point, rather than exploiting Stanton's prestige, Anthony lent her prestige to Stanton, and asked her supporters to vote for Stanton rather than for herself. Stanton resisted Anthony's pressure to play a central part in the reunion of the two groups. Not only did she feel her broad agenda for change would be constrained by the new coalitions in the audience, but she also was ready to maintain distance from Anthony's relentless demands on her time and energy.

In her speech, "The Solitude of Self," Stanton broke new ground for justifying the rights of women, going beyond the eighteenth-century rights of man ideology to build her analysis on an existentialist framework. Her most profound point is that all men and women are fundamentally alone in an indifferent universe. Women, she argued, cannot rely on men as protectors because both are equally alone. Because women are equally alone, they have an equal right to armor themselves with every available resource—physical, economical, political, educational, and legal.

The participants recognized the brilliance of the speech, but Anthony was uneasy about it. It may be that Anthony understood the subtext—that Stanton was declaring her independence, and she would no longer be available to meet Anthony's needs or to participate in her projects. In that subtext, Stanton was publicly divorcing Anthony.

In the opening lines she stated: "In discussing the rights of woman, we are to consider, first, what belongs to her as an individual, in a world of her own, the arbiter of her destiny, an imaginary Robinson Crusoe, with her woman, Friday, on a solitary island. Her rights under such circumstances are to use all her faculties for her own safety and happiness." Alone with her "woman Friday" evokes associations of the early relations between Stanton and Anthony, when Stanton was marooned in Seneca Falls with only Anthony—her Friday—to link her to the outside world. But Stanton then argued that all men and women, inside or outside of marriage, are fundamentally alone and cannot rely on anyone but themselves:

> [T]he strongest reason for giving woman all the opportunities for higher education, for the full development of her faculties, her forces of mind and body; for giving her the most enlarged freedom of thought and action, a complete emancipation from all forms of bondage, of custom, dependence, superstition; from all the crippling influences of fear—is the solitude and personal responsibility of her

own individual life. . . . No matter how much women prefer to lean, to be protected and supported, nor how much men desire to have them do so, they must make the voyage of life alone. . . . It matters not whether the solitary voyager is man or woman; nature, having endowed them equally, leaves them to their own skill and judgment in the hour of danger, and, if not equal to the occasion, alike they perish.

She continued, as if carrying out a life review, reflecting on how she had been alone, without even a Friday, at the most critical junctures:

[T]hink for a moment of the immeasurable solitude of self. We come into the world alone, unlike all who have gone before us, we leave it alone, under circumstances peculiar to ourselves. . . . In youth our most bitter disappointments, our brightest hopes and ambitions, are known only to ourselves. Even our friendship and our love we never fully share with another.

. . . Alike amidst the greatest triumphs and darkest tragedies of life, we walk alone. . . .

Alone [a woman] goes to the gates of death to give life to every man that is born into the world; no one can share her fears, no one can mitigate her pangs, and if her sorrow is greater than she can bear, alone she passes beyond the gates into the vast unknown. . . . [H]ow few the burdens that one soul can bear for another!

She left no doubt that she was referring to more than just husband-wife relations when she stated: "So it ever must be in the conflicting scenes of life, in the long, weary march, each one walks alone. We may have many friends . . . to smooth our pathways . . . , but in the tragedies and triumphs of human experience, each mortal stands alone." Finally, she concluded with an image of her self that even her woman Friday could not penetrate:

And yet there is a solitude which each and every one of us has always carried with him, more inaccessible than the ice-cold mountains, more profound than the midnight sea; the solitude of self. Our inner being which we call ourself, no eye nor touch of man or angel has ever pierced. It is more hidden than the caves of the gnome, the sacred adytum of the oracle; the hidden chamber of Elusinian mystery, for it only omniscience is permitted to enter.

(DuBois 1992, 247–54)

Stanton had once described her relationship with Anthony as one in which they were locked "heart to heart with hooks of steel" (plate 36). Now

she was sending another message. After this speech, Stanton wrote the *Woman's Bible,* in which she "fires a volley" into the laps of her old enemies, the clergy. The book once again created a "breeze," and the negative publicity was an embarrassment to Anthony. Despite their long friendship and her desire to redeem Stanton's central position in the movement, Anthony thought it just as well that Stanton kept her distance in the final years.

Conclusions

The collective action stage is a turning point in the development of circles. To carry out the complex, interdependent tasks requires escalation of commitment from the members. As we have seen, new roles, norms, and cycles of activity emerge during this stage, and new tensions emerge that eventually contribute to the disintegration of the circle. The tasks of the collective action stage lead to a change in the type of leadership needed. In place of the charismatic visionary, the circle must find a pragmatic executive who can monitor the opportunities, mobilize the members for action, and tend to the endless details of organizing events. Sometimes circles do not find such people among their members. People who can do the introspective work required to build a new vision may not be good at this kind of organizational work. In the Impressionist circle during this stage, leadership shifted from Monet and Renoir to Pissarro and Caillebotte. In the Fugitive group, leadership shifted from Ransom and Hirsch to Davidson. For the Ultras, as they moved more squarely into the collective action stage, Anthony moved into a central position. She became the "Napoleon of the woman's movement," and the other members became her lieutenants.

As we have seen, a number of factors contribute to the disintegration of circles during this stage. First, the interdependent tasks make it more likely that members will frustrate one another. Their dependence upon one another now becomes instrumental as well as psychological, and the possibilities for disappointing one another multiply. Second, in most circles, as each member develops a more mature, differentiated view of the shared vision, disagreements become more intense, contributing to the disintegration of the group. Third, as members marry, have children, and embed their lives in family relationships, they become less emotionally dependent upon one another for support, and the demands of family life pull them away. Fourth, in the repeated cycles of interaction with public audiences, some members receive more recognition than others. Jealousy and conflicts develop over who deserves the most credit for the circle's ideas and accomplishments. Finally, as each member acquires more expertise, and as each

member begins to master the skills of other members—including their parts in maintaining one another's psychological cohesion and stimulating creative work—the members become less dependent upon one another. Ultimately, the dynamics of this stage contribute to the disintegration of most circles.

Gender and the Dynamics of Collaborative Circles
Although the men's circles I have studied disbanded after ten or fifteen years, the women's rights circle lasted more than forty years. In part its longevity was due to the scope of the task the members took on—redefining the ideological foundation of women's roles, and changing these roles in every system in American society—familial, economic, educational, legal, political, and religious. The task was enormous, and they encountered resistance in each system they attempted to change. In her final speech Susan B. Anthony proclaimed, "Failure is impossible," but along the way the Ultras frequently encountered humiliation, frustration, and defeat. The scale of their objectives meant that the goals could not be achieved in a short time.

For most circles the frustrations of dealing with so large a task would demoralize the group early in its development. It may be that the gender of members of this circle contributed to its longevity. The Ultras seem to differ from the male circles in the degree of intimacy and the scope of interdependence that they built during their early stages of development. Although the Impressionists did live with one another and worked side by side, it is unlikely they would go so far as to watch one another's children while they worked, as Brown and Stone did for one another, and as Anthony did for Stanton. It also is not likely that they would walk hand in hand, express undying love, and share their hopes and dreams, as Brown and Stone did while at Oberlin (Lasser and Merrill 1987, 72). Tolkien had marital problems throughout the time he participated in the Inklings circle, but as far as we know, he never discussed them with Lewis. Although men may develop profound trust and openness about their work, their personal intimacy is usually much less than that of women (House, Umberson, and Landis 1988). It may be that this personal intimacy contributed to the durability of the women's rights circle. Particularly within dyads—Stanton and Anthony, Stone and Brown, Mott and Wright—the bonds were deep and enduring.

The women also seem to have had greater tolerance for instrumental intimacy during the quest and creative work stages. As Harper (1898, 170)

noted, it is impossible to sort out who wrote what in the speeches of Stanton and Anthony, particularly during the 1850s. Of course, as we have seen, many of the members of male circles had this kind of psychological interdependence at some point in their work. Conrad and Ford collaborated in work that is difficult to disentangle. Likewise, as Freud admitted, the importance of sexual drives in hysterical symptoms was suggested by Breuer, and the concept of bisexuality originated with Fleiss. Although men in collaborative circles may establish instrumental intimacy and profoundly influence one another's work, it is difficult to imagine them announcing with pride how interdependent they are—as Stanton and Anthony often did throughout their lives. The intimacy that is the foundation of creative work in pairs seems to come more readily to women than to men.

Chodorow (1978) and, more recently, Pollack (1999) both have suggested that, because of the structure of the mother-child roles in families, males and females have different developmental experiences as children that may contribute to their readiness for intimacy. As they develop through infancy and childhood, females are likely to experience a gradual process of individuation from their mothers; and even after they achieve a degree of separation, their fundamental gender identities as females are rooted in a relatively continuous experience of identification with their mothers. Because a girl's primary caregiver is almost always a woman, she is free to maintain a continuous identification with her, and the boundaries between her developing self and her mother remain relatively permeable throughout her life. This developmental experience may contribute to less anxiety about being open, letting down boundaries, being empathic, and identifying with another person. For males, the primary identification with the caregiving mother is disrupted at an early age. Early on a young boy comes to understand that he is fundamentally different from his mother, and that his gender identity, a cornerstone of his self, must rest on separating himself from his mother and feminine things and doing something else, adding something, defining himself through action rather than relationships. He affirms his gender identity through separation rather than communion. Once he does break free from his mother and achieve a sense of masculinity rooted in separation and action, he becomes wary of psychological openness, letting down boundaries, being dependent or even empathic, which are associated with femininity. Perhaps these developmental differences leave women better prepared to function in collaborative relationships, less anxious about participating in the dynamics of paired collaboration and collective action. Regardless of how and why it occurs,

the profound intimacy of the women in the Ultras circle, as well as their tolerance for interdependence, may have contributed to the resilience and durability of their circle.

However, other characteristics of women's lives, especially in the nineteenth century, would lead us to expect earlier group disintegration rather than greater durability of circles of women. Even in the late twentieth and early twenty-first century, early in the family life course women are likely to be more constrained than men by their family role responsibilities first as daughters, then as wives, then as mothers. Until recently, in their adolescent years females were granted less autonomy than males; if they married, their husbands' careers were given priority; and if they had children, they set aside their career goals to raise them. The typical life course for women included education followed by work until the first child was born. After the birth of the first child, women withdrew from the workforce and did not start reentry until their youngest child was in school (Rossi 1980).

In the nineteenth century, these role constraints were even more severe. The doctrine of "spheres" provided scripts for women's lives directing them toward domestic responsibilities—caring for children, husbands, and sick or aging relatives. Except for Anthony, who chose not to marry, the participation of each one of the Ultras was limited during the years of childrearing. With only one child, Stone dropped out completely during the 1860s. Stanton was continuously caught between the demands of her husband and her seven children, on the one hand, and on the other the demands of Anthony and the movement. Raising six children also pulled Brown away during most of her childrearing years. These constraints could have led to the early disintegration of the Ultras circle, and perhaps they did play a part in the erosion of the bonds between the members during the 1860s and 1870s. However, once their children were raised, all of the mothers in the circle found a second wind, most notably Stanton and Stone, who escalated their involvement in the 1870s. The reduction of family responsibilities freed them to devote more energy to the movement. In short, until recently women's involvement in collaborative circles may have been curvilinear—high in their twenties, dropping off in their thirties and forties during the time of heaviest family responsibilities, then high again in their fifties, sixties, and seventies. The final individuation of the members from the circle and the disintegration of the group may be delayed until after members come back together in their fifties.

However, recent changes in women's roles may reduce the constraints on women's participation in collaborative circles. Although men far outnumbered women in college for most of the twentieth century, women now out-

number men; and they are overtaking men in numbers in many graduate and professional programs. By the mid-1990s the life course data show that women's participation in the labor force is barely affected by the birth of the first child (Cherlin 1996). These demographic changes suggest that the constraints on women's participation in circles have lessened. Although children may create an "undertow," slowing women's participation during their thirties and forties, it is likely that their patterns of involvement will soon become more like that of men. What differences remain may be due to gender differences in psychological development alone.

Of course, this discussion of gender differences is speculative. Although I have examined the roles of women in some mixed-gender circles, such as the Bloomsbury group and the Impressionist circle, I have not systematically studied women's circles other than the Ultras. The Ultras were a unique group with a large social reform agenda. It may be that outside of the political arena, circles of women in literature and in the arts endure no longer than the men's groups and have similar dynamics. Nevertheless, my hunch is that women function more effectively and with less anxiety in some phases of the development of collaborative circles; men function more effectively and with less anxiety in others (Farrell 1986). For example, men may be more at ease in the "delinquent" rebellion stage, whereas women may function most comfortably in the collaborative pairing stage. It may be that mixed-gender circles freed of the constraints of traditional gender roles benefit from the assets of both genders. The questions raised by this chapter need to be explored in future research.

Chapter 7

———

Toward a Theory of Collaborative Circles

A collaborative circle is a set of peers in the same discipline who, through open exchange of support, ideas, and criticism develop into an interdependent group with a common vision that guides their creative work. Like friendships and marriages, circles develop over time. It takes time to develop the trust, commitment, and instrumental intimacy necessary for collaboration. Only at the culmination of a developmental process do we find the kinds of episodes of collaboration that lead to creative work. Although the development of circles often follows a predictable sequence, that sequence does not unfold automatically, like the predictable differentiation of a cell into a complex organism. Rather, collaborative circles are likely to form if certain conditions are present in the group's environment and composition, and if some members of the circle have the leadership skills necessary to guide the group at critical points in its history. Without the right external and internal conditions, even the most effective leader could not make a collaborative circle work. Without the right kinds of leadership at the right times, a circle will flounder, even under the best of circumstances.

Structural Conditions Conducive to Circle Formation

It is possible to view all the members of a profession or discipline as a network of people who exchange information, resources, rewards, and sanctions. To visualize the network, picture a loosely woven net stretched across a three-dimensional topographical map. Each member of the discipline is represented by a node in the network, and the line linking two nodes represents the flow of communication and resources from one member to the other. The members perched on higher ground have more status and resources than those lower down, and they send and receive more informa-

tion to both nearby and distant nodes. Consequently, their nodes have numerous lines radiating out. The network has peaks where there are many high-status members linked together in a single place; and it has valleys where there are no high-status persons. It is woven thick—a dense network—where a group of people communicate frequently among themselves. It is threadbare where individuals are relatively isolated from the flow of information. In some locations there are multiple peaks, where competing schools with alternative visions vie for centrality. In such places, linkages are dense among members clustered on each peak, but there are few links between peaks. Where in this topography are collaborative circles of peers most likely to form?

In 1862, Paris was a location where multiple peaks formed within the network of artists. Ingres, who was the most prestigious proponent of the classical style valued by the French academy, represented the highest peak. The networks centered on Delacroix, the romanticist, and Corot, the realist landscape painter, can be seen as minor peaks. It was because of these peaks that Paris became a magnet place for young artists. They were drawn by the concentration of expertise, resources, and fame, as well as by the opportunities to develop their own skills, sell their work, and perhaps become famous themselves. Some of the novices gained access to the peaks at the center of the network, worked in the studios of the most respected masters, and learned the established theories and methods. Among these privileged novices were protégés such as Cabanal who rose rapidly over the next decade. Other novices, like the young Impressionists, were highly ambitious and talented, but for a variety of reasons found themselves in one of the valleys in the network. They were in Paris near the center of the action, but they were cut off from the most respected masters who controlled access to resources and rewards. Marginalized in relation to the established authorities, they wove a dense network of exchange within a set of peers.

My findings suggest that collaborative circles are likely to form under conditions like those in which the Impressionists came together—in a magnet place where the high-status masters are gathered, but within the valleys on the periphery of that network. Highly ambitious, talented novices who are attracted to a magnet place but find themselves cut off from prestigious mentors are more likely to turn to their peers for support and guidance. Although they are highly motivated to succeed, they receive a thin stream of reward or support from those in authority. In weighing the rewards and costs of courting and working with a mentor as compared to those they find in working with their friends, circle members find commitment to their friends more promising, so they choose their friends.

As Chubin (1976) found in his study of innovations in science, people in marginal positions in a discipline are more likely to be a source of new ideas than are people at the center. Perhaps because they have been marginalized, they are more tolerant of experimentation and deviant visions in a field. Ambition, coupled with their marginalization, may be what fuels the resentment and rebellious tone characteristic of their early interaction with their peers. As they interact, if they discover that the members of their circle share their feelings, their irreverent attitudes toward authority are reinforced. The validation of their attitudes and aspirations enhances their self-confidence. If we view collaborative circles as new forms of life, we could say that they evolve in the dark valleys rather than on the brightly lit peaks of a discipline. The peaks are where the elite organize into hierarchical groups and work to preserve and extend the visions of a previous generation; the valleys are where collaborative circles of peers create new visions.

Cultural Conditions Conducive to Circle Formation

If the discipline network with its peaks and valleys is the topographical landscape in which circles form, then the cultural environment of the circle is the weather pattern that passes over the landscape. Collaborative circles that develop innovative visions flourish in turbulent cultural environments, where two or more visions of a discipline, like high and low pressure fronts on a weather map, vie for centrality in a single place. As Louise Cowan (1959) noted in her study of the Fugitive poets, in certain times and places the proponents of competing visions confront one another and dramatically highlight the differences in their thinking. For those already committed to one or the other vision, the confrontation has the effect of polarizing them even further. Particularly among those at the center of the network— the masters and their protégés—the conflict leads to increased commitment to the established visions. When under attack, prestigious mentors usually expect loyalty from their disciples, and categorize others as either for or against them. But on the periphery of the network, the conflicts at the center encourage the spectators to weigh one vision against the other and to reconsider basic assumptions. The dialogue at the center empowers those on the periphery to synthesize elements of the old perspectives and to conceive an alternative vision of their own.

The clash of alternative visions can come about for a variety of reasons. At times, the turbulence occurs because of rapid change in a society. Contacts with other cultures may lead to the introduction of new ideas and the questioning of old assumptions. Thus, for example, contact with Japanese

art in the 1850s offered new ways of seeing to artists in France. Inventions and rapid technological change may affect social roles and suggest new possibilities in art, literature, science, and other fields. For example, in the mid–nineteenth century, the invention of photography and the new candid photographs of landscapes and families had repercussions in the larger world of art. Likewise, in Nashville, Tennessee, in the early twentieth century, the imaginations of the young poets were stimulated by the spread of Northern manufacturing technology into a South that was still haunted by the glory and guilt of the past. In the Northeast United States in the late 1840s, the Ultras drew from the values and methods of persuasion developed by the abolitionists, the temperance leaders, and the religious revivalists to construct their vision. Some geographical locations may be in a state of cultural turbulence because they are major intersections of diverse cultures where people with alternative worldviews are continuously interacting with one another. With an abundance of intellectual refuges from World War II, New York City took on this character in the late 1940s and early 1950s, and it became an international center of new developments in art and literature.

Major changes in the demographic composition of a discipline network may also lead to clashes of visions—as happened in the nineteenth century when women became active participants in the abolitionist and temperance networks. Each vision within a discipline almost always has a political constituency. As the demographic composition of a discipline changes, for example, the gender or ethnic balance, the political structure of a discipline is also likely to change, generating conflict over visions at the center.

The Macro Effects at the Micro Level

The dialogues between proponents of different visions at the center of a discipline network often are reenacted in the dialogues within friendship circles. The great debates of the day are taken up in the circles and argued again and again, as they were in Café Guerbois in Paris in the 1860s and in the kitchens and parlors of the Ultras in the 1850s. If communication within a friendship group is open, if the members are not dominated by a defensive mentor anxious to preserve a particular vision of the field, the interaction in the group may start percolating toward a new vision.

In the debates, some members identify with one side, some with the other, and still others are ambivalent or undecided about where they stand. Especially during the rebellion stage of circle formation, some members are ambivalent about both the traditional visions in a field and the radical alternatives under consideration. For example, in the debates in the Guerbois,

Renoir was drawn to the conventional linear style and dark colors of Ingres even while he was following Monet and rebelling against these conventions. He saw himself as the "cork," adrift in a stream of conflicting currents. Ingres's classical vision was also attractive to Degas, who nevertheless incorporated elements of the Impressionists' style. Despite his commitment to the Impressionists, he was the defender of the conventional artists in the circle's extended network. In the debates between Monet and Degas, the ambivalent members, such as Renoir, could externalize the poles of their ambivalence and identify first with Monet then with Degas. By vicariously participating in the dialogue, the ambivalent "corks" sharpen their understanding of the issues and eventually develop an individual synthesis of the alternatives. In the discussions among the members of the Ultras of the women's rights movement, Susan B. Anthony worked through her ambivalence and uncertainty about strategies to reform women's roles. Her gradual radicalization—her drift from temperance worker to spokesperson for Stanton in the women's movement—was an outcome of these dialogues. Her gradual acceptance of the radical vision could be traced in her early doubts and later acceptance of the bloomer dress and the bobbed hair of the Ultras. Through participation in the debates, and through identification with the spokespersons for both sides, the conflicted members eventually resolve their ambivalence, firmly commit themselves to a vision, and become free to work more productively.

Circles as Buffers against Pressures to Conform

Once formed, a circle constructs its own subculture. At the heart of the subculture is the shared vision of the members—a new theory and methodology that they introduce into their discipline. For the Impressionists, it was their emerging theory and method of art—a set of ideas about what to paint and how to paint it. For the Ultras, it was their vision of the oppression of women, their arguments for women's rights based on that vision, and their strategies for social change. Whatever the content, a new vision is often viewed with suspicion by authorities in a field. A new vision not only raises questions about the value of existing visions, it also can have political and economic consequences for those who have built their careers on existing visions. Not surprisingly, those who advocate the new vision are often viewed as threats by the established authorities at the center of a discipline network. These deviant innovators often become targets of formal and informal sanctions.

In the early stages of circle development, the supportive friendships within a circle enable the members to resist pressures to conform to the dominant

vision of their field. The pressures may come from family members as well as peers, teachers, and other authorities in the discipline. For example, in addition to the pressure she felt from the news media, the clergy, and the conservative reformers, the young Elizabeth Cady Stanton was pressured to moderate her stands by both her father and her husband. During the quest stage of circle development, the group provides a supportive context where the members are free to explore new, "deviant" ideas. During the collective action stage, when the members take the new vision into the community, the circle provides the support they need to cope with rejection, ridicule, and sometimes even legal sanctions.

The dynamics of the circle thus not only buffer the pressures to conform, but encourage experimentation. The charismatic leader's sense of mission, self-confidence, and daring are contagious. Under the spell of the charismatic leader, the members are willing to try many things they would never have done alone. For example, Stanton's lead in advocating the vote for women and in wearing the bloomer dress affected the thinking and behavior of both Lucy Stone and Susan B. Anthony. Those who resist the momentum of the circle—the conservative boundary markers who cling to conventional visions as well as the radicals who go too far in rebelling—stimulate discussion and clarification of the circle's emerging vision. For example, with his advocacy of T. S. Eliot's poetry, Allen Tate was seen as too "modernly modern" in the Fugitive circle, but his position stimulated the core group to clarify their own vision of what poetry should be. Likewise, Antoinette Brown's conservative arguments for women's rights based on biblical sources, though rejected by the Ultras, stimulated them to clarify the foundation of their views based on the values of the American political tradition. Within the space between the radical and conservative boundary markers, the center coalition constructs a new vision—a new theory and method that guide them in doing creative work in their discipline.

The Limitations of Delinquency Theory for Circle Dynamics

The structural conditions under which circles form—a marginalized group with a disjunction between their ambitious goals and the means to attain those goals—resemble those in which some types of delinquent gangs form (Cohen 1965; Short and Strodtbeck 1965). Like marginalized working-class adolescents, the circle members discover they cannot succeed within the existing rules, so they turn to their peers and develop an alternative subculture. From the perspective of their subculture, the standards of the dominant group are defined as "decadent," "passé," or "irrelevant." In other words, to use Sutherland's (1940) term, deviance is ra-

tionalized and the conventional arguments for conformity are "neutralized." Like delinquents spray painting graffiti on community monuments, circle members sometimes symbolically attack or mock the revered symbols of authority in their discipline. Just as the delinquent adolescents redefine failure in school as a form of success and conformity to the teachers' expectations as treason, the members of a collaborative circle define approval by authorities as "selling out." The shared vision of the circle of collaborators includes or implies an alternative set of values by which the members measure their worth.

But unlike delinquents, members of collaborative circles have a stake in the system. Circles form at a later point in the life course than adolescence, usually during the young adult years. The members of collaborative circles usually have acquired more skills and resources than have adolescents, and they aspire to make valued contributions to their field. Unlike delinquents who use shortcuts, such as theft, to acquire the rewards of hard work, circle members seek to master a discipline and to achieve recognition within their field. In contrast to delinquents who usually try to keep their subculture and illegal activities secret, the circle members attempt to convert the authorities and the public to their vision. Especially during the collective action stage, circle members campaign to win converts and to institutionalize their views. For example, the Ultras did not settle for privately deviating from the restrictions on women; they campaigned for change in the laws and norms of their society. Likewise, the Impressionists did not try to obtain the rewards of painting through surreptitious means; they struggled to change the values of the critics and the public. Thus, although collaborative circles may form under structural conditions similar to those in which delinquent gangs form, and although they may have some of the dynamics of gangs, circle members are less alienated from authority. They are more socially mature, have more skills and resources, and have the goal of converting the public to their emergent vision.

The Composition of Collaborative Circles
Collaborative circles form among highly ambitious members of a discipline network who share a common set of attitudes and values and who speak the same language. Often the commonalities are a consequence of similarities in their social backgrounds—their common gender, class, race, age, religion, ethnicity, or upbringing. Because of these commonalities, when they begin interacting they find they agree about many issues, and they reinforce one another's beliefs and values. For the Fugitive poets, for example, the experience of growing up male in the early twentieth-century South provided

a foundation for their discussions. The Ultras' vision was shaped by their shared experiences of growing up female in the mid-nineteenth-century Northeast, participating in the religious revivals as adolescents, reading the works of Mary Wollstonecraft, and internalizing the rhetoric of the abolitionists. Because of their commonalities, members of successful circles share many assumptions about what is important and unimportant, they can laugh at one another's jokes, and they do not have to justify every opinion or explain every detail of their thinking. In short, they feel almost a familial sense of being at home with one another.

Even if they do not have common background characteristics, there are two additional reasons why members of collaborative circles are likely to have similar values and attitudes. First, although initially the members may be from diverse geographical and social areas, circles often form in a magnet place perceived as rich in resources. Because the magnet place has a reputation and sends out similar signals to a wide network, those who go there are likely to have much in common. Second, within the social network at the magnet place, circles often form when one or two people—the gatekeepers or matchmakers—bring the members together. The gatekeeper's criteria for friendship filter potential members so that those chosen have many attitudes and values in common. The magnet place ensures some degree of homogeneity, and the gatekeeper's selection criteria reinforce it.

Once members of a circle escalate the exchange of ideas to the point where they can talk openly about their current work, they begin to homogenize their group culture further. In their discussions, they discover inconsistencies in one another's thinking, or they challenge the taken-for-granted beliefs and attitudes of their companions. In their dialogues, they pressure one another toward consistency and agreement. Without the common language and values that enable members to validate one another's basic assumptions and argue with one another persuasively, a circle is likely to disintegrate during the quest stage, if not sooner.

It is in the quest stage that the members move beyond criticizing authorities and attempt to forge a shared vision; and it is during this stage that the members pair off into dyadic working friendships characterized by trust and instrumental intimacy. Within the pairs, they open their private thoughts to one another, rely on one another as sympathetic critics, and expose to one another their most outrageous ideas. When they are engaged in this kind of dialogue, they are most vulnerable to one another. Without the commonalities of background, values, and styles of discourse, they may react to one another in destructive ways. The disastrous disintegration of the relationship between Henry James and H. G. Wells is an example of a de-

structive outcome. Their wide differences in age, cultural background, and stages of career contributed to the suppressed disagreements and misunderstandings that culminated in public attacks on one another's work. Their intimacy during the periods of collaborative pairing made them all the more vulnerable to one another.

Equality in Capital in Circles

Bourdieu (1993) makes the distinction between economic, social, and cultural capital. Economic capital is income and wealth. Social capital is the support a person can rely upon from others as a result, for example, of their obligations for past favors. For professionals in a discipline network, cultural capital is the expertise acquired through education or exposure to those with knowledge and skills in that discipline.

In a mentor-protégé relationship, the balance of all three types of capital is uneven. Usually, the mentor has more resources on all three dimensions, and the protégé depends on the relationship to acquire capital. The relationship engenders a power imbalance and dependency in the protégé (Blau 1964). It may be that the imbalance of resources in such relationships contributes to their instability (Levinson et al. 1978). The mentor often resists movement toward equality, and the protégé comes to resent the requirements of deference and dependency. Such tensions seem to have lurked just beneath the surface in the unequal relationship between Henry James and H. G. Wells, and they finally broke through the veneer of friendship. Such tensions also may have contributed to the strains in Freud's relationship with Breuer, who was older, wealthier, and more established as a physician and scientist.

In the initial encounters of members of successful collaborative circles, usually all members are roughly equal in their possession of capital. Although some may have more economic capital, others more cultural capital, and still others more social capital, circle members are able to trade off one type of currency for another, so long as, consciously or unconsciously, they have negotiated a degree of consensus on the rate of exchange. As in any relationship, the exchanges may become unbalanced, but the friendship still can develop and stabilize so long as the exchanges have the potential for returning to a balanced state. Because the members are roughly equal in overall capital, they are able to make equivalent exchanges and balance their accounts.

When Bazille, Monet, Renoir, and Sisley formed their circle in 1862, they were not equal on all three dimensions, but they were able to maintain bal-

anced accounts through the exchange of different types of currency. Bazille and Sisley had access to economic capital through their families. Bazille also had social capital through his family contacts with the upper middle class, including Edouard Manet's family. Monet and Renoir had more cultural capital in the form of skill at painting and knowledge of contemporary art. Monet also had social capital in the form of connections with several older landscape painters. When they formed their first collaborative pairs while painting landscapes in the spring of 1863, Monet paired with Bazille, and Renoir with Sisley. In each dyad, one member had relatively more cultural capital, the other more economic and social capital. Monet and Renoir could exchange their relative abundance of knowledge and skill; Bazille and Sisley could trade on their relative abundance of wealth and income. Sisley took Renoir on a cruise to his family summer home; Bazille provided an apartment and supplies to both Monet and Renoir. Renoir taught Sisley new techniques; Monet inspired Bazille with his daring experiments in outdoor painting. The exchanges are gratifying for all parties so long as the accounts are relatively balanced. Toward the end of the 1860s, the relationship between Monet and Bazille became strained. Perhaps the value of Monet's cultural capital had diminished for Bazille. Bazille may have felt he had learned all he could about painting from him, and Monet's talent was no longer worth the drain on his resources. Bazille pulled away from the dyad and turned to Edouard Manet as a model. Claude Monet then paired with Renoir, who was his equal in both cultural and economic capital. Out of their exchanges of ideas came the new synthesis that led to the Impressionist vision.

The relative equality in resources contributes to the formation of an egalitarian group. No member is overly dependent upon any other. The members can disagree with one another openly, even insult one another with humor, as friends can, without fear of retaliation. In male groups, like the group that met at Café Guerbois, the open, egalitarian style is illustrated by the tone of conversation that Manet and Degas modeled with their acerbic, witty banter. Elizabeth Cady Stanton's description of the witty and caustic interaction in her parlor suggests that the communication was equally open when they met as a group. Although the members might tease or mock one another, group meetings are relatively safe places to speak their minds. The balanced, egalitarian relationships contribute to open communication among all members. In the quest stage, the sense of equity in the distribution of rewards contributes to the trust and intimacy necessary for instrumental intimacy and creative work in pairs.

The Stages of Circle Development

As a circle develops, there are changes in the group structure and culture, changes in the relationships between members, and changes within each member. At the structural level, the leadership, network properties, coalitions, and rituals of interaction evolve in response to new challenges. At the cultural level, the shared beliefs, values, and group vision become more clear and explicit. In their interpersonal relationships, the individual members first court one another, form strong dyadic friendships, then escalate the value of their exchanges and negotiate a deeper level of interdependence. As time goes on, the individuals acquire greater expertise and autonomy, they become less dependent on the circle, and they drift apart, pursuing more individuated paths. In discussing the stages of circle development, I focus on the structural, cultural, and individual changes that characterize each stage. In table 1, I present a brief summary of the network structure, informal roles, type of social support, and interaction processes that characterize each stage.

Formation Stage
Friendships in an occupational network often form among persons with similar values and relative equality in status and resources, but not all such friendships become collaborative circles. In most cases, the activities of colleagues and friends in a discipline are like parallel play among children in a sandbox. They may be aware of one another's work, but they do not discuss it, influence one another, or carry out cooperative projects that draw out creativity in one another. Like students in a traditional classroom, like faculty in adjacent offices, or like staff members in a bureaucracy, they work alongside one another but they all mind their own business. What is necessary to move a group of homogenous equals toward becoming a collaborative circle? The structural and cultural conditions in the environment and the composition of the group are the ingredients, but it takes leadership to combine the ingredients.

THE GATEKEEPER'S CRITERIA FOR FRIENDSHIP. Successful circles usually form as radial networks. At the center of the network is the gatekeeper, a person who is instrumental in drawing the members together and introducing them to one another. On the edges of the network are novice members who often do not know one another well. Initially, rather than forming a dense network of interdependent members, these newcomers are like a squadron of planes flying in formation, linked only by a common bond to one member, the gatekeeper.

Table 1. Stages of Circle Development

	Formation	Rebellion	Quest/Creative Work	Collective Action	Disintegration/ Individuation	Reunion
Network Structure	Radial	Dense, centered on charismatic leader	Moderately polarized; collaborative pairs	Dense, centered on executive manager	Fragmented	Temporarily dense
Emergent Roles	Gatekeeper, novices	Charismatic leader, cork, lightning rod, tyrant, scapegoat, peacemaker	Conservative and radical boundary markers, center coalition, collaborative pairs	Executive manager, peacemaker	Roles discarded, individuated selves	Alumni organizer, revived informal roles
Types of Social Support	Companionship, validation of self-concept	Resolution of ambivalence; courage to rebel; buffering pressures to conform; exchange of economic, social, and cultural capital	Instrumental intimacy; strengthening internal cohesiveness through mirroring and serving as idealized selfobject; sharing cognitive processes, skills, and half-formed ideas; creating new ideas, critiquing current work	Goal setting, planning, monitoring progress, finding resources, buffering setbacks	Support during personal crisis	Reaffirmation of value of shared vision and each other's work
Distinguishing Processes	Socializing in public settings	Ritualized meetings in set place	Creative work in pairs; exchanging works in progress, clarifying and integrating vision in group meetings	Collective project to win public support (e.g., journal, exhibition, convention, book); interdependent division of labor coordinated by executive manager, increasing conflict	Working alone; individualizing shared vision; conflict over ownership of ideas, authorship, and recognition	Reminiscing, constructing history

The gatekeeper in successful circles is likely to have particular criteria in selecting friends. The gatekeeper's criteria—the foundation of the culture of the circle—are based on work-related expertise rather than kinship, neighborhood proximity, recreational skills, or some other nonoccupational criteria. The gatekeeper selects friends who are highly ambitious and committed to the same line of work—people who aspire to make a mark and gain recognition in their field. Some if not all the members selected by the gatekeeper may have an inflated sense of their own destinies—like the young Wilhelm Fleiss, Claude Monet, Joseph Conrad, or Lucy Stone. They may have moments of doubt, but within their chosen field, they aspire to have a great impact. They see something lacking in the mainstream vision of their discipline, and they want to do something about it. If the gatekeeper's criteria work well as a filter, most members of a collaborative circle will share the gatekeeper's values and career aspirations.

The gatekeeper's work-related criteria lay a foundation for a norm of "shoptalk" in the circle. Because of the kinds of people the gatekeeper chooses as friends, early in the circle's development the members set a norm that it is appropriate to talk about their work. Rather than centering their conversations on escapist, recreational activities, gossip, or discipline politics, they talk about the central activity in their discipline, whether it is art, literature, science, social reform, or something else.

During the formation stage, the circle does not yet have a shared vision that guides members' work. Instead, the members are still striving to understand the established theories and methods of their field. Often, what initially draws them together is a shared reaction to established visions. Without fully understanding why, they are attracted to the work of some, repulsed by that of others, and divided about the accomplishments of still others. For example, the Fugitives discovered some poets they all admired, some they all rejected, and others, such as T. S. Eliot, who caused endless debate.

On the personal level, the members often are in a state of transition. Usually they are in the process of disengaging from the social networks of their adolescent years, but they are not yet established in an adult network. If they are well beyond the adolescent years, as Conrad was when he met Ford or as Freud was when he met Fleiss, they are likely to be in a state of transition into a new stage of family or professional life. They may have high aspirations, but they feel far from being masters of their chosen disciplines. In other words, they see themselves as incomplete and in the process of building an identity or reputation in their discipline.

The initial type of social support provided to one another may be limited

to companionship. Like Bazille, Renoir, Sisley, and Monet, they may find they enjoy one another's company and establish a ritual of relaxing together. At first they may share only opinions, ideas, and works that they are confident will impress their new friends. Writers may share their published works. Painters may share finished work that has already won praise. They exchange only work that does not make them vulnerable to criticism. For example, when Freud gave a copy of his translation of Bernheim's work to Fleiss, he stayed well within a safety zone. The translation was his work, and he approved of Bernheim's ideas, but because the ideas were Bernheim's, he left room to disassociate himself from these ideas if they generated negative reactions from Fleiss. Most important, because he was not exposing his own half-formulated ideas, he did not open himself to criticism or the possibility of being plagiarized.

Rebellion Stage

In the rebellion stage, the structure of the group changes. The initial radial network centered on the gatekeeper evolves into a dense network centered on a charismatic leader. The charismatic leader is a narcissistic member who is most vocal and dramatic in rejecting the established visions of the discipline. Like Monet when he led the young Impressionists out of the studio and into the forest to paint contemporary landscapes, the charismatic leader urges the group to try something daring, sometimes even forbidden in the discipline. In interpersonal relationships, this person may become an idealized selfobject to other members. When other members are following his lead, they feel they are on a mission, their doubts are relaxed, and they feel stronger and more internally cohesive.

During this stage, other roles may appear that contribute to the solidarity of the group and the internal cohesiveness of individual members. The members may identify a tyrant on the edge of their network—an authority associated with a vision they reject. One ritual in group meetings may be relating stories that deflate this tyrant. By sharing a target of contempt, the circle members reinforce their solidarity.

The members may also identify a scapegoat, a peer on the edge of their network who adheres to the rejected vision. Many members may be ambivalent about their own rebellious urges. Although they are enticed by the charismatic leader, they still may harbor an inclination to conform to the authoritative vision. As we have seen, Renoir showed this kind of ambivalence throughout most of the time he was associated with the Impressionists. By projecting onto the scapegoat their own urges to conform to the mainstream, and by ritualistically attacking the scapegoat either directly or

in their discussions, members gain control of these urges to conform. The external consensus of the group reinforces their internal suppression of impulses to "sell out" the circle. By articulating the reasons to reject the scapegoat's behavior, the rest of the members reassure themselves that their rebellious course is the right course to pursue—for now.

A single member—the lightning rod—may take on the role of expressing hostility toward the tyrant and the scapegoat. Although other members share the hostility, the lightning rod is the one who actually gives it voice. By expressing the feelings shared by the group, the lightning rod frees other members from the anxiety and guilt generated by being rebellious and aggressive. In other words, like the scapegoat, the lightning rod contributes toward more internal cohesion in the members.

Finally, in response to the negativity that emerges during this stage, one member may take on the role of peacemaker. The peacemaker is the member who attempts to modulate the negativity, resolve conflicts, and restore harmony to the circle when the interaction becomes openly hostile. The peacemaker contributes to the integration of the group as whole and acts as therapist to agitated members.

When the members are sizing one another up, the exchanges may stabilize at a relatively superficial or guarded level. But eventually, for reasons that vary for each group, trust reaches a critical point, and one member takes a risk and opens the door to more intimate disclosures. In the Fugitive group, when Ransom shared his first poem with Davidson, he redefined the nature of their exchanges. When Tolkien gave Lewis an early draft of his epic poem, he took a similar risk. Likewise, when Freud sent his first unfinished manuscript to Fleiss to criticize, he raised the ante in their communication. If the recipient of the "gift" follows the lead and reciprocates, the process can quickly intensify until all members are openly sharing their most secret, undeveloped ideas. With artists, the effect can be more rapid and immediate. For example, in the 1860s, Cézanne usually painted alone in his studio. When he agreed to work alongside Pissarro in 1872, the exchanges between them escalated rapidly, and the influence of their relationship on their individual work was dramatic.

Once again, leadership plays a critical part in escalating the exchange process. If a charismatic leader models a new level of exchange, and if the others reciprocate, a circle has the potential to become collaborative. The charismatic leader may first escalate the exchanges within the confines of a dyadic relationship. If the partner responds in an appreciative, mirroring fashion, then the pair may draw the rest of the circle into a more demand-

ing fellowship. If the charismatic leader can succeed in stabilizing the exchange process in the whole circle at this new level, the members have the chance to develop a shared vision. For example, when Tolkien agreed to read his work aloud to Lewis, and when the new members who joined the group were required to comply with this norm, their potential for becoming a collaborative circle was established. Likewise, when Ransom and Davidson instituted the rule that each member of the circle had to arrive at the Saturday evening meetings with a typewritten poem and copies for all members, the foundation was laid for negotiating a group vision. Davidson and Tate's correspondence confirmed and deepened their collaborative relationship. After they made their covenant to include a new poem with each letter and to respond with detailed criticisms to the other's work, their influence on one another was profound. When Davidson reported on these exchanges at the meetings of the whole circle, he modeled the more demanding level of exchange for other members, and it helped shape the emerging group culture.

The Quest Stage

A marker event that lays the foundation for the group's entry into the quest stage is the establishment of a ritualized time and place for meeting to discuss work. In the meetings, the members systematically sort through existing visions in their field and consciously attempt to develop a vision of their own. In thinking through what is wrong about the traditional visions and what they wish to include in their own, they often cast members of their circle into two types of boundary-marker roles, the conservative and the radical. The conservative boundary marker is a member of the circle who argues in favor of the traditional vision of the field. Like the scapegoat, he or she may be accused of "selling out" the nascent vision of the circle in order to win the approval of conventional authority. At the opposite extreme of the conservative boundary marker is the radical boundary marker—a member who "goes too far" in rebelling against convention. This member may be perceived as a wild, undisciplined, "loose cannon" in the circle. As they react to the positions taken by the boundary markers, the circle members begin to clarify their shared agenda for change.

During the formation and rebellion stages of circle development, the emergent roles meet the expressive needs of members. The charismatic leader serves as an idealized selfobject, the peacemaker provides emotional support, the lightning rod expresses shared hostility, and the scapegoat serves as a safe target of attack. But as the group moves into the quest stage,

and as members strive to achieve consensus about what they like and do not like about existing visions, they self-consciously work on a more cognitive level and engage one another in open intellectual dialogue.

Turner and Colomy (1993) make the distinction between functional and representational roles in groups. While functional roles emerge as a more or less rational division of labor to carry out complex tasks, representational roles serve as signposts marking ideal and devalued performances of roles. Representational roles are boundary markers that embody idealized or devalued directions for members to follow. During the quest stage, the representational roles of conservative and radical boundary markers become salient. Rather than attacking scapegoats outside the group, the members engage their boundary-marking members in an ongoing dialogue.

What distinguishes the boundary markers from scapegoats is their inclusion as recognized members of the group. Rather than being a target of ridicule, their ideas are taken seriously and openly discussed. If the level of trust and commitment within the circle is high, the members are able to tolerate the boundary markers' differences in perspectives and argue with them effectively. As Degas did in the Impressionist group, the conservative boundary marker often acts as a devil's advocate—giving voice to the perspectives of the circle's enemies. Likewise, the radical boundary marker—like Cézanne for the Impressionists or Stanton for the Ultras—may push the rebellious agenda of the group further than the circle can accept.

Although boundary markers may create strains on the group's solidarity, they can have significant positive effects on members' creativity. For example, in experimental studies of problem-solving groups, Nemeth (1993) found that groups with a vocal internal opposition developed more sophisticated and complex solutions to problems they were given to solve than did less contentious groups. The presence of a questioning minority stimulates thinking in other members, and, confronted with the negative feedback, the group develop more creative and workable solutions to their problems. Ultimately, circles with a high tolerance for irritant boundary markers in their midst may be more likely to develop new visions in their fields. Such groups are less prone to conformist "groupthink" dynamics (Janis 1982).

Collaborative Pairs and the Creative Work Stage

Beginning in the quest stage and continuing into the creative work stage, the network structure of the circle changes once again. Although in earlier stages the members alternate between working alone and meeting as a group to discuss their work, now their interactions include a pattern of working in pairs. Pairing may have begun in earlier stages, but during the

quest and creative work stages it becomes a central feature of the group's structure. In part, pairing is shaped by the distribution of economic, social, and cultural capital within the circle. Each member may weigh the relative costs and rewards of all possible relationships within the circle, gravitating toward the one that appears most equitable. Equity exists when the partners perceive that what they each bring to the relationship and what they get out of it are roughly equivalent. Although the exchanges are multidimensional, both partners perceive that the contributions, costs, and rewards balance out. Of course, as in courtship and marriage, the sorting process is not always rational. Sometimes it is guided by proximity or by superficial similarities, such as age, religion, or life stage. Often personality plays a part. For example, some people, like Lucy Stone and Antoinette Brown, find they enjoy one another's company even though their initial exchanges may be unbalanced; while others, like Conrad and H. G. Wells, rub each other the wrong way. Whatever guides the selection process, by the time the circle enters the creative work stage, the collaborative pairs have usually been established. It becomes taken for granted that certain pairs will work together. Within the pairs, although the members may be equals on many dimensions, there may be differences in the distribution of resources. Like Conrad and Ford, or like Stanton and Anthony, they each may have skills and resources that the other lacks, but in the exchanges, weighing what the partners contribute and receive, there is a sense that each gets a fair share of the rewards and costs.

MIRRORING AND IDEALIZED SELFOBJECTS. In addition to exchanging skills and resources, collaborative pairs also exhibit important exchanges at a psychological level. The "other" in the dyad becomes important as both an audience and a role model, or in Kohut's terms, as a mirror and as an idealized selfobject. As many of the circle members we have examined reported, one of the most important contributions of a collaborator is to serve as an enthusiastic audience. As Freud said about Fleiss, and as Tolkien said about Lewis, for a while the "other" may be the only audience. A respected peer who serves as admiring but demanding audience can be a powerful stimulus to creative work. When the mirroring other takes the creative person seriously, attends to small advances, and responds with appreciative criticism, the person becomes more centered and invests more in the creative process. Likewise, by identifying with and participating in the mission of an idealized selfobject, the creative person feels stronger and more internally cohesive. For example, when Freud, depressed and racked with doubts, had one of his "congresses" with Fleiss, he often returned to

his creative work with renewed energy. When he and Fleiss were together, he found his tentative thoughts valued by someone he idealized; and as they shared their emerging theories, he gained a sense of being part of an important joint mission. As a consequence, he recovered his ability to invest in his own intellectual work. Because Fleiss took him seriously, he took himself more seriously. Likewise, Conrad's relationship with Ford stabilized his self-system and enabled him to explore more penetrating themes in his writing.

INSTRUMENTAL INTIMACY: A DEEPER LEVEL OF SOCIAL SUPPORT. In the early stages of circle development, the level of exchange among members is familiar to anyone who has studied social support (e.g., House, Umberson, and Landis 1989; Thoits 1995). The members of the group provide companionship and validation of one another's self-concept. They exchange resources, emotional support, and advice in decision making. However, social support theorists have stopped short in their analysis of the more penetrating exchanges characteristic of collaborative circles in the quest and creative work stages. Even relationships between "confidants," as described by social support theorists, involve exchanges of information and advice between bounded personality systems. Social support theorists seem to assume that each confidant possesses information, expertise, or sympathy that can be shared with the other to help in coping with an illness, loss of a job, or some other acute or chronically stressful situation. Although creative solutions to problems may emerge from such relationships, social support theorists have not yet conceptualized how creative outcomes emerge. More often they suggest that social support entails an exchange in which one person, usually a patient or client, has a "lack" or "need" that is fulfilled by what another person, often a caregiver, provides. Nothing really creative occurs in the transaction, and each participant remains a separate, bounded entity. Theorists usually focus on relatively short periods of interaction, rarely examining how the supportive ties form, develop, and eventually dissolve over the life course. However, as illustrated by our collaborative case studies, once a circle forms, and once the members pair off into working collaborations, these supportive exchanges can grow into something much more profound.

Circle members develop the highest degree of trust, take the greatest risks, and demonstrate the most interdependence in thinking when they work in pairs. Under optimal conditions, each member of the pair provides an admiring, "mirroring" audience as well as an idealized "selfobject" for the

other. Besides leading to more cohesive self-systems for each partner, this kind of interpersonal environment seems to nourish creative work for two reasons. First, for each member of the pair, the attentive support from an idealized partner releases the energy and courage to explore one's most tentative ideas. Being taken seriously by an idealized friend leads one to take one's inner world more seriously. The creator "takes the role of the other," sees how the idealized other values the offer of creative thoughts, and begins to invest more in them. Second, thinking aloud together, the collaborative partners draw on one another's memories, ideas, and thought processes. They operate almost as one mind—or, as Conrad often said when working with Ford, they become like a "third person writing." Sharing one another's "hard drives" and "software," the members of the pair develop solutions to problems that neither would have conceived alone. I refer to this state of openness as instrumental intimacy.

In this state, partners often take on the role of sympathetic critic for one another. Each delegates to the other the responsibility for critically evaluating creative explorations. Because each can count on the other to do the work of critical evaluation, each is more free to follow through on creative ideas without inhibition. The level of trust and openness is so great that partners will share their most half-baked ideas, trusting that the other will not destructively attack or plagiarize them. Once a new idea crystallizes and the creative person approaches the final stages of shaping it, the feedback from the critic enables the creator to anticipate the responses of an audience. By attending to the feedback, the creator develops a more polished final product.

CONSOLIDATION OF THE CIRCLE'S VISION IN THE CENTER COALITION. When a group ritualizes occasions where all members meet together, a center coalition of members often develops the final synthesis of the circle's vision. As the Impressionist circle moved toward consolidating a style in the early 1870s, Pissarro was at the heart of the center coalition. While Monet and Renoir arrived at the style, it was Pissarro working with them who was best able to codify the new vision into a set of principles. He became recognized as the group's theoretician and mentor for the marginal members, such as Cézanne, as well as for the younger generation. In the Fugitive poets group, Ransom and Davidson formed the center coalition. The center coalition consists of the members who consolidate the insights that emerge within collaborative pairs, integrate them into a coherent theory, and convey the vision to newcomers into the circle.

Collective Action Stage

The collective action stage of a circle begins when the members decide to carry out a group project aimed at winning support for their vision outside their own network. The project could be a journal, an art exhibition, a grant proposal, or some other task that requires interdependent work. Whereas in previous stages, the objective was to create a new vision, in this stage the objective becomes to win support for the vision from authorities and from the public. Up to this point, the journey has been inward to mine the creative process; now it turns outward.

It is often the case that the leadership structure of a circle changes as members move into the collective action stage. Once the center coalition crystallizes the shared vision, the introspective activity of collaborative pairs is no longer essential to the circle. To succeed at the new tasks, a new type of leader is required—one who can balance budgets, make contacts with influential people, talk to the media, orchestrate the group members for organized events, and in other ways act as an executive manager. As we saw, Caillebotte took on this role for the Impressionists; Davidson took it on when he became editor for the Fugitives; Ford took it on as editor of the *English Review;* and Anthony took it on when she became the "Napoleon" of the women's movement. Without this kind of leadership, the circle would flounder during the collective action stage. Led by the executive manager, the circle takes on features of a formal organization. For example, the Impressionists wrote a formal charter for their group during this stage. In it they codified the rules for submitting paintings, hanging them in the exhibitions, and receiving payment for sales. A formal normative code may replace the authority of the charismatic leader.

Member Individuation and Group Disintegration in the Separation Stage

During the early stages of circle development, most of the work goes on behind the scenes. Working alone or in pairs, members can act as relatively autonomous agents. But during the collective action stage, the type of work done by the group requires coordinated efforts organized on a public schedule. Group decisions are made that are binding on all the members. When the Impressionists mobilized to do the exhibitions, they had to make decisions about when and where to have them, who to include, who to exclude, and how to share the expenses and the earnings. In the Ultras group, someone had to arrange for a convention hall and to schedule speakers. Speakers who had committed themselves were expected to arrive on time and be prepared. All this interdependence creates more occasions for conflict and disappointment. Relationships between the managerial executive and the

other group members may become particularly strained. Although the peacemaker may try to keep the group together, as Pissarro attempted to do for the Impressionists, it is not unusual for the peacemaker to be overwhelmed by the burden of sustaining relationships. The accumulating frustration and anger contributes to the disintegration of the circle.

As the members of a circle develop their skills and expertise in a discipline, they become less dependent upon one another for support. They may begin to receive recognition outside of the circle. Some may feel that, rather than freeing them to be creative, the circle's vision is now constraining them. If they are highly ambitious and seeking individual recognition, they may even decide to sharpen the differences between themselves and other members of the circle. First some members then others may break away from the circle and attempt more individualized projects. Those left behind may feel abandoned or betrayed, and those who leave may feel guilty for their "disloyalty." Earlier, ideas seemed to flow out of the members' interactions, and the ownership of ideas was unimportant. But during the separation stage, members become concerned about who gets recognition for what. Concerns about plagiarism and equity in recognition may divide the group further. As the negative feelings accumulate, the disintegration of the group accelerates.

Reunion Stage

Years after a group disbands, one or two members may attempt to bring the circle back together. For example, the Ultras had a reunion in 1888, the fortieth anniversary of the first convention at Seneca Falls. Two years later, the whole group came together once again—Lucy Stone's faction of the movement and the faction led by Susan B. Anthony and Elizabeth Cady Stanton joined to form the National American Woman's Suffrage Association. By the time the factions reunited, each member of the circle had developed new skills and loyalties, and each had become more individuated. Nevertheless, like sisters at a family reunion, the aging members of the circle were cast into their familiar roles. Most notably, Anthony, although by then revered as "Aunt Susan" and seen as the central figure of the movement, stepped aside and persuaded her supporters to cast Stanton into the central role of president, just as she had done when she formed the Women's Temperance Society in the early 1850s.

Perhaps the most remarkable documentation of a reunion is the transcription of tape recordings of four meetings of the Fugitive poets in Nashville, 3–5 May 1956 (see plate 19). The organizer of the reunion, Louis Rubin, notes in the introduction to the transcripts: "[O]nce the in-

dividual Fugitives were convened together behind closed doors, and the tape recorder began turning, something strange, even a little awesome happened. The various individuals, despite some thirty years of separate and individual achievements, became the Nashville Fugitives once more" (Purdy 1959, 19). Although this was true in many respects, it did not happen immediately. Sidney Hirsch, the initial charismatic leader, was not present at the first two meetings, and several members noted his absence, recalling his "dominant character. . . . You almost had to break away from [Hirsch] to get clear of this hypnotic, mesmeric kind of . . . influence" (Purdy 1959, 126). In the first reunion meeting, rather than recreate their ritual of discussing a work in progress by one of the members, the Fugitives were prodded and goaded by William Elliott, one of the earliest members, to discuss why none of the group had ever written an epic poem. As the group tried to muster interest in the topic and struggled toward consensus, Allen Tate, though he stayed out of the discussion, repeatedly derailed conclusions by referring to them as too intellectually abstract and "highfalutin." Merrill Moore, who had by then become a psychiatrist, pointed out Tate's subversive moves and tried to direct the group toward more in-depth discussion.

Despite the initial guardedness, the group began to reassemble its structure. For example, despite the age and status of all the men in the group at this point, several members treated Ransom with deference, reaffirming his old leadership role. Both Tate and Warren, now highly successful in the literary world, nevertheless assumed their roles as junior members, hardly speaking until spoken to. Davidson eventually took on his peacemaker role, relieving the tension that built in the wake of Elliott's confrontational style with a quiet, self-deprecating joke about Ransom: "What impressed me then was that a man I knew could not only write poems but could get them published." Davidson and Tate eventually revived their old coalition, and the discussion smoothed out. But the most electrifying moment occurred on the third day when Sidney Hirsch suddenly appeared. Someone must have hunted him down, and although most of the members had not seen him in many years, and although the others had left him behind at his home in Nashville when they carved out their reputations on the national stage, he suddenly assumed command of the group. Stepping into his Socratic role, he derailed the discussion with a series of statements and questions asked with the air of a somber master who possesses secret knowledge. He zeroed in on one of Tate's poems, and following each pronouncement with a question—"Am I correct about that?"—he led Tate toward agreeing with him that his use of words in a recent poem indicated intuitive knowledge of

some esoteric ancient wisdom. Reading the transcript a half century after the reunion, I felt the force of his charismatic role in the group. It took several moments before the discussion recovered momentum, and the group once again "broke away" from him.

Although the group rituals and member roles may be reawakened by the reunion, it is rare that the members are able to revive their impact on one another's creative work. Usually the individuation process is much too far along, each of the members now has an individual vision and agenda, and each experiences the circle's shared vision as well as their roles in the group as constraining.

Is This sequence of Stages Necessary?

To a certain extent, this study began with my curiosity about how well stage theories of group development based on laboratory research generalized to live historical groups. Although the method has been inductive, my conceptualization of the development of collaborative circles has been influenced by previous theorists (for recent reviews, see Hare, Blumberg, Davies, and Kent 1994; McCollom 1990; Mills 1984). As the work progressed, I found some of the concepts from these theories useful, others irrelevant; and at times I had to introduce new concepts for processes that none of the theorists discussed. A thorough review of past theories, comparing them to my conceptualization of circle development, would not be appropriate here. It would take another book to do the theories justice. Nevertheless, it is useful to address a question often raised about stage theories: is the stage sequence observed in this study necessary in any causal sense? For example, is there some reason why the formation stage is followed by the rebellion stage, which in turn is followed by instrumental intimacy in paired collaboration? Are there some underlying causal dynamics that push the whole process forward?

It is premature to give a definitive answer to these questions. Even the laboratory theoreticians have not yet proposed a compelling theory of the stages of group development. For example, probably the most well known "theory" is Tuckman's heuristic model. After reviewing the stage theories derived from more than fifty studies of groups in a variety of contexts, Tuckman (1965) proposed four stages of group development: forming, storming, norming, and performing. In a second review Tuckman and Jensen (1977) added a final separation stage. Collating concepts from the previous theorists, Tuckman listed the characteristics of group structure and process most commonly found in each stage. His summation is ultimately descriptive because he did not provide a causal model to explain the developmen-

tal sequence; nevertheless, his has been the most frequently cited theory of group development over the past thirty years. Beyond this descriptive approach, theorizing about group development has progressed slowly.

I think that one reason for the slow progress has been the lack of a methodology for building and testing theories of group development outside of a laboratory or a therapeutic context. Most of the older theories are based on studies of groups brought together by a researcher or a therapist to meet over the course of a few months. Because of the expense of running these groups, usually the researchers have studied only one case at a time. While much has been learned from this approach, I think we need new methodologies if we are going to take small group theory any further.

The historical case study approach introduced here is one suggestion. Using it, I have tried to limit myself to conceptualizing only regularities that could be observed through the data at hand: interviews, journals, letters, and accounts of group interaction. This approach has led to some important discoveries about the sequence of roles, rituals, and group processes that characterize each stage of circle development; and these regularities seem robust in that they occur in circles in a variety of disciplines at different points in history. Although the approach has the advantage of enabling us to study real groups over their whole life course, it also has limitations: most notably, it does not allow us to observe live interaction or to interview the members about their experiences. In addition to the advances that can come from historical studies, I think advances in theory also will occur through direct observation of contemporary circles. Not only will studies of contemporary circles enable us to learn whether the sequence of stages can be generalized, they will also enable us to study in depth the overt behaviors and the subjective experiences of members during each stage as it occurs. This kind of in-depth observation is necessary before we can fully account for the stages of development.

Variations in Circle Development

In this research, looking across disciplines and at different points in history, I have attempted to isolate the common conditions under which circles form and the common processes in their stages of development. Although these commonalities are present in most of the successful circles I have studied, there are also important variations. Circles vary in their overall duration, in their intensity of involvement, and in their degree of success in generating a new vision and establishing it in the mainstream of their discipline. In this section I will discuss some of the sources of variation.

Gender, Ethnicity, and Age

The analysis of the Ultras, as well as the roles of women in mixed-gender circles, leads me to think that there may be important differences in circles due to gender. Compared to the male groups, the Ultras achieved greater intimacy in their collaborative pairs, and they developed and sustained more intricate interdependence over a longer period of time than any group I have found. Perhaps because woman are more adept at handling intimacy and interdependence in their friendships (Fehr 1996; House, Umberson, and Landis 1988; Farrell 1986), they are better able to build the trust and instrumental intimacy necessary for collaborative pairing. If so, it may be that in the next century as women become more integrated into professional disciplines, collaborative circles will become more common. Future research should examine how female and mixed-gender circles differ from all-male circles.

In addition to examining gender differences in collaborative circles, it may also be fruitful to examine ethnic differences. For example, cultural theorists have frequently noted the differences between Eastern and Western cultures. Whereas Western cultures have valued individualism and have fostered the myth of the lone genius as the source of creative advances in a field (Williams 1960), Eastern cultures have valued collectivism and emphasize cooperation as the means to successful achievement (Triandis 1995). It may be that collaborative circles are more common in Eastern cultures, and that Asian circles are better able to sustain the kind of instrumental intimacy observed in collaborative pairs.

The disciplines in which collaborative circles form are not only becoming more inclusive of women, they are also becoming more diverse ethnically and racially. It will be interesting to examine how gender and ethnic diversity affect the formation and development of circles. My findings suggest that homogenous circles are more likely to be successful. People from similar backgrounds are more likely to speak the same language, feel at home together, and build the degree of trust characteristic of collaborative pairs. However, I have also found that some degree of diversity within the circle, exemplified by the circle boundary markers, contributes to creativity and to the clarification of the circle's new vision. It may be that there is a range of diversity that is most conducive to successful circles. Too much diversity may lead to the kind of conflicts that undermined the Rye circle that included Henry James, H. G. Wells, and Joseph Conrad. Too little diversity may lead to "groupthink" discussions in which members validate inferior work and develop a simplistic, sterile vision (Janis 1982). These questions should be explored in future research.

In this research, I have found that circles are usually formed by people in their twenties and early thirties, when they are likely to be in the early stages of their careers. However, as societies deindustrialize and as the population ages, the relationship between age and circle formation may change. People are living longer, and either because of personal preference or because of the downsizing and restructuring of corporations, universities, and other institutions, more and more people change careers in midlife. If this trend continues, perhaps there will be more people who, like Joseph Conrad, join collaborative circles in middle age. If so, it will be interesting to examine whether there are differences in the dynamics of circles formed by older novices as they enter new disciplines.

Discipline Differences in Circle Dynamics

Although I have emphasized the commonalities in the formation and development of circles, it is likely that there are variations across disciplines. As we have seen, compared to artists and writers, political reformers spend more time interacting with the public. Reformers are often thrust into the collective action stage at an early point in the development of their circle while they are still developing their common vision and learning the skills of organizing, speaking, and agitating for change. On the other hand, as artists and writers are developing their skills and vision, they usually work privately in a studio or study. This difference in the degree of privacy in the circle's development may affect the internal dynamics and the developmental timetable of the group. For social reformers, the pressure that comes from early public exposure may mean the group has less time to experiment with new ideas and clarify their vision. Instead of honing their vision while working in the sheltered relationship of collaborative pairs, they may be forced to shape it in a public arena. Just as the Ultras worked out their dress code in response to feedback from the public, other social reform circles may find themselves altering not only their costumes but the details of their vision in a more public context.

Because circles of artists and writers can develop in a more backstage setting, the charismatic leader with a vision may remain central for a longer period of time in these groups, and work in collaborative pairs may continue for a longer time. Among reformers, the executive leaders, such as Susan B. Anthony, may take charge at an earlier point in the circle's development, and these leaders may hold influence over a longer period than they do in artistic or literary circles. More attentive to the conventional perspectives of the public, the executive leader may constrain the more

radical members of the circle. All in all, these dynamics suggest that the pace of development may be different in circles of social reformers, and that the vision they negotiate will be more sensitive to the conventions of the public and perhaps less radical than those of circles of artists and writers.

Internet Communication and Collaborative Circles

Disciplines vary in how much they rely on magnet places as training grounds for new members. Those that do not form in magnet places are more dependent on informal networking to locate potential members. As Internet communication becomes more common, it may be that circles will form among widely scattered, like-minded people who discover one another through electronic communication. In addition, Internet communication may make it easier for marginalized people in a discipline to discover one another.

When a person sits alone in a study and communicates with another person by computer, there often is a sense of immediate intimacy. Because they give off minimal personality cues and nonverbal feedback, they can play parts for one another like that of a therapist who maintains the optimal, empathic distance (Kohut 1980) and permits her image to be filled in with projections and transference. It seems to me that this kind of communication, like the correspondence that developed between Freud and Fleiss, can be particularly conducive to collaborative pairing. Some researchers suggest that Freud may have stumbled into a relationship of optimal distance with Fleiss, enabling him to create and maintain an idealized image of his friend—the image of the good therapist, and this relationship sustained him through his self-analysis and creative work (e.g., Jones 1961; Bonaparte, Freud, and Kris 1954). Future collaborators may discover that Internet communication provides that right mix of intimacy and distance to nurture collaborative pairing, egalitarian openness, and instrumental intimacy. However, without the depth and breadth of communication that occurs in a face-to-face meeting, I doubt that a group can have the kind of profound influence on its members that we have seen in the case studies presented here. Internet communication may facilitate the formation of circles, and, like the letters between Freud and Fleiss, it may enable them to maintain contact between meetings, but I do not think it allows for the kind of in-depth dialogue that leads to meaningful personal development and creative work. For this kind of interaction, there is no substitute for ritualized meetings and working side by side.

Conclusions: Practical Implications

As we have seen, circles play an especially critical part in the development of artists and writers, but they also play a part in the development of creative work in numerous other disciplines. Virtually every participant in the collaborative circles I have studied testifies to the profound role that the circle played in his or her development. If collaborative groups are so important to people who make original contributions to their disciplines, it would be useful to have a theory that could provide guidelines in forming them.

Before we can develop a logically integrated set of propositions linking one construct to another in a causal argument, we must first identify and conceptualize the regularities we observe. At this point, our theory of collaborative circles is essentially descriptive. I have identified some of the regularities that occur in the formation and development of circles, and I have conceptualized some of the variables that should be included in a theory. At a few points, I have sketched out causal hypotheses that can guide future research. Although the theory still needs to be tested and refined, what have we learned that would be useful to someone who wanted to create a collaborative circle?

Although we may be able to shape some of the conditions for forming circles, for other conditions we have to find the settings where they already exist. For example, it may be theoretically possible to create a magnet place that draws together talented and ambitious novices in a discipline, but usually this takes a long time and a great many resources. Few people can create overnight a University of Chicago or a Black Mountain College. Rather than create a magnet place, it is more feasible to seek out candidates for a circle in an existing one.

Once we have located the magnet places where masters of a discipline are concentrated, then we need to search for one where there is a high degree of cultural turmoil. Rather than being a hierarchical setting dominated by a single vision in the discipline, it should be a place where two or more visions are vying with one another for centrality. Finally, collaborative circles are more likely to form in a magnet place that is overloaded with novices, and that is demographically diverse, so that not every novice in the setting can easily establish a mentor-protégé relationship.

Once we have located such a setting, we must find a set of highly ambitious novices who are marginalized because of their gender, ethnicity, theoretical orientation, or some other characteristics. Ideally, most of these relative outcasts will have enough commonalities in their backgrounds that

they can talk to one another. They at least must have the potential to understand the nuances of one another's reactions to the discipline.

Once these external conditions have been found, to develop a collaborative circle we will need at least three types of leaders: the gatekeeper, the charismatic leader, and the executive manager. The gatekeeper is someone in the magnet setting who sets out to build a friendship circle within the network of novices in a discipline. Successful gatekeepers are people who, like Donald Davidson and Frederic Bazille, are skilled at reading their own needs and at judging the compatibility of other people. Alone and marginalized like numerous other novices in the magnet place, the gatekeeper is someone who decides to take action to satisfy a need for companionship, intellectual stimulation, and friendship. One by one, the gatekeeper begins to court some of the most talented and ambitious people in the network. In the cases I have observed, the person who plays this role usually does it unselfconsciously. That is, the gatekeeper does not actively seek to form a collaborative circle, but does take action to form interesting friendships and to bring those friends together in a setting where they can talk about their ideas. This kind of leadership could be cultivated in a wide range of people.

The second type of leadership necessary to start a circle is more difficult to cultivate. The charismatic leader is a highly narcissistic novice who has more expertise than most other novices in the network, and who for some reason attracts their admiration. This person is often someone who is not linked to a mentor, but more likely is in open rebellion against the visions of the mentors in the magnet place. Restless and discontent, the charismatic leader is someone determined to do something new. Like many narcissistic people, the charismatic leader thrives in the presence of an audience. The attention of the group encourages the leader to perform, and the performances challenge the other novices to keep pace. What is important is that the charismatic leader directs the others into an exploration of new problems in the discipline and encourages them to mine their own inner worlds. This leader sets the pace in acquiring skill and expertise and in imaginative creative work. Like Ransom writing his first poetry, or like Claude Monet attempting his ambitious outdoor paintings, the charismatic leader sets a high standard and has the courage to model the creative process. From this point on, if the conditions in the environment of the group remain stable, and if the cohesion of the group holds, the group has a high probability of becoming a collaborative circle.

The next conditions that need to be established are structural. To create the conditions for critical review of members' work, it is important to ritu-

alize group meetings and the exchange of works in progress. The group should establish a norm of open, critical communication in meetings, while at the same time keeping hostility within acceptable bounds. Often the charismatic leader and the gatekeeper form a coalition to ritualize meetings and set the norms for exchange. In addition to participating in the group meetings, it is important that compatible members be encouraged to pair off and work together. Although I do not think it is possible to instill idealization and mirroring relationships in pairs, nevertheless, members of collaborative pairs are more likely than a larger group to develop the trust and openness necessary for instrumental intimacy to occur. It may be helpful to encourage instrumental intimacy—sharing unfinished work, wild ideas, and thinking out loud. Through cycles of pairing, working alone, and meeting as a group, the members of the circle have the potential for developing a new vision to guide their work. Of course, it is not guaranteed they will evolve such a vision, but chances are now greater that new insights will emerge, be nourished, and be integrated into an innovative vision.

As the group moves into the collective action stage, the executive manager role becomes important. Once again it may be possible to cultivate the kinds of skills necessary to perform this role. The executive manager is someone who is alert for opportunities in the environment for marketing the work of the members. It is someone who is adept at organizing others, setting goals, planning strategies of action, scheduling events, monitoring progress toward goals, delegating and coordinating tasks, and balancing budgets. Although the charismatic leader guides the group in developing a new vision, he or she often does not have the skills needed by an executive manager. One difficult task for members at this point is to manage the transfer of leadership from the charismatic leader to the executive manager without disrupting the solidarity of the group.

It should be clear that these suggestions are not a recipe guaranteed to produce a successful collaborative circle. At this point, the theory is tentative. The guidelines presented here will make it more likely that a collaborative circle will form, but not a certainty. As we have seen, most collaborative circles take years before the members acquire the expertise to create a new vision for a discipline. Then they take years more to win acceptance for their innovative work. For each group that is formed following the guidelines proposed here, it may take a decade or more before we know whether the experiment has worked. Nevertheless, given how important these groups are, it is important that we try. If nothing else, I hope these guidelines enable those who find themselves in a collaborative circle to recognize and value what is happening to them.

References

Anthony, Susan B. 1854. "Diary of a Lecture Tour with Ernestine Rose to Washington, Baltimore, and Philadelphia." In *Elizabeth Cady Stanton–Susan B. Anthony Reader: Correspondence, Writings, Speeches,* edited by Ellen Carol DuBois, 70–77. Boston: Northeastern University Press.

Arieti, Silvano. 1976. *Creativity: The Magic Synthesis.* New York: Basic Books.

Bacon, Margaret Hope. 1980. *Valiant Friend: The Life of Lucretia Mott.* New York: Walker.

Bales, Robert Freed. 1970. *Personality and Interpersonal Behavior.* New York: Holt, Rinehart, and Winston.

Banner, Lois W. 1980. *Elizabeth Cady Stanton: A Radical for Woman's Rights.* Boston: Little, Brown.

Baroody-Hart, Cynthia, and Michael P. Farrell. 1986. "The Subculture of Serious Artists in a Maximum Security Prison." *Urban Life* 15:421–48.

Barry, Kathleen. 1988. *Susan B. Anthony: A Biography of a Singular Feminist.* New York: Ballentine Books.

Becker, Howard. 1982. *Art Worlds.* Berkeley: University of California Press.

Bell, Quentin. 1972. *Virginia Wolf: A Biography.* New York: Harcourt Brace Jovanovich.

Bellony-Rewald, Alice. 1976. *The Lost World of the Impressionists.* London: Weidenfeld and Nicolson.

Bennis, Warren G., and Herbert A. Shephard. 1974. "A Theory of Group Development." In *Analysis of Groups,* edited by Graham Gibbard, John J. Hartman, and Richard Mann. San Francisco: Jossey-Bass.

Berger, Joseph, and Morris Zelditch. 1985. *Status, Rewards, and Influence: How Expectations Organize Behavior.* San Francisco: Jossey-Bass.

Berger, Joseph, and Murray Webster, Cecilia Ridgeway, and Susan Rosenholtz. 1986. "Status Cues, Expectations, and Behavior. *Advances in Group Processes* 3:1–22.

Bernard, Bruce. 1986. *The Impressionist Revolution.* Boston: Little, Brown.

Billington, James H. 1980. *Fire in the Minds of Men: Origins of the Revolutionary Faith.* New York: Basic Books.

Blatch, Harriet Stanton, and Alma Lutz. 1940. *Challenging Years: The Memoirs of Harriet Stanton Blatch.* New York: G. P. Putnam's Sons.

Blau, Peter M. 1964. *Exchange and Power in Social Life.* New York: John Wiley.

Bloomer, D. C. 1895. *Life and Writings of Amelia Bloomer.* Boston: Arena Publishing.

Blunden, Marie, and Godfrey Blunden. 1970. *Impressionists and Impressionism.* New York: World Publishing.

Bonafoux, Pascal. 1986. *The Impressionists: Portraits and Confidences*. New York: Rizzoli International Publications.

Bonaparte, Marie, Anna Freud, and Ernst Kris. 1954. *The Origins of Psycho-analysis*. Translated by Eric Mosbacher and James Strachey, introduction by Ernst Kris. New York: Basic Books.

Bourdieu, Pierre. 1993. *The Field of Cultural Production*. New York: Columbia University Press.

Bradbury, John M. 1958. *The Fugitives: A Critical Account*. Chapel Hill: University of North Carolina Press.

———. 1963. *Renaissance in the South: A Critical History of the Literature, 1920–1960*. Chapel Hill: University of North Carolina Press.

Brebach, Raymond. 1985. *Joseph Conrad, Ford Madox Ford, and the Making of Romance*. Ann Arbor: University of Michigan Press.

Brettell, Richard R. 1986. "The 'First' Exhibition of Impressionist Painters." In *The New Painting: Impressionism, 1874–1886*, edited by Charles S. Moffett, 189–202. San Francisco: Fine Arts Museum of San Francisco.

Carpenter, Humphrey. 1977. *Tolkien*. Boston: Houghton Mifflin.

———. 1979. *The Inklings: C. S. Lewis, J. R. R. Tolkien, Charles Williams, and Their Friends*. Boston: Houghton Mifflin.

Cassell, Richard A., ed. 1987. *Critical Essays on Ford Madox Ford*. Boston: G. K. Hall.

Charon, Joel M. 1998. *Symbolic Interactionism: An Introduction, an Interpretation, an Integration*. Upper Saddle River, N.J.: Prentice Hall.

Cherlin, Andrew. 1996. *Public and Private Families*. New York: McGraw-Hill.

Chodorow, Nancy. 1978. *The Reproduction of Mothering: Psychoanalysis and the Sociology of Gender*. Berkeley: University of California Press.

Chubin, Daryl. 1976. "The Conceptualization of Scientific Specialties." *Sociological Quarterly* 17:448–76.

Clark, Ronald W. 1980. *Freud: The Man and the Cause*. New York: Random House.

Cohen, Albert K. 1965. *Delinquent Boys*. Glencoe, Ill.: Free Press.

Cohen, Sheldon, and Thomas A. Wills. 1985. "Stress, Social Support, and the Buffering Hypothesis." *Psychological Bulletin* 98:310–57.

Conkin, Paul K. 1988. *The Southern Agrarians*. Knoxville: University of Tennessee Press.

Conrad, Jessie. 1926. *Joseph Conrad as I Knew Him*. Garden City: Doubleday Page.

———. 1964. *Joseph Conrad and his Circle*. 2d ed. Port Hashingoton, N.Y.: Kennicat Press.

Conrad, Joseph. 1925. *A Personal Record*. London: Gresham Publishing.

———. 1942. *Heart of Darkness*. In *Great Modern Short Stories*, edited by Bennett A. Cerf, 3–110. New York: Random House.

Cook, Karen. 1982. "Network Structures from an Exchange Perspective." In *Social Structure and Network Analysis*, edited by Peter Marsden and Nan Lin, 177–99. Thousand Oaks, Cal.: Sage Publications.

Cowan, Louise. 1959. *The Fugitive Group*. Baton Rouge: Louisiana State University Press.

Cowley, Malcolm. 1973. *A Second Flowering: Works and Days of the Lost Generation*. New York: Viking Press.

Csikszentmihalyi, Mihaly. 1990. "The Domain of Creativity," In *Theories of Creativity*, edited by Mark A. Runco and Robert S. Albert, 190–214. Newbury Park: Sage Publications.

Davidson, Donald. 1958. *Southern Writers in the Modern World*. Athens: University of Georgia Press.

———. 1966. *Poems, 1922–1961*. Minneapolis: University of Minnesota Press.

Delbanco, Nicholas. 1982. *Group Portrait: Joseph Conrad, Stephen Crane, Ford Madox Ford, Henry James, and H. G. Wells*. New York: William Morrow.

Denvir, Bernard. 1987. *The Impressionists at First Hand*. London: Thames and Hudson.

———. 1990. *The Thames and Hudson Encyclopedia of Impressionism*. London: Thames and Hudson.

———. 1993. *The Chronicle of Impressionism*. Boston: Bullfinch Press.

DiMaggio, Paul, and John Mohr. 1985. "Cultural Capital, Educational Attainment, and Marital Selection." *American Journal of Sociology* 90 (6): 1231–61.

Dorr, Rheta Childe. 1970. *Susan B. Anthony: The Woman Who Changed the Mind of a Nation*. New York: AMS Press.

DuBois, Ellen Carol. 1978. *Feminism and Suffrage: The Emergence of an Independent Women's Movement in America, 1848–1869*. Ithaca: Cornell University Press.

———, ed. 1992. *The Elizabeth Cady Stanton–Susan B. Anthony Reader: Correspondence, Writings, Speeches*. Revised edition. Boston: Northeastern University Press.

Dunphey, Dexter. 1968. "Phases, Roles, and Myths in Self-analytic Groups." *Journal of Applied Behavioral Science* 4 (2): 195–225.

———. 1972. *The Primary Group: A Handbook for Analysis and Field Research*. New York: Appleton-Century-Crofts.

Duret, Theodore. 1878. *Les Peintres Impressionistes*. Paris: Librairie Parisienne.

———. 1910. *Manet and the French Impressionists: Pissarro–Claude Monet–Sisley–Renoir–Berthe Morisot–Cézanne–Guillaum*. Philadelphia: J. B. Lippincott.

Edel, Leon. 1969. *Henry James: The Treacherous Years, 1895–1901*. New York: J. B. Lippincott.

———. 1972. *Henry James: The Master, 1901–1916*. New York: J. B. Lippincott.

———. 1979. *Bloomsbury: A House of Lions*. Philadelphia: J. B. Lippincott.

Edel, Leon, and Gordon N. Ray. 1958. *Henry James and H. G. Wells: A Record of Their Friendship, Their Debate on the Art of Fiction, and Their Quarrel*. London: Rupert Hart-Davis.

Eisenman, Stephen F. 1986. "The Intransigent Artist, or How the Impressionists Got Their Name." In *The New Painting: Impressionism, 1874–1886*, edited by Charles Moffett, 51–60. San Francisco: Fine Arts Museum of San Francisco.

Ellenberger, Henri F. 1970. *The Discovery of the Unconscious: The History and Evolution of Dynamic Psychiatry*. New York: Basic Books.

Epstein, Barbara Leslie. 1981. *The Politics of Domesticity: Women, Evangelism, and Temperance in Nineteenth-Century America*. Middletown, Conn.: Wesleyan University Press.

Erikson, Erik. 1964. *Young Man Luther: A Study in Psychoanalysis and History*. New York: W. W. Norton.

———. 1989. "The First Psychoanalyst." In *Sigmund Freud: Critical Assessments*, edited by Laurence Spurling, 1:382–403. New York: Routledge.

Erikson, Kai. 1966. *Wayward Puritans: A Study in Deviance*. New York: John Wiley.

Fain, John T., and Thomas D. Young. 1974. *The Literary Correspondence of Allen Tate and Donald Davidson*. Athens: University of Georgia Press.

Farrell, Michael P. 1976. "Patterns in the Development of Self-analytic Groups." *Journal of Applied Behavioral Science* 12:524–42.

———. 1979. "Collective Projection and Group Structure: The Relation between Deviance and Projection in Groups." *Journal of Small Group Behavior* 10 (1): 81–100.

———. 1982. "Artist Circles and the Development of Artists" *Journal of Small Group Behavior* 13 (4): 451–74.

———. 1986. "Friendship between Men." *Marriage and Family Review* 3/4:163–98.

Farrell, Michael P., Gloria D. Heinemann, and Madeline H. Schmitt. 1986. "Informal Roles, Rituals and Humor in Interdisciplinary Health Care Teams: Their Relation to Stages of Group Development." *International Journal of Small Group Research* 2:143–62.

Farrell, Michael P., and Stanley D. Rosenberg. 1981. *Men at Midlife*. Boston: Auburn House Press.

Faulkner, Robert R. 1983. *Music on Demand: Composers and Careers in the Hollywood Film Industry*. New Brunswick: Transaction Books.

Fehr, Beverley Anne. 1996. *Friendship Processes*. Thousand Oaks, Cal.: Sage Publications.

Fine, Gary Allen, and Richard Stoeker. 1993. "Can the Circle Be Unbroken? Small Groups and Social Movements." In *Social Psychology of Groups,* edited by Edward J. Lawler and Barry Markovsky, 225–52. Greenwich, Conn.: JAI Press.

Fischer, Claude. 1982. *To Dwell among Friends: Personal Networks in Town and City*. Chicago: University of Chicago Press.

Ford, Ford Madox. 1924. *Joseph Conrad: A Personal Remembrance*. New York: Ecco Press.

———. 1932. *Return to Yesterday*. New York: Liveright.

———. 1989. *The Good Soldier*. New York: Vintage Books.

Frady, Marshall. 1996. *Jesse: The Life and Pilgrimage of Jesse Jackson*. New York: Random House.

Freud, Renst, Lucie Freud, and Ilse Grubrich-Simitis. 1985. *Sigmund Freud: His Life in Pictures and Words*. New York: W. W. Norton.

Freud, Sigmund. 1910. "The Origin and Development of Psychoanalysis." *American Journal of Psychology* 221 (2): 181–218.

———. 1935. *An Autobiographical Study*. Translated by James Strachey. New York: W. W. Norton.

———. 1965. *Interpretation of Dreams*. Translated by James Strachey. New York: Avon Books.

Friedrich, Otto. 1992. *Paris in the Age of Manet*. New York: Harper Collins.

Garnett, Edward 1928. *Letters from Conrad, 1895–1924*. Indianapolis: Bobbs Merrill.

Gay, Peter. 1988. *Freud: A Life for Our Time*. New York: W. W. Norton.

Gemmell, George. 1989. "The Dynamics of Scapegoating in Small Groups." *Small Group Behavior* 20 (4): 406–18.

Geoffrey, Gustave. 1922. *Claude Monet, sa vie, son temps, son oeuvre*. Paris: Cres.

Greene, Graham. 1987. "Ford Madox Ford." In *Critical Essays on Ford Madox Ford,* edited by Richard A. Cassell, 173–74. Boston: G. K. Hall.

Griffith, Elisabeth. 1984. *In Her Own Right: The Life of Elizabeth Cady Stanton*. New York: Oxford University Press.

Guerard, Albert. 1958. *Conrad the Novelist*. Cambridge: Harvard University Press.

Gurko, Miriam. 1974. *The Ladies of Seneca Falls*. New York: Shocken Books.

Hare, A. Paul, Herbert H. Blumberg, Martin F. Davies, and M. Valeria Kent. 1994. *Small Group Research: A Handbook.* Norwood, N.J.: Ablex Publishing.

Harper, Ida Husted. 1898. *The Life and Work of Susan B. Anthony.* Vol. 1. Indianapolis: Hollenbeck Press.

Harrington, David M. 1990. "The Ecology of Human Creativity: A Psychoanalytic Perspective." In *Theories of Creativity,* edited by Mark A. Runco and Robert S. Albert, 143–69. Newbury Park: Sage Publications.

Hays, Elinor Rice. 1978. *Morning Star: A Biography of Lucy Stone, 1818–1893.* New York: Octagon Books.

Hewitt, D. 1952. *Conrad: A Reassessment.* Cambridge: Bowes and Bowes.

Hewitt, John P. 2000. *Self and Society: A Symbolic Interactionist Social Psychology.* Boston: Allyn and Bacon.

Hooper, Walter. 1996. *C. S. Lewis: A Companion and Guide.* London: Fount Paperbacks, HarperCollins Publications.

House, James S., Doris Umberson, and K. R. Landis. 1988. "Structures and Process of Social Support." *Annual Review of Sociology* 14: 293–318.

Isaksen, Scott G. 1987. *Frontiers of Creativity Research.* Buffalo: Bearly Limited.

James, Henry. 1909. *Hawthorne.* London: Macmillan.

Janis, Irving. 1982. *Groupthink: Psychological Study of Policy Decisions and Fiascos.* 2d edition. Boston: Houghton Mifflin.

Johnson, Stanley. 1925. *Professor.* New York: Harcourt, Brace.

Johnston, Johanna.1967. *Mrs. Satan: The Incredible Saga of Victoria Woodhull.* New York: G. P. Putnam's Sons.

Jones, Ernest. 1961. *The Life and Work of Sigmund Freud.* Garden City, N.Y.: Anchor Books.

Kanter, Rosabeth Moss. 1976. *Men and Women of the Corporation.* New York: Basic Books.

Karl, Frederick. 1979. *Joseph Conrad: The Three Lives.* New York: Farrar, Strauss and Giroux

Kerr, Andrea Moore. 1992. *Lucy Stone: Speaking Out for Equality.* New Brunswick: Rutgers University Press.

Kohlberg, Lawrence. 1984. "Essays on Moral Development." In *The Psychology of Moral Development.* San Francisco: Harper and Row.

Kohut, Heinz. 1976. "Creativeness, Charisma, Group Psychology: Reflections on the Self-analysis of Freud." In *Freud: The Fusion of Science and Humanism,* edited by John H. Gedo and George H. Pollock, 379–438. New York: International Universities Press.

———. 1977. *The Restoration of the Self.* New York: International Universities Press.

———. 1984. *How Does Analysis Cure?* Chicago: University of Chicago Press.

———. 1985. *Self Psychology and the Humanities.* New York: W. W. Norton.

Kris, Ernst. 1952. *Psychoanalytic Explorations in Art.* New York: International Universities Press.

Kuhn, Thomas. 1962. *The Structure of Scientific Revolutions.* Chicago: University of Chicago Press.

Lasser, Carol, and Marlene Deahl Merrill. 1987. *Friends and Sisters: Letters between Lucy Stone and Antoinette Brown Blackwell, 1846–93.* Urbana: University of Illinois Press.

Lavie, Smadar, Karin Narayan, and Renato Rosaldo. 1993. *Creativity in Anthropology.* Ithaca: Cornell University Press.

Levinson, Daniel J., Charlotte N. Darrow, Edward B. Klein, Maria H. Levinson, and Braxton McKee. 1978. *Seasons of a Man's Life.* New York: Alfred A. Knopf.

Lewis, C. S. 1960. *The Four Loves.* New York: Harcourt Brace Janovitch.

———. 1995. *Surprised by Joy: The Shape of My Early Life.* New York: Harcourt Brace.

Mack, Gerstle. 1989. *Paul Cézanne.* New York: Paragon House.

Mahoney, Patrick. 1979. "Friendship and Its Discontents." *Contemporary Psychoanalysis* 15:55–107.

Masson, Jeffrey M. 1985. *The Complete Letters of Sigmund Freud to Wilhelm Fliess.* Cambridge: Belknap Press of Harvard University Press.

McCollom, Marion. 1990. "Reevaluating Group Development: A Critique of the Familiar Models." In *Groups in Context: A New Perspective on Group Dynamics,* edited by Jonathon Gillette and Marion McCollom, 34–48. Reading, Mass.: Addison Wesley.

McGrath, William J. 1986. *Freud's Discovery of Psychoanalysis: The Politics of Hysteria.* Ithaca: Cornell University Press.

Meixner, John A. 1987. "Ford and Conrad." In *Critical Essays on Ford Madox Ford,* edited by Richard A. Cassell, 13–25. Boston: G. K. Hall.

Mencken, H. L. 1949. "The Sahara of the Bozarts." In *Mencken Chrestomathy.* New York: Alfred A. Knopf.

Meyer, Bernard C. 1967. *Joseph Conrad: A Psychoanalytic Biography.* Princeton: Princeton University Press.

Miller, Stuart. 1983. *Men and Friendship.* San Leandro, Cal. Gateway Books.

Mills, Theodore M. 1964. *Group Transformation: An Analysis of a Learning Group.* Englewood Cliffs, N.J.: Prentice Hall.

———. 1984. *The Sociology of Small Groups.* Englewood Cliffs: Prentice Hall.

Mills, Theodore M., and Michael P. Farrell. 1977. "Group Relations and Science: The Question of Compatibility." *Journal of Personality and Social Systems* 1:11–29.

Mizener, Arthur. 1971. *The Saddest Story: A Biography of Ford Madox Ford.* New York: World Publishing.

Moffett, Charles S., ed. 1986. *The New Painting: Impressionism, 1874–1886.* San Francisco: Fine Arts Museum of San Francisco.

Moore, George. 1972. *Confessions of a Young Man.* Montreal: McGill–Queen's University Press.

Morey, John Hope. 1960. "Joseph Conrad and Ford Madox Ford: A Study in Collaboration." Ph.D. diss., Cornell University.

Moser, Thomas. 1957. *Joseph Conrad: Achievement and Decline.* Cambridge: Harvard University Press.

Nardi, Peter. 1992. *Men's Friendships.* Newbury Park: Sage Publications.

Nemeth, Charlan Jeanne. 1985. "Dissent, Group Process, and Creativity: The Contribution of Minority Influence." *Advances in Group Processes* 2:57–75.

Oldenburg, Ray. 1999. *The Great Good Place.* New York: Marlowe.

Peterson, Richard A. 1997. *Creating Country Music: Fabricating Authenticity.* Chicago: University of Chicago Press.

Piaget, Jean. 1952. *The Origins of Intelligence in Children.* New York: Humanities Press.

Pollack, George. 1999. *Real Boys: Rescuing Our Sons from the Myths of Boyhood.* New York: Henry Holt.

Purdy, Rob Roy. 1959. *The Fugitives' Reunion: Conversations at Vanderbilt, May 3–5, 1956.* Nashville: Vanderbilt University Press.

Renoir, Jean. 1988. *Renoir, My Father.* San Francisco: Mercury House.

Rewald, John. 1973. *History of Impressionism.* New York: Museum of Modern Art.

Rogers, Mary. 1970. "The Batignolle Group: Creators of Impressionism." In *The Sociology of Art,* edited by M. Albrecht, J. H. Burnett, and M. Griff. New York: Praeger.

Rossi, Alice. 1985. *Gender and the Life Course.* New York: Aldine.

Runco, Mark A., and Robert S. Albert, eds. 1990. *Theories of Creativity.* Newbury Park, Cal.: Sage Publications.

Sabatelli, Ronald, and C. L. Shehan. 1993. "Exchange and Resource Theories." In *Sourcebook of Family Theories and Methods,* edited by Pauline Boss et al., chap. 16. New York: Plenum.

Schwartz, Benjamin. 1997. "The Idea of the South." *Atlantic Monthly* 280 (6): 117–26.

Schur, Max. 1972. *Freud: Living and Dying.* New York: International Universities Press.

Sherr, Lynn. 1995. *Failure Is Impossible: Susan B. Anthony in Her Own Words.* New York: Times Books.

Shone, Richard. 1992. *Sisley.* New York: Harry N. Abrams.

Short, James F., and Frederick L. Strodtbeck. 1965. *Group Processes and Delinquency.* Chicago: University of Chicago Press.

Silvestre, Armand. 1892. *Au pays des souvenirs.*

Slater, Philip. 1967. *Microcosm: Structural, Psychological, and Religious Evolution in Groups.* New York: John Wiley.

Smith, Thomas Spence. 1992. *Strong Interaction.* Chicago: University of Chicago Press.

Stansky, Peter. 1996. *On or about December 1910: Early Bloomsbury and Its Intimate World.* Boston: Harvard University Press.

Stanton, Elizabeth Cady. 1993. *Eighty Years and More: Reminiscences, 1815–1897.* Boston: Northeastern University Press.Stanton, Elizabeth Cady, Susan B. Anthony, and Matilda Joslyn Gage. 1881. *History of Woman Suffrage.* 2 vols. Rochester, New York: Charles Mann.

Stewart, John L. 1965. *The Burden of Time: The Fugitives and Agrarians.* Princeton: Princeton University Press.

Stuckey, Charles F. 1995. *Claude Monet, 1840–1926.* Chicago: Art Institute of Chicago and Thames and Hudson.

Storr, Anthony. 1988. *Solitude: A Return to the Self.* New York: Free Press.

Sulloway, Frank J. 1979. *Freud, Biologist of the Mind: Beyond the Psychoanalytic Legend.* New York: Basic Books.

———. 1996. *Born to Rebel: Birth Order, Family Dynamics, and Creative Lives.* New York: Pantheon Press.

Sutherland, Edwin H. 1940. "White Collar Criminality." *American Sociological Review* 5 (1): 1–12.

Swales, Peter. 1989. "Freud, Fleiss, and Fratricide: The Role of Fleiss in Freud's Conception of Paranoia." In *Sigmund Freud: Critical Assessments,* edited by Laurence Spurling. New York: Routledge.

Tate, Allen. 1975. *Memoirs and Opinions.* New York: Swallow Press.

Thoits, Peggy A. 1995. "Stress, Coping, and Social Support Processes: Where Are We? What Next." *Health and Social Behavior,* extra issue: 53–79.

Tinterow, Gary. 1994. The Realist Landscape. In *Origins of Impressionism,* edited by

Gary Tinterow and Henri Loyrette, chap. 3. New York: Metropolitan Museum of Art.

Tinterow, Gary, and Henri Loyrette, eds. *Origins of Impressionism.* New York: Metropolitan Museum of Art.

Tolkien, J. R. R. 1967. "Letter to William Luther White." In *Letters of J. R. R. Tolkien,* edited by Humphrey Carpenter and Christopher Tolkien, 387. London: Allen and Unwin.

Triandis, Harry C. 1995. *Individualism and Collectivism.* Boulder: Westview Press.

Tuckman, Bruce. 1965. "Developmental Sequence in Small Groups." *Psychological Bulletin* 63:384–99.

Tuckman, Bruce, and M. A. Jensen. 1977. "Stages of Small Group Development Revisited." *Group and Organizational Studies* 2:419–27.

Turner, Ralph, and Paul Colomy. 1993. "Role Differentiation: Orientation Principles." In *Social Psychology of Groups,* edited by Edward J. Lawler and Barry Markovsky, 23–50. Greenwich, Conn.: JAI Press.

Vollard, Ambroise. 1925. *Renoir, an Intimate Record.* New York: Alfred A. Knopf.

———. 1938. *En ecoutant Cézanne, Degas, Renoir.* Paris.

Wallace, Anthony F. C. 1972. *The Death and Rebirth of the Seneca.* New York: Vintage Books.

Wallace, Doris B., and Howard E. Gruber. 1989. *Creative People at Work.* New York: Oxford University Press.

Watkins, Floyd C., and John T. Hiers. 1980. *Robert Penn Warren Talking: Interviews, 1950–1978.* New York: Random House.

Wells, H. G. 1934. *Experiment in Autobiography.* New York: MacMillan.

Wells, LeRoy. 1990. "The Group as a Whole: A Systemic Socioanalytic Perspective on Interpersonal and Group Relations." In *Groups in Context: A New Perspective on Group Dynamics,* edited by Jonathon Gillette and Marion McCollom, chap. 3. Reading, Mass.: Addison Wesley.

Whitaker, Dorothy Stack, and Morton Lieberman. 1964. *Psychotherapy through the Group Process.* New York: Atherton.

White, Harrison C., and Cynthia A. White. 1965. *Canvases and Careers: Institutional Change in the French Painting World.* New York: John Wiley.

Williams, Raymond. 1960. *Culture and Society, 1780–1950.* New York: Columbia University Press.

Wilson, A. N. 1990. *C. S. Lewis: A Biography.* London: Flamingo.

Wolf, Ernest S. 1988. *Treating the Self: Elements of Clinical Self Psychology.* New York: Guilford Press.

Wolff, Kurt. 1952. *The Sociology of Georg Simmel.* New York: Free Press.

Young, Thomas D., and M. Thomas Inge. 1971. *Donald Davidson.* New York: Twayne Publishers.

Zabel, Morton Dauwen. 1975. *The Portable Conrad.* New York: Penguin Books.

Zola, Emile. 1946. *The Masterpiece.* Translated by Katherine Woods. New York: Howell and Soskins.

Index

interaction styles (*continued*)
ists', 45–55, 81–82; Rye circle's, 118–19. *See
also* group dynamics; norms, interaction
interdependence: Anthony, Stanton and, 206,
233; conflict due to, 241, 253–54, 261, 286–
87; Freud, Breuer and, 167–68; Freud, Fleiss
and, 174–75, 184–87, 188; gender and devel-
opment of, 262–63, 291; individuation and,
256, 257–58; instrumental intimacy and,
160, 284. *See also* mergers; self–other
internal cohesion. *See* cohesive self
internal conflict. *See* ambivalence
Internet communication, 293
interpersonal relationships: maturation of, 257,
276; polarization in, 102–5; self-develop-
ment through, 152–54; strains in, disintegra-
tion and, 126–29. *See also* collaborative
pairs; group dynamics
Interpretation of Dreams (Freud), 161, 177, 185–
86, 187, 190, 193
intimacy: boundaries for, 188–89, 204, 293; gen-
der differences in, 82, 262–64, 291; Internet
communication and, 293; paired collabora-
tion and, 34, 113, 143, 151, 273–74; rebellion
stage and, 280. *See also* instrumental inti-
macy
"Intransigents," 56, 59
Invisible Man, The (Wells), 117
Irish shantytown women, 221
isolation, creativity and, 1, 16–17

Jackson, Jesse, 154
James, Henry, 1, 5; Conrad and, 120–21, 127–29,
150; cultural background of, 117, 126; early
career of, 117–18; Ford and, 128–29; infor-
mal roles, 124, 126; and shared vision, 121–
22, 133, 144; Wells and, 116, 119–20, 121,
126–27, 130–32, 273–74
James, William, 128
Janis, Irving, 65
Japanese art, 41, 115, 268
jealousy, differential recognition and, 255–56,
261
Jensen, M. A., 289
Johnson, Stanley: boundary marker conflicts
portrayed by, 98–99; group polarization
and, 92, 108; group rebellion portrayed by,
86, 88–89, 91; informal roles of, 90–91, 98–
99, 100, 102; meeting rituals portrayed by,
80–81, 82, 83; meetings with, 69, 78, 79;
scapegoating portrayed by, 89–90

Jones, Ernest, 201, 202
Jongkind, Johan Barthold, 35
Joseph Conrad: A Psychoanalytic Biography
(Meyer), 114
journalists, reviews by. *See* press reviews

King, Martin Luther, Jr., 154
Kohut, Heinz, 16–17, 152–54, 201, 283
Korzeniowski, Joseph Conrad. *See* Conrad,
Joseph
Kris, Ernst, 115, 161, 162, 177
Kuhn, Thomas, 178

labor force, women's participation in, 264, 265
landscape painting: developing vision through,
39, 40–42; group commitment to, 60;
paired collaboration on, 33–37, 114, 115; re-
alists and, 28
language: circle formation and, 19, 272–74;
Conrad and Ford's, 139; Conrad's problems
with, 136, 137, 138, 141; Fugitives', 76; shared
vision based on, 7, 9–11; Ultras', 212–13
leadership: absence of, disintegration and, 123–
25; Anthony's rise to, 238–44; cultivating
roles for, 295, 296; escalating exchange
through, 271, 280–81; reunion and revival
of, 287, 288; shifts in, 83–84, 239, 261, 286,
296. *See also* charismatic leader; executive
manager; gatekeeper; peacemaker
Lee, "Light Horse" Harry, 109
Lee, Robert E., 109–10
"Lee in the Mountains" (Davidson), 109–10
Leonardo da Vinci, 14
Leroy, Louis, 59
letters, Freud and Fleiss's, 161–62, 168–69
Lewis, C. S.: Inklings and, 4, 7–11; on internal-
izing roles and vision, 11–12, 135; mirroring
by, 156; on rebellion dynamics, 14, 16, 88;
role conflict of, 250; Tolkien and (*see* collab-
orative pairs, Lewis–Tolkien)
Lewis, Warner, 7, 9
liberals, social reform and, 211–12, 218–19
Liberator (Garrison's paper), 218
life stage: circle formation and, 19, 75–77; col-
laborative pairing and, 139
lightning rod, 277; Anthony as, 240–42; Caille-
botte as, 49, 59, 61–62; functions of, 22, 25,
90–91, 112, 280; Johnson as, 90–91; Tate as,
91, 102, 104; Zola as, 49
Lily (Bloomer's paper), 228
Lise (Renoir), 36

self-analysis, Freud's, 161, 187–90
self-analytic groups, 3
self-cohesion. *See* cohesive self
self-concept. *See* identity
self-development theories, 152–54, 201
self-doubt: Conrad's, 133, 135, 137–38; Freud's, 175; Lewis's, 149; scapegoating and, 89
self-esteem: boosting, scapegoating and, 89–90; Conrad's, Ford and, 135; mirroring, idealization and, 201, 202
selfobject, concept of, 17. *See also* idealized self-object
"sellouts": Breuer as, 181–82; functions of, 162, 280, 281; protégés as, 52, 53; role conflict and, 250; Wells as, 122
Seneca County Courier, 223–24, 226
Seneca Falls, NY: group meetings in, 208; Stanton's move to, 220–21; women's rights convention in, 223–27
Seneca tribe, Quakers and, 221, 223
sensitivity. *See* empathy
separation stage, 277; disintegration and individuation in, 25–26, 286–87; Fugitives', 70–71. *See also* disintegration; individuation
Seraphina (Ford), 139, 141–42, 145
Seurat, Georges, 59
sexuality, theories on: Breuer–Freud collaboration on, 166, 167, 168; Breuer's ambivalence toward, 180–81; conflict over ownership of, 196–200; Freud–Fleiss collaboration on, 186–87, 200; vision for, 178–80, 191–93
Shakespeare, William, 170, 190
shared vision. *See* vision, shared
sharing. *See* exchange
Shaw, George Bernard, 122
Shifting of the Fire, The (Ford), 139, 140
"shoptalk," norm of, 278
Signac, Paul, 59
Silvestre, Armand, 46–47
Simmel, Georg, 54
Sisley, Alfred, 3, 5; Bazille's recruitment of, 30–31, 32, 84; café meetings with, 29, 44; exhibitions with, 56, 58, 59, 61, 62, 63; individuation by, 65–66; marginal status of, 45, 50–51, 53, 68–69; Renoir and, collaboration between, 34–35, 36; role conflict of, 40; social support and, 37–38, 274–75, 279
skills, exchange of, 141–42, 226–27, 256
slavery. *See* anti-slavery movement
Smith, Aaron, 139–40, 141
Smith, Elizabeth Oakes, 240, 241

Smith, Gerrit, 216
"sociability," 54
social background. *See* cultural background
social capital: equality in, 20, 274–75, 283; exchange of, 37–39, 45–46
social class, circle formation and, 17–18
social environment. *See* cultural environment
socialization: circle formation and, 18; circle's role in, 12–13; Mead's theory on, 153; Rye circle and, 124–25, 126
social networks. *See* informal networks
social reform movement: alliances in, 208; Anthony's entry into, 228–30; collective action in, 205, 206–7, 292–93; ideologies in, 210–12; Quakers and, 221–24, 228–30; Ultras' formation from, 214–16; vision for, 22; women's roles in, 209–10. *See also* temperance movement; women's rights movement
social status: circle formation and, 17–18, 20; external, group reaction to, 82; interaction norms and, 45; network structure and, 266–67; Rye circle and, 117; women's, 209–10, 264
social support, 277; buffering conformity through, 270–71; experimentation and, 88; survey research on, 3–4; sustaining commitment through, 256. *See also* emotional support; instrumental support
social support, exchange of: Anthony, Stanton and, 231, 234; Breuer, Freud and, 165; Brown, Stone and, 215, 252; Conrad, Ford and, 133, 140, 147, 148–49; creative work and, 184–85; formation stage and, 120, 278–79; instrumental intimacy and, 151–52, 283–84; reunion and, 26; Rye circle and, 120, 124–25
solidarity: critical roles for, 123, 279; differential recognition and, 255; Impressionists' sense of, 38–39; maintaining myth of, 91; reunion and, 67
"Solitude of Self, The" (Stanton), 259–60
Sons of Temperance societies, 228, 232
Southern culture: alienation from, 87; Fugitives' defense of, 69, 71, 74–75, 111; secularization of, 72–73; tradition of conversation in, 76; turbulence in, 269
Southern Renaissance literary movement, 68, 71
Southern Writers in the Modern World (Davidson), 68
speeches: Anthony and Stanton's collaboration on, 206, 233–36, 246, 252; campaigns and